DAVID SHAPIRO, Professor of Fine Art at
Hofstra University and member of the
Seminar in Early American History and
Culture at Columbia University, is himself
a painter and printmaker. *Social Realism*
is the first in a series of critical documents
in American art to be edited by him.

Social Realism:
Art as a Weapon

CRITICAL STUDIES
IN AMERICAN ART

Social Realism:
Art as a Weapon

EDITED AND
INTRODUCED BY
David Shapiro

With halftone illustrations

Frederick Ungar Publishing Co.
New York

Copyright © 1973 by Frederick Ungar Publishing Co., Inc.

Printed in the United States of America

Library of Congress Catalog Card Number: 72-80263

Designed by Irving Perkins

ISBN: 0-8044-3264-3

For Cecile,
without whom this book
would not have been possible

ACKNOWLEDGMENTS

I am pleased to acknowledge my deep gratitude to two great American scholars: the late Oliver Larkin, who introduced me to American art when I was a young artist teaching at Smith College, and Broadus Mitchell, who more recently helped to bring that interest to productivity by inviting me to join the Columbia University Seminar in Early American History and Culture.

I owe a great debt to the Hofstra University Library, particularly to Elsie Reynolds and her reference staff for their constant help and resourcefulness in finding materials, and to the reference librarians at the Great Neck Public Library for their generous assistance in uncovering a wide range of details. I would like to thank the Archives of American Art for permitting me to use their files; the American Institute for Marxist Studies for making their library available to me; William Gropper, Jacob Lawrence, and Jack Levine for their cooperation in updating and revising their chronologies; the Terry Dintenfass Gallery, the Kennedy Galleries, and the ACA Galleries for information and catalogs; and the many authors and publishers who have allowed me to include their material. I am grateful to my colleagues who read this manuscript, particularly Dr. Milton Brown of City University, and I am very appreciative of Dr. George Jackson's many thoughtful comments and suggestions. I thank my editor, Stanley Hochman, for his perceptive assistance.

I would also like to thank the following for the pictures that appear in these pages: the Whitney Museum for *Through the Mill* by Philip Evergood and *Gangster Funeral* by Jack Levine; the Museum of Modern Art for *The Feast of Pure Reason* by Jack Levine, *One of the Largest Race Riots Occurred in East St. Louis* by Jacob Lawrence, and *The Senate* by William Gropper; the ACA Gallery for *Capitalist Cartoon No. 1* by William Gropper; the Kennedy Galleries for a sketch for a mural in the Federal Security Building in Washington, D.C. by Ben Shahn, and *Sacco and Vanzetti* by Ben Shahn; the Terry Dintenfass Gallery for *Praying Ministers* by Jacob Lawrence; and Mrs. Armand Erpf for *American Tragedy* by Philip Evergood.

Most of all, my thanks are to my wife, who participated in every aspect of this book.

Contents

ix

SECTION III FIVE SOCIAL REALISTS

CRITICAL STUDIES
IN AMERICAN ART

Social Realism: Art as a Weapon is the first in a series of books that
aim to present the best—or most pertinent, revealing, or typical—
critical response to American art over the years. The changing
estimates and assumptions of each generation of critics as each examines
works of art from its own point in time has become part of our
cultural history. American art has come to be valued and recognized
as never before. If only for this reason, it is imperative that we begin
to see American art more clearly, both in itself and in relation to art
all over the world.

<div align="right">D.S.</div>

Section I
Introduction

Social Realism Reconsidered

DAVID SHAPIRO

BLOOD soaks the ground. Gunsmoke floats in the air. The central figure in this turbulent, bright, almost garish painting of the violent dispersal of picketing strikers is an angry, defiant worker, dressed in a white shirt and tie that ironically remind us that this is a Memorial Day massacre. While attempting to protect his pregnant wife with one arm, he holds off a nightstick- and revolver-wielding policeman with the other. Surrounding this tableau are groups of workers being clubbed to the ground by cops with brutal faces. The workers are taking a thorough beating and are being driven out of the left side of the canvas. In the background there is a steel mill, glowing orange, part of an industrial complex.

This is the 1937 painting of social realist Philip Evergood called *American Tragedy*. After exhibition at the ACA (American Contemporary Art) Gallery it was purchased by millionaire collector Armand Erpf. More recently, in 1960, the painting was included in the retrospective exhibition of Evergood's work at the Whitney Museum, an exhibition that subsequently traveled to several other major museums around the country. Both the painting and its history are very typically American.

The iconography of this Evergood painting, archetypical Social Realism,[1] is no more unexpected that that of a painting of the Mother and Child or of the Annunciation during the Renaissance. Both, in their time, were favorite subjects and vehicles of expression for artist and patron. Social Realism attempted to use art to protest and dramatize injustice to the working class—the result, as these artists saw it, of capitalist exploitation. In narrative content this was an art boldly and often fiercely anti-Establishment, although the term itself had not yet come into use.

This study is an attempt to answer some persistent questions about American art and the unique aspect of it represented by Social Realism. Is American Social Realism a matter merely of the

3

sort of subject matter summarized above? Was it the economic depression alone that caused "social protest painting," as it was also known, to capture the minds of so many artists during the 1930s? Was Social Realism as it developed here a uniquely American phenomenon? What part was played by the Communist Party? Is Social Realism a part of a living American art tradition that predates the Depression and continues today? What was its aim and what did it achieve? These are some of the questions toward which this essay is directed.

In looking back at the period, in reading the journals (both art and political), in studying the exhibition catalogs of museums and galleries, I am confirmed once again in my conviction that Social Realism was the dominant art in the America of the Thirties.[2] Scarcely an issue of any art journal of any political or social hue was published without some article, review, or story on an aspect of Social Realism, the role of the artist in Depression society, or both. The other major and pervasive movement in the Thirties was American Scene painting, as most prominently represented by Regionalists Grant Wood, Thomas Hart Benton, and John Steuart Curry.[3] The movement least noticed, exhibited, and practiced then, although in subsequent decades it was to become the most influential of all, was, of course, abstract and nonobjective painting and sculpture.

The style that came to be called Social Realism arose in the United States in the 1930s and for a decade or so was practiced more widely here than anywhere else in the world. So strong was its lure and so true to the realities of life did it seem, that its assumptions influenced an entire generation of artists. To the artists of the Depression years, America seemed, even more than it had in the past, to offer no rewards for their abilities or talent. This appeared to be true not only for those whose work was politically or socially committed but also for those who espoused "art for art's sake."[4]

The effects of the Depression on the art world were disastrous: the already small art market shrank to almost nothing. Private buyers disappeared first, but museums also curtailed purchases of original work and cut their staffs and therefore museum hours. Then the museums dealt a more direct blow by reducing their

exhibition schedules, thereby further reducing the artist's oppor-
tunity to show his work. "May the artist live?," a question that
artists were forced to ask themselves more persistently than ever
before, was also the title of an article that outlined and docu-
mented the problems.⁵ That the matter was serious was underlined
by the action taken in 1932 by the College Art Association, which
was both a response to this kind of criticism and a foreshadowing
of vaster Federal projects that came later. (It is worth remarking
that at the time the College Art Association would have been
almost entirely composed of art historians with scarcely a sprink-
ling of actual painters and sculptors, for few colleges then em-
ployed artists as teachers.) The Association petitioned the Gibson
Committee of the Emergency Work Bureau to create a depart-
ment for unemployed artists, and shortly thereafter about a hun-
dred artists were put to work under the program. Each received
$25 a week if married, $18 if unmarried. They worked at non-
profit institutions, with the institutions paying for materials and
the Emergency Work Bureau responsible for salaries. In New
York, for instance, some of these artists produced wall paintings
for the Hudson Guild (a settlement house), the Spanish Depart-
ment of New York University, and the auditorium of St. Ambrose
Roman Catholic Church. Some taught art classes in such lower
East Side settlement houses as Christadora House and the Educa-
tional Alliance. Also active in attempting to alleviate the artists'
condition was the small federal Public Works of Art Project under
the direction of Mrs. Juliana Force.⁶

Arguing that art was not to be classed as a luxury along with
"Rolls-Royces, Kohinoors, and Palm Beach," A. M. Frankfurter
urged that museums be kept open, "if necessary by a volunteer
staff of unoccupied young men and women who are able to devote
their time as custodians." Such people might constitute an "aristoc-
racy to lead the vanguard of culture."⁷

These comments are samples of those voiced by that small por-
tion of the public that concerned itself with art. The suggestions
were occasionally acted upon to some extent, and thus the eco-
nomic problems of some artists were alleviated. The artists them-
selves were not silent. Stuart Davis in the mid-Thirties voiced
some of the perennial complaints of artists. The considerations

raised by Davis, a well-known abstract painter even then, were not peculiar to the Depression. Economic problems had simply become more acute and painful in a shrinking market, he said. Davis saw the contemporary American artist as one who had been forced by circumstance to become a part of respectable business-oriented society, an entrepreneur, an individualist who worked within the framework of middle-class culture—with a subject matter acceptable to that culture—and one who marketed his product through channels set up by the middle class. In so doing he was badly exploited by art dealer and patron alike. When an artist's work is accepted by a gallery, Davis pointed out, it is accepted on consignment only, and the dealer will deduct thirty to fifty percent of the sale price as commission if and when it is sold. The cost of a catalog, advertising, and even the mailing will frequently be charged to the artist having a one-man show. Davis continues a citation of the specifics in the exploitation of the artist as entrepreneur and businessman, but the artist as worker, as union man, member of the Artists' Union, and potential member of the AF of L, as employee in Municipal, State, and Federal Arts Projects would, he hoped and believed, "develop as an artist through development as a social human being."[8]

Former expatriates also swelled the roster of artists without money; when their sources of income had dried up, they had been forced to return and confront American life, many of them for the first time. Some were frightened, others disillusioned. Some who had encountered Socialist, Marxist, or related theories in Europe— and had dismissed them as irrelevant—now began to believe that they had a special applicability to America's economic distress. One of this number, the young literary critic Malcolm Cowley, announced that joining up with the Left would enable the artist to find a new audience, a new subject matter, and a new view of himself, as well as a new relationship to the dying and decadent ruling class.[9]

Such conversions and assertions, along with the lack of money that was common to almost all, were factors that led to the fusion of Bohemia with the Left, or, as they often characterized themselves, the Revolutionary Movement. In the 1920s both the Bohemians and the radicals despised those who dominated society

(the "booboisie" as Mencken dubbed them)—the Bohemians because they felt the arts were stifled by the materialist culture of America, and the radicals because "the system" forced the artist to work in an atmosphere that resembled, in Oliver Larkin's phrase, "a grotesque carnival." In characterizing the Twenties, Larkin notes that this was the country in which Bruce Barton, a prominent advertising executive, wrote a book to prove that "Christ had been the very pattern of the business executive," a country in which it was notoriously illegal to teach evolution in Tennessee, in which Negro, Jew, and Catholic were victims of the Ku Klux Klan, in which Sacco and Vanzetti had been executed.[10]

Even though the Armory Show of 1913 had seemed to open America to the experimentation in painting and sculpture that had been developing in France and Germany for several decades, by the Thirties those working in modern techniques and forms had lost their paying audience, for although collectors here continued to buy the works of the new European masters, they largely ignored the home-grown experimentalist, as did the museums, whose funds for the purchase of contemporary American art were small in any case. The situation of neglect in which these artists found themselves helped add one more group to those who were reexamining their place in society.[11]

American art was searching for a style at the time Social Realism was urging its claims, and this too was an element in the latter's growth and acceptance. Although the Armory Show had introduced abstraction to America, it had never overcome the inertia of America's distrust of it as foreign and inimical to native thought. And although the American Scene had been newly rediscovered— and was easily understood and popular—to many artists it did not seem to have dynamic force or complexity of thought.

But it was not economics alone that made the Thirties frightening enough to force serious reevaluation. The horrifying specters of war and fascism loomed over a nation that had on the whole truly believed that all wars were in the past. One by one the chances to forestall these menaces were lost while the country— and much of the world—was divided among those who welcomed the "wave of the future," those who hated and feared it, and those who were oblivious to the threat, willfully or innocently. Japan in-

vaded Manchuria in 1931, Hitler made himself chancellor and then dictator of Germany in 1933, Mussolini grabbed Ethiopia in 1935. The League of Nations was impotent, as it was throughout the Spanish Civil War (1936–1939), a war that turned out to be both training and proving ground for the world war that finally began with the invasion of Poland by Hitler's army in 1939.

In an atmosphere of this kind, in which the artist felt powerless, creative workers of every persuasion suggested every variety of answer. T. S. Eliot called for a community of Christians regulated by an elite, whereas his fellow poet W. H. Auden (who later, reversing Eliot's action, gave up British citizenship for American) wanted artists to work for the masses, saying that anyone fearful of working for a mass audience did not know the meaning of art.[12] To many American artists who knew of the succession of walls Mexican artists were painting in public buildings, Auden's seemed to be the path to follow.

Paradoxically, in terms of the Depression, but providentially, in terms of the artist's fresh confrontation with America, in 1929 the Museum of Modern Art was established in a Fifth Avenue office building, and the following year the Whitney Museum set up shop in a townhouse on Eighth Street. Both of these New York museums became important elements, albeit often overlapping, in the search for the place and identity of American art.[13] The Whitney exhibited American art only, providing from its inception a base for the exploration of varying concepts of contemporary native art. For the first time an American museum provided space in which the works of living American artists could be seen without the distraction of work from the past or from other cultures.

In its early years the Museum of Modern Art too sponsored American work. It showed in its first year "Living American Painters" as well as work by Eakins, Ryder, and Homer, and it continued to offer such innovations as an exhibit of American folk art in 1938. In 1935 the Whitney surveyed American genre painting and, in 1938, a century of our landscape painting. The powerful Metropolitan Museum of Art ended the decade with a large-scale panoramic show, "Life In America." Year after year, such exhibitions developed into a forum that did much to give importance to American subject matter and thought, affording many

artists a measure of independence from foreign, particularly French, art.

Furthering the sense of American identity and validity in art, a few pioneering scholars, critics, and museum people began studying its past. Long before the existence of any departments of American studies at any of our universities, men and women such as J. T. Flexner, Oskar Hagen, Suzanne LaFollette, Virgil Barker, Lewis Mumford, Holger Cahill, Alfred H. Barr, Lloyd Goodrich, and even a popularizer like Thomas Craven began to research, to write about, to exhibit, and to criticize the creative work of Americans past and present, thereby giving yet another impetus and theoretical basis for the development of Social Realism. Despite all these factors—the Depression itself, the questioning of capitalism to which many citizens felt driven, the burgeoning of art work programs and the subsequent development of art trade unions, the return of the expatriates and the marriage of Bohemian and radical, the opening of museums that encouraged a new consciousness of the American artistic past by promoting American painting and sculpture—the single greatest element in the development of this explicitly political and social art may very well have been the United States government itself.

II

Although the Gibson Committee's efforts resulted, as we have seen, in the small beginnings of publicly supported salaried work for artists, it was the New Deal of Franklin Delano Roosevelt that innovated programs of "relief, recovery, and reform . . . that took shape in agencies with alphabetical designations—the CCC, the NYA, the WPA, the PWA, the TVA."[14] These agencies became the instruments that for a time gave training in skills to some and relieved the more pressing anxieties of a few others by providing work. Whatever the demerits, inefficiency, waste, boondoggling involved in such undertakings—and there were assuredly sins of omission and commission in such vast enterprises—federal funds were used in a fashion that transformed the country, most especially in the arts. Painters and sculptors were given an opportunity to

participate in this huge program—unprecedented and radical—
through the Federal Arts Projects of the Works Progress Admin-
istration, the Civil Works Administration, and later in the Fine Arts
Section of the Treasury Department, which, in the main, sponsored
Post Office murals.[15] Programs that included artists were estab-
lished not only "to give these people work and relief,"[16] but to
offer the citizens of the country as a whole the opportunity to look
at graphic art, hear music, and see plays.

That art was being brought to a wider public was noted by
Holger Cahill, head of the WPA Federal Arts Project, in a review
of the year's work in 1936. In that year, he said, nearly 450 murals
had been painted for schools, post offices, city halls, prisons, and
hospitals.[17] Helen and Robert Lynd, in their second landmark study
of a "typical" middle American city, *Middletown Revisited*, showed
that the construction of an Art Center to house the local collection
had increasingly wider ramifications, since the building led to the
formation of groups involved in art, whereas ten years before no
activity of this sort had existed.[18] In cities across the country new
community art centers, with classes in painting and sculpture in
which thousands were enrolled, familiarized the artist and the com-
munity with each other. The 1936 exhibition at the Museum of
Modern Art called "New Horizons in American Art" epitomized
this trend by showing the paintings, sculpture, and graphics pro-
duced under WPA Arts Projects auspices.

Not only were the visual arts introduced to more people, but in
towns and cities that had never seen a painting, never heard a
symphony orchestra, never watched a live performer, life was
changed in some way when orchestras, plays, exhibitions, were
introduced, giving the ordinary person his first opportunity to par-
ticipate in the cultural life of the nation.[19] A deliberate attempt
was made at cultural dispersion, to reverse the movement of the
arts toward concentration in our largest cities, to make of art,
instead, a possession of a whole people. Such an aim found its echo
in the responses of the Social Realists, who insisted that art be-
longed to the people, not to the ruling class.

Yet the Arts Projects cast their longest shadow by allowing
artists to live and work as painters and sculptors, in most cases for
the first time in their lives.[20] The Projects turned out to be the

single largest training ground for art that America had ever known, the first time the training of artists had been federally subsidized in this country, and the last time this happened except for its tangential occurence under the GI Bill after World War II and the Fulbright Act since then. No restrictions, on the whole, were placed by the Project on subject matter, on ways of painting; there was no distinction on grounds of style, race, religion, or even politics.[21] This freedom, combined with a regular paycheck, was the exemplary part of the Project, nurturing both the artists' lives and their work,[22] but entry in and out of what might have seemed a paradise was restricted by high gates labeled "means." The WPA Arts Project, employing as it did at its height over five thousand people, among them easel painters, art teachers, photographers, and craftsmen, became, in effect, a huge employer. The artists objected to being forced to sign a pauper's oath in order to qualify for employment, although the same condition was required of all other WPA workers as well.[23] The artists claimed that such an oath was demeaning to any human being, let alone creative workers.

There were other sources of discontent. Work conditions and work places, which were of course makeshift and "temporary," were almost always inadequate and a cause of friction. Since the artists were salaried employees and not individual entrepreneurs, as had become traditional in post-Renaissance society, rules and regulations, along with supervisors to enforce them, were part of the package; on the whole artists found them to a greater or lesser degree restrictive. A widespread trend of the Thirties found expression here when, as in so many other large organizations at that time, the workers—in this case, artists—banded together to form a union. In 1933 they formed the Artists' Union. It was frequently at odds with the administration and it tended to radicalize the artists, calling attention to indignities and injustices involving them as well as other workers. Because of its point of view, public statements, and its public exhibitions, the Artists' Union born of the projects became yet another prod to paintings and sculpture that made social comments.[24]

Further, both inside the Union and outside it, artists were actively participating in politics. Philip Evergood, who had been a supervisor of an art project as well as one of the leaders of the

Artists' Union, has said that he could not have painted his *American Tragedy* with so much feeling if he had not been the victim of just such a beating while on the picket line of the Artists' Union. "They beat me insensible . . . my nose was bleeding, blood was pouring out of my eyes."[25]

Congressional critics of the WPA used clashes between artists and arms of the government as proof of their contention that the government was supporting a frivolous activity—art—and also that it was nurturing left-wingers, indeed Communists, whose class-conscious paintings showed only the ugly parts of American life. Repeated Congressional attacks, threatening to cut back and even eliminate the Arts Projects, plus the unsatisfactory working conditions, and finally the summary firing of artists who began to organize their fellow employee-artists, were themselves the strongest impetus for the successful formation of the Artists' Union. The Union and the anti-capitalist stance of many of its members was further strengthened by its fight against the suppression or destruction of murals by Diego Rivera, David Alfaro Siqueiros, Ben Shahn, Lou Block, and Joe Jones.[26]

On its own, the Union held exhibitions around the country. Most of the paintings shown were Social Realist—some satirical, some sentimental, and others bitter and filled with scenes of police brutality, strikes, evictions, picket lines and bread lines. The identification of painter with subject, and audience with artist and picture, was often immediate, since frequently everybody was in the same predicament. Such a "shock of recognition," widely expressed and responded to, introduced a new dimension to twentieth-century American art.

Along with this sense of identification with other workers, with union men, with the down-and-out, a custom developed that fostered further interaction. When painting murals in small-town post offices, schools, town halls, and other public buildings, the artists attempted to depict those events that were considered most important in local history.[27] In so doing, the artists rediscovered certain traditions, subject material that often became grist for Social Realism.

The Artists' Union and, even more, the Federal Arts Projects that gave birth to it, were essential ingredients in the emergence of

Social Realism. It should be noted that of the five artists selected for inclusion in this study as exemplars of the best in Social Realism's style and thought, four worked on one or another of these government-sponsored art projects. (The fifth, William Gropper, was long employed as a cartoonist by a Communist Party newspaper.[28] However, Gropper painted several murals under the Treasury Department's program of decorations for Post Offices.)

Out of the upheaval caused by the Depression—and through the Federal agencies, the strikes, the union movement, the public protests, all part of the attempt to alleviate the worst effects of it— Social Realism came into being. If it is generally agreed that art is one of the aspects of human activity that gives point and value to life, then visual art is the focus of values in visual form. The conditions of life in the Thirties turned increasing numbers of artists from consideration of formal visual problems to consideration of man's place in the social order. Many artists came to interpret what they saw happening in the United States as a class struggle between capital and labor: in a word, they became Marxists. The Marxism of most artists, whether it included membership in one of the Marxist parties or not, tended to be uncomplicated by knowledge of Marxist theory, in spite of what Marxist scholars may have been writing and thinking during the Thirties. With rare exceptions, the painters and sculptors were not intellectuals. They saw American economic life as having failed because of the "inherent contradictions of capitalism." Therefore, capitalism was bad, a way of exploiting one class for the benefit of another, and it was doomed. Socialism promised to solve the economic problems; it would prevent exploitation, making a new ruling class of the workers. Therefore, socialism was good—and in any case, "inevitable." As icing on the cake, artists who had visited the Soviet Union reported that the artist lived far better under socialism than he did under capitalism.[29]

As artists, they came to see as their duty the exposure of privilege. Their paintings were to be both a demand for justice and an exhibition of the misery of unemployment, the fortitude of workers, the corruption of the ruling class, and the humiliation caused by poverty. Once they saw their role in this way, many artists deliberately divorced themselves from the still persuasive nine-

teenth-century idea of art as primarily a means for self-expression
and self-fulfillment; instead they embraced the idea of art as a means
of communicating social values. In the same way, other artists
disengaged themselves from the formalism that had been develop-
ing during the first decades of the twentieth century. (Some Social
Realists had studied and practiced cubism, dadaism, etc., although
others were scarcely aware of the existence of modern forms, or
they dismissed them solely on socio-political grounds.) Abandoning
both the study of new ways of seeing form and space and the
expression of personal emotion and private values, the Social Real-
ists now concerned themselves with the communication of ideas,
with an art that pointed a moral, told a story, or created an emo-
tion in the onlooker—preferably an emotion that led to militant
social action.

The painting of many periods, particularly that of the Renais-
sance, could be subsumed under similar aims, as most Social
Realists were aware. The difference is, of course, that the stories
told by the Social Realists were not about Christ, nor were the
morals necessarily Christian ones.

Social Realism is not an art of the studio—rarely does one see
a painting of the model, costumed or nude, and even less frequently
is a still life encountered. Social Realism's only landscapes are at
least partly cityscapes—a decaying mining village, or shacks along
the railroad tracks. A variety of genre painting, Social Realism
takes as its main subject certain significant or dramatic moments in
the lives of ordinary poor people. The moments in their lives
selected (and it is always a moment in someone's life—it is hard to
think of Social Realist painting that does not include a human
being) are almost always those that in some way focus on the
indignity or pathos of their situation—the hard work they perform,
the inadequate rewards they receive for it, or the miserable condi-
tions they work under. There is almost always, implied or explicit,
a criticism made of the capitalist system. With this as their subject
matter, Social Realists perforce showed those aspects of American
life that were the least "pretty." Not for them to glory in the
soaring mountains, or, for that matter, in the soaring skyscrapers.
Instead, they painted the people in the slums, the industrial suburbs,
the factory towns, and sometimes on the farm.[30] When rich people

do appear, they are the objects of satirical derision: art patrons unable to understand the pictures they look at, dowagers attending the opera for snob reasons only, millionaires dining in splendor while half the world goes hungry.[31]

At its best Social Realism was not merely imitative of people and objects in the real world. Its point of view sometimes allowed it to transform objective reality into symbols of transcendent meaning. The paintings often so idealized The Worker that Joseph Wood Krutch could comment with some justification that the "worker of communism is merely the Noble Savage of Rousseau all over again." But the artist, now a Worker either by virtue of his new employment in the Project or by virtue of his new poverty or new point of view, consciously sought a reintegration with society; he saw the working class as the dynamic new force, the bourgeoisie as broken, and the ruling class as wicked. As a recent critic said in an entirely different context, these notions may be "unfashionable but they are not ignoble or absurd."[32]

Social Realists further believed that paintings stemming from the attitude characterized as "art-for-art's sake" were the logical outcome of the conditions of life and art in modern industrial capitalist society, and were, therefore, to be forcefully shunned. In addition, the conditions themselves had to be transformed, for it was only by changing society, the artist reasoned, that he could both alter his economic and social position and fulfill himself in art. Socialism would transform art as well as the life of the artist. The Social Realist sought common cause with the workers: his role was to both portray and inspire their actions. He must direct his work toward the mass of people and remain indifferent to the praises or purchases of the small group of wealthy collectors.[33] Self-expression and anarchistic individuality were the result of the isolation and alienation of the artist in capitalist society. Art had become a commodity like any other commodity on the market, and the artist had sold himself as well as his picture. Instead of expressing his sense of loneliness and neglect, the artist must depict the values held by the people in their everyday lives. The Social Realist artist was not to practice the self-indulgent self-expression encouraged by a decadent capitalism for its own jaded amusement; instead, he was to use his freedom to interpret the aspirations of a free people.

(The Mexican muralists Orozco, Rivera, and Siqueiros were the exemplars.) He must learn how to communicate, by means of images understandable to all, what was in the minds and hearts of the people. Cultural means, now owned by the bourgeosie, must be wrested from them so that the new culture of the people will dominate, with the artist as their visual voice, their prophet.[34]

Such, then, was the ideological program for the artists who were convinced that their fulfillment could come only through Social Realism. Their livelihood was to be provided by their audience, not in the form of private buyers, but by that newly powerful organization of the masses, the trade unions.[35] The theory was that capitalist society tended to corrupt the worker through its values in art, but the new painting and sculpture reflecting working-class values would be immediately appealing to—and therefore purchased by—the unions. In the long run, such uncorrupted paintings would educate the union members who looked at them in their meeting places.

III

Social Realism is in the American grain. From its beginnings American art has been realistic and didactic.[36] It has been the art of a materialist people powered by the Protestant ethic of hard work and material rewards. Only when there were sufficient material things did we even begin to have art.[37] In its beginnings it echoed Puritan values: only portraits were important, but not merely as records of leading or wealthy individuals. They were useful because they presumably taught a moral lesson to the on-looker and constituted a visible example for emulation. In the late eighteenth century, as the country grew more prosperous and populous, artists brought back from Europe the idea of history painting. The purpose of history painting was to teach, commented Benjamin West, the American-born eighteenth-century artist who later became the president of the English Royal Academy. A history painting, he said, "should be able to inspire in a small boy ideas of greatness." Such paintings were valued because they were thought to give moral instruction. The relation-

ship between this tradition and the rationale of Social Realism
does not need belaboring.

Genre painting, too, has always occupied an important place in
American art. Beginning with the mid-nineteenth century pic-
tures of William Sidney Mount and George Caleb Bingham, and
including the Ash Can school in the early part of the twentieth,
this tradition continues to the present day.[38] Moreover, the the-
ory behind the Ash Can school was that ordinary life in the
streets was as valid a subject for art as any more elevated sub-
ject.[39]

The painters of the Hudson River school were in a real sense
the forerunners of American Scene painters (or Regionalists, as
they are sometimes called), although the former were extravaga-
gantly proud of the country's unspoiled beauty and the latter
began by searching for scenes that could still inspire pride and
then, finding them, celebrated the rediscovery. Separated by al-
most a century, each group reflected some of the values of its
time, and each forces us to acknowledge that the object, the
real world outside the studio, the connotative and denotative
meaning of images, are of consistent importance in American art.
It may be that a materialist society, demanding real or seemingly
real things in its pictures, was by its nature the logical begetter of
Social Realism.

Nor do subject and style considerations alone make the case.
The American art world has at times democratically catered to the
middle class, and not solely to the monied aristocracy who have in
most Western societies been its patrons. The American Art-Union,
from 1839 to 1853, as well as other art unions and similar organiza-
tions in various cities throughout the country, had promoted the
idea of an art available to all the people and reflective of national
values and life.[40] By purchasing paintings and publishing engravings
that reproduced them, these organizations supported artists. By
requiring as subject matter pictures that showed American lives,
activities, and attitudes, or American views and landscapes, they
influenced not only the kind of work artists did but the kind their
audience accepted. By distributing thousands of these prints
among their 19,000 members they created a widespread middle-
class audience whose taste they both educated and reflected.

Their achievements are not unlike the goals aimed at by the Social Realists.[41]

IV

Yet for all the authority that Social Realism derived from American cultural history, for all the effects of the Depression and the consequent Federal projects, Social Realism might never have become a major cultural force if it had not been actively promoted by Marxist artists, critics, and theoreticians.

The ideas and aesthetics of Social Realism were discussed and articles were published by such groups as the John Reed Clubs, the American Artists' Congress, the Artists' Union, the United American Artists, and the Young American Artists.[42] Not since the Artistes Républicains of 1848 or the Artists Federation of the 1870 Commune in France had there been such a ferment of political organization among artists.[43] Social Realists aimed at advantages for themselves and their audience by means of both their pictures and their political action. But they aimed for group advantage, not personal fame and fortune.[44] They confidently believed that art was a weapon—a phrase that became a rallying cry—and they were convinced that art could communicate ideas, change thinking, and free the imagination in ways that would benefit mankind.[45]

The John Reed Clubs were the first groups to promulgate these ideas in the United States; they were initiated by and were branches of the International Union of Writers and Artists, which met in Kharkov in 1929.[46] The preamble to the constitution of the Clubs states that they "recognize the irreconcilable struggle between workers and capitalists as two contending classes. We believe that the interests of all writers and artists should be identified with the interests of the working class."[47] There were John Reed Clubs at varying times in New York, Chicago, Boston, Washington, D. C., Philadelphia, Detroit, Newark, Seattle, Portland (Oregon), and Hollywood. In all, there were about eighteen clubs in the United States in 1932.[48] In addition to providing a regular meeting place at which matters of art and politics could

be discussed, the Clubs held art exhibitions, published journals, such as the *Partisan Review*,[49] and established art schools. (The John Reed Club Art School in New York, which opened in 1935, later became the American Artists School, lasting until 1939.) All this activity was directed toward organizing "a strong weapon for the struggle in the cultural field against capitalism and against social-fascism, which is rapidly coming to be capitalism's cultural front."[50]

From the beginning there was a sharp difference of opinion within the John Reed Clubs about who should be eligible for membership: one group wanted committed revolutionaries only, the other wanted all friendly intellectuals to be admissible.[51] This difference was never entirely resolved, but in point of fact the Clubs tended to seek and to be open to artists and writers with some reputation in their fields. (Many joined the Clubs or an exhibition because of the social and economic crises, and then left because of the shifts in policy engendered by the international political commitments of the Clubs.) With the advent of the Popular Front[52] policy in 1935, this question was formally resolved in favor of a broad organization. The John Reed Clubs were buried, first giving birth to the American Writers League and the American Artists' Congress, hybrid infants fathered by a shifting political policy and mothered by many of the same people who had nurtured the John Reed Clubs.[53]

A reviewer of the first art exhibition held by the John Reed Club in New York in 1932 thought that it was not successful. The very title of the exhibition—"The Social Viewpoint in Art"—betrayed the "uncertainties of revolutionary art," he said in the *New Masses*. More than half the exhibits expressed no revolutionary ideas. Instead there were some simple enactments of the life of the worker. The art was not sufficiently militant. It was mostly a rehash of current genre painting, with at most some small change in choice of subject matter. So far as critic John Kwait could make out, the artists had no clear idea of the issues in the class struggle.[54]

Reviewing the second annual, in which nonmembers again participated, Louis Lozowick noted improvement over the first. He saw a clearer connection between conception and execution,

a more militant class consciousness "seeking an embodiment of form" necessary to transmit more eloquently the emotional impact of the work. Yet he felt compelled to admit that some of the work did not live up to the "dynamic process" of depicting the theme of the exhibition—"Hunger, Fascism, and War"—from a class viewpoint. Because it was such a difficult and high aim, Lozowick wrote, "our standards must be correspondingly strict." He pointed out, therefore, that some of the work was muddled, some immature, and some suffered from "a disharmony between manner and matter."[55]

The shortcomings noticed by Kwait and Lozowick remained the key problems of Social Realism from the time of its first exhibition to its demise as a major school in American art. Scenes from the lives of American workers remained its distinctive subject matter, but "revolutionary art," whatever might be understood by those words, was not achieved.

The Leftist critics demanded a great deal of the artists, perhaps because they shared their goals. Others were better pleased. *The Nation's* reviewer even thought that the first show was as "significant as the historic Armory exhibit which brought the aesthetic heresies of twentieth century Europe to the United States." She noticed that "the shift of interest from things to people is aggressively marked; also the shift from decoration to emotional experience, from sensory pleasure to human anger and pain. . . . These things give the show as a whole a beat of life."[56] To the writer in *Creative Arts* magazine the first exhibition was "significant," with "little derivative painting," although she saw a "spiritual kinship with Daumier, Goya, Nolde, and Roualt." Instead of propaganda for its own sake, she said, "the drab, frustrated existence of the worker and his clashes with his hostile environment provided the inspiration for most of the canvases." The exhibition was "not only interesting as a cross-section of the proletarian ideology that is coloring artistic expression today, but impressive because of its high average of technical facility."[57]

In the Thirties young artists who were attracted to the Left in general and the Clubs in particular were most often from the lower middle-class, sometimes the working class, although there were a few like George Biddle who came from wealthy or illus-

trious families. Many of them had been shut off from other cultural currents either by narrow backgrounds, poor educations, or very limited supplies of money.[58] With few exceptions they were white males, and either they, their parents, or their grandparents had emigrated from Europe. Generally speaking, the artist had stumbled on revolutionary or socialist or communist theories either at art school (rarely had he attended college) or when he had arrived in the big city to live and work as an artist. Marxist ideas were often immediately attractive because they offered an escape from the deadly pall that had settled over America, a demoralizing environment directly attributable, it seemed to many young painters and sculptors, to the Depression and the economic system that had allowed the catastrophe to occur. To the young artist it seemed that the American dream had lost even its mythic validity, and he began to articulate a more up-to-date version.

To such artists, the John Reed Clubs seemed both a refuge from the frustrations of the Depression and a place where they could fill in the outlines of their ideas. The cultural program of the John Reed Clubs was launched by chance at exactly the right psychological moment (1929), just as the failure of the economy startled the country. In the face of this the Clubs offered hope of solutions and of becoming an intellectual center. Some of their values and judgments seem limited and utilitarian today; at the time they appeared bold and all-encompassing. By seeing artists in reference to all of society, they gave artists a key rather than a peripheral role in changing it.

Social Realism, then, in addition to stemming from American traditions, added to them new political notions. The artists were political, saw themselves as political, produced a political art, and were a conscious part of a political movement with worldwide ramifications. Most Club members considered themselves Marxists and the Soviet Union a Marxist nation. As a result, they quite naturally looked on the USSR with approval. Therefore, no "orders from Moscow" were necessary to inspire policies that furthered the kind of art that they believed would intellectually and aesthetically help transform what they saw as a decaying

capitalist society. The same is true of policies that promoted Soviet political aims.

The "Call for an American Artists' Congress," published in the art journals as well as *The New York Times* and *New Masses*, was both a political and an artistic move. As the introduction to the *First American Artists' Congress 1936* stated, the Congress was not a mere "spontaneous explosion." Rather, it was a result of nearly a year of "meetings and planned effort" by such initiators as George Ault, Arnold Blanch, Henry Billings, Peter Blume, Maurice Becker, Nicolai Cikovsky, Aaron Douglas, Stuart Davis, Adolph Dehn, William Gropper, Hugo Gellert, Harry Gottlieb, Minna Harkavy, Eitaro Ishigaki, Jerome Klein, Louis Lozowick, Jan Matulka, Saul Schary, William Siegel, Niles Spencer, Harry Sternberg, and Moses Soyer, who "took the initiative in searching for a way out of the economic and cultural impasse confronting virtually all artists."[59] Signatures on the Call read like a Who's Who in American Art of the Thirties—artists, critics, museum curators, photographers, and designers. Included were people such as Max Weber, Ben Shahn, James Johnson Sweeney, Adolph Gottlieb, Eugene Higgins, William Gropper, Alexander Calder, Margaret Bourke-White, Peter Blume, Norman Bel Geddes, Berenice Abbot, Milton Avery, Philip Evergood, Lewis Mumford, Isamu Noguchi, Fairfield Porter, Meyer Schapiro, David Smith, Moses and Raphael Soyer, Niles Spencer, Joseph Stella, and Carl Zigrosser. They represented virtually the entire spectrum of the art world.

The public session held at Town Hall in New York on February 14, 1936, was opened by Lewis Mumford, who set the tone with his salutation: "Friends, comrades, ladies and gentlemen." The formation of the Congress was necessary, he said, because there were those who wanted to solve the catastrophe of the Depression by means of a "counter-irritant"—war and fascism. "The time has come," he continued, "for the people who love life and culture to form a united front against them [war and fascism] to be ready to protect, and guard, and if necessary, fight for the human heritage which we, as artists, embody."[60]

In a series of four closed sessions, papers were read on such topics as "The Artist in Society," "Problems of the American

Artist," and "Economic Problems of the Artist." Participants in
these sessions included art historian Meyer Schapiro, artists Max
Weber, Arnold Blanch, and Henry Billings, and the Mexican
muralists Orozco and Siqueiros. The excitement engendered by
the Congress was felt throughout the American art world, al-
though not everyone agreed about the aims, policies, or accom-
plishments of the Congress.

The artist is not a group man, argued Peyton Boswell in re-
sponse to a speech made at the Congress by Heywood Broun,
who urged artists to organize their own trade unions. "The very
nature that leads him to be an artist," the editor of the *Art
Digest* wrote, "makes him intensely individualistic: to such men
the very thought of unionization is distasteful. They are not the
same as coal miners. The loss of personal initiative means the loss
of creative spirit."[61] Rockwell Kent replied that Renaissance art-
ists had been Guild members: "I point out that Leonardo was
enrolled among the Company of Painters in Florence." He sug-
gested that the powerful conservative groups in the art world
"lend their ears to the voice of necessity which the Artists' Con-
gress has raised and their brains to the movement's support.
Join," he wrote, "and you *may* find in the movement an equiva-
lent for a religion of today, which so many people feel to be
America's profoundest need."[62] A Chicago art critic, reviewing a
Congress exhibition there, said that the American Artists' Con-
gress was "too much involved with international politics to com-
mand confidence as a leader in the art liberation of Chicago and
of America."[63] At the risk of being called a red-baiter, as Arthur
Millier wrote of a Congress show in Los Angeles, he nonetheless
insisted that the Congress was "a potential tool of the Communist
Party" and that the rank-and-file artist members were "duped
liberals who had been tricked by clever slogans."[64] F. Gardner
Clough, the former editor of a Woodstock, N. Y., newspaper, at-
tacked the Congress and summarized the objections of many of
those opposed to it: "Let's eliminate the humbuggery by divorc-
ing this stupid union of Art and Politics."[65]

Anti or pro, virtually everyone talked or wrote about this new
and even unique phenomenon in American art: organizations of
creative people—cultural workers, as they were then often called

—that had been formed not as exhibition or sales societies, but as a means of promoting an aesthetic and of working toward a political goal through both their creative works as artists and their activities as citizens. Statements followed counter-statements; the columns of the art magazines were a forum. Artists Yasuo Kuniyoshi, Saul Schary, and Hugo Gellert, for instance, replied to Clough. His comments, they wrote, were full of distortions. "The trail of the red herring meanders over the land. . . . It is exactly this type of mentality displayed in Mr. Clough's tirade which confirms our belief in the need for a Congress such as ours and convinces us of the necessity of redoubling our efforts in the fight against Fascism and War."[66] The Los Angeles branch of the Congress replied to Millier that he ought to worry himself less about artists as dupes and concern himself more with their art. Ironically and somewhat disingenuously, they asked, "Why your preoccupation with politics, Mr. Millier? Remember, you are an art critic."[67]

All this ferment helped advance the goal of these politically oriented artists—to bring art out of the studio and into the streets. As early as 1933 a perceptive art critic had pointed out that propaganda and conviction were two of the strongest influences in the shaping of art destinies. "During the last decade in America," she wrote, "art has been slowly developing its own style of propaganda. More and more in exhibitions one meets with paintings and sculpture devoted to man's thoughts on the subject of his own condition. Since the depression especially has this trend been noticeable. . . . A man who knows hunger," she continued, "whether physical or spiritual, has within him a genuine spur to self-expression. If he be inarticulate he seeks the breadline; but if there is within him creative fire, he seeks through art to protest in terms sufficiently realistic to be generally convincing. . . . There are indications that an art of social repercussions is breaking ground."[68]

Politically oriented painting appeared more and more in the exhibitions sponsored by museums, galleries, and other art organizations,[69] but it was the discussions and example of the artists who were part of the organized movement that had made for a pervasive change in the subject matter of a great many

American painters—perhaps the majority of them. Nor was it conviction alone that brought all these artists under the umbrella of social protest. Fashion, then as ever, no doubt attracted some artists, for in the Thirties, Social Realism was "in."

In addition, the exhibition programs of the Congress and the Union, especially the former, were national in scope, and artists and viewers throughout the country were affected by their content. Sections of the Congress's first exhibition opened simultaneously in eight cities in the United States: New York, Chicago, Philadelphia, Los Angeles, Detroit, Cleveland, New Orleans, and Portland (Oregon). The artists included, well known at that time, were Social Realists, American Scene painters, academicians, satirists, and others less easy to categorize. Among the names, some still familiar, were those of Leon Kroll, Paul Manship, Alexander Brook, Peggy Bacon, Philip Evergood, Harry Gottlieb, Yasuo Kuniyoshi, Max Weber, George Biddle, Raphael Soyer, Rufino Tamayo, Art Young, as well as "three recent Guggenheim Fellowship winners": William Gropper, Joe Jones, and Aaron Bohrod. Typical of the paintings reproduced in the art magazines was Henry Billing's *Arrest, Number 2*, which shows a worker who has been beaten to the ground by four detectives now about to arrest him. Behind them the steps and base of an official building with its Greek columns can be seen. At the top of the steps part of a statue, obviously of a great statesman, can be seen upon its pedestal, the finger of its right hand pointing down to the brutal action. Another reproduction, *May Day*, by Theodore G. Haupt, shows three militant workers carrying red flags, the composition a deliberate echo of "The Spirit of '76," a painting familiar to generations of Americans.

Artists' Congress exhibitions were usually based on a specific theme. One called "America Today" was a print show that opened simultaneously in thirty cities on December 1, 1936; it was the first such event in American art history. "Social themes and abstraction jostled with each other" in this exhibition which was hung in museums, libraries, and galleries.[70] The tone of the exhibition was caught by *Print* magazine when it reproduced a lithograph by Mervin Jules, *The Dust Bowl*, a comment on the plight of the Oklahoma farmer.

The Artists' Union had its own gallery in Chicago, where it frequently held exhibitions. The art world took note and sometimes indulged in flights of optimism: "The opening of a Gallery by the Artists' Union makes an end of something in Chicago and it makes a beginning of something else. The Federal Art Project has freed artists from the caprice of patrons; now they have no more need of dealers, and now they need not suffer at the hands of reactionary juries. They can go simply to the people for themselves. It is their first step toward the thing in which Van Gogh believed: 'An association of artists who guarantee each other's work and living.' "[71] Although the Union did not have its own gallery in New York, it frequently sponsored exhibitions at the ACA Gallery. Of one of its exhibitions in 1936 a critic concluded that "revolution begins at home" was the policy of the Artists' Union. Although one "nude doesn't look as if she ever worked in a sweatshop or stood on a picket line," a good portion of the paintings were based on themes of "workers in the home, the shop, the factory, the mine." He noted a "fair amount of trenchant or humorous anti-bourgeois satire."[72] That such an ACA show was a fair survey of what was being hung on the walls of many galleries in America at that time can be seen by a glance at the list of titles in the catalogs of exhibitions given under various sorts of sponsorship.

By the time of the Russo-German pact in 1939, the mood of artists on the Left was changing from angry yet hopeful elation to disillusion. Painters and sculptors who had been politically active, who had marched in the parades of the Thirties—on May Day, for Spain, against war, for the Soviet Union, against evictions, for strikers, and for a host of related pivotal and peripheral causes—began to return to their studios to reconsider. They became skeptical about means and ends that had seemed certainties only a short time before. The possibility of creating a proletarian culture began to seem remote and its desirability problematical.

The reasons for the shift are many: just as the Depression had served as tinder to fire the Left, so its slow easing served to quench it. Federal attempts to alleviate the grosser social inequities by means of government projects quieted some dissidents. At

the same time, party line shifts in the art organizations, as Communists attempted to accommodate Soviet policy, destroyed the trust of others in the Left and made active enemies of even more. Furthermore, public works projects, including those created for art workers, were gradually phased out as American involvement in the war provided jobs. Although such closeouts did not endear the system to artists, the demise of the government agencies did effectively destroy the bases of group activities for artists. Finally, America's entry into the war marked the end of an era. (Note in the bibliography the hiatus of discussion of Social Realism during the war years.)

In writing of literary movements of the period Lionel Trilling said that Left political aims and values gave "a large and important part of the intellectual middle class . . . 'something to live for,'" be it merely "a point of view, an object for contempt, a direction for anger, [or] a code of excited humanitarianism."[73] This states the case for painters and sculptors as well. The war itself replaced former aims and values, and winning the war became the primary aim, the "something to live for." Social Realism continued after the war to be a major force during the last half of the Forties, even attracting new adherents. But the fading of the Depression, the conclusion of World War II, and the end of government employment for artists had so weakened the leftist movement that it was unable to maintain its attractiveness to either a significant number of talented artists or to the most influential segments of the art public when it was challenged by Abstract Expressionism in the Fifties.

There are still artists in America who base their work on social comment. Some, like those selected for inclusion in this volume, grow directly out of the theories of the Thirties, although there are others who continue the role with entirely new forms and philosophies. Pop artists, for instance, have made telling social statements.[74] But there is no gainsaying that on the whole Social Realism has passed into history and become one more strand in the American tradition. Whether we consider Social Realism to have been an important—or beneficial—addition to the tradition depends to some degree on our view of politics and aesthetics and what we think the artist's relation to each ought to be. It

is possible that Social Realism never reached fruition because it was based on faulty reasoning, that it could produce no real revolutionary art where no real revolution had occurred. Perhaps it failed to fulfill its promise because it never found its audience, or to be more accurate, its putative patrons; most often the art was purchased by the bourgeoisie, and this indicates that it must in some way have satisfied their taste.[75] Trade union audiences in the main were not pleased with Social Realism; they did not want to relive their miseries by viewing them in pictorial form.

In most periods art has had a particular place in a specific social setting, but it may be that in our time art cannot be made for a social setting. It may have to be addressed "to whom it may concern."[76] Perhaps art has evolved into just another commodity, a product that comes to market and awaits a buyer. The isolation of the work of art from a continuity with society or a use within society may in itself constitute its social setting. It may be too early to judge whether Social Realism was a success or failure or whether, as is more likely, it contained elements of each. What is worth seeing is that the movement developed in America for historical and social reasons, that it contributed viable paintings and ideas to the repertoire of American art, and that, like so many cultural movements, as it recedes into the past we can begin to see some parts of it more clearly.

NOTES

1. Social Realism and Social*ist* Realism are different from each other. Social Realism, opposed to the ruling class and its morés, predominantly selects as its subject matter the negative aspects of life under capitalism: labor conflicts, poverty, the greediness of capitalists, the nobility of long-suffering workers. Socialist Realism, as it has developed in the Soviet Union, supports the ruling class and the form of government. It selects as its subject matter the positive aspects of life under socialism: happy, cooperating workers, the beauty of factory and countryside, well-fed, healthy children, and so on. Mexican Social Realism, somewhere between these two, shows both the struggle of the people to gain control of the means of production and some of the fruits of that power. The present volume is concerned with the first named, Social Realism, as it has developed in the United States.

2. This needs to be stressed because the "Art of the Thirties" exhibition at the

Whitney Museum in 1968, directed by William Agee, seemed to revise history by selecting a distorted sampling of material. However, a comparison of the catalog of the show with any selection of catalogs of the Whitney Annuals during the relevant period confirms that a quixotic and personal choice was made for this exhibition that was either badly titled or badly selected.

3. It has been argued that Social Realism was in actuality merely another aspect of American Scene painting, its urban and industrialized facet. Yet the record shows that from the mid-Thirties on the Social Realists were at ideological loggerheads with the American Scene painters. (The latter group is today held in lower critical esteem than any other movement of the period. It may be that because some of the issues raised by Social Realism are once more in the news, it will enjoy a revival that has thus far not been granted the American Scene.)

4. The feeling that America offered no rewards for the artist was not, of course, a new one. It is a thought that has echoed and re-echoed through the documents of American artists almost from the very inception of our art. According to Henry James, Washington Allston, an internationally renowned early nineteenth-century painter who returned from England to work in the United States, was one of the earliest victims of this typically American neglect of art and artists. The words of such other nineteenth-century American painters as Samuel F. B. Morse and John Vanderlyn are still on the record to attest to America's failure to reward them. The expatriates of the 1920s were a direct expression of the belief that art could flourish better outside the United States. The prototype of Sinclair Lewis's Babbitt had been around long before he appeared on the fictional scene in 1922.

5. Audrey McMahon, "May the Artist Live?", *Parnassus* 5, October 1933, pp. 1–4. Mrs. McMahon, later appointed Director of the New York WPA/FAP, considered the question vital to the 8000 known artists and the thousands not known; she also implied that "cultural aridity" would follow economic failure if the artist was not enabled to survive by means of some sort of work created for him. She, too, blamed American society and tradition for the particular isolation of the American artist. The indifference to art and artists, she said, was "due, in part, to the fact that art has been kept remote from our daily lives." See also Francis V. O'Connor, *Federal Support for the Visual Arts: The New Deal and Now* (Greenwich, Conn.: New York Graphic Society, 1969), pp. 47–48, for Mrs. McMahon's later comments. O'Connor's study is a valuable source for a full discussion of the government's role in the Arts Projects.

6. O'Connor, *Federal Support for the Visual Arts*, p. 32.

7. A. M. Frankfurter, "Art and the Depression," *Fine Arts*, December 1932, p. 31.

8. Stuart Davis, "The Artist Today—Standpoint of the Artists' Union," *American Magazine of Art* 28 (August 1935), p. 476.

9. Daniel Aaron, *Writers on the Left* (New York: Harcourt, Brace & World, Inc., 1961), p. 286.

10. Oliver Larkin, *Art and Life in America* (New York: Rinehart & Company, Inc., 1949), p. 372.

30 *Introduction*

11. It should be noted, too, that in its time Social Realism was the avant-garde and was therefore attractive to younger artists, especially in its "épater les bourgeois" philosophy. Then, as today, the young wanted to be where the action was, and in the Thirties the action was in Social Realism.

12. Larkin, *Art and Life in America*, pp. 405–406.

13. The formation of the Whitney Museum of American Art was publicly announced on January 6, 1930, and was opened to the public on November 18, 1931. Its director was Juliana Force, Mrs. Whitney's secretary, and its curatorial staff consisted of artists only. The museum grew out of the Whitney Studio Club founded in 1918; this was a social and exhibiting center for artists, with dues of five dollars a year. It was succeeded by the Whitney Studio Galleries in 1928. The desire was, as Mrs. Force put it, for a museum of American art "unhampered by official restrictions, but with the prestige which a museum invariably carries." (Lloyd Goodrich and John Baur, *American Art of Our Century* [New York: Frederick Praeger, 1961] pp. 13–15.) The Museum of Modern Art was established by seven art collectors: Lillie P. Bliss, Mrs. W. Murray Crane, Frank Crowninshield, A. Conger Goodyear, Abby Aldrich Rockefeller, Paul J. Sachs, and Mrs. Cornelius J. Sullivan.

14. Larkin, *Art and Life in America*, p. 409. The initials stand for the Civilian Conservation Corps, 1933–1942, which employed youths, mainly in conservation of national resources; the National Youth Administration, 1935–1944, which was established mainly for the purpose of providing part-time work for young people, many of them students; the Works Projects Administration, 1935–1943 (from 1939–1943 called the Works Progress Administration), which provided work mainly by launching building programs. The Federal Art Project (which lasted only four years in all), the Federal Writers Project, and the Federal Theatre Project all functioned under the WPA aegis, as did the NYA during its first years. The Public Works Administration, 1933–1947, administered construction of public works and made loans to states and municipalities for such purposes. The Tennessee Valley Authority was created in 1933 to develop the entire Tennessee River basin. See also O'Connor, *Federal Support for the Visual Arts*, p. 130, for the complicated table of organization for the various federal arts projects.

15. Edward Bruce, "Uncle Sam's Plan: Treasury Department Art," *Art Digest*, Vol. 9, 1 December 1935, pp. 3–4.

16. Larkin, *Art and Life in America*, p. 409.

17. Larkin, *Art and Life in America*, p. 412. See also Francis V. O'Connor, "Official Reports on Artists' Relief Work," *Art News*, 32 (7 April 1934), p. 11.

18. Larkin, *Art and Life in America*, p. 412. See also Anon., "WPA Takes Stock at Washington," *American Magazine of Art*, 29 (August 1936), pp. 504–506, and Edward Bruce as quoted by Garnett McCoy in "Poverty, Politics, and Artists 1930–1945," *Art in America* 53 No. 4 (August–September 1965), p. 96.

19. For a discussion of the impact of the federal projects on theater, see Hallie Flanagan, *Arena* (New York: Duell, Sloan, and Pearce, 1940). For a further discussion of their impact on the visual arts see O'Connor, *Federal Support of the Visual Arts*. The Federal Writers Project supported the Federal Writers Guidebooks which, state by state, retell their history and folklore. See also Erwin O. Christensen, *Index of American Design* (New York: The Mac-

millan Company, 1950) for a sampling of hundreds of drawings from a unique study of the decorative arts in America made by Project artists. Thousands of the originals repose in the Smithsonian.

20. "When I came back from Germany where I studied with Hans Hofmann, and also did some movie picture work at the studios, I got on WPA. Now that gave me a certain kind of freedom and I think that our great artists like Rothko, de Kooning, Franz Kline, all these people that have promise today and are creative, had that moment of peace, even if it was in a loft, to continue with their work. So, I feel that was a great benefit, a great contribution to our creative people and very important in the history of art. And not only in the visual arts but in the theater, and the folk arts, there wasn't a thing they didn't touch on. The wonderful buildings that came up, and the highways. At that period, people in our country didn't have jobs and the head of the government was able so intelligently to use mankind and manpower. I think it's a highlight of our American history . . ." Louise Nevelson as quoted in a 1964 interview by McCoy, *Art in America*, p. 100. Note also, in the biographical outlines in this volume, that four of the five artists were at some time employed by the federal government.

21. Burgoyne Diller as quoted by McCoy, *Art in America*, p. 96.

22. "When else could an American artist be assured of his materials, a place to work, and $23 every week?" commented Jack Levine some years later (quoted by Frank Getlein in *Jack Levine* [New York: Harry N. Abrams, Inc., 1966], p. 14).

23. O'Connor, *Federal Support of the Visual Arts*, pp. 70–78. For a time, however, a certain small number of established artists were accepted on the Projects regardless of means.

24. Davis, "The Artist Today."

25. "So I got into things like the 219 sit-in strike to defend artists on the WPA. I was one of the smaller organizers. Paul Bloch, the sculptor who was killed in Spain a short time later, was the really brave man and conspicuously the revolutionary leader of it, you might say. He stuck his chin right out and put his arms right around that post and they had to beat him insensible to get him out of there. They beat me insensible, but just because I was standing in the front line and refused to ungrip my arms with the others around me, and refused to leave the building. My nose was broken, blood was pouring out of my eyes, my ear was all torn down, my overcoat had been taken and the collar ripped off. I was pushed out by the police at the bottom of the elevator and thrown into a Black Maria. Later they took us to a vile jail up on the West Side, and they put us in cells where the toilets had overflowed and we were standing, ankle deep, men and women, all night in that filth. We were tried en masse, and escaped with a warning.

"Perhaps I overdid the action—not because my convictions aren't the same now as then—but maybe I could have done just as much by putting the time into my work. Still what's lost on action may be gained in feeling. This is putting it a little crudely, or rather too simply, but I don't think that anybody who hasn't been really beaten up by the police badly, as I have, could have painted an *American Tragedy*." John I. H. Baur, *Philip Evergood* (New York: Frederick A. Praeger, 1960), p. 52.

26. Davis, "The Artist Today," and Walter Pach, "Rockefeller, Rivera, and Art,"

Harper's Monthly 167 (September 1933), pp. 476–483. See also Phillipa Whiting, "Speaking About Art: Riker's Island," *American Magazine of Art* 28 (August 1935), pp. 492–496.

27. Peyton Boswell, *Art Digest* 9 (1 December 1935), p. 3 and Edward Bruce, "Uncle Sam's Plan."
28. Gropper worked for the Communist Jewish language newspaper "Freiheit" throughout the Thirties.
29. Louis Lozowick, "Artist in the Soviet Union," *Nation* 135, pp. 35–36.
30. For scenes of mining villages, see Harry Sternberg's paintings of this period; for black farm workers, see the entire oeuvre of Robert Gwathmey. Such paintings (and titles) as the following are typical: Evergood's *Toiling Hands, Through the Mill, Mine Disaster*; and Shahn's *Mine Disaster, Vacant Lot*, and *Handball*. For a typical review of this kind of art, see E. M. Benson, "Artists' Union Hits a New High," *Magazine of Art* 29 (February 1936), pp. 113–114.
31. See, for instance, such paintings as Evergood's *Still Life*, Mervin Jules' *Museum of Modern Art*, Levine's *Welcome Home*.
32. Noel Annan, "Love Story," *The New York Review of Books*, 21 October 1971, p. 13.
33. At no time, however, did Social Realists stop selling their work to museums and to private buyers. The latter were mainly middle-class sympathizers, small businessmen, and professional men in medicine, dentistry, and the law. The ACA Gallery almost exclusively and the Downtown Gallery along with other modes handled the work of the Social Realist artists included in this volume. The ACA Gallery was known as the main source of exhibition and sales of Social Realist painting. Evergood and Gropper exhibited there, while the Downtown Gallery showed Shahn, Levine, and Lawrence.
34. The aims and audience of Social Realism, its proper imagery and iconography, are still a topic of worldwide discussion, although the present volume of Social Realist debate in the United States is smaller than in the past. Yet the spread of Socialism in eastern Europe and Asia has engendered a parallel growth of discussion of Marxism and Art. The following articles, in addition to those reprinted in this volume, will be useful to those wishing to investigate the subject further: Michael Harrington, "A Marxist Approach to Art," *The New International*, Spring 1956, pp. 40–49; Vernon Clark, "The Guernica Mural, Picasso, and Social Problems," *Science and Society*, Winter 1941, pp. 72–78; Marion Summers, "The Prospects for Social Art," *The Daily Worker Supplement*, 3 February 1947, p. 6; Leonard Baskin, "The Necessity for the Image," *The Atlantic*, April 1961, pp. 73–76; David Alfaro Siqueiros, "Open Letter to Soviet Painters," *Masses and Mainstream*, March 1956, pp. 1–6; Leon Trotsky, "Art and Politics," *Partisan Review* V (August–September 1938) p. 9; Arnold Hauser, "The New Outlook," *Art News*, June 1952, pp. 43–46; Sidney Finkelstein, "Form and Content of Art," *Masses and Mainstream*, January 1963, pp. 30–50; Stefan Morawski, "Vicissitudes of Socialist Realism," *Diogenes*, Winter 1961, pp. 110–136; Max Reiser, "The Aesthetic Theory of Socialist Realism," *Journal of Aesthetics and Art Criticism* XVI (December 1957), pp. 237–248; John Berger, "Problems of Socialist Art," *Labour Monthly* (London, March 1961, pp. 135–143 and April 1961, pp. 178–186; Melvin Rader, "Marx's Interpretation of Art and Aesthetic Value," *British Journal of Aesthetics*, July 1967, pp. 237–249.

35. Several unions did commission works. For instance, the National Maritime Union in the late Forties commissioned a mural by Hugo Gellert, and Anton Refregier did a mural for a local of the Electrical Workers Union. Generally speaking, however, the trade unions and the left-wing fraternal organizations neither bought nor commissioned art.

36. To say this is to ignore American Indian art, which of course was not "realistic," but since its influence on what became the central tradition was peripheral despite its high sophistication, it cannot be accounted a factor in the development of American painting and sculpture in the eighteenth and nineteenth centuries. It is also to ignore other non-white traditions as well as the folk arts brought by various European groups, but the nature of the dominant American society prevented any of these from affecting the central tradition, which stemmed from English and later from high Continental art. American art, of course, has not always been realistic and didactic, but these qualities have always been lurking somewhere behind the canvas.

37. Note that this is not axiomatic in all cultures—American Indian, for example.

38. Andrew Wyeth's popular paintings typify a more recent kind of genre painting.

39. In painting the notion originated in France in the middle of the nineteenth century when Courbet (1819–1877), who was a socialist, was one of the earliest to paint pictures that reflected this theory.

40. For more information about this unique phenomenon, see Mary Bartlett Cowdrey, *American Academy of Fine Arts and American Arts-Union, 1816–1852* (New York: New-York Historical Society, 1953).

41. For further discussion of the similarities between the goals, such as government patronage of the arts, of the artists of the mid-nineteenth century and the Social Realists, see Larkin, *Art and Life in America*, p. 153.

42. The membership in these groups frequently overlapped, with the same artist sometimes a member of two or three of them at the same or consecutive periods. The John Reed Club, 1929–1935, was an organization of artists and writers who considered themselves revolutionaries. The Clubs were the American branch of the International Union of Revolutionary Writers and Artists. The other groups noted above—the American Artists' Congress (1936–1940), the United American Artists (1936–1940), and the Young American Artists (1937–1940)—(the Y.A.A. composed mainly of students)—were of American origin and unaffiliated with international bodies.

43. Boris Ternovetz, "John Reed Club Art in Moscow," *New Masses*, April 1933, p. 25.

44. It would be naïve to believe that no artist hoped to achieve fame and fortune —it is, after all, an occupational disease—and in any case the record shows that more than a few did, but it was unnecessary to suggest, as Philip Rahv did in the *New Leader*, 10 December 1938, that Communists and "fellow travelers" joined or remained under the Communist Party aegis solely for careerist reasons. It seems likely that Communists and their followers were driven no more and no less by self-interest than were other political and social groups. Rahv makes a more telling point in this piece when he says that the artists did not really think through the bases, meanings, and implications of Social Realism, but rather followed along on emotional appeal.

45. Ternovetz, "John Reed Club."

46. Mike Gold, "Kharkov Conference," *New Masses*, February 1931, p. 14, and March 1931, p. 7.
47. Oakley Johnson, "The John Reed Club Convention," *New Masses*, July 1932, p. 14.
48. Johnson, "The John Reed Club Convention," p. 14.
49. The *Partisan Review*, which was the literary organ of the John Reed Club of New York City, later broke with the Communist Party and subsequently represented a different facet of the Left. See Aaron, *Writers on the Left*, pp. 297–299.
50. Johnson, "The John Reed Club Convention." The quotation is from the "Call for a Conference" sent out by the John Reed Club of New York.
51. Johnson, "The John Reed Club Convention," p. 14.
52. The Popular Front was the name given the policy urging the Left political parties to join together, forgetting for the time their internal differences, in order to fight against the common enemy: fascism. This was spelled out at the Seventh World Congress of the Communist International in Moscow, 25 July to 30 August 1935. See Georgi Dimitroff, *The United Front Against Fascism and War* (New York: Workers Library Publishers, 1935).
53. Orrick Johns, "The John Reed Clubs Meet," *New Masses*, 30 October 1934, pp. 25–26. Note the proposal made by Alexander Trachtenberg, who "greeted the conference in the name of the Central Committee of the Communist Party." He urged that the Clubs "bend every effort to hold a National Writers' Congress at some time within the next eight months. . . . [A] writers' organization [that should] be followed by a similar action uniting American artists. Such a mobilization . . . will organize American revolutionary culture against the imperialist war plans." With Johns as one of its organizers, the First Writers' Congress met in 1935, a year before the First Artists' Congress.
54. John Kwait, "John Reed Club Art Exhibition," *New Masses*, February 1933, p. 23.
55. Louis Lozowick, "The John Reed Club Show," *New Masses*, 2 January 1934, p. 23. Among the artists exhibiting were Ben Shahn, Orozco, George Biddle, Nicolai Cikovsky, Walter Quirt, Edward Laning, William Gropper.
56. Anita Brenner, "The Revolution In Art," *The Nation*, 8 March 1933, p. 268.
57. Gertrude Benson, "Art and Social Theories," *Creative Arts*, March 1933, p. 216.
58. See Alan Calmer, "Portrait of the Artist as a Proletarian," *Saturday Review of Literature*, 31 July 1937, p. 3, for a more extended discussion.
59. Stuart Davis, "Introduction," *The First American Artists' Congress*, 1936.
60. Lewis Mumford, "Opening Address," *First American Artists' Congress*, p. 2.
61. Peyton Boswell, *Art Digest*, 1 March 1936, p. 3.
62. Rockwell Kent, *Art Digest*, 15 April 1936, pp. 14–16.
63. C. J. Bulliet, *Art Digest*, 15 April 1937, p. 6.
64. Arthur Millier, *Art Digest*, 10 January 1938, pp. 12–13.
65. F. Gardner Clough, *Art Digest*, 15 November 1935, p. 19.
66. Yasuo Kuniyoshi, Saul Schary, Hugo Gellert, *Art Digest*, 1 December 1935, p. 34.
67. *Art Digest*, 15 January 1938, p. 13.
68. Dorothy Grafly, art critic for the Philadelphia *Public Ledger*, in *Art Digest*, 15 January 1933, p. 26.

69. The Young American Artists, for instance, sponsored by both the American Artists' Congress and the United American Artists, promulgated the ideas of the parent organizations in the art schools. The Young American Artists also exhibited publicly—on one occasion at R. H. Macy's, where in keeping with the store's advertised policy all the works were marked down six percent for cash. The author was one of the exhibitors.

70. Elizabeth McCausland, *Print* 7, December 1936, pp. 110–111.

71. J. Thwaites and M. Thwaites, *Magazine of Art*, January 1938, p. 38.

72. Benson, "Artists' Union Hits a New High," pp. 113–114.

73. Lionel Trilling, *Partisan Review*, 4, Fall 1939, p. 109.

74. Pop artists Claes Oldenburg, George Segal, Edward Kienholz, and others have frequently produced art of social comment by appropriating things from the "real" world, with all their denotative and connotative meanings, and looking at them from new angles, or placing them in new settings.

75. "I thought workers would dash for those pictures," Edith Gregor Halpert, director of the Downtown Gallery, recalled in speaking of Ben Shahn's Sacco and Vanzetti series. "But all the buyers, from the Rockefellers on down, were from the other side of the track—or, politically speaking, fence. I got in touch with the Sacco-Vanzetti Club in Little Italy and offered to pay ninety dollars myself so that the Club could own one of the pictures, each of the members to pay ten cents to make up the remaining ten dollars. They came to the show. They thought the pictures were grotesque. Their answer was a decisive NO. I was *so* anxious to be able to tell Ben that he had reached the right audience! But it was the rich—whether because of a guilty conscience or a more perceptive taste, who knows?—who bought the pictures." (Selden Rodman, *Portrait of the Artist as an American, Ben Shahn* [New York: Harper & Brothers, 1951], p. 119.)

76. K. Mitchells, "The Work of Art in its Social Setting and in its Aesthetic Isolation," *Journal of Aesthetics and Art Criticism*, Summer 1967, pp. 369–374.

Section II
Background, Social and Aesthetic

We Capture the Walls!

HUGO GELLERT

During these years of joblessness, Rockefeller Center with its huge wall spaces loomed big, as a mural decoration possibility for many an artist. They waited the completion of the buildings with impatient expectancy. Then came the news: these walls had been assigned without competition. Feeling ran high, the art pages of the bourgeois press were filled with indignation and protest. Something had to be done. The architects of the Rockefeller Center issued a statement denying that the contracts were assigned.

Upon the heels of this upheaval the Museum of Modern Art, of which Mrs. John D. Rockefeller, Jr. is treasurer, invited artists to participate in an exhibition of mural decorations.

"At the present time such an exhibition would be particularly valuable for the information of many interested architects in New York who are in search of competent decorators for buildings proposed or in construction. . . . The exhibition will be hung to display the work of each artist to the best possible advantage before as many architects and as great a public as can be brought together."

A day or two after we delivered our murals, the writer was called to the Museum and told that his use of a horizontal, instead of a vertical panel was contrary to specifications. He agreed to paint a new panel. After this talk, he received the following letter:

"I was thinking, when you are doing over your mural, if it would not be a good idea in a way to do the panel of Lenin instead of the one you did . . . I think that the large figure of Lenin that you indicated would really be a definite and different aspect of the symbolism of the whole social struggle, and also as there is a single large figure, it might take you less time to do it over.

From *New Masses*, June 1932, p. 29. Reprinted by permission of *American Dialog*.

Also, in a way—it is a more monumental design. . . . It was so terribly understanding of you to be willing to paint the panel over and the Museum and myself are really grateful."

Later a telephone call: inquiries, which panel was the writer working on? Shortly after William Gropper learned that three murals had been rejected: Ben Shahn's *Sacco and Vanzetti*, Gropper's *The Writing on the Wall*, and Gellert's *"Us Fellas Gotta Stick Together"—Al Capone*. Then another letter from the Museum.

"I must inform you that (unknown to me) any picture which can be interpreted as an offensive caricature or representation of a contemporary individual, cannot be exhibited. This applies to part of your composition."

The trustees of the museum held conferences with their attorneys. Ivy Lee [public relations expert] was summoned. A. Conger Goodyear, President; Samuel A. Lewinsohn, Secretary; Stephen C. Clark, a trustee, were the most violent in denouncing our pictures.

"How can Mr. [Herbert] Hoover come to the opening!" exclaimed Mr. Goodyear, "and how can I face J. P. Morgan if these pictures are hung in the museum of which I am a trustee!"

Gropper and myself got in touch with a few of the artists and told them of the rejections. They were indignant. One of them volunteered to organize a group and all would withdraw their pictures from the exhibition. The museum heard about it and backed down; all the murals were hung. The victory was the artists'. The strength of numbers shows what can be done if they *stick together*.

Young Nelson Rockefeller, chairman of the advisory committee, went to J. P. Morgan to break the news, and he agreed that it was better to hang the pictures than have a lot of unfavorable publicity.

The Museum crowded our paintings into a little room downstairs and later, finding that the attendance at that room was great, they moved them up to the fourth floor where visitors are unaware of their existence. Photographs in the possession of the Museum were withheld from newspapers. Photographing was

forbidden. Only the insistence of the writer won for a cameraman permission to take pictures.

Throughout the entire procedure the Museum was evasive. Even now it endeavors to place all the blame and responsibility of the exhibition upon the shoulders of Lincoln Kirstein, in spite of the fact that Nelson Rockefeller is the Chairman of the Advisory Committee. The critics are only too ready to be of service: "The exhibition is so bad as to give America something to think about for a long time," says [art critic Edward Alden] Jewell in the [New York] Times. That releases the architects of Rockefeller Center from their obligation to the artists.

"The class struggle orgies may be dismissed as harmless trifles —not because of their theme, but because of the childish or generally uninspired way in which they are handled."—Another gem of Mr. Jewell which releases the Museum from any obligation to us.

And [art critic] Murdock Pemberton says in the New Yorker: "The show easily divides itself into two classes; a few serious artists, who really hoped that they would snare a contract, or at least interest the American architect in their potentialities, and a great many young men who saw only an opportunity to stick out their tongues and have a little prankish fun with their hosts."

Yes, snaring contracts is a *serious* business. To observe your times, and to boldly state your findings, regardless of contracts, is *sticking out your tongue!*

Draft Manifesto of the John Reed Clubs

The Editors of New Masses *take pleasure in publishing this Manifesto which is a draft prepared by the John Reed Club of New York to be submitted to the conference of John Reed Clubs of the United States, meeting in Chicago, on May 30. The conference was called following a suggestion to the International Union of Revolutionary Writers. The International Union then empowered the Executive Board of the New York Club to constitute itself a national organizing committee, to function until a regularly elected National Executive Board could be formed.*

MANKIND is passing through the most profound crisis in its history. An old world is dying; a new one is being born. Capitalist civilization, which has dominated the economic, political, and cultural life of continents, is in the process of decay. It received a deadly blow during the imperialist war which it engendered. It is now breeding new and more devastating wars. At this very moment the Far East seethes with military conflicts and preparations which will have far-reaching consequences for the whole of humanity.

Meantime, the prevailing economic crisis is placing greater and greater burdens upon the mass of the world's population, upon those who work with hand or brain. In the cities of five-sixths of the globe, millions of workers are tramping the streets looking for jobs in vain. In the rural districts, millions of farmers are bankrupt. The colonial countries reverberate with the revolutionary struggles of oppressed peoples against imperialist exploitation; in the capitalist countries the class struggle grows sharper from day to day.

The present crisis has stripped capitalism naked. It stands more revealed than ever as a system of robbery and fraud, unemployment and terror, starvation and war.

The general crisis of capitalism is reflected in its culture. The

From *New Masses*, June 1932, p. 14. Reprinted by permission of *American Dialog.*

economic and political machinery of the bourgeoisie is in decay, its philosophy, its literature, and its art are bankrupt. Sections of the bourgeoisie are beginning to lose faith in its early progressive ideas. The bourgeoisie is no longer a progressive class, and its ideas are no longer progressive ideas. On the contrary: as the bourgeois world moves toward the abyss, it reverts to the mysticism of the middle ages. Fascism in politics is accompanied by neo-catholicism in thinking. Capitalism cannot give the mass of mankind bread. It is equally unable to evolve creative ideas.

This crisis in every aspect of life holds America, like the other capitalist countries, in its iron grip. Here there is unemployment, starvation, terror, and preparation for war. Here the government, national, state and local, is dropping the hypocritical mask of democracy, and openly flaunts a fascist face. The demand of the unemployed for work or bread is answered with machine-gun bullets. Strike areas are closed to investigators; strike leaders are murdered in cold blood. And as the pretense of constitutionalism is dropped, as brute force is used against workers fighting for better living conditions, investigations reveal the utmost corruption and graft in government, and the closest cooperation of the capitalist political parties and organized crime.

In America, too, bourgeois culture writhes in a blind alley. Since the imperialist war, the best talents in bourgeois literature and art, philosophy and science, those who have the finest imaginations and the richest craftsmanship, have revealed from year to year the sterility, the utter impotence of bourgeois culture to advance mankind to higher levels. They have made it clear that although the bourgeoisie has a monopoly of the instruments of culture, its culture is in decay. Most of the American writers who have developed in the past fifteen years betray the cynicism and despair of capitalist values. The movies are a vast corrupt commercial enterprise, turning out infantile entertainment or crude propaganda for the profit of stockholders. Philosophy has become mystical and idealist. Science goes in for godseeking. Painting loses itself in abstractions or trivialities.

In the past two years, however, a marked change has come over the American intelligentsia. The class struggle in culture has assumed sharp forms. Recently we have witnessed two major move-

ments among American intellectuals: the Humanist movement, frankly reactionary in its ideas; and a movement to the left among certain types of liberal intellectuals.

The reasons for the swing to the left are not hard to find. The best of the younger American writers have come, by and large, from the middle-classes. During the boom which followed the war these classes increased their income. They played the stock-market with profit. They were beneficiaries of the New Era. The crash in the autumn of 1929 fell on their heads like a thunderbolt. They found themselves the victims of the greatest expropriation in the history of the country. The articulate members of the middle-classes—the writers and artists, the members of the learned professions—lost that faith in capitalism which during the twenties trapped them into dreaming on the decadent shores of post-war European culture. These intellectuals suddenly awoke to the fact that we live in the era of imperialism and revolution; that two civilizations are in mortal combat and that they must take sides.

A number of factors intensified their consciousness of the true state of affairs. The crisis has affected the intellectual's mind because it has affected his income. Thousands of school-teachers, engineers, chemists, newspapermen and members of other professions are unemployed. The publishing business has suffered acutely from the economic crisis. Middle-class patrons are no longer able to buy paintings as they did formerly. The movies and theatres are discharging writers, actors and artists. And in the midst of this economic crisis, the middle-class intelligentsia, nauseated by the last war, sees another one, more barbarous still, on the horizon. They see the civilization in whose tenets they were nurtured going to pieces.

In contrast, they see a new civilization rising in the Soviet Union. They see a land of 160,000,000 people, occupying one-sixth of the globe, where workers rule in alliance with farmers. In this vast country there is no unemployment. Amidst the decay of capitalist economy, Soviet industry and agriculture rise to higher and higher levels of production every year. In contrast to capitalist anarchy, they see planned Socialist economy. They see a system with private profit and the parasitic classes which it nourishes abolished; they see a world in which the land, the factories, the mines, the rivers, and

the hands and brains of the people produce wealth not for a handful of capitalists but for the nation as a whole. In contrast to the imperialist oppression of the colonies, to the lynching of Negroes, to Scottsboro cases, they see 132 races and nationalities in full social and political equality cooperating in the building of a Socialist society. Above all, they see a cultural revolution unprecedented in history, unparalleled in the contemporary world. They see the destruction of the monopoly of culture. They see knowledge, art, and science made more accessible to the mass of workers and peasants. They see workers and peasants themselves creating literature and art, themselves participating in science and invention. And seeing this, they realize that the Soviet Union is the vanguard of the new Communist society which is to replace the old.

Some of the intellectuals who have thought seriously about the world crisis, the coming war and the achievements of the Soviet Union, have taken the next logical step. They have begun to realize that in every capitalist country the revolutionary working class struggles for the abolition of the outworn and barbarous system of capitalism. Some of them, aligning themselves with the American workers, have gone to strike areas in Kentucky and Pennsylvania and have given their talents to the cause of the working class.

Such allies from the disillusioned middle-class intelligentsia are to be welcomed. But of primary importance at this stage is the development of the revolutionary culture of the working class itself. The proletarian revolution has its own philosophy developed by Marx, Engels and Lenin. It has developed its own revolutionary schools, newspapers, and magazines; it has its worker-correspondents, its own literature and art. In the past two decades there have developed writers, artists and critics who have approached the American scene from the viewpoint of the revolutionary workers.

To give this movement in arts and letters greater scope and force, to bring it closer to the daily struggle of the workers, the John Reed Club was formed in the fall of 1929. In the past two and a half years, the influence of this organization has spread to many cities. Today there are thirteen John Reed Clubs throughout the country. These organizations are open to writers and artists, whatever their social origin, who subscribe to the fundamental program adopted by the international conference of revolutionary writers

and artists which met at Kharkov, in November, 1930. The program contains six points upon which all honest intellectuals, regardless of their background may unite in the common struggle against capitalism. They are:

(1) Fight against imperialist war, defend the Soviet Union against capitalist aggression;

(2) Fight against fascism, whether open or concealed, like social-fascism;

(3) Fight for the development and strengthening of the revolutionary labor movement;

(4) Fight against white chauvinism (against all forms of Negro discrimination or persecution) and against the persecution of the foreign-born;

(5) Fight against the influence of middle-class ideas in the work of revolutionary writers and artists;

(6) Fight against the imprisonment of revolutionary writers and artists, as well as other class-war prisoners throughout the world.

On the basis of this minimum program, we call upon all honest intellectuals, all honest writers and artists, to abandon decisively the treacherous illusion that art can exist for art's sake, or that the artist can remain remote from the historic conflicts in which all men must take sides. We call upon them to break with bourgeois ideas which seek to conceal the violence and fraud, the corruption and decay of capitalist society. We call upon them to align themselves with the working-class in its struggle against capitalist oppression and exploitation, against unemployment and terror, against fascism and war. We urge them to join with the literary and artistic movement of the working-class in forging a new art that shall be a weapon in the battle for a new and superior world.

The John Reed Club Convention

OAKLEY JOHNSON

"ONE year ago was held the Kharkov congress, guided by some of the most politically mature writers in the world's working class movement. This congress gave out, as its two main directives, the following:

"(1) It is our task to create a proletarian literature out of the workshops, out of the factories and mines.

"(2) It is the task of every workers' cultural group to bring in, also, those who are of the middle class, which is in a state of collapse. This class will vacillate. Marx said that vacillating is their historic role. They will bring in dangerous elements. But everything in the Revolution is dangerous."

It is Michael Gold, of the John Reed Club of New York speaking. The place is Lincoln Center Auditorium, Chicago, and the occasion the National Organizing Conference of May 29-30. Thirty-eight delegates, representing eleven John Reed Clubs, with a total membership of about 800 writers and artists, are assembled. They are discussing the correct revolutionary attitude to take toward "fellow travelers"—bourgeois artists and writers who are sympathetic but are not fully won over.

"We can't by taking thought produce great writers or artists," Michael Gold continued. "We can only take concerted action. We can have very clear political lines. At Kharkov the platform was simple, and political. Any writer who subscribed to the political platform was admitted. It should be clear that no one is asked to change his mental habits. Nothing will be dictated to him. You who are here believe in proletarian or colloquial or journalistic writing, and some middle class liberal believes in Proustian writing—but I say bring him into the movement if he is a writer of influence and talent. We cannot afford to have aesthetic quarrels."

From *New Masses*, July 1932, pp. 14–15. Reprinted by permission of *American Dialog*.

Harry Carlisle of the John Reed Club of Hollywood was not satisfied with the conciliatory invitational attitude of Mike Gold toward middle class intellectuals.

"We must not cringe in our approach to these intellectuals," he declared. We must teach them that the first thing is to approach an organization on an organizational basis. We must not be short-sighted. Upton Sinclair, who is on the editorial board of *Literature of the World Revolution,* is at the same time a perennial candidate on the ticket of the California Socialist Party. He appears on programs in debates with Aimee Semple McPherson. The German Communists, we know, have taken a very definite attitude against Upton Sinclair. Is our need of Sinclair so great that we can afford to fall down on principles?

"The sooner we face this thing the better. Middle class intellectuals should have proven to them that they are going through an historical process, and their world is being disintegrated. They are being thrust down into the ranks of the workers. College professors in California, for example, can be told that 2000 university students were unable to register last semester because of the economic crisis.

"I suggest," Carlisle concluded, "that we don't lose sight of the fact that not all intellectuals are middle class. There is a certain proportion of artists and writers of distinctly working class origin, who can be approached on the basis of working class principles. We must not lose sight of that. There we have a connecting link on the basis of revolutionary development."

These speeches epitomized, in a way, not conflicting viewpoints but conflicting emphases. Not *what* is important, but which is more important, was the issue.

"We should meet the intellectual on his own ground by pointing out to him that under capitalist society he lacks opportunity for freedom of expression," Conrad Komorowski of Philadelphia, taking his own line of approach to the problem of the middle class writer, stated. "It is here that the John Reed Club enters. We have to demonstrate that it has given artists and writers their means of highest expression. There is no great art which is not animated by a purpose. Capitalist art is decadent because it has no dynamic pur-

pose. We must point out to the intellectual that only the proletariat has the possibility of building a great and forward-looking culture."

Sharply bringing the delegates themselves, through a precise definition, into the envisaged problem, Joseph Freeman declared, "All members of the John Reed Clubs who are not members of the Communist Party are, strictly speaking, fellow travelers. We don't use the word, 'fellow-traveler,' as an insult. In fact the movement needs fellow-travelers. We know the weaknesses of fellow-travelers as a class, but it is also true that we must not underestimate the importance of sympathetic individuals who have the same background as our own members and have potentially the same future."

Such was the tone of the Monday session of the Conference, in discussing the reports of the commissions. Four main commissions had worked most of the preceding night—the Commissions on the Manifesto, the Organizational Plan, the Program of Activities, and on an Anti-Imperialist War Declaration and various other resolutions. A distinctly high and enthusiastic note was struck for the entire Monday session by the greetings from the International Union of Revolutionary Writers and Artists, read before the opening of the discussion.

"*International Union Revolutionary writers greets National Conference John Reed Clubs and great development American proletarian literature. International situation demands we sharpen struggle against imperialist war menace, against all pacifist and 'returning prosperity' illusions, and against increasing danger of intervention in Soviet Union. We urge you to support heroic struggle of Japanese revolutionary writers against Japanese imperialism. In all your work, prime duty is to show that only way out of present crisis lies with proletarian revolution. We with help of all our sections pledge to build up work of our international union to fulfill growing tasks facing us.*"

The radiogram was signed by the Secretariat.

A wire to the Conference from the Progressive Arts Club and *Masses* of Toronto, Canada, sent proletarian greetings to the Conference, and pledged the solidarity of Canadian writers and artists in the struggle of the working class against imperialist war and exploitation. To the organizations from which these greetings came the Conference sent enthusiastic replies, and also messages of com-

radeship to Maxim Gorky, Romain Rolland, and to the organized
Latin-American, German, Japanese and Chinese writers and artists,
and to the 2000 beet-workers then in a militant and heroic strike-
struggle in Colorado.

A resolution of endorsement of *New Masses*, the leading cultural
organ of the revolutionary American intellectuals, was passed by
the Conference, urging contributions from members of all John
Reed Clubs in the United States. At the same time, the resolution
expressed satisfaction at the establishment of other periodicals for
writers and artists by various local John Reed Clubs, such as the
New Force published by the JRC of Detroit, the *John Reed Bul-
letin* published by the JRC of Washington, D.C., and *Left*, re-
cently taken over by the JRC of Chicago. The strengthening and
expanding of these publications, and the establishment of others
where they are needed and can be satisfactorily handled, was urged
as a part of the activity of the various Clubs.

The Conference was officially opened Sunday, May 29, by Jan
Wittenber of Chicago. The following were elected as members of
the Presidium: Joseph Freeman, New York; Jan Wittenber,
Chicago; Maurice Sugar, Detroit; Conrad Komorowski, Philadel-
phia; Kenneth Rexroth, San Francisco; Charles Natterstad, Seattle;
Harry Carlisle, Hollywood; George Gay, Portland; Carl Carlson,
Boston; and Jack Walters, Newark (Jack London Club). Honorary
members of the Presidium were also elected, consisting of Maxim
Gorky, Romain Rolland, John Dos Passos, Fujimori, Lo Hsun,
Johannes Becher, Vaillant-Couturier, and Langston Hughes.
Maurice Sugar of Detroit was chosen permanent chairman of the
Conference, and Oakley Johnson of New York its secretary.

The reports from the various delegates ranged from the enthu-
siastic and encouraging, to the critical. The John Reed Club of
New York was criticised for its failure to provide effective and
responsible leadership to the other clubs throughout the country.

Absorbed in its own local activities, the New York group had
not seen the importance of carrying forward the work of national
cooperative effort, and had neglected to cement its relationship
with the other clubs by regular correspondence and organizational
assistance. It was not until the John Reed Club of Philadelphia had
urgently proposed that the New York Club begin at once the

formation of a national federation of the Clubs that action was finally taken, and the Conference called.

On the other hand, during the two and a half years since October, 1929, when the John Reed Club of New York was formed, over a dozen similar clubs have sprung up in other cities. It is no small accomplishment that now, as this report is written, notice has been received of the formation of a half dozen other John Reed Clubs that wish affiliation with the national organization, making almost a score of Clubs of revolutionary artists and writers in the United States.

It is impossible to give in detail the speeches of the delegates. When the Sunday evening session was over, at the end of several tense and absorbing hours, the four Commissions began their work. All the thirty-eight delegates served on one or another of these Commissions. The chairmen were as follows: Commission on Manifesto, Joseph Freeman; on Constitution and Organization, Jan Wittenber; on Program of Activities, Conrad Komorowski; on the Declaration against Imperialist War and on other resolutions, Harry Carlisle. After intensive work during much of the night and during most of Monday morning, the second general session, Monday afternoon, May 30, was held. All the delegates were prepared with suggestive plans for organization and for work, but the most complete were those offered by the New York Club as a basis for discussion. These included a draft for a Manifesto, published in the June *New Masses*, drafts of a proposed Constitution and of a proposed schedule of activities, mimeographed copies of which were distributed to all delegates, and a draft of an Anti-War Declaration. The discussion, altering, and expanding of the New York drafts constituted most of the work of the four Commissions.

Briefly, the JRC activities are of two general kinds, described, in the document finally adopted, as follows:

"(a) To make the Club a functioning center of proletarian culture; to clarify and elaborate the point of view of proletarian as opposed to bourgeois culture; to extend the influence of the Club and the revolutionary working class movement.

"(b) To create and publish art and literature of a proletarian character; to make familiar in this country the art and literature of the world proletariat, and particularly that of the Soviet Union;

to develop the critique of bourgeois and working class culture; to develop organizational techniques for establishing and consolidating contacts of the Clubs with potentially sympathetic elements; to assist in developing (through cooperation with the Workers Cultural Federation and other revolutionary organizations) worker-writers and worker-artists; to engage in and give widest publicity to working class struggles; to render technical assistance to the organized revolutionary movement."

The means worked out in detail for the accomplishment of these purposes included publication of pamphlets, sponsoring of national contests for proletarian stories, plays, songs, drawings, etc., distribution of literature, exhibiting revolutionary drawings and paintings, holding public lectures and debates, establishing JRC art schools and schools for worker-correspondents, active participation in strikes and demonstrations, making of posters and contributing of literature to working class organizations, giving of chalk talks, dramatic skits and other entertainment at workers' meetings, and active assistance to campaigns (Scottsboro, Mooney, Berkman) involving special issues.

The organizational work began, naturally, with the recognition that in the United States the John Reed Clubs are an integral part of the Workers' Cultural Federation, and owe an important duty to the work of this larger group. Internationally, on the other hand, the John Reed Clubs are a part of the International Union of Revolutionary Writers and Artists, which has sections in all countries of the world. With relation to each other, the John Reed Clubs of the United States are a federation, each Club having autonomy within the general limits of the purposes of the federation, the general supervision and direction to be given by a National Executive Board of eleven members, elected annually. One of these eleven is National Executive Secretary, and one, International Secretary. The national office, located in New York at 63 West 15 Street, is to be supported by dues of five cents per member per month from all the Clubs.

The Preamble states, most appropriately, that the Clubs are named "in honor of the revolutionist and writer," John Reed, author of *Ten Days that Shook the World*, who, after a brilliant and heroic career here and abroad, died in the Soviet Union in the

fall of 1919. The John Reed Clubs "recognize the irreconcilable struggle between workers and capitalists as two contending classes, and believe that the interests of all writers and artists should be identified with the interests of the working class." Membership in a JRC is open to any writer or artist who subscribes to the Preamble.

The officers elected were Oakley Johnson, of New York, National Executive Secretary, and Louis Lozowick, of New York, International Secretary. The nine other members of the Board are Joseph Freeman, William Gropper, and Whittaker Chambers, of New York; Eugene Gordon, Boston; Conrad Komorowski, Philadelphia; Duva Mendelsohn, Detroit; Jan Wittenber, Chicago; Charles Natterstad, Seattle; and Harry Carlisle, Hollywood. An annual Conference is provided for; the United States is divided into four regional sections for convenience in organizational work; the executive secretaries of all John Reed Clubs constitute a National Advisory Board, functioning in part as a link between the National Executive Board and the membership, and in part, through the regional groupings, as a means of carrying out local activity.

In a call for a Conference sent out by the John Reed Club of New York it was stated that the Clubs should be "organized into a strong weapon for the struggle on the cultural field against capitalism and against the social-fascism which is rapidly coming to be capitalism's cultural front." This recognizes, of course, that the conception of art and literature as an ivory tower affair is now outgrown, and that writers and artists must align themselves with the revolutionary proletariat, looking toward a classless society and toward an infinitely higher culture than capitalism offers—or they must align themselves with the capitalist enemy. The John Reed Clubs advance for American intellectuals a program of active support for the revolutionary working class and call upon them to join the only movement that offers a vital hope for the further development of civilization.

The Revolutionary Spirit in Modern Art

DIEGO RIVERA

ART is a social creation. It manifests a division in accordance with the division of social classes. There is a bourgeois art, there is a revolutionary art, there is a peasant art, but there is not, properly speaking, a proletarian art. The proletariat produces art of struggle but no class can produce a class art until it has reached the highest point of its development. The bourgeoisie reached its zenith in the French Revolution and thereafter created art expressive of itself. When the proletariat in its turn really begins to produce its art, it will be after the proletarian dictatorship has fulfilled its mission, has liquidated all class differences and produced a classless society. The art of the future, therefore, will not be proletarian but Communist. During the course of its development, however, and even after it has come into power, the proletariat must not refuse to use the best technical devices of bourgeois art, just as it uses bourgeois technical equipment in the form of cannon, machine guns, and steam turbines.

Such artists as Daumier and Courbet in the nineteenth century were able to reveal their revolutionary spirit in spite of their bourgeois environment. Honoré Daumier was a forthright fighter, expressing in his pictures the revolutionary movement of the nineteenth century, the movement that produced the Communist Manifesto. Daumier was revolutionary both in expression and in ideological content. In order to say what he wanted to say, he developed a new technique. When he was not actually painting an anecdote of revolutionary character, but was merely drawing a woman carrying clothes or a man seated at a table eating, he was nevertheless creating art of a definitely revolutionary character. Daumier developed a drastic technique identified with revolutionary feeling, so that his form, his method, his technique always expressed that feeling. For example, if we take his famous laundress,

From the *Modern Quarterly*, Vol. 6, No. 3 (Autumn 1932), pp. 51–57.

we find that he has painted her with neither the eye of a literary man nor with that of a photographer. Daumier saw his laundress through class-conscious eyes. He was aware of her connection with life and labor. In the vibration of his lines, in the quantity and quality of color which he projected upon the canvas, we see a creation directly contrary and opposed to the creations of bourgeois conservative art. The position of each object, the effects of light in the picture, all such things express the personality in its complete connection with its surroundings and with life. The laundress is not only a laundress leaving the river bank, burdened with her load of clothes and dragging a child behind her; she is, at one and the same time, the expression of the weariness of labor and the tragedy of proletarian motherhood. Thus we see, weighing upon her, the heavy burdens of her position as woman and the heavy burdens of her position as laborer; in the background we discern the houses of Paris, both aristocratic and bourgeois. In a fraction of a second, a person, unless he be blind, can see in the figure of this laundress not only a figure but a whole connection with life and labor and the times in which she lives. In other paintings of Daumier are depicted scenes of the actual class struggle, but whether he is portraying the class struggle or not, in both types of painting we can regard him as a revolutionary artist. He is so not because he was of proletarian extraction, for he was not. He did not come from a factory, he was not of a working class family; his origin was bourgeois, he worked for the bourgeois papers, selling his drawings to them. Nevertheless, he was able to create art which was an efficacious weapon in the revolutionary struggle, just as Marx and Engels despite their bourgeois origin were able to write works which serve as basis for the development of the proletarian revolutionary movement.

The important fact to note is that the man who is truly a thinker, or the painter who is truly an artist, cannot, at a given historical moment, take any but a position in accordance with the revolutionary development of his own time. The social struggle is the richest, the most intense and the most plastic subject which an artist can choose. Therefore, one who is born to be an artist can certainly not be insensible to such developments. When I say born to be an artist, I refer to the constitution or make-up of his eyes, of

his nervous system, of his sensibility, and of his brains. The artist is a direct product of life. He is an apparatus born to be the receptor, the condenser, the transmitter and the reflector of the aspirations, the desires, and the hopes of his age. At times, the artist serves to condense and transmit the desires of millions of proletarians; at times, he serves as the condenser and transmitter only for small strata of the intellectuals or small layers of the bourgeoisie. We can establish it as a basic fact that the importance of an artist can be measured directly by the size of the multitudes whose aspirations and whose life he serves to condense and translate.

The typical theory of nineteenth century bourgeois esthetic criticism, namely "art for art's sake," is an indirect affirmation of the fact which I have just stressed. According to this theory, the best art is the so-called "art for art's sake," or "pure" art. One of its characteristics is that it can be appreciated only by a very limited number of superior persons. It is implied thereby that only those few superior persons are capable of appreciating that art; and since it is a superior function it necessarily implies the fact that there are very few superior persons in society. This artistic theory which pretends to be a-political has really an enormous political content—the implication of the superiority of the few. Further, this theory serves to discredit the use of art as a revolutionary weapon and serves to affirm that all art which has a theme, a social content, is bad art. It serves, moreover, to limit the possessors of art, to make art into a kind of stock exchange commodity manufactured by the artist, bought and sold on the stock exchange, subject to the speculative rise and fall which any commercialized thing is subject to in stock exchange manipulations. At the same time, this theory creates a legend which envelops art, the legend of its intangible, sacrosanct, and mysterious character which makes art aloof and inaccessible to the masses. European painting throughout the nineteenth century had this general aspect. The revolutionary painters are to be regarded as heroic exceptions. Since art is a product that nourishes human beings it is subject to the action of the law of supply and demand just as is any other product necessary to life. In the nineteenth century the proletariat was in no position to make an effective economic demand for art products. The demand was all on the part of the bourgeoisie. It can be only as a striking and

heroic exception, therefore, that art of a revolutionary character can be produced under the circumstances of bourgeois demand.

At present art has a very definite and important role to play in the class struggle. It is definitely useful to the proletariat. There is great need for artistic expression of the revolutionary movement. Art has the advantage of speaking a language that can easily be understood by the workers and peasants of all lands. A Chinese peasant or worker can understand a revolutionary painting much more readily and easily than he can understand a book written in English. He needs no translator. That is precisely the advantage of revolutionary art. A revolutionary painting takes far less time and it says far more than a lecture does.

Since the proletariat has need of art, it is necessary that the proletariat take possession of art to serve as a weapon in the class struggle. To take possession or control of art, it is necessary that the proletariat carry on the struggle on two fronts. On one front is a struggle against the production of bourgeois art,—and when I say struggle I mean struggle in every sense—and on the other is a struggle to develop the ability of the proletariat to produce its own art. It is necessary for the proletariat to learn to make use of beauty in order to live better. It ought to develop its sensibilities, and learn to enjoy and make use of the works of art which the bourgeoisie, because of special advantages of training, has produced. Nor should the proletariat wait for some painter of good will or good intentions to come to them from the bourgeoisie; it is time that the proletariat develop artists from their own midst. By the collaboration of the artists who have come out of the proletariat and those who sympathize and are in alliance with the proletariat, there should be created an art which is definitely and in every way superior to the art which is produced by the artists of the bourgeoisie.

Such a task is the program of the Soviet Union today. Before the Russian Revolution, many artists from Russia, including those who were leading figures in the Russian revolutionary movement, had long discussions in their exile in Paris over the question as to what should be the true nature of revolutionary art. I had the opportunity to take part, at various times, in those discussions. The best theorizers in those discussions, misunderstanding the doctrine

of Marx which they sought to apply, came to the conclusion that revolutionary art ought to take the best art that the bourgeoisie had developed and bring that art directly to the revolutionary masses. Each of the artists was certain that his own type of art was the best that the bourgeoisie had produced. Those artists who had the greatest development of collective spirit, those who had grouped themselves around various "isms," such as Cubism and Futurism, were convinced that their particular group was creating the art which would become the art of the revolutionary proletariat as soon as they were able to bring that particular "ism," that particular school of art, to the proletariat. I ventured to disagree with them, maintaining that while it was necessary to utilize the innumerable technical developments which bourgeois art had developed, we had to use them in the same way that the Soviet Union utilizes the machine technique that the bourgeoisie has developed. The Soviet Union takes the best technical development and machinery of the bourgeoisie and adapts it to the needs and special conditions of the new proletarian regime; in art, I contended, we must also use the most advanced technical achievements of bourgeois art but must adapt them to the needs of the proletariat so as to create an art which, by its clarity, by its accessibility, and by its relation to the new order, should be adapted to the needs of the proletarian revolution and the proletarian regime. But I could not insist upon their accepting my opinion, for, up to the time of that discussion, I had not created anything which in any way differed fundamentally from the type of art that my comrades were creating. I had arrived at my conclusion in the following manner: I had seen the failure and defeat of the Mexican revolution of 1919, a defeat which I became convinced was the result of a lack of theoretical understanding on the part of the Mexican proletariat and peasantry. I left Mexico when the counter-revolution was developing under Madeiro, deciding to go to Europe to get the theoretical understanding and the technical development in art which I thought was to be found there.

The Russian comrades returned from Paris to Russia immediately after the Revolution, taking with them the most advanced technique in painting which they had learned in Paris. They did their best and created works of considerable beauty, utilizing all the tech-

nique which they had learned. They carried on a truly heroic struggle to make that art accessible to the Russian masses. They worked under conditions of famine, the strain of revolution and counter revolution, and all the material and economic difficulties imaginable, yet they failed completely in their attempts to persuade the masses to accept Cubism, or Futurism, or Constructivism as the art of the proletariat. Extended discussions of the whole problem arose in Russia. Those discussions and the confusion resulting from the rejection of modern art gave an opportunity to the bad painters to take advantage of the situation. The academic painters, the worst painters who had survived from the old regime in Russia, soon provided competition on a grand scale. Pictures inspired by the new tendencies of the most advanced European schools were exhibited side by side with the works of the worst academic schools of Russia. Unfortunately, those that won the applause of the public were not the new painters and the new European schools but the old and bad academic painters. Strangely enough, it seems to me, it was not the modernistic painters but the masses of the Russian people who were correct in the controversy. Their vote showed not that they considered the academic painters as the painters of the proletariat, but that the art of the proletariat must not be a hermetic art, an art inaccessible except to those who have developed and undergone an elaborate esthetic preparation. The art of the proletariat has to be an art that is warm and clear and strong. It was not that the proletariat of Russia was telling these artists: "You are too modern for us." What it said was: "You are not modern enough to be artists of the proletarian revolution." The revolution and its theory, dialectical materialism, have no use for art of the ivory tower variety. They have need of an art which is as full of content as the proletarian revolution itself, as clear and forthright as the theory of the proletarian revolution.

In Russia there exists the art of the people, namely peasant art. It is an art rooted in the soil. In its colors, its materials, and its force it is perfectly adapted to the environment out of which it is born. It represents the production of art with the simplest resources and in the least costly form. For these reasons it will be of great utility to the proletariat in developing its own art. The better Russian painters working directly after the Revolution

should have recognized this and then built upon it, for the prole-
tariat, so closely akin to the peasant in many ways, would have
been able to understand this art. Instead of this the academic
artists, intrinsically reactionary, were able to get control of the
situation. Reaction in art is not merely a matter of theme. A
painter who conserves and uses the worst technique of bourgeois
art is a reactionary artist, even though he may use this tech-
nique to paint such a subject as the death of Lenin or the red
flag on the barricades. In the same fashion, an engineer engaged
in the construction of a dam with the purpose of irrigating Rus-
sian soil would be reactionary if he were to utilize the bourgeois
procedures of the beginning of the nineteenth century. In that
case he would be reactionary; he would be guilty of a crime
against the Soviet Union, even though he were trying to con-
struct a dam for the purpose of irrigation.

The Russian theatre was safe from the bankruptcy which Rus-
sian painting suffered. It was in direct contact with the masses,
and, therefore, has developed into the best theatre that the world
knows today. Bit by bit, the theatre has attracted to it painters,
sculptors, and, of course, actors, dancers, musicians. Everyone
in the Soviet Union who has any talent for art is being attracted
to the theatre as a fusion of arts. In proportion with the progress
made in the construction of socialism in the Soviet Union, artists
are turning more and more to the theatre for expression and the
masses are coming closer and closer to the theatre as an "expres-
sion of their life." The result is that the other arts are languish-
ing and Russia is producing less and less of the type of art which,
in the rest of Europe, serves as shares on the Stock Exchange.

Mural art is the most significant art for the proletariat. In
Russia mural paintings are projected on the walls of clubs, of
union headquarters, and even on the walls of the factories. But
Russian workers came to me and declared that in their houses
they would prefer having landscapes and still-lives, which would
bring them a feeling of restfulness. But the easel picture is an
object of luxury, quite beyond the means of the proletariat. I
told my fellow artists in Russia that they should sell their paint-
ings to the workers at low prices, give them to them if necessary.
After all, the government was supplying the colors, the canvas,

and the material necessary for painting, so that artists could have sold their work at low prices. The majority, however, preferred to wait for the annual purchase of paintings made by the Commissariat of Education when pictures were, and still are, bought for five hundred rubles each.

I did not feel that I had the right to insist upon my viewpoint until I had created something of the type of art I was talking about. Therefore, in 1921, instead of going to Russia where I had been invited by the Commissariat of Education, I went to Mexico to attempt to create some of the art that I had been exalting. This effort of mine had in it something of the flavor of adventure because, in Mexico, there was a proletarian regime. There was in power at that time, a fraction of the bourgeoisie that had need of demagogy as a weapon in maintaining itself in power. It gave us walls, and we Mexican artists painted subjects of a revolutionary character. We painted, in fact, what we pleased, even including a certain number of paintings which were certainly communistic in character. Our task was first to develop and remake mural paintings in the direction of the needs of the proletariat, and, second to note the effect that such mural painting might have upon the proletarians and peasants in Mexico, so that we could judge whether that form of painting would be an effective instrument of the proletariat in power. But let me note also another fact. In Mexico there existed an old tradition, a popular art tradition much older and much more splendid than even the peasant art of Russia. This art is of a truly magnificent character. The colonial rulers of Mexico, like those of the United States, had despised that ancient art tradition which existed there, but they failed to destroy it completely. With this art as background, I became the first revolutionary painter in Mexico. The paintings served to attract many young painters, painters who had not yet developed sufficient social consciousness. We formed a painters' union and began to cover the walls of buildings in Mexico with revolutionary art. At the same time we revolutionized the methods of teaching drawing and art to children, with the result that the children of Mexico began producing artistic works in the course of their elementary school development.

As a result of these things, when in 1927, I was again invited

to go to Moscow, I felt that I could go, as we Mexicans had some experience which might help Soviet Russia. I ought to remark at this point that among the painters in Mexico, thanks to the development of the new methods of teaching painting in the schools of the workers, there developed various working-class painters of great merit, among them Maximo Patcheco, whom I consider the best mural painter in Mexico.

The experience which I tried to offer to the Russian painters was brought to Russia at a moment of intense controversy. In spite of the fact that it was a poor time for artistic discussion and development, Corrolla, the comrade who was formerly in charge of "Agitprop" work, organized a group, "October," to discuss and make use of the Mexican artistic experiments. I was engaged to paint by the metallurgical workers who wanted me to paint the walls in their club, the "Dynamo Club" on the Leningrad Chaussée. Soon, however, owing to differences, not of an aesthetic but of a political character, I was instructed to return to Mexico to take part in the "election campaign beginning there." A few months after my return to Mexico I was expelled from the Party. Since then, I have remained in a position which is characteristically Mexican, namely that of the guerilla fighter. I could not receive my munitions from the Party because my Party had expelled me; neither could I acquire them through my personal funds because I haven't any. I took them and will continue to take them, as the guerilla fighter must, from the enemy. Therefore, I take the munitions from the hands of the bourgeoisie. My munitions are the walls, the colors, and the money necessary to feed myself so that I may continue to work. On the walls of the bourgeoisie, painting cannot always have as fighting an aspect as it could on the walls, let us say, of a revolutionary school. The guerilla fighter sometimes can derail a train, sometimes blow up a bridge, but sometimes he can only cut a few telegraph wires. Each time he does what he can. Whether important or insignificant, his action is always within the revolutionary line. The guerilla fighter is always ready, at the time of amnesty, to return to the ranks and become a simple soldier like everybody else. It was in the quality of a guerilla fighter then that I came to the United States.

As to the development of art among the American workers, I have already seen paintings in the John Reed Club, which are undoubtedly of revolutionary character and at the same time aesthetically superior to the overwhelming majority of paintings which can be found in the art galleries of the dealers in paintings.

I saw yesterday the work of a lad [Ben Shahn]—formerly a painter of abstract art—who has just completed a series of paintings on the life and death of Sacco and Vanzetti which are as moving as anything of the kind I have ever seen. The Sacco and Vanzetti paints are technically within the school of modernistic painting, but they possess the necessary qualities, accessibility, and power, to make them important to the proletariat. Here and there I have seen drawings and lithographs of high quality, all by young and unknown artists. I am convinced that within the United States there is the ability to produce a high development of revolutionary art, advancing upward, from below. The bourgeoisie at times will be persuaded to buy great pictures in spite of their revolutionary character. In the galleries of the richest men there are pictures by Daumier. But these sources of demand are most precarious. The proletariat must learn to depend upon itself, however limited its resources may be. Rembrandt died a poor man in the wealthy bourgeois Holland of his day. In spite of his innumerable paintings there was scarcely a crust of bread in his house when he was found dead. His painting knew how to offend the wealthy Dutch bourgeoisie. In Rembrandt I find a basis of profound humanity and to a certain extent of protest. This is much more definite in the case of Cézanne. It is sufficient to point out that Cézanne used the workers and peasants of France as the heroes and central figures of his paintings. It is impossible today to look at a French peasant without seeing a painting of Cézanne.

Bourgeois art will cease to develop when the bourgeoisie as a class is destroyed. Great paintings, however, will not cease to give aesthetic pleasure though they have no political meaning for the proletariat. One can enjoy the *Crucifixion* by Mantegna and be moved by it aesthetically without being a Christian. It is my personal opinion that there is in Soviet Russia today too great a veneration of the past. To me, art is always alive and vital, as it

was in the Middle Ages when a new mural was painted every time a new political or social event required one. Because I conceive of art as a living and not a dead thing, I see the profound necessity for a revolution in questions of culture, even in the Soviet Union.

Of the recent movements in art, the most significant to the revolutionary movement is that of Super-Realism. Many of its adherents are members of the Communist Party. Some of their recent work is perfectly accessible to the masses. Their maxim is "Super-Realism at the service of the Revolution." Technically they represent the development of the best technique of the bourgeoisie. In ideology, however, they are not fully Communist. And no painting can reach its highest development or be truly revolutionary unless it be truly Communist.

And now we come to the question of propaganda. All painters have been propagandists or else they have not been painters. Giotto was a propagandist of the spirit of Christian charity, the weapon of the Franciscan monks of his time against feudal oppression. Breughel was a propagandist of the struggle of the Dutch artisan petty bourgeoisie against feudal oppression. Every artist who has been worth anything in art has been such a propagandist. The familiar accusation that propaganda ruins art finds its source in bourgeois prejudice. Naturally enough the bourgeoisie does not want art employed for the sake of revolution. It does not want ideals in art because its own ideals cannot any longer serve as artistic inspiration. It does not want feelings because its own feelings cannot any longer serve as artistic inspiration. Art and thought and feeling must be hostile to the bourgeoisie today. Every strong artist has a head and a heart. Every strong artist has been a propagandist. I want to be a propagandist and I want to be nothing else. I want to be a propagandist of Communism and I want to be it in all that I can think, in all that I can speak, in all that I can write, and in all that I can paint. I want to use my art as a weapon.

For the real development on a grand scale of revolutionary art in America, it is necessary to have a situation where all unite in a single party of the proletariat and are in a position to take over the public buildings, the public resources, and the wealth of the

country. Only then can there develop a genuine revolutionary art. The fact that the bourgeoisie is in a state of degeneration and depends for its art on the art of Europe indicates that there cannot be a development of genuine American art, except in so far as the proletariat is able to create it. In order to be good art, art in this country must be revolutionary art, art of the proletariat, or it will not be good art at all.

John Reed Club Art Exhibition

JOHN KWAIT

THE current exhibition of paintings, drawings, prints and sculptures at the John Reed Club of New York is the first large important enterprise of the club in promoting an active revolutionary art. The exhibition committee deserves warm praise for the manner in which the works were arranged and exposed, for the wide publicity given to the show, and for the public meetings at which the show was discussed by invited critics and artists and by members of the club.

Nevertheless the exhibition cannot be considered a success. More than half the objects shown express no revolutionary ideas; and of the rest, only a few reenact for the worker in simple, plastic language the crucial situations of his class.

The very title of the exhibition betrays the uncertainties of our revolutionary art. What is *The Social Viewpoint in Art?* It is as vague and empty as "the social viewpoint" in politics. It includes any picture with a worker, a factory or a city-street, no matter how remote from the needs of a class-conscious worker. It justifies the showing of Benton's painting of Negroes shooting crap as a picture of Negro life, or a landscape with a contented farmer, or a decorative painting labelled "French factory." The mere presence of such "social" elements in a picture does not indicate any social viewpoint, since these elements are often treated abstractly and picturesquely without reference to a social meaning of the objects. Sometimes the worker is only a remote spot on the horizon. Such pictures are dragged into the exhibition as any picture with a fish might be shown in an exhibition of "The Fish in Art" arranged by a group of art-loving fishermen.

The Social Viewpoint in Art is a confused effort to designate a united artistic front, to rally together all painters who represent

From *New Masses*, February 1933, pp. 23–24. Reprinted by permission of *American Dialog*.

factories, workers and farmers, in opposition to painters who represent bananas and prisms. The John Reed Club has just been guided by the vague liberalism of the critic Thomas Craven and the painter Benton, for whom the real goal of art is the reproduction of "American Life." But this "life" is conceived as a meaningless, picturesque, turbulent activity. It is arranged in banal and cynical contrasts, rendered in a pretentiously virile manner. How far it is from our own understanding of American society can be judged from Benton's murals in the Whitney Museum where Negro life is summarized by a revival meeting and crap-shooting boys, and the city is an intentionally confused panoramic spectacle of overlapping speakeasies, strikers, gunmen, and movies, that corresponds to the insight of the tabloid press. The concern with American life is to some degree a chauvinistic response of American critics and painters to the competition of French art, which is technically far superior and enjoys the prestige of an imported luxury. It flatters the patron ruling class to hear that its factories, industries, and cities are noble subjects of art, in fact the materials of a renaissance, and that the American artist, to produce great art, must confront "life," like a hard-boiled businessman.

The John Reed Club cannot accept such a view of art, yet it has been guided by such views in the title of the exhibition, in the selection of pictures, and in its mistaken devotion to mural painting as a "social" form of art. The club should not have invited in the name of an imaginary united front the prominent painters who could submit only tame picturesque views of cowboys, crap-shooters and fat shoppers issuing from department-stores. These pictures were to be expected, for they are exactly what these artists have been making, with the applause of bourgeois critics, for many years, and will continue to make when this exhibition is over. The exhibition of their works might lend a little respectability to the John Reed Club. But shown under such auspices, they could only confuse young artists as to the nature of revolutionary art. Better to have a small show of twenty good, genuinely militant paintings than two hundred mixed works of unequal quality and of all shades of social opinion.

Undoubtedly the American painter has no clear idea of the

world about him or the issues of the class struggle. But this exhibition, encouraging him to confront life and to ally himself with the workers, offers him no bearings, no technical aid, no definite model of action. Is this too much to ask of an exhibition? I do not think so. For an exhibition could easily have been arranged with a carefully prepared series of pictures, illustrating phases of the daily struggle, and reenacting in a vivid, forceful manner the most important revolutionary situations. It could have included examples of cooperative work by artists—series of prints, with a connected content, for cheap circulation; cartoons for newspapers and magazines; posters; banners; signs; illustrations of slogans; historical pictures of the revolutionary tradition of America. Such pictures have a clear value in the fight for freedom. They actually reach their intended audience, whereas the majority of easel paintings are stuck away in studios. (Sometimes they are purchased by a sympathetic dentist in exchange for a tooth-pulling.) The John Reed Club must offer specific tasks, especially cooperative tasks, to the revolutionary artist. Only in this way will it develop an effective revolutionary art. The artist who must produce daily a trenchant pictorial commentary on daily events for a workers' newspaper quickly develops an imagination and form adequate for his task; but the artist left to himself remains a confused individual, struggling for a precarious living, fussing over a picture of "American life" which he would like to sell to a dealer, like his paintings of still-life. The good revolutionary picture is not necessarily a cartoon, but it should have the legibility and pointedness of a cartoon, and like the cartoon it should reach great masses of workers at little expense. A cooperative program of agitational prints for cheap distribution by the thousands, of agitational pictures for every militant occasion, is within the means of the John Reed Club. In this way the artists can be as effective as the writers and speakers, and develop their own powers in the process.

Sectarianism in Art

JACOB BURCK

and

Reply to Burck

JOHN KWAIT

THE review in the February *New Masses* of the John Reed Club exhibition *The Social Viewpoint in Art* by John Kwait displays a dangerous tendency to approach the problem of proletarian culture from a purely mechanical viewpoint without taking into account existing cultural conditions and traditions, and the problems they present to the revolutionary artist. In his review Kwait says: "The John Reed Club has been guided by the vague liberalism of the critic Thomas Craven and the painter Benton *for whom the real goal of art is the reproduction of 'American Life'* " [Emphasis J.B.]. If Kwait had read the foreword to the catalog of the exhibit he would have found a quite different formulation of the policy which guides the John Reed Club. Says the foreword: "We have undertaken the program of expressing in art terms the *struggle* between the old and the new that is going on before our eyes and all about us." [Emphasis J.B.]. Assuming that he had read this foreword and thinks nevertheless that despite its declaration the Club did display the "vague liberalism" of Craven, how does he prove it?

First by his introductory sentence: "The current exhibition of paintings, drawings, prints and sculptures at the John Reed Club of New York is the first large important enterprise of the Club in promoting an active revolutionary art." Further on Kwait takes issue with the phrasing of the name of the show by saying: "The very title of the exhibition betrays the uncertainties of our revolutionary art. What is the social viewpoint in art? It is as vague

From the *New Masses*, March 1933, pp. 26–27. Reprinted by permission of *American Dialog*.

and empty as 'the social viewpoint' in politics." It is the popular contention (and justified by the mental state of our bourgeois artists) that artists as a body are quite innocent people politically. But it is well known that the artists of the John Reed Club do not have such a "vague social viewpoint" in their art, but on the contrary are further developed along Marxist lines and are creating forms expressing the themes arising out of class conflict.

This fear that the John Reed artists have been seduced by the Craven ideology grows out of the fact that Kwait throughout his entire review shows an utter lack of understanding of revolutionary strategy. This is not surprising since Kwait takes the position of a "Marxian purist," that is of extreme leftism. It is inconceivable to him why we should invite in "the name of an imaginary united front the prominent painters who could submit only tame picturesque views of cowboys, crap-shooters and fat shoppers issuing from department stores." That these men happen to be the leaders in the leftward movement of the artists seems to Kwait a negligible factor and quite beside the point of revolutionary artists interested in building a new cultural movement. It was not "respectability" that was desired by inviting them, but to attract their vast following to the cultural program of the club. It was also made quite clear by the member-signs placed under each John Reed picture (and the foreword to the catalog) that the club took no ideological responsibility for Benton's crap-shooters or for that matter the work of any of its guest artists.

But Kwait dumps the whole show into Craven's lap because we committed the sin of rubbing elbows with Craven's followers. (The clarity with which Kwait in his review destroys the chauvinism of Craven's viewpoint as expressed by Thomas Benton's murals in the Whitney Museum makes his accusation all the more serious. It confuses the artist who knows of the revolutionary position of the John Reed Club to hear that it is so hospitable to Craven's. If Kwait had shown the existence of Craven's ideology in some of the works on exhibition, both by John Reed Club members and by invited artists it would have served a very necessary function.) All the contemporary revolutionary paintings available were included in this exhibition. We are still await-

ing Kwait's analysis, for not one revolutionary picture did he discuss in his tirade on united fronts. He says, "Better to have a small show of twenty genuinely good militant paintings than two hundred mixed works of unequal quality and for all shades of social opinion." If there were anywhere twenty militant paintings, they would have been found in this exhibit. Surely such works should excite a revolutionary art critic to discussion. But it seems later on that Kwait considers painting not a legitimate medium for revolutionary cultural expression, so why get excited about it altogether? Throughout his entire treatment of this enterprise of the club there runs the concept that proletarian art (painting and sculpture) must either await the final victory of the working-class, or be abandoned as a peculiar bourgeois phenomenon, and that the *only* art suitable for the working class is agitational, *i.e.*, "cartoons, black and white prints, posters, banners, signs, and illustrations of slogans." The idea is not new, of course. It comes very close to the formulation Trotsky made in his *Literature and Revolution* years ago. Namely, that proletarian art can exist only in a classless society. The fallacy of such a position is now quite evident to any revolutionary who has passed out the cafeteria stage of "Marxism."

The future classless culture will not spring full-blown from the brow of the proletariat. It is up to the revolutionary artists to help pave the way for a complete break with bourgeois culture by developing new plastic revolutionary expressions which are an outgrowth of the class struggle and which embody the aspirations of the working class for the desired classless state. In this respect, incidentally, Kwait correctly points out the necessity for participating in the every day struggles of the workers when he says that "the artist who must produce daily a trenchant pictorial commentary on daily events for a workers' newspaper quickly develops an imagination and form adequate for his task."

The revolutionary artist (this applies equally to the revolutionary critic) cannot remain aloof from the class struggle and expect to create revolutionary art. He must consider himself as a unit in the struggle. In no other way can he acquire vitality

and development in his work and escape from an individualistic subjectivity.

Such an organization as the John Reed Club is a means for revolutionary artists to engage in the class struggle politically and as creative individuals. It is also a testing ground for their creative ideas and in this way develops a collective art in the real sense, and not in the technical one of "cooperating on a series of prints."

The John Reed exhibition was the first effort to rally all artists whose sympathies are swinging leftward. It served its function well historically by making a thorough resume of this new development among the artists. Until the economic crisis, art, (painting, sculpture) was entirely a snobbish, individualistic expression based on the "gold standard" of bourgeois society. The "social viewpoint" in politics, is of course absurd, but the social viewpoint in art is a *decided change* leftward from its former one of "bananas and prisms."

Sad as the political backwardness of the artists is, the present economic situation has brought a ray of hope for their future development. The John Reed Club has shown its political and artistic alertness by inviting these artists to hang their "left" subject matter side by side with more conscious revolutionary works, and in this way orientating them still farther to the left—to the scenes of the class struggle of the workers. It said to them that a "social viewpoint" was not sufficient, that only a *revolutionary* social viewpoint was the one that can produce vital, dramatic works of art, and that a mere decorative treatment of working-class subject matter was static, inert art without the dynamic, lifegiving force of class struggle in their compositions. That was the function of the "Social Viewpoint in Art" exhibition, and it performed that function, in that several of the most able bourgeois artists are now joining the club.

The exhibition had still another function. And that was to show the members of the club, by a juxtaposition of their own works with the works of the invited artists, to what degree they themselves retain the same illusions as the guest exhibitors, and to what extent they have succeeded in breaking with bourgeois culture in their progress toward a revolutionary class culture.

In short, Kwait's thesis is a sectarian one, and can lead only to isolation of the John Reed Club from the main stream of leftward moving artists. It amounts to quarantining revolutionary art and expecting it to grow and develop and exert influence. While we must be critical of the ideology expressed in the works of the artist who is just leaving the bourgeois fold, on the other hand, we must encourage him and try to guide him. We cannot demand of him overnight 100% revolutionary content which takes many years of work and struggle to develop.—Jacob Burck

REPLY TO BURCK

The criticism of Jacob Burck attributes to me a sectarian aversion to a "united front" of artists. Actually, in my review of the exhibition, I discussed, not a united front as such, but the obvious weakness of this particular front, its vague enemy, its unallied members, its lack of a conspicuous leadership. I stated that the social viewpoints expressed in the paintings were too various, too confused to guide young painters toward a revolutionary art. The common purpose was not sufficiently clear. The fact that pictures by members of the John Reed Club were especially labelled did not help to clarify the show. On the contrary, it implies a further confusion, since so many of these works were also without genuine revolutionary content or high artistic value. The idea of inviting artists who have shown leftward tendencies is good enough in itself, but it is the function of the John Reed Club to guide such artists, to direct their tendency into an open and effective partisanship, a function which was not adequately fulfilled in the exhibition. That Burck can speak of men like Benton and Miller as "the leaders in the leftward movement of the artists" alone indicates the necessity of such guidance and confirms my criticism of the show.—John Kwait

Revolution in Art

ANITA BRENNER

CRITICS bred to believe with Clive Bell that good painting is good art only to the degree that it detaches itself from meaningful subject to emphasize form, design, color and other purely sensory and technical qualities, and that the only business of a critic is to be a "connoisseur of pleasure" and to "put the public in the way of aesthetic pleasure," must serve up the [Jean-Louis] Forain show at the Grand Central Galleries with routine references to Daumier and Goya and with knowing remarks about the forceful design and economy of line which accompanies the artist's humanitarian rage at the white-slave traffic, the lecheries of courts, the horror of life for the bottom dog. And because Forain chose to "illustrate" and "caricature" up to the year of his death, 1931, while most of his contemporaries were concerning themselves with aesthetic revolutions, his stature as an artist is inevitably pegged down by academic modernism with some observation or other to the effect that he did pretty well in spite of his deplorable insistence on "subject." Which is about like saying that Dean Swift wrote well in spite of being a social satirist.

A good many of the Forain pictures would look very much at home in the current show at the John Reed Club, which includes the work of most well-known living American artists, some of whom are guest exhibitors, and others members of the club. But since the pictures and sculptures in this show emphasize social distress rather than sensory pleasure, a phrase with "propaganda" in it seems to be the correct note. Biddle, Coleman, Davis, Dehn, Hirsch, Pollet, Miller, Robinson, Walkowitz, Benton, our happy Pop Hart, and so on to Zorach, have gone slumming. And will recover their prestige somewhere else.

But as a matter of fact this show is as significant as the historic Armory exhibit which brought the aesthetic heresies of twentieth-

From *The Nation*, 8 March 1933, pp. 267–269.

century Europe to the United States. Not that the walls of the John Reed Club display a blaze of genius. There are a few sound and vigorous pictures whose signatures were new to this critic: H. O. Hoffman, Ben Kopman, Phil Bard, Chuzo Tamotzu, Anton Refregier, H. S. Strom, Prentiss Taylor, and, not so new, Albert Wilkinson and William Siegel. There are also a few pictures which add a new impressiveness to familiar names: Biddle's *Sacco and Vanzetti*, Pop Hart's *Working People*, Siegel's *Miner's Funeral*, Käthe Kollwitz's *Visit to the Hospital*, Adolf Wolff's sculptured *Working-Class Mother*.

Like the Armory show this exhibit is not primarily important as a discovery of individual talents, but for what it means as a point of departure for a kind of art sharply different from the current mode in appearance, idea, aesthetics, and function. There is not a single still life among the two hundred pieces in the show. The shift of interest from things to people is aggressively marked; also the shift from decoration to emotional expression, from sensory pleasure to human anger and pain. There is a change in attitude, too—artists trying, with some self-consciousness and strain but with all their strength, to be common people. These things give the show as a whole a beat of life, a connection with the things uppermost in your mind and mine, provocative and stirring after the discreet isolation of row upon row of tastefully framed apples, bottles, picturesque ladies, and pretty landscapes inclosed within other walls.

This is to the credit of the rebels. Against most of them a grave mistake can be charged. Modern art, brought into the world by France and artists of various nationalities living in France, signifies primarily, we have been taught, a divorce from "subject." It has no taste, says Bell again, for "contemporary actualities." But if the history of this development is examined closely, the impulse to be seen within it is fundamentally the same impulse at work in a different way in the rebellion at the John Reed Club. For the feeling in modern art is, and was when it broke away from the academic mode of the late nineteenth century, precisely a taste for contemporary actualities. More than a taste, it was a determination to smash the cage of prescription, convention,

convention, and dogma in which artists performed like trained monkeys for the edification and benefit of Victorian morals.

Art, going "modern," left the service of religion, ethics, civic virtue, and domestic duty, and gave its attention and sympathies to science. Hence the emphasis on intellectual pleasure and technical experimentation, the search for method, the insistence on aesthetic discovery. The impressionists repudiated studio formulas and went out to look at light through a spectroscope. Picasso used his mind as a laboratory for inquiry into the mechanics and physics of form. And given a neatly mechanistic world destroyed in vibration and flux by modern physics, then Cézanne follows. But since the break for artistic freedom involved a break with nothing less than a social scheme, the hate and bitterness aroused were out of all proportion to the issues which established convention raised as reasons for its violent attack.

The battle was fought longest and hardest on the most superficial, most easily intelligible grounds, which can be summed up in the question of "subject"; and the spokesman for the defense, therefore, devoted much time, thought, and ingenuity to this point, producing an *ex post facto* set of doctrines and a system of aesthetics expressed in the command: Thou shalt not traffic with "subject." Therefore the artist whose intellect and feeling move him primarily in the direction of contemporary actualities is hampered by modern academism precisely as were the moderns of years past; and he rebels, mistaking the issue, by scrapping the store of knowledge and resource accumulated to his advantage in the previous fight and jumping backwards, as have many of the young artists in the John Reed show, to pre-modern methods —most obviously, to Daumier and Goya. But they cannot adequately and movingly paint or carve their time and place in the technical and emotional terms of another age.

Fifty years of intense and active attention to the material nature of the arts have produced a new comprehension of the nature of materials. In painting—form, light, movement; in sculpture—rock, wood, metals, instruments, structure, and rhythm; in literature—rhythm, typography, sound. New techniques and new modes have been developed in each of these arts. It happens in every kind of cultural development that one

phase grows faster than another. Our social scheme breaks through our legal system like water through a paper bag. None of our types of theatrical spectacle can use the auditorium at the Rockefeller Center Music Hall to artistic advantage. A painter can command at least three new and powerful methods—impressionism, cubism, surréalisme; convention allows him every liberty in manner, but restricts him in matter. Yet it would be easy enough to trace a development of political and social thinking in the pictorial and plastic arts at least, paralleling the development in style: from Cézanne's snorts about "dirty bourgeois" to the surréalist manifesto prescribing "in politics, communism."

This connection between surréalisme and social revolution is generally forgotten or dismissed as irrelevant, for though the surréaliste mode significantly shifts weight from intellect to emotion and sensitivity, its expression is more often than not highly personal. Utilizing, however, the interests of subject as presented in dreams, fantasy, visions, and other "enlargements" of emotion and sensory perception, it throws wide the doors to personal and collective symbolism, to tragedy and passion in more than personal terms, to heroic connection between what is visible and what is emotionally significant, super-realistic. Surréalisme, as Diego Rivera shrewdly pointed out not long ago, is potentially a revolutionary weapon. The motif—hands—which recurs in the work of most surréaliste painters is no more accidental than the cross and halo in Renaissance fresco; though perhaps less consciously symbolic.

Inasmuch as a work of art expresses the cultural prejudices of the artist as well as his personal synthesis with the world in which he lives, his work is propaganda. To object that it is not conscious propaganda is almost equal to saying that the artist did not or does not know what he is doing, and this can be true to a degree. But to minimize the aesthetic value of his work with the observation that it has an ax to grind is to force doctrine upon historical fact. For all art everywhere has had an ax to grind; and what expression of human effort has not? To distinguish, therefore, between propaganda and "pure art" on the ground of presence or absence of easily comprehensible content is itself a distinction with an ax to grind.

The thing which distresses critics who use the word propaganda in a derogatory rather than a descriptive way is, apart from the emotional antagonism to the artist's social attitude, the process of fitting a predetermined set of ideas upon a set of forms in themselves not emotionally and aesthetically expressive. It accuses the artist of a kind of pedagogic dishonesty, of having sold himself to a service, of grinding somebody else's ax. In this sense the word propaganda is most clearly synonymous with advertising; as even a Babbitt cannot put his emotions, his senses, and his intellect at the service of a brand of ham and not produce work aesthetically false. On the other hand, an artist whose heart and head make him a social revolutionist can make posters and banners which, besides being ideologically militant and immediately useful, may be as beautiful and aesthetically sound as any religious or romantic work of other days. We shall have to admit, if we are honest historians, critics, and connoisseurs, that there is room indeed for good art in what we call propaganda. And we must also recognize that in good propaganda there is no room for bad art.

Art and Social Theories

GERTRUDE BENSON

In a bare loft on lower Sixth Avenue, a significant exhibition of paintings, sculpture, water colors and prints, provocatively labeled "The Social Viewpoint in Art," was held last month by the John Reed Club of New York. Among the 101 contributors were such well-known men as Orozco, Benton, Curry, Stuart Davis, "Pop" Hart, Kenneth Hayes Miller, and many others seldom, if ever, seen or heard above Fourteenth Street. Strangely enough, it was from the latter group that the largest number of animated and competent canvases came.

On the whole, there was refreshingly little derivative painting, although spiritual kinship with Daumier, Goya, Nolde and Rouault was occasionally in evidence. The drab, frustrated existence of the worker and his clashes with a hostile environment provided the inspiration for most of the canvases, but there was surprisingly little propaganda for its own sake. One saw the worker in the Second Avenue "L", in the sweat-shop, on the park bench, in "Hooverville," on the bread-line, at his breadless table, or battling the police in street demonstrations, fighting eviction, moving with stubborn determination in grim "hunger marches."

The facile but mild realism of Allen Tucker or Kenneth Hayes Miller and his numerous satellites, of Stuart Davis, with his pale, linear, disemotionalized constructions—even the stylized, if expert, Benton—seemed to look on the social scene from a safe and comfortable second-story window. Contrasted with such deeply felt and vigorously executed conceptions as those of Egas or Lee Hersch or Orozco, theirs seemed lacking in conviction. The canvases of Brevannes, Marsh, Biel and Soyer were skilful translations of a social mood into terms of color.

But when such painters as Cikovsky, Loew, Ribak, Meltzner and Siegel gave vent to tirades or homilies in oil against imperialism,

From *Creative Arts*, Vol. 12, No. 3 (March 1933), pp. 216–218.

class inequality and class oppression, the social mood became a militant message, a call to arms. Prominent in this group were the canvas, *We Want Bread*, by Cikovsky, the imaginative narratives of W. W. Quirt, the sombre, powerfully unified *Lynching* of Kopman.

George Grosz, Käthe Kollwitz, Abramovitz, Irwin D. Hoffman and Adolf Dehn contributed sardonic observations, trenchant caricatures, and poignant sketches in black-and-white.

It was almost inevitable that an exhibition defining its scope so vaguely as "the social viewpoint in art" should run into difficulties. The undogmatic character of the exhibition was the despair of the more uncompromising members of the club. It is true that the hospitality of the committee was at times too elastic. The social viewpoint in some canvases (Stuart Davis's, for example) was altogether absent, or concealed behind technical trickery or subject matter only remotely social in its implication (as in the Pollet landscape). On the other hand, a few of the canvases were good propaganda but poor art. Furthermore, such contrasted commentators on the social scene as Tucker and Cikovsky, Miller and Ribak, Curry and Quirt speak languages so radically different that a loss of clarity in the general impression was to be expected.

Despite these shortcomings, the club's decision to open its doors to many social viewpoints and varying degrees of class consciousness was responsible for an exhibition, not only interesting as a cross-section of the proletarian ideology that is coloring artistic expression today, but impressive because of its high average of technical facility.

Art and Propaganda

THOMAS CRAVEN

"I was not one of those fools who are capable of producing something rather graceful but entirely without significance."—CELLINI.

THERE has been extraordinary commotion in the art of painting. At a moment of great complacency, when the mysteries of painting, guarded by specially nurtured young men and their critical fathers, are flourishing in cultivated society; when the ability to talk the cabalistic lingo of modern esthetics becomes the mark of superior discernment, a calamity occurs. The discovery is made that the mysteries are only the stageplay of illusions; that the high-toned emotions and delicate sensibilities garlanded round the altar of modern art are devoted to something which has no substantial existence. The man who precipitated the commotion is Diego Rivera.

The trouble began in Detroit when Rivera, commissioned to decorate the walls of the Institute of Arts, painted a panorama of frescoes which are certainly not flattering to the capitalist régime, nor to preconceived notions of beauty. But Mr. Edsel Ford, having engaged the artist, honorably supported him and paid him handsomely for his services; and Rivera departed for New York amid the wails of the obscurantists. What happened in New York is history. Hired, because of his international reputation, by friendly enemies who had, two years before, exploited his fame in a fashionable exhibition, he went to work in Rockefeller Center, did what he was in the habit of doing and what could only have been expected of him; and then, when the job was three-quarters finished, he was, for no sensible reason, suddenly expelled. It is not my purpose to discuss the quality of his murals; nor to examine the charges preferred against him by his rivals, Mexican or American; nor to

From *Scribner's*, Vol. 95, No. 3 (March 1934), pp. 189–194. Reprinted by permission of the Estate of Thomas Craven.

comment on the alacrity with which he accepts and cashes checks. My concern is with the issues raised by his paintings, and with his repeated verbal challenges to the existing order of art.

The portly Mexican has carried painting from the ivory tower into the market-place—into the news columns of the press, the camps of the communists, and the arena of belligerent social ferments. He has shocked the specialists and their cultural victims by a proclamation reducing their "plastic mysteries and purities" to bourgeois affectations. He has said that "Art is propaganda or it is not art"; and his answer to the question "What Is Art For?" (*The Modern Monthly*, June, 1933) though crudely expressed, conceited and bombastic, has fallen into the chosen circle of art fanciers like a communist bomb. For nothing could be more painful to the esthetic snob than to be convicted of bourgeois refinements. To compensate social restlessness, he had turned to art; and he was convinced that in modern art lay the one hope of emancipation from the vulgarities of bourgeois society. By practical necessity, he was, of course, forced to live physically in an unenviable environment; but in art, with its involved and elaborate mysteries, he found a glorious escape from reality. By embracing and reciting the new esthetic creed, he proved that he was not just a contemptible bourgeois battening on the miseries of the worker. In modern art he saw before him a vast field for the play of profound thoughts and emotions aloof from the pressures of environment and indelicate physical habits. The distinction, often exquisitely subtle, between representation and form, between the apparent and the real, offered unlimited opportunities for the demonstration of acumen and sensibility.

Then Rivera appears, with the brutal statement—frightful in its rawness—that all these distinctions and their accompanying subtleties are but the outcome of a bourgeois psychology, the culmination of an over-refined, peevish, and soulless way of living. And this statement cannot be dismissed as mere ruffian adherence to party principles—the wedding of art to doctrine—though it receives most of its advertising from such connections. Fundamentally, it relates to the eruption of feelings and dissatisfactions much more deeply rooted than political tenets; it springs from the historically recurrent search for overt meanings, for actual order in life—the search

attending the breakdown, also recurrent, of the instrumentalities of living. Under the pressure of this search, individual artists, as well as individuals in other fields, rush wildly for the security of some sort of position. A centre of orientation seems to be an absolute necessity. Communism, with its well-bolstered doctrine and its social guarantees, affords the obvious support. When all the world is apparently meaningless and purposeless, here is certitude.

On the face of it, communism would appear to be the most portentous movement in art since the lords of the High Renaissance robbed painting of its holy office and made it the agent of vanity. For we find, on consulting our history, that art, as a living activity, has been united to dominant idealisms. The great arts of Egypt, Assyria, and Greece lived and prospered by representing beliefs and convictions shared by large social bodies. The art object —the painting or carving—was a communicative instrument. In calling art to its service, communism is appealing to this instrument. It has denounced the stupidity of studio art and the empty elegance of schoolmen like Matisse and Picasso; it has demanded the expression of ideals inseparable from daily human conflicts. It has faced the fact that art cannot live on itself alone; and, by making form the servant of meaning, has unconsciously returned to the classic attitude. For the first time since the Christian Church, emerging from the Roman wreckage, employed humble zealots to embody its ideals in stone and color, has the artist been called to a social function. I do not exaggerate the case. Let us review briefly the course of painting.

Occidental painting rose to its most splendid heights during the Renaissance, but in its pompous extravagance the seeds of decay were planted. Esthetic interests were isolated; art erected its own culture, and became the servant of riches and aristocratic display. It became the property of a class which, eventually, was to lose every real connection with life, to dwell in a world of illusions and remembrances, a world of fantastic play-acting. Since the Renaissance, art has been slowly withdrawn from common life. For a considerable time, in spite of the fierce antagonisms of individual artists, it followed a patronizing aristocracy, removing itself farther and farther from the representation of the ideals, beliefs, and habits of the dominant members of society. As long as the aristo-

crats actually controlled the people, as long as they functioned by directing the machinery of living, the art they fostered retained a certain amount of health and vitality. Rubens, for instance, belonged to an organic social group, not to a sham society, an obsolete class. But with the rise of the bourgeoisie—the result of the evolution of the instrumentalities of production and exchange—the old aristocracy, with its tributaries in art, ceased to function, existing as a social appendage serving no better purpose than to set the standards of gentility and fashion.

Christian mythology had prescribed a subject-matter which brought the artist into direct contact with an idealism universally shared and professed. Accepting this mythology literally, the artist at first produced only childish concepts or meaningless visions and abstractions; and it was not until skepticism had broken the rigid doctrinaire attitudes of the Church that he was able to connect his subjects with living things and to build an art of human values. By expressing Christian faiths and myths in terms of his own experiences with his fellow men, the artist remade his subjects: nominally they represented Christian mythology; actually they represented current realities. The symbolical use of personal experiences is characteristic of the other great art forms, Egyptian, Assyrian, Greek, Indian, and Chinese. It is the most important element in the relation of art to meaning, and is the answer to the question, "Is Art Propaganda?"

With the revival of learning—the popularization in aristocratic circles of scholarly voyages into the art and thought of the Greeks and Romans—art, as I have said, began slowly to retire from the field of common experiences, and to dally with subjects bearing no relation to life as it is actually lived. In its retirement, however, it managed to retain one vital factor, one redeeming preoccupation which saved painting from utter uselessness and extinction. I refer to the interest in natural phenomena, an interest originating in the efforts of artists to make Christian myths more convincing and lifelike. Leonardo, you will remember, was a profound student of natural phenomena; Titian, in his old age, experimented with broken color; Velasquez was a slave to photographic appearances; the Dutch tone painters achieved miracles of naturalism; Manet fol-

lowed their example; and with the Impressionists, the analysis of light became a mania and a scientific novelty.

The facts of nature, as presented to the eye, offered a field for fresh investigation which restrained the painter from complete abdication, along with his patrons, into the realm of cultivated illusion. Though the painter was attached to an aristocratic society consecrated to operatic pretensions and was living above the exigencies of plain human affairs and though he was compelled to deal in Greek and Roman mythologies—subjects above common beliefs—above all beliefs, yet he contrived to produce an art that was not wholly without meaning long after the social function of art had disappeared. The research into natural phenomena was its own reward, a content of a sort, in spite of a subject-matter that drove him away from life experience into studio eclecticism, and eventually into modern academic seclusion.

The first decisive step in the elimination of the meanings of art— the separation of form and content—was taken by Poussin, the father of the Academy. Poussin's paintings were originally, have been, and are today the toys of connoisseurs and the envy of all artists doomed to live and die in the museums. His studious, archeological correctness served as a model for all those stilted, neoclassic pictures solicited by a decaying aristocracy. Though there have been intractable or revolutionary individuals such as Rembrandt, Hogarth, Goya, and Daumier, who do not fit into the scholastic pattern, occidental painting since Poussin has been segregated from society. Its researches and discoveries have been of little consequence—the property of small esthetic cults.

Art has lost its historical connection with dominant idealisms, lost its most important function. There is no need to disguise this fact. Its claims, for the most part, are preposterous; its accomplishments negligible. Modern art—the art succeeding Impressionism—which seemed to promise so much, now promises nothing. Its exhibits are stale and nonsensical—of no value whatever save as adjuncts to the vanity of wealthy collectors who find in it a parallel to their own spiritual emptiness. Its obscurities and aberrations still inspire the drivel of the esoteric scribes; but it has no meaning save that which is read into it by the dictates of idiosyncrasy.

Democracy, you see, has provided no mythology adaptable to

the symbolical apparatus of painting; its ideals have been continually shifting, have accommodated themselves to the rapid changes in the mechanics of production and distribution. Democratic society has created no background of vital belief, no general conviction that behind the shifting dance of expedients there exists a spiritual reality, absolute and unchangeable. Democracy has drained the substance from the old illusions to which art was faithfully united: the illusion that eternal life actually lay beyond the horizon of fact; that the King was divine and his antics inspired. Today the King is not even a figurehead—he is an obsolete dunce; and the Church, like the old aristocracy with its ideals of power, grandeur and gentility, survives as a clearing-house for social indulgences.

Enter communism with concepts which would seem to parallel those of the early Church—concepts treated as realities. It has a fine mythology—Marxian economics—and a program, a celestial vision promising universal participation in the good. And it poses the equivalent of the old functioning aristocracies and priesthoods in its notion of a dominant proletariat, a specially favored class in whose hands rests the ultimate happiness of mankind. The set-up would seem to be perfect for the symbolical powers of the plastic arts. And the artist is restless, ready for a call. Intelligent young men everywhere are aware of the fact that their connection with the polite society which supports art is artificial and dependent on vogues—on fashionable whims capitalized by dealers.

Rivera's declaration, therefore, cannot be disposed of with a sneer. As I have said, it goes deeper than party affiliations; it enters into the profound restlessness of the human spirit confronted with inevitable change. By implication, at least, it voices the old undying truth that art cannot subsist on itself. And inasmuch as that is exactly what art has been trying to do, it will be worth while to consider a system which, whatever its claims, would relieve art from the ignominy of self-consumption.

The communists assume that, at last, they have identified art with a general ideal; whereas, in reality, they have done no such thing. They have only bound art to a specific program; they are using art as the tool for the propagation of economic notions which, though distributed geographically, are far from universal in their application. This, I submit, is the basic error of the new system.

There is a vast difference between the kingdom of heaven, as visualized by the early Christian worshippers, and the heaven on earth, as formulated by the apostles of the proletariat. The characters of communist mythology are living people—obstreperous human beings. And the workers of the world—the proletariat in the best sense—cannot be squeezed into a general concept without the most violent distortions of fact. Nor can they be represented in conventional symbols.

And I must again point out that the great religious arts of the world attained vitality only when their conventional symbols had been subordinated to the study and appreciation of fact; when religion had lost its intense concentration on spiritual ideals and had grown tolerant of the parade of life. The Church employed art as the tool for its propaganda, but no real art appeared until the artist had disregarded propaganda in favor of the realities of his life experience. The art of Italy, though enclosed in the framework of Christianity, a general ideal which prescribed its subject-matter, was composed of various local schools expressing local psychologies, each dominated by a powerful personality.

This historical fact should be borne in mind by those artists who, conscious of the true condition of modern art, its essential worthlessness and its snobbery, are ready to cast their lot with a political party, a militant organization preaching concepts assumed to be of universal significance, and by nature religious. No art can be enslaved to doctrine. Art, in its proper manifestations, is a communicative instrument; but it communicates its own findings—*not what is doled out to it*; not what an economic theory imposes upon it, but its discoveries in any department of life.

The most dangerous aspect of the present situation is this: the artist expects to win salvation merely by transferring his allegiance from one social group to another, an act amounting to no more than affixing a different label to the bag of tricks which art, since the War, has become.

Among the intellectuals offering lip-service to proletarian ideals, but living carefully by the pseudo-aristocratic standards sifting down through democracy, one finds as many fakers and opportunists as are attached, on the other side, to the dying powers of wealth. It is true that the dilettante communists have been spared

the most offensive element in modern art—the gigolo and the homosexual playing on the vanities of bored women; but nevertheless, to gain access to their doctrine, one is obliged to tunnel through a quagmire of affectation and dishonesty. In this field all sorts of artificial standards are erected to authenticate the revolutionary nature of works of art. Psychologically, there is no difference between such standards and those erected to determine whether an art is "pure" or "truly plastic." The esthetic intellectuals prepared art for the salons of society and wealth by inventing the correct mysteries; the proletarian playboys cleared the way for the powers and advocates of communism by passing on the correctness of the artists' attitudes. So far as the artist is concerned, there is little to choose between them: both are as dictatorial as were the old Church Fathers who not only ruled that art must proclaim the ideal through mortification of the flesh, but also specified the symbols to be used. Both demand that the artist conform to a pattern.

Unfortunately, no viable or healthy art can be forced into a pattern. The health and growth of art depend on the artist's original discoveries in life and nature where the logic of a pattern, even if it appears to exist, is but the transfer of an intellectual or emotional illusion. Neither life nor nature contains logical relationships: they must be made, and it is the business of art to make them. Art and philosophy—the "as ifs" of the human mind—are the vehicles through which experience is integrated and the human desire for rational order, or logic, is satisfied. That is their supreme function. But they fail to operate effectually with second-hand material. The man who rearranges and catalogs the thought-forms and systems evolved by others, without referring to the adventure of life, is not a philosopher—he is a professor; the man who rearranges the art-forms evolved by others, or who illustrates economic theories, is not an artist—he is an ingenious eclectic, like Picasso, or a political accomplice, like the cartoonist of the industrial workers.

An art limited to propaganda has no choice but to deal with given material, and to deal with it arbitrarily—to stack the cards in the interest of a political game. The critical questioning of life and along with it the discovery of the unexpected—of new and exciting things which, fitting no old patterns, must be communi-

cated in fresh terms—this independent exploration, which is the very soul of art, is forbidden by the rules of propaganda. Cartoons, broadsides, and illustrations may be highly useful in the promulgation of doctrine, and may, indeed, point a very bitter moral; but true art, which is the discovery of a specific world, a personalized world of the artist's own making, must penetrate beyond the facts into the emotional beliefs and habits of an environment; must range far beyond the patterns of doctrine into the complexities and contradictions of reality.

If communist propaganda is to father a new art, its proponents must be prepared to submit to the most ruthless treatment of its doctrine. The true artist is never numbered among the faithful. If communism should happen to tempt the powers of a young Daumier, it would find itself in the unpleasant position of harboring a heretic. For Daumier, an underdog reared in a radical atmosphere and using his art at the beginning of his career, as an active revolutionary weapon, lost faith in his youthful dreams of the sovereignty of the people, and subjected all political agitators, irrespective of creed or party, to merciless critical examination. He was always on the right side—the side of humanity—but his interest in French life was not consistent with political doctrines.

Communism, instead of linking art with a general idea, has enslaved it to a specious internationalism in which meanings and values are regarded as absolute and universal. This form of internationalism is not more conducive to the growth of art than the international bohemianism of the esthetes. Art is a local phenomenon. It may find its subject in ideals aiming at universality, but it must treat that subject simply as a frame for the richer content derived from experience. Great art has never deviated from this practice. Buddhist art, for example, is so named for historical convenience; intrinsically it is the art of various peoples who, by means of local experiences and psychological attitudes shaped by special environments, transformed doctrine into living expressions. Let us look into the troublesome question of the meanings of art.

Meanings are neither constant nor absolute; they vary from age to age, changing, dying, and reappearing with the different trends of civilization. Nor are they, in the strictest sense, universal. Huckleberry Finn is unintelligible to the Chinese; more acceptable

to the Americans than to the British; and closer to Middle West-
erners than to New Englanders. And the art of China, with its elab-
orate symbology developed from indigenous beliefs and habits, is,
for most occidentals, only an archeological toy—this, in spite of the
precious gabble of connoisseurs. I do not say that the art of the
past may hold no meaning for the modern man; my point is that
the strongest appeal of art—its full content, its specifically human
message—is to the civilization producing it. In short, meanings are
largely of a contemporary nature, contemporary in the broadest
sense, the social life and characteristic mental attitudes of one or
more generations. I grant that the psychological insight of Leo-
nardo may interest the modern American, atheist, or Catholic; that
we may still be moved by the power and grandeur of Michael
Angelo's brooding athletes; that Rembrandt, closer to Americans
than are the Italian masters, appeals to many of us with the force
of a contemporary. But it is not reasonable to suppose that any
past art, considered as a movement affecting the lives of men, can
carry the significance of an art drawn directly from an environment
in which we are living participants. Most of us—artists too, if they
are alive—while we may study and admire the achievements of the
past, devote the greater part of our interest and discussion to the
books, pictures, and buildings of the present. The painful truth is
that the major appeal of past art is to the specialist; and no great
art was ever founded on the limited attention of specialists. To the
artist, if he is more than an academic or a slave to canonized
beauty, the old forms serve as disciplinary tools in the ordering of
his own experiences.

The forms of art are interesting in proportion to the richness of
the personality creating them; and the elements composing the
interesting personality are derived from two sources—the charac-
ter and intensity of experience, and its processes of integration.
These two elements in combination produce the artist; one without
the other is helpless. No matter how acute or striking the experience
may be, if the artist cannot contrive an appropriate form for its
objectification, his meanings are vague and unsubstantial. On the
other hand, no matter how extensive his traditional knowledge, if
his acquired method is not fertilized by experience, his forms will
be academic and imitative. What happens with the successful artist

is that the realities of environment actually work upon his spirit, forcing him to modify traditional processes and to create a new and personal instrument of expression.

The communists assert that ideas are indispensable to art. They are right; without ideas, or concepts, nothing would be done, and the cult of sensitivity has become the refuge of quacks and neurotics. But the idea is the generative factor, not the end of art. An idea may, in itself, be vital, but it will not produce an interesting form unless referred to the actual conditions of experience as presented to the vision. It is not the physiological nose or head that is expressive, but a particular nose or head observed by the artist in some significant situation. In the process of construction the head may be idealized, as in Greek sculpture, but its character and meaning are determined by the stuff of life involved with and conditioned by environment. Rubens had ideas—grandiose classical concepts lending their names to his pictures—but his ideas, transformed in the crucible of his experiences, came out not as goddesses, but as Flemish housewives, whose truth and reality were recognized and enjoyed by men and women totally unfamiliar with the generating idea.

With the communists the beginning and end of art are in the moral idea. The artist is drafted into the illustration of an economic theory, and the best that the idea can do is to inflame his moral indignation. No experience, no observation, no discovery is allowed to interfere with his political duty. He takes a method, for the most part, the modernist pattern, and bends it into the service of a verbal idea. Most ideas, I need hardly say, owing to the early conditioning of our communicative needs, are verbal; but the idea, passing through the imagination of the true artist, is transmuted into a pictorial form which carries a new meaning. Albert Ryder's paintings were inspired by verbal concepts of the tragedy of man, but his paintings cannot be translated into words. Ryder, poet and mystic, represents to perfection the yearning that runs so easily into sentimentality, the strange sadness underlying the drift of so much of American life. He is true to a psychological type which I have met, not only in New England but throughout the Middle West; not only among tenant farmers of the South, but under the conventions of many a Babbitt. In his art is the nostalgia of the

roving, bewildered American people. That fine Western painter, John Curry, has verbal ideas of his love and interest in the homeland—a conception of himself in relation to his subjects—but neither the titles of his pictures nor any verbal description can convey the poetry interfused in his rustic themes.

When art is wedded to propaganda, its content is limited to the expounding of doctrine. Once the moral is pointed, there is no further use for it. I examine and enjoy and applaud the brutal force and savage energy with which our radical cartoonists attack some current villainy; but I do not find myself returning to these diatribes, as I return to Hogarth, the meaning of whose art lies not in the specific subject but in the psychology of the British people, or as I return to Daumier whose best work is not merely an illustration of an evil, but the integrated experiences of a profound personality. The propaganda plays of Bernard Shaw, written to expose corruption or to prove a theory, but without depth of feeling or convincing emotional experiences, are as stale today as the trumped-up estheticism of Oscar Wilde's dramas. Shaw once said that a knowledge of economics was as necessary to the structure of his plays as a knowledge of anatomy to the structure of Michael Angelo's figures. He forgot that Michael Angelo was not trying to prove anything.

You will have noticed that the propaganda artists display very meager acquaintance with the American background, and indeed, very meager knowledge of the figure and the way in which behavior and occupational interests actually affect the human anatomy. Doing what they are told to do, they turn out dreadful concepts— bestial stuffed shirts, monstrous forms so fiercely exaggerated, so remote from reality as to defeat their own purpose. Thus their art runs swiftly into trade symbols and conventions; into stock forms and stereotypes of no more enduring value than the stereotypes of the bohemians.

The learned Mexican, Rivera, in his own country was an artist. His native murals, in spite of annoying mannerisms acquired from the forcing of experience into French and Italian moulds, have, to a considerable degree, the character of original discoveries welded into forms. At home, he painted pictures containing social meanings which his countrymen, capable of sharing either praise or

regret, and this is sufficient proof, I think, of the genuine quality of his Mexican experience. His American murals seldom rise above the level of prodigious competence. Rivera is now a fad, a public character, a politician playing shrewdly on the sympathies of the workers and on the snobbery of the highbrows. The trouble with him is that he has had no real American experiences—he is too busy squaring himself with the communists to get acquainted. A day in a laboratory, or a visit to the Ford plant, in the company of the younger Ford, does not educate an artist in the industrial life of a foreign country. In his American murals he disregards experiences entirely. With the help of his assistants, he assembles his data—machines and properties snatched from industrialism—and with amazing skill converts them into symbolical claptrap. He must, of course—and this is an honest conviction—abuse the capitalists; but his huge mechanisms, expressly designed to uphold the worker, have none of the deadly effectiveness of the cartoons of young William Gropper. They are full of wooden Indians, stock figures, and threadbare emblems—the result of his muscular efforts to force the obvious factors of the American environment into forms developed from the social upheaval in Mexico.

In contrast, we have the murals of Thomas Benton—paintings influenced, like those of Rivera, by past styles and methods, but taking their final form and character from the American environment. The meanings of these murals are consistent with their form, and can be verified by any one familiar with American life. Benton's historical interests act as generative ideas: transmuted in the crucible of his extraordinary experiences, his ideas derive their meaning, not from history, but from first-hand contacts with a hundred kinds of life. Benton's murals reveal and communicate the actual conditions of his native land; its restless spirit, its interest in facts and details, its exaggerated buffoonery, and some of its pathos. He has created a valid American art.

Propaganda cannot produce an original art—cannot produce any art, though it may superficially accompany it. I recently asked one of our best cartoonists, a truly radical young man and an excellent painter, why he was not a communist. His answer was: "The moment I become a communist, I cease to be an artist. My hands are tied; my independence sacrificed to a system. If I want to paint

my wife and baby as I know them—to express what they mean to me—I cannot do so. I must paint them as starving victims of capitalist crimes. Propaganda is to art what the gun is to the soldier—not an expression but an explosive." There would be no room in propagandist art for a skeptic like Leonardo; an outcast, like Rembrandt, who shirked every social obligation; a turncoat and a trimmer, like Goya; an old Tory, like Cézanne, who lived on inherited wealth.

I have only one medicine to prescribe for the painter—an interest in living. The nature of the interest is his own problem; it may be metropolitan or rural, poetic or realistic; but it must be genuine and exceptional. Unless he has this interest, this intelligent curiosity and relish for living, he will never be an artist. I do not ask him to celebrate America; no self-respecting artist could glorify capitalism. I ask that he have some basic conviction, some point of departure. His business is not to teach but to reveal; to communicate meanings which may be confirmed, shared, and enjoyed by an intelligent audience. He must preserve his independence. I do not mean that he must be free in the bohemian sense, that he must live in a state of irresponsibility which prevents him from facing any useful experience. He must be free to question any system, creed, or situation.

It would be a fine thing, if we had in America a dominant idealism, a spiritual force uniting artists in a common purpose, making them practitioners again, affording them legitimate markets, and circulating their pictures. But I see no signs of the coming of this Utopia. Certainly the Church has no use for artists; and communism is the haven of malcontents. In the absence of a Utopian scheme, the artist must adapt himself to realities, put living above painting, and do his best in the worst of worlds.

Answers to Ten Questions

THOMAS BENTON

In its last number The Art Digest *printed some paragraphs from the attack made by Stuart Davis in* The Art Front *on American nationalism in art and particularly on Thomas Benton, Reginald Marsh, Charles Burchfield, John Steuart Curry and Grant Wood as exemplars of "the American scene." Davis said some very rough things about Benton, and the editors of* The Art Front *invited him to reply. He declined, but said he would answer any ten questions the editors might ask him. Because of his leading position as a mural painter and a teacher,* The Art Digest *takes pleasure in presenting in full the ten questions and Mr. Benton's anwers:*

1. Is provincial isolation compatible with modern civilization?
This involves two further questions: What is provincial isolation? What is modern civilization? The first question is tied up with the meaning of the word "province" which is a division of a state or empire—an area which is dependent. Now dependence is a relative factor and the degree of dependence of any area would determine its provincialism. If the degree is large, the element of provincialism is large and the status of an area, quite apart from nationalist ties, could be set within the meaning of the word province. (As, an economic province.) This would not do for the United States, to which the reference here seems to be directed. The United States is not dependent on any state or empire, even though it imports goods, mental and material, from states and empires. (Note the plural.) It is true that there are provincial areas within the United States. The Communist party, for instance, as it is presently constituted, inhabits such an area. This area is not physical but psychological. It is none the less an area—an area of thoughts and beliefs.

From *Art Digest*, 15 March 1935, p. 20. Reprinted by permission of *The Art Digest, Arts Magazine.*

The provincial character of that area is determined by the degree in which it is dependent upon a body of centrally controlled thought—an empire of ideas and beliefs. The Communist party at present is an isolated mental area in the United States. It is a dependent, a province of certain kinds of thought, and it is set in a region where the sort of social behavior and instrumentation which actually objectifies that thought is checked and frustrated.

Is this kind of provincial isolation compatible with the existence of a kind of civilization where communist behavior is presumably unchecked? The question here seems, when the factual side is considered, to need an affirmative answer. This does not, however, cover the whole of our question which is complicated by the concept, modern civilization.

A civilization, in fact, is a thought and behavior complex. Factually regarded, there are at present a number of modern civilizations which think and behave quite differently though they possess the same tools. The question here deals with something which has no factual existence. It deals with a concept. Though it refers to observable fact (use of like tools, for instance) this concept sets up a unity which is not in observed fact itself but in the verbal techniques that describe it.

Our question, if it is to be realistic or intelligible, now reads "Are areas of provincial isolation compatible with modern civilizations?" The word "compatible" involves "beliefs" about relations which are too complex for discussion here, so I am forced to answer this question by saying that areas of provincial isolation do exist and that modern civilizations do exist and that as long as they are able to co-exist, there must be congruities present which allow for that co-existence. In view of "what is" my answer to this question is "Yes." May I say, however, that I regard the question as fundamentally nonsensical. It does not deal with observable things but with notions.

2. Is your art free of foreign influence?

This is a straightforward question, free of devious intellectualities. The answer is "No."

3. What American art influences are manifest in your work?

This question can only be answered by defining "art influences." Art influences are historically of two kinds. There are instrumental

and perceptive influences. (Perception is regarded here as that psychological process which sets up relations between the individual and phenomena external to him. The artist's perception is regarded here as it is directed to the world which exists apart from the specific instrumentalities of artistic process—To the "real" world.) The instrumental influences of art are the "ways of doing" that are *known* to the artist. The more that is *known* of the history of art process, the greater the body of influence. The less that is *known*, the more limited the body of influence and the more obvious any particular influence. American practitioners, for the greater part, look like French practitioners, because they know (have learned) only French practice. With a wider knowledge of historic process as a whole, they would have escaped the sort of provincialism which is involved in the imitation of French process. This provincialism is analagous to the sort of provincialism touched upon in the first question. It indicates dependency. French process was and is influenced by the French practitioner's knowledge of a considerable body of historical process which is not French. French process, nevertheless, gives results which are French. Why? Because of the entrance of influences which are not instrumental but perceptual— influences which come, not from process but from perceptions of things and relations of things in the French environment. These perceptions have forced modifications in historically known traditional practices. These traditional practices were developed in other than French environments where perception dealt with other than French phenomena. These practices could not, consequently, without modification "cover" the "stuff" of perception in the French environment. It is in this forced modification of process by the "stuff" of perception that forms are developed. Forms, that is, which are not *imitations* of other forms. There is apparently no other way of doing it. Any study of Symbolism, of the "read in" meaning in its connection with art, will show that meanings, when they are transferred from beliefs to forms do not affect changes in forms. Forms are changed only by the effects on process of perceptions that processes fail to cover. Perceptions are the contradictions to the form thesis when it (the thesis) is taken to a new environment—these contradictions are "resolved" by a new form which "covers" the contradictions involved in perceptions. The new form

is in actuality a synthesis. If this seems too material a view of art, remember that it is in harmony with the pragmatic aspects of Marxist thought, to the whole body of which your beliefs are committed.

The answer to this question is in the Form of my actual work, where my perceptions of the American environment have influenced my historical knowledge of processes (French and other) and set up a new synthesis which no one can confuse with other syntheses, French, Mexican or what not.

 4. Was any art form created without meaning or purpose?

Any art Form is a complex of practices. First, it is practice which is learned. Second, it is practice undergoing modification through the pressure of perceptions which the learned practice does not "cover." It is, third, a new "statement of relations" between the elements of practice after these have been modified. This new statement involves a new logic (formal relations) and has generally new associations. This is true whether practice deals with geometrical forms which represent nothing or with geometrical forms which represent something. All art Form elements may be reduced to geometrical or sensational factors. An art Form is then in the last analysis a material thing. To translate a picture or other Form into its geometrical and sensational components is, however, an intellectual feat. It is not necessary for setting up those relations which in practice, for instance, make a picture. It is not necessary or in my opinion advisable to cut away the associative content of the perceptually affected elements of form-making. Where this is done, symbolic meanings are "read in" to the Form to make up for the lost content. Art Forms are involved with purpose even when they are simply embellishments. When they are representations they are involved with the meaning of our perceptions—which involve, again, a great body of associated meanings. The answer to the question, with the information I have at present, is "No." This question cannot be answered as if "aesthetic" values were separate from human ways of perceiving and doing.

 5. What is the social function of a mural?

This is for society, as it develops, to determine.

 6. Can art be created without direct personal contact with the subject?

If I am to understand the word art to denote an original Form type and the word "subject" to mean what the Form type represents rather than what it symbolizes, the answer is "No."

7. What is your political viewpoint?

I believe in the collective control of essential productive means and resources, but as a pragmatist I believe actual, not theoretical, interests do check and test the field of social change.

8. Is the manifestation of social understanding in art detrimental to it?

"Social understanding" is simply the outcome of a body of beliefs which are more intellectual than directly perceptual. "Proof" for such beliefs is afforded by submitting perceptual stuff to ideas which explain it—to rational conceptions. Rational conceptions impose orders on the flow of experience and remembered experience (history). Conceptions become theses, when, for any of a dozen reasons, they are regarded as true. When a thesis is accepted as true, it becomes an object of belief and gets involved with all the emotional accompaniments of will. Many various kinds of "social understanding," forms of the "will to believe" have, through history, undoubtedly affected artists. Beliefs do affect the relations that are set up between things which are perceived, but it is actual perception of things in their environmental setting which finally determines the nature of a form. Beliefs may themselves be read into any traditional and stereotyped Form—they may also accompany or affect highly original ones. Belief, when it becomes dogma, has been historically detrimental to the evolution of artistic practice because belief, as an intellectual attitude, is satisfied with symbols and resents discoveries in perception which might force modifications in belief structures (as well as Form structures). I refer you to the history of Early Christian art—to Navajo sand painting—to any area where Form making became crystallized in a style (way of doing) dominated by belief meanings. Particular historical references, however, cannot make us sure that beliefs are always detrimental to the development of Form types. Evidence indicates only that they are generally so. I will say then that "social understanding" as a belief form is generally detrimental, though not necessarily so. The "social understanding" of Daumier and

90967

Thomas Nast did not keep them from being great artists, any more than Marx's conception of history ("systematic unity of the concrete world process" progressively unrolled, an "ought to be" in a dialectical movement) kept him from making intelligent statements about his perceptions of fact. (Greater part of Chapters 12 & 13 of *Capital*.)

9. Is there any revolutionary art tradition for the American artist?

The answer here lies in the history of America where the "turns" of affairs have a form not to be confused with "turns" in other areas, though they may develop structures which are similar in intellectual analysis to structures in other areas. (The case of private ownership structures in the United States and throughout the world is here to the point.)

Intellectual analysis is a reducing process of thought which takes the individual and characteristic from phenomenal things in order that they may, as abstractions be logically related in theory. Theory is directed generally to imposing "meaning and purpose" through logical orders on the flow of phenomena.

In the current Communist sense, there is no revolutionary tradition for the American artist. In the sense which I have developed above, which declares a necessary relation between perception (of phenomena) and original Form making, there is plenty of revolutionary tradition. It began with the first effects of the frontier upon provincial Forms in the East and South and continues to this day in the actual moves of conflicting interests.

The answer is "Yes" if you know your America.

10. Do you believe that the future of American art lies in the Middle-West?

Yes. Because the Middle-West is, as a whole, the least provincial area in America. It is the least affected, that is, by ideas which are dependent on intellectual dogmas purporting to afford "true" explanations of the flow of phenomena—those rational schemes which arise in and with groups who do not labor with things but with verbal abstractions supposedly representing them.

Because in that area the direct perception of things, since it is less weighted with intellectual conceptions of meaning, purpose

and rational progression, has a better chance to modify "ways of doing" in an unstereotyped and uncategorical manner. Because unlike the East, as a whole, it has never had a colonial psychology, that dependent attitude of mind which acts as a check on cultural experiments motivated in the environment.

Because in spite of the crudities and brutalities inseparable from its life and heritage of frontier opportunism it has provided the substance for every democratic drive in our history and has harbored also the three important collective experiments in the United States. (Rapp, Owen, Amana.) These experiments are important, even if untimely and utopian, because they attempted in fact the realization of a profound human dream and provided thereby, if nothing else, an illustration of the error of trying to make dreams come true through "the mere holding of idealistic conceptions."

Because of the rapid contemporary growth of interest in artistic construction and expression which is now providing the rising Middle-Western student of art with magnificently equipped schools and libraries in which he can find illustrated and exemplified the whole history of aesthetic practice. Here in a large field of choice he will find his instruments, his knowledge of historical "ways of doing" without having them so conditioned by subservient attitudes that he can never use them in reference to his real experience.

Because the Middle-West is going to dominate the social changes due in this country and will thereby determine the nature of the phenomena to which the artist must react if he is to make Forms which are not imitations of other Forms.

And because there is among the young artists of the Middle-West as a whole less of that dependent, cowardly and servile spirit which in a state of intellectual impotence and neurotic fear is always submitting itself to the last plausible diagnostician "just to be on the safe side."

Rejoinder to Thomas Benton

STUART DAVIS

In its last number, The Art Digest *printed the answers which Thomas Benton made to ten questions propounded to him by the editors of* The Art Front, *which is America's left wing art periodical, following an attack on some of the chief proponents of "the American scene" by Stuart Davis. Davis now answers Benton, in an article written for* The Art Digest:

THIS article is not for the purpose of establishing a personal feud with Benton, who as an individual has a right to his mistakes. But the Benton who at all times, by the written and spoken word and graphic illustration, ballyhoos himself as the ancestrally qualified savior of American painting is another matter. I wish here simply to discuss the ideas and contradictions and evasions contained in his answers to the ten questions, submitted at his request, by the editors of *Art Front*, the organ of the Artists' Union.

Benton allows himself plenty of word footage in answering these ten direct questions, but the nucleus of thought contained in the involved verbal barrage is characterized by a quantitative restraint. In all fairness I submit the following propositions as a true synopsis of the ideological content of his answers.

1. Art forms are the product of learned practices and perceptual modifications.

2. The future of American art lies in the Middle West, because the artist there has a minimum of process knowledge. Acceleration in the construction of museums and libraries will allow him to acquire this knowledge.

3. Art values are inseparable from human values.

From *Art Digest*, 1 April 1935, p. 12. Reprinted by permission of *The Art Digest, Arts Magazine.*

4. Social understanding usually hurts the artist.

5. Real art forms cannot be created without direct contact with the subject.

6. The future alone can tell the social function of a mural.

7. All art forms have meaning and purpose.

8. There is no revolutionary tradition for the American artist in the political sense.

So much for the positive assertions. In addition there is a basic and conscious evasion in the form of definition out of context. The first question, "Is provincial isolation compatible with modern civilization?", is clear in meaning. Provincial, in this context, has its common usage of "cultural backwardness." Benton's deliberate evasion by limiting the word to its political and geographical meaning, "a division or dependency of a state," doubtless indicates a sense of inferiority so far as the word "provincial" is concerned.

By this evasion he is able to state that the Middle West is the least provincial area in the United States and at the same time the most culturally isolated in the aesthetic field. Being relatively uninformed, the Middle Western artist, says Benton, can react to his environment better than the artist of the Atlantic seaboard. I agree with Benton that the perception of environment is primary, but possession of the weapon of theory does not render the artist unable to perceive his environment. Benton conceives the Middle West as provincial, he sees it in his own image. I too, think that great art will come out of the Middle West, but certainly not on the basis of Benton's presumptions. It will come from artists who perceive their environment, not in isolation, but in relation to the whole. Their historical perspective will not be in terms of public school history books or the Buffalo Bill nickel novel type of drama. Regional jingoism and racial chauvinsim will not have a place in this great art of the future which Benton foresees, but the ideological basis of which he is unable to understand.

The contradiction, confusion and evasion in thinking which Benton exposes in his answers to these questions have a special value. They make clear for the first time the cause for the revulsion that most artists feel in the presence of a mural by Benton.

It is now clear that the disorganization, the bad color, the unpleasant surface and the social Nihilism of his work are not, as he himself boasts, the crudities of a man of the soil and of the pioneer stock, but rather the logical result of an innate inability to think straight and realistically. The compositional enigma of the applied picture mouldings to his murals in the New School of Social Research is an outstanding example of his inability to think logically in terms of materials. Another example is his persistence in the use of some painting surface which cracks badly. Witness the murals in the New School and the Whitney Museum. These irresponsibilities are characteristic of Benton's public acts as an artist and one has to allow oneself the bad taste to call attention to them. A cracked surface is of relatively little importance, but cracked thinking may have disastrous effects on American art and artists when indulged in by an aggressive man.

In his answers Benton states that all art forms have meaning and purpose and are inseparable from human values. This clearly shows an appreciation of the responsibility of the artist to the public. This is followed by the amazing statement that social understanding is detrimental to the artist and that the social function of a mural is an unknown quantity. These triple-strength contradictions expose Benton, the petty opportunist. Especially now that government murals are being held out as bait, it would be a mistake for an artist to commit himself. However, on past performances Benton has committed himself, and how! On past performance Benton should have no trouble in selling his wares to any Fascist or semi-Fascist type of government that might set itself up. His qualifications would be, in general, his social cynicism which allows him to depict social events without regard to their meaning. Specifically he could point to his lunette in the library of the Whitney Museum of American Art where his opinion of radical and liberal thought is clearly symbolized. It shows a Jew in vicious caricature holding the *New Masses* and saying "the hour is at hand." Hitler would love that. For Huey Long he can point to his *Puck* and *Judge* caricatures of crap shooting and barefoot shuffling negroes. No danger of these negroes demanding a right to vote even if the poll-tax has been taken off. If art

forms have meaning and purpose and are inseparable from human ways of perceiving and doing, then in the examples given it is quite clear what Benton has perceived and what the purpose of his forms are.

Art values are inseparable from human values and social understanding is detrimental to the artist, says Benton. When Huey Long is asked why, on state construction work, employees get as low as ten cents an hour, he has an answer. He says, in effect, "I'm a 100 percent for labor and labor's a 100 percent for me, but there is no such thing as unions on state highways around here. I can't get messed up in that." Like Huey, Benton is 100 percent for human values but when it comes to specific constructive thought regarding them, he can't get messed up. If Benton were the ivory tower, still life artist, the above would not apply to him. But we are dealing with Benton the ancestrally qualified man of the American soil: the Benton who says that real art forms cannot be created without direct contact with the subject and the Benton who is out to place large murals in public buildings. If he thinks that the farmers he paints are not "messed up" and involved with social theories, let him ask the farmers.

Benton disclaims all ability to evaluate the social function of a mural. At that time when he abandons his "cowboy and Indian game" outlook on the historical events he portrays, he will find that his employers are not so ignorant in this matter as himself. Rockefeller is not an artist but he has a sharp eye for the social function of a mural. He spotted the social function of Rivera's mural in Radio City before it was completed and destroyed it. The outdoor mural by Alfaro Siqueiros in the Plaza Art Center in Los Angeles has been whitewashed. This is the treatment which Jonas Lie, president of the National Academy of Design and member of the La Guardia Municipal Art Commission, prescribes for the murals passed by him on the municipal art projects. In the above and other cases the employers didn't wait for "society as it develops" to make the decision.

A large part of Benton's answers are concerned with the monotonous repetition of the learned practice and direct perception formula—mechanical formulation of the act of creation. He states that his perceptions of the American environment have made

him an American artist, not to be confused with a Mexican or a French artist. I deny that he has ever perceived the American environment on the evidence of his own work and statements. No, Benton's environment is the *Puck* and *Judge* school of caricature, reproductions of muscle painting in the Italian Renaissance, Hearst politics, which can run an editorial against the brutality of the prize fight on the front page and promotes a milk fund bout on the sports page, and a dime novel version of American history. Compilation of sketches from life does not constitute understanding of environment. Benton's sketches may be from life, but their co-ordination in mural form is conditioned by sketchy ideas as to their political, social and economic significance.

The subject matter of Benton's murals is the American environment, and that environment is not characterized by its visual aspects alone. Any artist who undertakes the portrayal of that environment automatically takes on the obligation of understanding its social meaning as well, as such social meaning is inseparable from his subject. Benton has recognized this obligation in his statement that aesthetic values are inseparable from human ways of seeing and doing. He has recognized the obligation but has not accepted it.

There is no revolutionary tradition for the American artist in the current Communist sense, says Benton. His answers are answered from the Communist viewpoint in the April number of *Art Front* by [Jacob] Burck, since Benton drags in Communism. Not being qualified on this point, I prefer to read the statement, "There is no revolutionary tradition for the American artist in the political sense." Were the events leading up to the signing of the Declaration of Independence non-revolutionary? Was the war for liberation from England non-revolutionary? The simple way to show the absurdity of Benton's reply to the question is to look at Rivera's *Portrait of America* mural at the New Workers School on Fourteenth St., New York. Then go to Benton's murals of the American scene in the Whitney Museum if you think my characterization of his work as "dime novel American history" too harsh. Also, after you have seen Rivera's mural, read Siqueiros'

analysis of it in the *New Masses* of May 29, 1934, for a better understanding.

In brief, Benton shows himself in word and deed as a hard worker but a man of complete philosophical irresponsibility and incompetent in every way to occupy the position he demands for himself as the painter of the American scene in the mural field.

What Should the American Artist Paint?

JOHN STEUART CURRY

In the midst of the current controversy between the nationalists and internationalists in art, the studio-painters and the exponents of the so-called "American Scene," the question, "What should the American paint?" inevitably comes up. John Steuart Curry, one of eleven painters picked by the Treasury Department's art section to decorate the new Post Office and Justice buildings in Washington, gives in the following paragraphs his answer to that question. Mr. Curry, whose own paintings carry a powerful dramatic appeal, feels that the American artist should paint and imbue with drama that which is most alive to him, most indigenous to his background, at the same time not sacrificing subject matter on the altar of abstract aesthetic theory—Art Digest

THE artist must paint the thing that is most alive to him. To do this in a distinguished manner takes thought and a realization of what is to be accomplished. Thousands of us are now painting what is called "the American scene." We are glorifying landscapes, elevated stations, subways, butcher shops, 14th Street, Mid-Western farmers, and we are one and all painting out of the fullness of our life and experience.

Now, because the artist is an American and paints a skyscraper, that will not make a great work of art, nor even a distinguished one. There must first be a lively interest in the subject; then comes the step of designing the form so that the feeling and underlying motive that comes through will be sharpened and given its full dramatic power. It is a fault that we all fall into—to paint a fact without first considering the dramatic or spiritual side of the subject. It is well to remember always that

Originally published as "Curry's View: What Should the American Artist Paint?" *Art Digest*, September 1935, p. 29. Reprinted by permission of *The Art Digest, Arts Magazine*.

thing which is beyond the power of the camera eye to report.

Grant Wood is producing an art that is real, indigenous to the life of his people. He has brought the town of Cedar Rapids and the state of Iowa renown and is, in my mind, the perfect example of that situation talked about now—"the artist as a part of his civilization." Not only have the people of Cedar Rapids bought 400 of his pictures, but his advice is asked on the architecture and design of public buildings; the leading hotel is decorated by his hand.

Reginald Marsh will put into a Coney Island Beach crowd something more than the fact—there is in these people the squirm of life. In the work of Burchfield and Hopper there is more than the reporting of a mansard roof—there is in them the history of a period. Jacob Burck painted a picture of a striker being slugged by mine guards; it is one of the few propaganda pictures that has enough reality to be remembered.

The artists who are moved to paint propagada, particularly those with Communistic leanings, should look to the realities of their subjects and at the same time become better propagandists. It would be a good thing for the John Reed Club to go *en masse* to a sweat shop and sketch the workers. At the Forum held last year after the social conscious art show, I heard a letter from a worker read. The workers from the sweat shop had been invited to attend and see themselves as an artist had depicted them. This one was insulted and voiced the united disapproval of the group. He said, "if this in reality is what the workers are, miserable beasts, then we are poor material out of which to build a new social order."

Cartoonists, illustrators, fashionable portrait painters are all loaded down with stock mannerisms and symbols, but none so much as the radical artist. There is a great opportunity for a new viewpoint. A little intelligent observation and a more powerful art expression would arise. It would be better propaganda too. Suppose we take the subject of a mounted cop cracking a Union Square radical over the head. The dramatic element of a man on horseback and a man on foot in combat is the best of drama. The instinctive recoil of the man on foot from the trampling hoofs of the horse is good drama. Then observe the people, the open, yell-

ing, screaming mouths. Take the worker being struck. Usually he is depicted as a flat-headed oaf, who would not be hurt much by anything, or else he appears as an emaciated wretch, for whom the cop would immediately call an ambulance. It would be better drama and better history if the type were a flesh-and-blood Union Square type.

I point out this opportunity for a new and truer approach to a very popular subject matter. I do not say there is any set manner or method of handling a subject. Some artist may come along tomorrow and, using all the old clap-trap, make something out of it—but to do it will take a fresh and vivid enthusiasm.

All good picture making depends on a design significant to the subject. I believe in subject matter. The artist ought to paint people doing things, or if he paints a portrait, to show the personality and inner meaning of the life before him. The use of life as an excuse for clever arrangements of color or other pictorial elements ends where it begins. It is well, if you would make a dramatic design to think of the life before you. If you feel the significance of the life, the design builds itself. The feeling inherent in the life of the world cannot be ignored or trifled with for the sake of a theory.

Every sincere artist knows that there is no band wagon that goes all the way; no seeming success of the moment that will atone for the thing he knows in his heart he has not accomplished or for that thing he has left undone.

The Artist Today: The Standpoint of the Artists' Union

STUART DAVIS

THIS article deals with the artistic, the social, and the economic situation of the American artist in the field of fine arts, regarding the situation in the broadest possible way, and does not intend to stigmatize individuals except as they are the name-symbols of certain group tendencies.

The most superficial contact with artists makes it clear that the artist today is in a state of confusion, doubt, and struggle. He is not alone in his plight but has the respectable company of business men, chambers of commerce, politicians, congresses, presidents, and supreme courts. In short, the artist participates in the world crisis.

The immediate past of the American fine-artist was briefly as follows—he came in general from families of the lower middle class who could afford to send their children to art school, in many cases to European schools. These schools were, in their nature, schools of the middle class, and it is also generally true that the art taught in these schools was oriented towards the middle class. Consequently the work of the future artists was supposed to be absorbed by that class through the appropriate commercial channels. This does not mean, of course, that the middle class as a whole were art patrons; it means that the upper strata of the class, who were the wealthy art buyers, still retained their lower middle class psychology and were qualitatively one with the class as a whole in culture.

Thus the artist exercised his talents within the framework of the middle class culture. Still-lifes, landscapes, and nudes were the chief categories of subject matter, and the artists competed

From the *American Magazine of Art*, August 1935, p. 476. Reprinted by permission of The American Federation of Arts, 41 East 65th Street, New York, New York 10021.

freely against each other for originality within this framework of subject material. In addition, there were of course the different schools of theory and method such as the impressionists, the post-impressionists, the Cézanneists, the Cubists, the *Surrealists*, and always the reactionary Academy in different forms. The commercial contact of the artist was through the art dealer and gallery and the private patron, as well as the museum, which is really a collective of art patrons conditioned by the art dealer.

It follows, then, that the artist of the immediate past was an individualist, progressive or reactionary, in his painting theory, working within the framework of middle class culture with a subject matter acceptable to that culture and marketing his product through channels set up by the middle class. His economic condition in general was poor and he was badly exploited by art dealer and patron alike.

For those unaware of this exploitation, I will briefly specify. The dealer opened shop with a free choice of the field for his stock in trade. His stock cost him nothing but promises, and these promises were not promises to pay, but promises of a vague future of affluence to the unorganized and wildly competing artists. In many cases the artists were actually forced to pay gallery rent, lighting and catalogue and advertising costs in return for the promises of the dealer. In addition, commissions of from a third to a half and more were charged for sales. In the few cases where certain artists were subsidized by dealers the situation was not different in kind but only in degree. What resulted? In each gallery two or three artists emerged as commercial assets to the dealer, and at that point a certain character was given to the gallery. This character was the result of the planning of the one-man and group exhibitions around the works of the artists that time had shown to be the easy sellers. The body of artists of the gallery were used chiefly for window dressing and quantitative filler. In addition, the dealers carried variously old masters, early American, folk art, etc., which they bought at bargain prices and sold at enormous profit, frequently to the exclusion of the work of the contemporary artists they were supposedly marketing. Art for profit, profit for everybody but the artist. With the art patron and museum the situation is similar, free choice without

responsibility, but there is the additional feature of social snobbery. Artists are subsidized with the hope of financial gain on a statistical basis; a number are picked for low subsidy with the hope that one of them will bring home the bacon financially speaking. There is also the desire of the patron to be regarded as an outstanding person of culture among his fellow traders, social snobbery, or, in cases of extreme wealth, the ability of the patron to add the prestige of charity to the excitement of gambling. For these reasons the term "badly exploited" surely applied directly to the artist.

This is a factual description of the social-economic relations of the artist body to society as a whole in the immediate past, and of course today as well.

Today, however, there are certain developments which are peculiar to the time and which directly affect the artist in his social-economic relations. They are: (1) Federal, State, and Municipal Art Projects; (2) street exhibitions and art marts; (3) the Mayor's Committee of One Hundred in New York City, appointed over the protests of the artists, whose supposed function is the creation of a Municipal Art Center; (4) suppression and destruction of murals, as in the case of Diego Rivera, Alfaro Siqueiros, and Ben Shahn, and the Joe Jones affair in Missouri; (5) gallery rackets, self-help plans, such as the Artists Aid Committee in New York, artists and writers dinner clubs, five and ten dollar gallery exhibitions, etc.; (6) a rental policy for all exhibitions as adopted by the American Society of Painters, Sculptors and Gravers, and the refusal of museums and dealers to accept it; and (7) the organization of the Artists' Union of New York and the "firing" of members for organizational activities on the projects.

These events and others are not isolated phenomena peculiar to the field of art. They are reflections in that field of the chaotic conditions in capitalist world society today. The artist finds himself without the meagre support of his immediate past and he realizes now, if not before, that art is not a practice disassociated from other human activities. He has had the experience of being completely thrown overboard and sold out by art dealer and patron, and his illusions as to their cultural interests are de-

stroyed. He realizes now that the shallowness of cultural interest of his middle-class audience was retroactive on his own creative efforts, resulting in a standard of work qualitatively low from any broad viewpoint. Looking about him, he sees sharp class distinction, those who have, and those (the great majority) who have not. He recognizes his alignment with those who have not— the workers.

With these realizations the artists of New York have taken certain actions. They organized the Artists' Committee of Action and undertook a struggle for a Municipal Art Gallery and Center, administered by artists. Mass meetings and demonstrations were held. The mayor of the city, La Guardia, refused to see their delegations, gave them the runaround and finally appointed a Committee of One Hundred to plan a municipal gallery and center. This committee was appointed without consulting the artists and is composed for the most part of names of socially prominent people who have no conception of the problems involved. Their first act was to hold an exhibit in a department store, their idea of solving the artists' problem. Most of those invited to exhibit withdrew their work from the walls on the opening day in protest, and the whole story with photographs, phoned in to papers by reporters on the spot, was killed in the press because the department store was a big advertiser. After this farcical first step the Committee of One Hundred went into temporary retirement and is now planning some summer festival, another attempt to give the present administration of the city credit for patronizing the arts without doing it.

The formation of the Artists' Union over a year ago is an event of greatest importance to all artists. With a present membership of thirteen hundred artists, the Union invites all artists to membership, and locals in other cities are being formed. The most direct action taken by the Union has been on the Municipal Art Projects. Over three hundred art teachers, painters, and sculptors are employed, a small fraction of those needing employment. Those employed have the necessity of proving themselves paupers before they are eligible and after employment are often badly misplaced in regard to their best abilities. All organization by the artists on these projects is frowned upon by the adminis-

tration, which subscribes to the ancient adage that paupers cannot be choosers. The administration is wrong; paupers today can choose when they are organized, and through their Artists' Union they have won some rights, have had "fired" members reinstated, and through their picket lines have shown the authorities that they are not to be kicked around at will. They fight steadily for increase in projects, against lay-offs, against time and wage cuts, for genuine social and unemployment insurance, for trade union unity, against the degrading pauper's oath on the projects, and for free expression in art as a civil right. Through their struggles in the Artists' Union the members have discovered their identity with the working class as a whole, and with those organized groups of artist-craftsmen such as woodcarvers and architectural modelers and sculptors in particular. With this realization a morale has developed which grows in spite of the efforts of the administration and its agents to break it. Exhibitions of the work of the members of the Union during the past winter showed a quality comparable in every way with the gallery exhibitions. This quality will change and improve, for reasons I will give later. The Artists' Union has an official organ, *The Art Front*, which has been widely hailed as the most vital art magazine in the country, with critical articles of high quality. The slogan of the Union, "EVERY ARTIST AN ORGANIZED ARTIST" means something which no artist can afford to disregard. Negotiations are now under way for the entrance of the Union into the American Federation of Labor.

The question of the civil right of free expression is a vital one today for the artist. It affects his life as a man and as an artist. Fascism is a powerful trend in the current political world set-up. Fascism is defined by the Methodist Federation for Social Service as "the use of open force (against the workers) by big business." We have seen it at work in Germany and Italy, and one of its first acts is the suppression of freedom in the arts. Schools are closed; artists, scientists, and intellectuals are driven into exile or thrown into concentration camps. Culture in general is degraded and forced to serve mean and reactionary nationalistic ends, and the creative spirit of the artist is crushed ruthlessly. Such trends exist in this country, as any newspaper reader

knows, and already individuals and small groups have committed Fascist-like acts of suppression, for ideological and political reasons. The destruction of the Rivera mural, the Siqueiros murals in Los Angeles, the suppression of the Ben Shahn and Lou Block mural for Riker's Island Penitentiary in New York by Jonas Lie of the Municipal Art Commission are examples. No artist can afford to remain complacent in the face of these and a thousand other similar cases, nor can he feel that they do not concern him directly. Organization by the artists and cooperation with the organized workers is the only method to fight these attacks on culture.

The question of quality interests artists. They say, "Yes, we agree with your ideas of organization, but what standards have you? We can't have everybody in a Union who calls himself an artist. We have a standard and we resent the implication that our standard of quality is unimportant in the type of organization you say is necessary for artists." The answer to this point is as follows: A work of art is a public act, or, as John Dewey says, an "experience." By definition, then, it is not an isolated phenomenon, having meaning for the artist and his friends alone. Rather it is the result of the whole life experience of the artist as a social being. From this it follows that there are many "qualities" and no one of these qualities is disassociated from the life experience and environment that produced it. The quality standard of any group of artists, such as the National Academy of Design for example, is valid for the social scheme of that group only. Its "world validity" depends precisely on the degree to which the life-scheme of the group of artists is broad in scope. We have, therefore, little qualities and big qualities. Any artist group which seeks to isolate itself from broad world interests and concentrates on the perpetuation of some sub-classifications of qualitative standard is by definition the producer of small quality. For such a group to demand that all artists meet this static qualitative concept is of course absurd. Art comes from life, not life from art. For this reason the question of the quality of the work of the members of the Artists' Union has no meaning at this time. The Artists' Union is initiating artists into a new social and economic relationship, and through this activity a quality will grow. This

quality will certainly be different from the quality standard of any member before participation in union activities and will take time to develop. As the social scheme of the Union is broad and realistic, directly connected to life today in all its aspects, so we confidently expect the emergence of an aesthetic quality in the work of the members which has this broad, social, realistic value. Therefore, an artist does not join the Union merely to get a job; he joins it to fight for his right to economic stability on a decent level and to develop as an artist through development as a social human being.

The Social Bases of Art

MEYER SCHAPIRO

WHEN we speak in this paper of the social bases of art we do not mean to reduce art to economics or sociology or politics. Art has its own conditions which distinguish it from other activities. It operates with its own special materials and according to general psychological laws. But from these physical and psychological factors we could not understand the great diversity of art, why there is one style at one time, another style a generation later, why in certain cultures there is little change for hundreds of years, in other cultures not only a mobility from year to year but various styles of art at the same moment, although physical and psychological factors are the same. We observe further that if, in a given country, individuals differ from each other constantly, their works produced at the same time are more alike than the works of individuals separated by centuries.

This common character which unites the art of individuals at a given time and place is hardly due to a connivance of the artists. It is as members of a society with its special traditions, its common means and purposes, prior to themselves, that individuals learn to paint, speak and act in the current manner. And it is in terms of changes in their immediate common world that individuals are impelled together to modify their no longer adequate conceptions.

We recognize the social character of art in the very language we use; we speak of Pharaonic art, Buddhist art, Christian art, monastic art, military art. We observe the accord of styles with historical periods; we speak of the style of Louis XV, of the Empire style and the Colonial style. Finally, the types of art object refer to definite social and institutional purposes—church, altarpiece, icon, monument, portrait, etc. And we know that each of these has special properties or possibilities bound up with its distinctive uses.

From *First American Artists' Congress, 1936* (New York: 1936), pp. 31–37. Reprinted by permission of the author.

118

When we find two secular arts existing at the same time in the same society we explain the fact socially. We observe, this is a peasant art, this is a court or urban art. And within the urban art, when we see two different styles, it is sometimes evident without much investigation that they come from different groups within the community, as in the official academic art and the realistic art of France in 1850. A good instance of such variety rooted in social differences are the contemporaries, Chardin and Boucher, an instance already grasped in its own time.

There is an overwhelming evidence which binds art to the conditions of its own time and place. To grasp the force of this connection we have only to ask whether Gothic sculpture is conceivable in the eighteenth century, or whether Impressionist (or better, Cubist) painting could have been produced in African tribal society. But this connection of time and place does not by itself enable us to judge what conditions were decisive and by what necessities arts have been transformed.

But all this is past art. The modern artist will say: yes, this is true of Giotto who had to paint Madonnas because he worked for the Church. But I today take orders from no one; my art is free; what have my still life paintings and abstract designs to do with institutions or classes? He will go even further, if he has thought much about the matter, and say: yes, Giotto painted Virgins for the Church, but what has that to do with his art? The form of the work, its artistic qualities, were his personal invention; his real purpose was to make formal designs or to express his personality; and if we value Giotto today, if we distinguish him from the hundreds of others who made paintings of the same subject for the Church, it is because of his unique personality or design, which the Church certainly could not command or determine.

If—disregarding here the question of Giotto's intentions—we ask the artist why it is then that the forms of great artists today differ from the forms of Giotto, he will be compelled to admit that historical conditions caused him to design differently than one does to-day. And he will admit, upon a little reflection, that the qualities of his forms were closely bound up with the kind of objects he painted, with his experience of life and the means at

his disposal. If Giotto was superior to other painters, his artistic superiority was realized in tasks, materials, conceptions and goals, common to the artists of his immediate society, but different from our own.

If modern art seems to have no social necessity, it is because the social has been narrowly identified with the collective as the anti-individual, and with repressive institutions and beliefs, like the church or the state or morality, to which most individuals submit. But even those activities in which the individual seems to be unconstrained and purely egoistic depend upon socially organized relationships. Private property, individual competitive business enterprise or sexual freedom, far from constituting non-social relationships, presuppose specific, historically developed forms of society. Nearer to art there are many unregistered practices which seem to involve no official institutions, yet depend on recently acquired social interests and on definite stages of material development. A promenade, for example (as distinguished from a religious procession or a parade), would be impossible without a particular growth of urban life and secular forms of recreation. The necessary means—the streets and the roads—are also social and economic in origin, beyond or prior to any individual; yet each man enjoys his walk by himself without any sense of constraint or institutional purpose.

In the same way, the apparent isolation of the modern artist from practical activities, the discrepancy between his archaic, individual handicraft and the collective, mechanical character of most modern production, do not necessarily mean that he is outside society or that his work is unaffected by social and economic changes. The social aspect of his art has been further obscured by two things, the insistently personal character of the modern painter's work and his preoccupation with formal problems alone. The first leads him to think of himself in opposition to society as an organized repressive power, hostile to individual freedom; the second seems to confirm this in stripping his work of any purpose other than a purely "aesthetic."

But if we examine attentively the objects a modern artist paints and the psychological attitudes evident in the choice of

these objects and their forms, we will see how intimately his art is tied to the life of modern society.

Although painters will say again and again that content doesn't matter, they are curiously selective in their subjects. They paint only certain themes and only in a certain aspect. The content of the great body of art today, which appears to be unconcerned with content, may be described as follows. First, there are natural spectacles, landscapes or city-scenes, regarded from the viewpoint of a relaxed spectator, a vacationist or sportsman, who values the landscape chiefly as a source of agreeable sensations or mood; artificial spectacles and entertainments—the theatre, the circus, the horse-race, the athletic field, the music-hall—or even works of painting, sculpture, architecture and technology, experienced as spectacles or objects of art; the artist himself and individuals associated with him; his studio and his intimate objects, his model posing, the fruit and flowers on his table, his window and the view from it; symbols of the artist's activity, individuals practising other arts, rehearsing, or in their privacy; instruments of art, especially of music, which suggest an abstract art and improvisation; isolated intimate fields, like a table covered with private instruments of idle sensation, drinking glasses, a pipe, playing cards, books, all objects of manipulation, referring to an exclusive, private world in which the individual is immobile, but free to enjoy his own moods and self stimulation. And finally, there are pictures in which the elements of professional artistic discrimination, present to some degree in all painting— the lines, spots of color, areas, textures, modelling—are disengaged from things and juxtaposed as "pure" aesthetic objects.

Thus elements drawn from the professional surroundings and activity of the artist; situations in which we are consumers and spectators; objects which we confront intimately, but passively or accidentally, or manipulate idly and in isolation—these are typical subjects of modern painting. They recur with surprising regularity in contemporary art.

Modern artists have not only eliminated the world of action from their pictures, but they have interpreted past art as if the elements of experience in it, the represented objects, were incidental things, pretexts of design or imposed subjects, in spite of

which, or in opposition to which, the artist realized his sup-
posedly pure aesthetic impulse. They are therefore unaware of
their own objects or regard them as merely incidental pretexts
for form. But a little observation will show that each school of
modern artists has its characteristic objects and that these derive
from a context of experience which also operates in their formal
fantasy. The picture is not a rendering of external objects—that
is not even strictly true of realistic art—but the objects assem-
bled in the picture come from an experience and interests which
affect the formal character. An abstract art built up out of other
objects, that is, out of other interests and experience, would
have another formal character.

Certain of these contents are known in earlier art, but only
under social conditions related to our own. The painting of an
intimate and domestic world, of moments of non-practical per-
sonal activity and artistic recreation (the toilette, the music-
lesson, the lace-maker, the artist, etc.), of the landscape as a pure
spectacle with little reference to action, occurs, for example, in
the patrician bourgeois art of Holland in the 17th century. In the
sporadic, often eccentric, works of the last three centuries in
which appear the playing cards, the detached personal parapher-
nalia, the objects of the table and the artistic implements, so
characteristic of Cubism, there we find already a suggestion of
Cubist aesthetic—intricate patterns of flat, overlapping objects,
the conversion of the horizontal depth, the plane of our active
traversal of the world, into an intimate vertical surface and field
of random manipulation.

Abstract forms in primitive societies under different condi-
tions have another content and formal character. In Hiberno-
Saxon painting of the 8th century the abstract designs are not
freshly improvised as in modern art, as a free, often grotesque,
personal fantasy; but are conceived ornamentally as an intricate,
uniformly controlled and minute, impersonal handicraft, subject
to the conventional uses of precious religious objects. Hence in
these older works, which are also, in a sense, highly subjective,
there is usually a stabilizing emblematic form, a frequent sym-
metry and an arrangement of the larger units in simple, formal-
ized schemes. In modern abstract art, on the contrary, we are

fascinated by incommensurable shapes, unexpected breaks, capricious, unrecognizable elements, the appearance of a private, visionary world of emerging and disappearing objects. Whereas these objects are often the personal instruments of art and idle sensation described above—the guitars, drinking vessels, pipes, books, playing-cards, bric-a-brac, bouquets, fruit and printed matter—in the older art such paraphernalia is completely absent. A more primitive and traditional content, drawn from religion, folklore, magic and handicraft—Christian symbols, wild beasts, monsters, knotted and entangled bands, plait-work and spirals—constitute the matter of this art.

A modern work, considered formally, is no more artistic than an older work. The preponderance of objects drawn from a personal and artistic world does not mean that pictures are now more pure than in the past, more completely works of art. It means simply that the personal and aesthetic contexts of secular life now condition the formal character of art, just as religious beliefs and practices in the past conditioned the formal character of religious art. The conception of art as purely aesthetic and individual can exist only where culture has been detached from practical and collective interests and is supported by individuals alone. But the mode of life of these individuals, their place in society, determine in many ways this individual art. In its most advanced form, this conception of art is typical of the *rentier* leisure class in modern capitalist society, and is most intensely developed in centers, like Paris, which have a large *rentier* group and considerable luxury industries. Here the individual is no longer engaged in a struggle to attain wealth; he has no direct relation to work, machinery, competition; he is simply a consumer, not a producer. He belongs to a class which recognizes no higher group or authority. The older stable forms of family life and sexual morality have been destroyed; there is no royal court or church to impose a regulating pattern on his activity. For this individual the world is a spectacle, a source of novel pleasant sensations, or a field in which he may realize his "individuality," through art, through sexual intrigue and the most varied, but non-productive, mobility. A woman of this class is essentially an artist, like the painters whom she might patronize. Her daily life is filled with aesthetic choices; she buys clothes, ornaments, furniture, house

decorations; she is constantly re-arranging herself as an aesthetic object. Her judgments are aesthetically pure and "abstract," for she matches colors with colors, lines with lines. But she is also attentive to the effect of these choices upon her unique personality.

Of course, only a small part of this class is interested in painting, and only a tiny proportion cultivates the more advanced modern art. It would be out of place here to consider the reason for the specialized interests of particular individuals; but undoubtedly the common character of this class affects to some degree the tastes of its most cultivated members. We may observe that these consist mainly of young people with inherited incomes, who finally make art their chief interest, either as artists and decorators, or as collectors, dealers, museum officials, writers on art and travellers. Active business men and wealthy professionals who occasionally support this art tend to value the collecting of art as a higher activity than their own daily work. Painting enters into little relation with their chief activities and every-day standards, except imaginatively, insofar as they are conscious of the individual aspect of their own careers and enjoy the work of willful and inventive personalities.

It is the situation of painting in such a society, and the resulting condition of the artist, which confer on the artist to-day certain common tendencies and attitudes. Even the artist of lower middle-class or working-class origin comes to create pictures congenial to the members of this upper class, without having to identify himself directly with it. He builds, to begin with, on the art of the last generation and is influenced by the success of recent painters. The general purpose of art being aesthetic, he is already predisposed to interests and attitudes, imaginatively related to those of the leisure class, which values its pleasures as aesthetically refined, individual pursuits. He competes in an open market and therefore is conscious of the novelty or uniqueness of his work as a value. He creates out of his own head (having no subject-matter imposed by a commission), works entirely by himself, and is therefore concerned with his powers of fantasy, his touch, his improvised forms. His sketches are sometimes more successful than his finished pictures, and the latter often acquire the qualities of a sketch.

Cut off from the middle class at the very beginning of his career by poverty and insecurity and by the non-practical character of his

work, the artist often repudiates its moral standards and responsi-
bilities. He forms on the margin of this inferior philistine world a
free community of artists in which art, personalities and pleasure
are the obsessing interests. The individual and the aesthetic are
idealized as things completely justified in themselves and worth the
highest sacrifices. The practical is despised except insofar as it
produces attractive mechanical spectacles and new means of enjoy-
ment, or insofar as it is referred abstractly to a process of inventive
design, analogous to the painter's art. His frequently asserted an-
tagonism to organized society does not bring him into conflict
with his patrons, since they share his contempt for the "public"
and are indifferent to practical social life. Besides, since he attributes
his difficulties, not to particular historical conditions, but to society
and human nature as such, he has only a vague idea that things
might be different than they are; his antagonism suggests to him no
effective action, and he shuns the common slogans of reform or
revolution as possible halters on his personal freedom.

Yet helpless as he is to act on the world, he shows in his art an
astonishing ingenuity and joy in transforming the shapes of familiar
things. This plastic freedom should not be considered in itself an
evidence of the artist's positive will to change society or a reflection
of real transforming movements in the every-day world. For it is
essential in this anti-naturalistic art that just those relations of visual
experience which are most important for action are destroyed by
the modern artist. As in the fantasy of a passive spectator, colors
and shapes are disengaged from objects and can no longer serve as
a means in knowing them. The space within pictures becomes
intraversable; its planes are shuffled and disarrayed, and the whole
is re-ordered in a fantastically intricate manner. Where the human
figure is preserved, it is a piece of picturesque still-life, a richly
pigmented, lumpy mass, individual, irritable and sensitive; or an
accidental plastic thing among others, subject to sunlight and the
drastic distortions of a design. If the modern artist values the body,
it is no longer in the Renaissance sense of a firm, clearly articu-
lated, energetic structure, but as temperamental and vehement
flesh.

The passivity of the modern artist with regard to the human
world is evident in a peculiar relation of his form and content. In

his effort to create a thoroughly animated, yet rigorous whole, he
considers the interaction of color upon color, line upon line, mass
upon mass. Such pervasive interaction is for most modern painters
the very essence of artistic reality. Yet in his choice of subjects he
rarely, if ever, seizes upon corresponding aspects in social life. He
has no interest in, no awareness of, such interaction in the every-day
world. On the contrary, he has a special fondness for those
objects which exist side by side without affecting each other, and
for situations in which the movements involve no real interactions.
The red of an apple may oppose the green of another apple, but
the apples do not oppose each other. The typical human situations
are those in which figures look at each other or at a landscape or
are plunged in a revery or simulate some kind of absorption. And
where numerous complicated things are brought together in ap-
parent meaningful connection, this connection is cryptic, bizarre,
something we must solve as a conceit of the artist's mind.

The social origins of such forms of modern art do not in them-
selves permit one to judge this art as good or bad; they simply
throw light upon some aspects of their character and enable us to
see more clearly that the ideas of modern artists, far from describ-
ing eternal and necessary conditions of art, are simply the results
of recent history. In recognizing the dependence of his situation
and attitudes on the character of modern society, the artist acquires
the courage to change things, to act on his society and for himself
in an effective manner.

He acquires at the same time new artistic conceptions. Artists
who are concerned with the world around them in its action and
conflict, who ask the same questions that are asked by the impov-
erished masses and oppressed minorities—these artists cannot per-
manently devote themselves to a painting committed to the aes-
thetic moments of life, to spectacles designed for passive, detached
individuals, or to an art of the studio.

There are artists and writers for whom the apparent anarchy of
modern culture—as an individual affair in which each person seeks
his own pleasure—is historically progressive, since it makes possible
for the first time the conception of the human individual with his
own needs and goals. But it is a conception restricted to small
groups who are able to achieve such freedom only because of the

oppression and misery of the masses. The artists who create under these conditions are insecure and often wretched. Further, this freedom of a few individuals is identified largely with consumption and enjoyment; it detaches man from nature, history and society, and although, in doing so, it discovers new qualities and possibilities of feeling and imagination, unknown to older culture, it cannot realize those possibilities of individual development which depend on common productive tasks, on responsibilities, on intelligence and cooperation in dealing with the urgent social issues of the moment. The individual is identified with the private (that is, the privation of other beings and the world), with the passive rather than active, the fantastic rather than the intelligent. Such an art cannot really be called free, because it is so exclusive and private; there are too many things we value that it cannot embrace or even confront. An individual art in a society where human beings do not feel themselves to be most individual when they are inert, dreaming, passive, tormented or uncontrolled, would be very different from modern art. And in a society where all men can be free individuals, individuality must lose its exclusiveness and its ruthless and perverse character.

Common Cause

OLIVER W. LARKIN

"WE are gathered together tonight for the first time partly because we are in the midst of what is plainly a world catastrophe." With these words Lewis Mumford on February 14, 1936, opened the first Artists' Congress in New York. Between three and four hundred painters, designers, photographers, and sculptors, among them a dozen Mexican visitors, heard Mumford say that fascism, war, and economic depression were at odds with all the forces of human culture: "The time has come for the people who love life and culture to form a united front against them, to be ready to protect, and guard, and if necessary, fight for the human heritage which we, as artists, embody."

Mumford declared that dictatorships fear art. A few months after he spoke, Hitler's oration at the Munich House of German Art proved his contention: the Nazi referred to the republican years as an era of shame and of artistic Bolshevism created by Jewish art dealers and critics, and exhibited the "degenerate" art of Grosz, Kokoschka, and Feininger, with Jews segregated even on the gallery walls.

Nothing but a world emergency could have brought together in New York men of such divergent personal philosophies and artistic principles as Peter Blume and Moses Soyer, Stuart Davis and Arnold Blanch, George Biddle and Hugo Gellert, Paul Manship and William Gropper. These men were willing to exchange an idle "freedom" for a concerted effort as artists to embody in form, line, and color the new aspirations and the old injustices, and to build a united bulwark against the powers of darkness at home and abroad. Stuart Davis, who was National Executive Secretary of the Congress, declared that this conference would be the biggest event since the Armory Show. Peyton Boswell, on the other hand, was

From *Art and Life in America* by Oliver W. Larkin, pp. 430–441. Copyright 1949 by Oliver W. Larkin. Reprinted by permission of Holt, Rinehart and Winston, Inc.

dubious. He refused to believe that artists could organize as other workers did, since "genius is not a walking delegate." To F. Gardner Clough collective action meant regimentation and suggested communism.

Among the photographers at the Congress were Paul Strand, Margaret Bourke-White, and Ben Shahn [who was then employed by the Farm Security Administration as designer and photographer]. Strand had made a superb film of the revolt of Mexican fishermen, *The Wave*, as head of the Department of Photography and Cinema in the Department of Fine Arts of Mexico; and he had worked with Ralph Steiner and Leo Hurwitz in 1935 on *The Plow That Broke the Plains*. Bourke-White and Shahn had seen the look of men whose last possessions had gone down a flooded river, and the sightless eyes of houses abandoned to sun and sand. Many of their prints would soon be published in *Land of the Free*: Ben Shahn's West Virginia deputy with his back, buttocks, and holstered pistol filling the page; the faces of men and women who asked, in the words of Archibald MacLeish,

> . . . If there's liberty a man can mean that's
> Men: not land
> We wonder
> We don't know
> We're asking.

In the sessions of the Congress sat painters who had learned that art is not made in a social vacuum. Joe Jones had fought Jim Crow at St. Louis to teach black and white children together; Paul Cadmus had seen his *The Fleet's In* removed from the Corcoran because an admiral denounced it as an insult to the Navy. A caricature of Hitler as a cloven-footed creature was banned by the Metropolitan Museum for its "bad taste"; Evergood's mural at Richmond Hill was barely saved from local critics of its "gross corporeal references." Colorado objected to the blood Curry painted on John Brown's hands; the Reverend Ignatius Cox denounced the Whitman quotation on a Ben Shahn mural as an affront to religion, and New York's Art Commission refused to accept Shahn's mural designs for the Riker's Island Penitentiary on the grounds of their "psychological unfitness."

The Congress not only discussed concrete issues but larger questions. They attacked the self-perpetuating board of trustees at the Mellon Gallery; they supported the Federal Art Projects. Like the Society of Painters, Sculptors, and Gravers they demanded a small rental fee for the showing of their work by museums which spent vast sums on the dead. Doris Lee criticized the false isolation of art colonies, and Lynd Ward reminded the nationalistic artists that a similar attitude had paved the way for Hitler in Germany. They sent exhibits of prints—*America Today* and *Against War and Fascism*—touring through the country, and at their second meeting in 1937 showed Picasso's *Dream and Lie of Franco* while church ladies picketed their hall.

There were more than six hundred members in that year, and within the Congress was a smaller group who had made the antifascist issue the core of their own work as avowed propagandists with brush and pen. The social artist, as Herman Baron remarked in later days, seemed to concentrate on three themes: policemen beating strikers, lynchings, and bloated capitalists. The danger for such an artist was the convenient stereotype which generations of cartoonists had made familiar to readers, and the urgency of the situation, which produced the violently obvious rather than the thoughtfully original. "His whole practice of art," as Thomas Willison observed, "has unfitted him for the representation of a large field, dense in meanings with interacting, changing, differentiated human beings. He must create for the first time images of great occasions," not simply render them as a spectacle whose composition "predominates over its inner life, its psychological tensions and latent meanings."

The cartoon was the most effective medium for social art in black and white, together with the cheap and easily distributed print. The democratic character of a lithograph, an etching, or a woodcut consists, as Elizabeth Olds has pointed out, in the fact that prints are in a sense original works of art, yet can be owned by many. The age of Jackson had richly made use of this fact, and now the print maker of the Federal Art Projects was finding a larger audience not only for conventional processes but for such unfamiliar ones as the silk screen color print, a stencil method explored by the Projects. The print was no longer a precious col-

lector's item, and one artist declared that he would rather be owned by large numbers of people because his work was good than by one or two because it was rare.

The titles of prints shown by the Congress in 1936 indicate their content: Harry Gottlieb's *Coal Pickers*, Hugo Gellert's *Pieces of Silver*, Louis Lozowick's *Lynching*, Fletcher Martin's *Trouble in Frisco*. Three years later the New York World's Fair saw James Egleson's lithograph of workers crowding through factory gates, the chained Negro prisoner of Julius Bloch, the pinched complacency of Mervin Jules's *Rugged Individualist* standing beside his ticker. There was no subtlety here, nor in the acid line of Art Young's cartoon of the gorilla of war stealthily moving again after twenty years. Robert Minor had learned about socialism from the grizzled driver of a freight wagon, and he used the broad side of a lithographic crayon with a tiger's strength. Firmly and a little coldly Hugo Gellert modeled the portrait head of Paul Robeson; Adolf Dehn drew the grotesque obesities of wealthy opera patronesses and connoisseurs of art.

What William Gropper had to say often required crayon, pen, and brush in the same cartoon. For twenty years he had been making at least one drawing a day. If his East Side garment workers haunted the observer it was because he had worked in sweatshops and had struggled with the same noisome bundles which he drew on men's and women's shoulders. He had been well paid for his caricatures in the *Tribune* and the *Dial*, and his prophetic *Vanity Fair* lampoon on Hirohito provoked a diplomatic incident six years before Pearl Harbor; but his best energies were given to the radical press, where he toiled like Daumier to interpret history as it happened. One could rediscover Daumier in Gropper's terrible figure of black-robed Death with a swastika on his sleeve, sharpening his scythe, and in the movement of his figures across the white page, in the reduction of a hated face to a few bony sockets and bosses. Out of Goya's nightmares had come the flying woman in his *Tornado*, skirts blown over head; and the plump manikins of Brueghel were the ancestors of his farmers and stockbrokers. In the manner of the modern *collage* he papered the wall behind his gaunt tenement wife with newspaper clippings which made their

own comment; his gnarled and crackling dry brush strokes re-minded one of Hokusai.

Out of many languages Gropper made one peculiar to himself: the gross bodies straining at their clothes, the iron-hard contours, the stippled textures, the corroding pen accent, the over-all design which drove his meaning into one's mind. A row of huge armored tanks thrusts straight to the edge of a page, and an angel of Peace forlornly thumbs a ride; the grinning Chamberlain cranks the triple grindstone for the knives of the Axis partners; lowered over a cliff by Hitler, a diminutive Daladier chips with his hatchet at the noble figure of Marianne, the French Republic. The man's power to give new forcefulness and mockery to the old pictorial clichés of cartooning was matched by an inventiveness of new symbols which seemed never to be exhausted.

When Gropper's canvases were shown in 1936 he had been painting fifteen years. One could see Brueghel in the turbulence of his *Wine Festival*, Goya in his *Bulldogging*; and the boldly silhouetted horses and upturned pushcarts of his *Strike* had the controlled disorder of the silk scrolls on which Oriental artists spread disaster. His senators thrashing the air among their desks reminded one of that rogue's gallery, the *Legislative Paunch* of Daumier. But here too Gropper had his own incisiveness of form, his own way of giving massive weight to rocks and a fearsome vitality to blasted trees. Every least shape worked for him; the hard edges of red congressional chair backs, the swift curve of a balcony, the gesture of a dead tree branch, the soiled white of poor men's shirts. On some occasions he could compose these elements with a terse finality; on others his impatience and his acquired fluency were too easily satisfied with forms which had been flung upon canvas before his mind discovered the relation between form and meaning.

George Biddle, whose portrait of Gropper was one of his most incisive characterizations, hoped that one of the effects of the depression would be a socially conscious art that transcended the literal and the accidental. Only out of deep personal conviction, it seemed, and with more than the illustrator's skill could one create images of great occasions. The thrusting diagonals of bayonets and falling pickets in a painting by Jacob Burck seized the dramatic moment but could not prolong it. The angularities of Orozco built

to no climax in Adelyne Cross's *CIO at Inland Steel*, and James Turnbull's *Chain Gang* was no more than a statement of facts. Rouault's bestial lawyers found a weaker echo in the satirical *Clergyman* of Benjamin Kopman, whose brush laid the rich pigment on canvas without the Frenchman's passionate conviction.

The three Soyer brothers—Moses, Raphael, and Isaac—reached further back in time for suggested forms and more quietly identified themselves with their subject. Their father had been a Hebrew scholar in Russia before the family came to New York's East Side, where the boys got such training as poverty allowed. "Our message," Moses said, "is People"; and he traced the tired lean gestures of ballet students against bare walls as Degas had done. As Daumier's crowds peered into print shops, so the shop girls of Moses Soyer stood before mannequins in department store windows; he built the head of an old worker with planes of thick ridged pigment and nervous linear accents, Daumier-fashion. The same quiet tones and reticent sympathy were in Raphael Soyer's *Waiting Room* and the *Employment Agency* of Isaac, whose gaunt men and stout women sat with a stubborn patience on hard benches among the shadows.

Would not the expressionist intensities or the surrealist's fusion of fact with nightmare better serve the social painter? The acid pen of George Grosz had once been the scourge of German profiteers, and his water colors, done with a blurred technique and colors which looked like bloodstains on the paper, had held a distorting mirror, as he said, to the face of hideous reality. Now he found refuge in America and although there was some of that earlier ferocity in his overdressed Manhattan promenaders, the American Grosz was done with politics; his thoughts turned inward and his vitriol was diluted. He painted his own face brooding among the smoke and ruins of a Europe he could not forget; in his *Wanderer* an old man stumbled through iridescent mud among thickets and brambles, a human spirit in a world of terror, behind him an explosion like a burst of bleeding flesh.

Peter Blume's immaculate white factories had the cubist austerity and he assembled girders, tugboats, and scows with an engineer's logic, but his *Parade* of 1930 at least hinted the present conflicts. Its brick walls, machines, and ventilators were as relentlessly

drawn as those of Sheeler in glaring whites, blacks, and brilliant reds, but more arbitrarily rearranged; and along the high wall with its purple door moved a workman holding above his head a glistening suit of armor—a riddle whose meaning was not obscure. The Corcoran Gallery refused in 1939 to hang the result of three or four years' work by Blume, the large and intricate *Eternal City*. It was a composite "painted essay," as one critic said, on life under Mussolini, and Dali himself could not have surpassed its jewel-hard brilliance: the fragments of white marble torsos, the ruins of the Forum, the garish shrine with its Crucifixion, the beggar woman crouched over her brazier, and lurching out of corruption and decay the jack-in-the-box head of a livid green Mussolini.

Blume was only thirty-three when he completed *The Eternal City*; at the same age Anton Refregier abandoned the delightful themes he had painted for stylish interior decorators and chose the subject of human rehabilitation for a Federal Art mural at Riker's Island. When the occasion called for flippancy, as it did in the mural commission for Café Society Uptown, he could set weird flying figures and crazy balloons among high clean arches like a Miro of the nightclubs; when he designed panels for the San Francisco Post Office or painted a modern madonna in *Heir to the Future*, his bold emaciations and the harsh geometry of his light and shade spoke his pity for suffering and his reverence for the courage of pioneers. In smaller scenes where men built stone walls, farmers pruned trees, and their wives churned butter, Refregier was close enough to the event in time, place, and sympathy to make genre in the best American tradition.

One could apply the term "modern" to Robert Gwathmey's *Across the Tracks*, where he found the very pattern of segregation. Here was no circumstantial and picturesque South but a region of brassy sun and hard flat earth, of shanties with garish circus posters which said one thing, and drab cotton pickers who said another. Gwathmey used the colors of the red earth, astringent green plants, blistering whites, and brown-black flesh not merely to weave a pattern but to make an ironic point. He was an eighth-generation Virginian who knew the difference between cheap fancy and brutal fact; and in *Non-Fiction* he set two black

children, their feet enmeshed in barbed wire, before a gaudy canvas with its minstrel caricature of the Negro.

The world of Joseph Hirsch and of Jack Levine was the northern city where slick lawyers whispered confidences and policemen hobnobbed with ward politicians in back rooms; and both were in their twenties when Federal Art gave them encouragement and support. Hirsch sculptured the huge muscles, bulging paunch, and muscled legs of *Masseur Tom* as though he had been Daumier at a bourgeois swimming tank, and when his *Two Men* was voted first place by visitors to the New York World's Fair it was because the white worker and his Negro companion had found the shapes for their tension—the huge fist slapping the palm, the taut planes of the speaker's face, the triangulations of the listener's effort to understand. Hirsch had been a pupil of George Luks and he had seen men toiling at Ceylon and Shanghai before he came home to Philadelphia to paint the theme of work for the meeting hall of the Amalgamated Clothing Workers. He was trying, he said, to castigate the things he hated and build monuments to what he felt was noble: "The great artist has wielded his art as a magnificent weapon truly mightier than the sword. . . . So it strikes me that a reaffirmation by today's sincere artist of his faith in the common ordinary man will be as natural as was, for example, the emphasis by El Greco, in his day, on faith in the Church."

Jack Levine's castigations lost none of their force for being wryly humorous. He worked with the thick pigment of a Rouault or a Soutine; and out of the black-brown shadows of his *Feast of Pure Reason* three faces glowed like live coals. Three pairs of hands, a glint of white spats, a striped shirt sleeve and a decanter bring to life his "urbane and case-hardened cronies" in the back room of a pawnshop. When Levine painted a slum street, he wished "to be a steward of its contents, . . . to present this picture in the very places where the escapist plans his flight," challenging the observer to read its implications.

Thanks also to the Art Projects, the Negro painter found his voice in the thirties. As one watched his effort to rid himself of the picturesque stereotype of the black man, and the notion that Africa had provided him with authentic racial forms, one saw that his form was no different from that of the white artist nor, save in details,

his fundamental content. Hale Woodruff's *Card Players* was scarcely more than a cubist fantasy, and his strenuous elongations were as brittle as Benton's before he rose to the occasion with his Amistad mural. Aaron Douglas was among those who issued the invitation to the Artists' Congress, but his lunette in the Harlem Y.M.C.A. was scarcely more than a pleasant decoration in cool greens, and the Negroes who danced in his panels were shadow shapes gesticulating behind a gauze curtain under pink or blue lights as they did in the island scene of *Porgy and Bess*. A harsh insensitivity pervaded the Harlem genre scenes of Motley; Charles White's *Fatigue* had the glistening lights and brutal voluminosity of Orozco's screaming child. The Mexican painter's hard abstractions of form and face appeared in White's portraits of Sojourner Truth and Booker T. Washington in a mural for Hampton Institute, a design whose sweep and strength made the figures of Romare Bearden seem stiffly archaic and willfully primitive.

At once more personal and more inventive, a twenty-one-year-old Negro, Jacob Lawrence, painted *Firewood* as a Project artist in 1938, the crisp flat shapes of the woman, cart, hatchets, and kindling like the scissored shapes of brightly colored paper, the whole pattern brilliantly alive. A later critic smugly missed the point of Lawrence when he wrote: "Long after . . . the inhabitants of Harlem have risen to affluence . . . these water colors may continue to give pleasure just because of a certain handsomeness they have." Precisely because Lawrence knew that that time showed no signs of coming, he worked at his picture-narratives, the lives of Toussaint L'Ouverture, of Frederick Douglass, of Harriet Tubman, of John Brown—each episode told with the simple directness of a child but with a man's love for the greatness of great men and his hatred for their persecutors. To praise Lawrence for his ingenious patterns was to belittle their meaning as the shapes of tortured and congested living, the arabesques of white brutality. Few mural artists could have built such nervous and powerful commentaries as Lawrence did on small panels in the *Harlem* and the *Migration of the Negro* series.

There was no dearth of talent among all these painterly consciences, white and black, old-timers and newcomers. What they seemed to lack was time for the event to ripen in their minds, for

the image to gather about itself richer implications and deeper human meanings. That maturity, however, was in the best of Ben Shahn and Philip Evergood. Shahn had been a lithographer's apprentice and had spent four years abroad, where he saw foreign crowds march in protest against the execution of Sacco and Vanzetti in Charlestown, Massachusetts. Five years of thinking shaped his feeling on that subject and defined the symbols of the twenty-odd paintings he showed in 1932—the governor's top-hatted committee above the two coffins, the pedimented courthouse, the stony face of the judge, the two Italians manacled to each other. The painted tones were nearly flat, and out of all possible contours Shahn abstracted the few meaningful lines of a creased coat, a black judicial robe, a malignant eye. Here was no blast of explosive hatred but a counterpoint of humor and compassion, of irony and anger.

Many of Shahn's details came from his photograph files but their authenticity went beyond fact, and his apparently mechanical vision, as Jean Charlot said, was "heavily loaded with moral values." When Shahn painted *Vacant Lot* with a lonely young ball player in a bare yard with a vast brick wall behind it, he said what the writers needed thousands of words to say about life in big cities. Some of his confrontations were as unexpected as those of the surrealists but served to deepen, not disperse, the human meanings: an acrid pink-purple satin shirt against tenderly painted autumn leaves on a hillside where a man played *Pretty Girl Milking the Cow* on his harmonica; the microscopic realism of a campaign poster against broadly painted boards in *Sunday Football*. Shahn's people were done with the freedom from visual consistency of a "primitive"; yet one had only to walk Seventh Avenue to see these people made flesh.

The murals of Shahn in Roosevelt, New Jersey, in the Bronx Post Office, and in the Social Security Building at Washington never mistook size for greatness or nervousness for strength. On the west wall of the Bronx building Whitman was quoted: "Democracy rests finally upon us"; and Shahn explained "us" in thirteen panels, assisted by his wife, Bernarda Bryson. His color was low-toned and on the warm side with earth-reds, green-yellows, ·and browns against the gray interior. His figures were greater than

life-size, and one of them sometimes filled a whole panel. No American could use fresco with such monumental simplicity; Shahn conveyed the stress and power of human effort without bulging biceps, giving a man's strength through the shape of his back, not the details of his garments. Here a nation of engineers, haymakers, steel and telephone workers went about their tasks steadily and with confidence. One massive girder with strong metallic reds told the story of construction; his textile maker was framed within the fine radiating threads of the machine itself—man, work, and instrument being one. Only the Italian masters of the fourteen hundreds could thus have achieved monumentality without monstrosity, graveness instead of melodrama, with a total absence of those hackneyed devices which lesser men used to "hold a wall together."

Philip Evergood was as talkative as Shahn was reticent. His men and women, like those of Shahn, had the force of symbols but were also remembered as people one had known—the pale girl at the tenement window, the boy soldier of Stalingrad, the fierce old lady ignoring a hurricane. Whitman's hearty affection for the children of Adam moved Evergood to paint "the play of masculine muscle through clean-setting trousers and waist-straps" and "the little plentiful manikins skipping about in collars and tailed coats." Living in a world of uncertainty, of conflict, of death and destruction, but believing it also a world of hope, he could not passively imitate its shapes or find escape in formal purity, form and content being one and inseparable in his mind. There was plenty of scope for invention, he said, in the objective world we have in common; and one found no well-tested cliché, no reassuring formula in what he did, but astonishing originality of theme and of plastic invention, joyousness hard to resist, explosive ridicule, fierce indignation, simple affirmation of plain realities, and undertones of fear, of dream, and of fantasy.

There were paintings where Evergood's desire to insist resulted in overemphasis, others whose powerful tensions he could not resolve. His spaces sometimes refused to hold their human content and a figure seemed to arrive too early or too late to find its place. His failures, however, were more honorable than the failure of the "successful" to do more than repeat themselves ad infinitum; and

his aim was high, being nothing less than "the prodigious feat of combining art, modernity, and humanity."

Still life for Evergood was not an excuse for playing with forms; the fruit on a table in *Expectation* was the materialization of a child's hunger. The red-brown shafts of trees and the moist greens in *Mill Stream* evoked not so much the image of a place where people lived as their affection for its ugliness and charm. In *Suburban Landscape*, with its sober row of stunted and standardized houses against snow, he not only recalled what each of us has seen from trains but quietly suggested the life behind those yellow-shaded windows. His brick factory became a shabby framework for toil, and each of its many windows opened on the life of the men and women who sat at its benches or stood among its machines.

Many a modern painter, faced with the discrepancies between man's capacities and his achievements, has imposed on his images of men the hard logical perfections of nonliving objects. Evergood reversed this process. He charged a brown wall with the bleakness in the mind of a man who has just received his dismissal slip, and made a brick one glow with the delight of Lily feeding sparrows; his locomotives were not the sleek constructions of Sheeler nor the frenzied, snorting engines of Benton, but they had the chunky and cheerful strength of the men who climbed over them or stood beside them.

My Forebears Were Pioneers was no scribbled message but a picture as rich in implications as in color. On a lawn which the hurricane had ravaged sat an old lady in a rocker, ramrod-straight. Beyond her the great boles of uprooted trees had fallen on a Victorian mansion which had the same battered dignity as its owner. Its colors were the faded yellow and dull green of her own flesh; like her, it stared defiantly at disaster, proclaiming its immunity to change. One could read here the story of unshakable courage, or a tragicomic reminder that men have a knack of averting extinction by the skin of their teeth.

Gropper, Shahn, and Evergood represented "social art" at its most eloquent and most convincing. The artist with a conscience, however, could reach only a few minds compared to those huge shapers of public opinion, the newspaper, the radio, and the motion

picture. On the few occasions when New Deal agencies made docu-
mentary films the motion pictures achieved maturity; and maturity,
as Harry Alan Potamkin wrote, "demands not illusions but reali-
ties." In 1937 Pare Lorenz produced *The River* for the Farm
Security Administration with a score by Virgil Thomson. It was
the story of a great valley destroyed and rebuilt; word followed
imagery and image was reinforced by music in a remarkable syn-
thesis, poetic and forceful. Its proud enumeration reminded one of
Whitman:

> Down the Rock, the Illinois and the Kankakee,
> The Allegheny, the Monongahela, Kanawha, and
> Muskingum . . .
> The Mississippi runs to the Gulf. . . .

One saw man's greed and his fear destroy the forests and build
levees to keep back the flood; one watched the precious soil
washed into the sea, and the poor land which made poor people.
One saw man's intelligence create the Tennessee Valley Authority,
build great dams to store the water in flood time and release it in
time of need, to make electric power for the people of Tennessee
while new trees were planted to hold the water in the earth and
new houses replaced the old hovels.

The mural painters must have envied the epic proportions of
The River and similar works; and one could only imagine what men
like Gropper would have done through the medium of the animated
cartoon. Walt Disney had established the latter as a true art form;
from the early film *Plane Crazy* to the sound picture *Steamboat
Willie* and from the first colored Silly Symphony to the full-
length *Snow White*, he never forgot that his medium had gifts of
its own for the fantastic and the droll, that his creatures need not
obey the laws of gravity or the logic of space, scale, and time.
Mickey Mouse joined Paul Bunyan in the world of the fabulous,
and Disney's brilliant translucencies offered new and lighthearted
satisfactions to millions of eyes.

In sober fact, however, the documentary films of the 1930's
were but a brief moment in Hollywood time; and the Disney enter-
prise, with its split-second planning and its correlation of the

separate efforts of an enormous staff, was too expensive to encourage experiment in any profound sense of the word. The artist with a message had to preach to a far smaller audience, while those intsruments which were capable of changing the lives of everyone remained in the hands of men who insisted that Americans never would pay to be treated as though they had minds.

Section III
Five Social Realists

Introduction

DAVID SHAPIRO

THE following section is devoted to the five artists who represent the best of Social Realism: Philip Evergood, William Gropper, Jacob Lawrence, Jack Levine, and Ben Shahn. Any such choice is to some degree subjective, but these artists are also the Social Realists who have won the widest acclaim—from the critics, their fellow artists, and the museums and their curators, as well as from the art-conscious general public. One expression of this recognition has been the retrospective shows enjoyed by each of these painters, each exhibition being sponsored by a major museum or by such circulators of national exhibitions as the American Federation of Arts. (In 1947 Ben Shahn became one of the rare Americans to be given a circulating exhibition by the Arts Council of Great Britain. Ten of his paintings were shown in four cities in England.) Works by each of these artists can be seen in the collections of major museums, and the substantial bibliographies devoted to them further testify to the interest in their painting.

What one sees in their work is a consistent commitment to art as both the expression of their personal response to experience, and as a vehicle for the expression of their social values. Their devotion to public concern is conveyed pictorially in work that celebrates the fortitude as well as certain moments of joy and sorrow in the lives of ordinary Americans. Equally important, their paintings are also committed to the clearly representational, to the figurative sign or symbol. To these artists, the proper study of mankind is still man—although, to be sure, the particular man who interests them is usually either noticeably poor or an exploiter of the poor. In a world in which for some twenty years every kind of non-figurative art has been pronounced superior, to continue to paint as they have bespeaks conviction. Evergood no doubt spoke for all when he said that "all good art through the ages has been social art."

Yet though each shares in this belief, each has a personal style and personal vision. The signs and symbols of Ben Shahn are different from the poetic flights of Philip Evergood, and Jack Levine's wryly ironic view is unlike the broad political caricature of Gropper or the immediacy of the stylization of Jacob Lawrence. Although for each the formal elements of painting are the servants of statement, each uses line, color, and space in disparate ways; if such pictorial qualities alone were considered, these five could in no way be said to constitute a school. What makes them a group (although they have never been a group that lived or worked together, nor have they even been intimate friends) is their common insistence on social statements as the core of their painting.

Technically each is a master in the use of paint for the making of that statement. Shahn virtually invented new ways of handling tempera, a medium he habitually used, as did Lawrence, whose technique is peculiarly his own. It would be difficult to find three artists more unrelated in terms of their handling of oil paint than Evergood, Levine, or Gropper. Except for Lawrence, all have worked in the print media, and Gropper had a long career as a political cartoonist.

All five come from outside the Establishment. Evergood stems from an upper middle-class "Wasp" family on his mother's side, but his grandfather was a Polish Jew named Blashki who had emigrated to England, from whence Evergood's father, an artist, in turn emigrated to this country, and later still to Australia. Shahn was born to Jewish parents in Russia and brought to the United States as a child, while Gropper and Levine were the sons of newly arrived immigrant Russian Jews. Indeed, it is only Jacob Lawrence, a black American, who can trace his American roots further back than a generation.

(A significant number of Social Realists came from Jewish backgrounds. There were more Jewish artists altogether in America in the Thirties than there ever had been before, for the ban against making images historically adhered to by Jews had not been defied before this generation of artists began work. It may be that a long pent up creative urge burst forth in this first generation of "enlightened," nonreligious Jews, so that a larger number than might otherwise have turned to pictorial expression became artists.

By no means were all Social Realists Jewish or from Jewish backgrounds. Among the more prominent non-Jews were Robert Gwathmey, Anton Refregier, Joe Jones, Henry Billings, Fletcher Martin, Arnold Blanch, Eugene Higgins, Yasuo Kuniyoshi, and George Biddle. Charles White, Aaron Douglas, and Jacob Lawrence are black.)

Shahn, Evergood, and Gropper were born within five years of each other near the turn of the century; Levine and Lawrence were born almost twenty years later. All five achieved recognition in the Thirties, and they have gained wider audiences in the years since.

Each of the following sections begins with a biographical chronology on the artist. Next, there is a statement by the artist himself. In some cases the statements were chosen because they were the only ones available that gave some idea of the values or creative process impelling the painter. In others, of many possible choices, the particular one selected seemed best to expose the artist's view.

The chronological arrangement of the critical articles that follow the artists' statements allows an overview of a part of the twentieth century's history of ideas about art; more simply put, the arrangement helps reflect changing taste. In making selections I have tried, within the limitations of space, to present the differing intellectual, political, and critical views representative of writers for varying audiences. Thus the liberal and scholarly remarks of Elizabeth McCausland in "The Plastic Organization of Philip Evergood" are made from a position not shared by "Marion Summers," who spoke for Communist Party cultural and political values in the *Daily Worker* article, "Evergood's Art is Based on the Infinite Richness of Reality." As a practicing painter, Fairfield Porter in "Evergood Paints a Picture" shows particularly clear insights into Evergood's way of work. George Dennison's article, written during the heyday of Abstract Expressionism, more than twenty years after Ms. McCausland's, is remarkable for its perception of the validity of imagination characterizing Evergood's art, particularly because the author at the outset acknowledges his "penchant for abstract art."

I have begun the section on Ben Shahn with two articles on the

1932 Sacco-Vanzetti exhibition that arrive at opposing conclusions, although both were written for similar liberal periodicals: *The Nation* and *The New Republic*. Fifteen years later, once again in *The Nation*, Clement Greenberg wrote grudgingly about the Ben Shahn retrospective at the Museum of Modern Art, while James Thrall Soby, who had preceded Greenberg on *The Nation* and was then the regular critic for the *Saturday Review*, wrote a glowing piece about Shahn at the time of the 1947 circulating exhibition in England. This second pair of articles also "had" to be included.

Working in this way, I have aimed to include the most important American critics whenever I have been able to uncover pertinent essays. Where possible I have used material incorporating the words of the artists, in their self-evaluations and in their comments on their fellow artists—as in the aforementioned Porter essay, in the pieces by Joe Jones and Philip Evergood on William Gropper, in the Clifford Wright article on Jacob Lawrence, and in Frederick Wight's piece on Jack Levine. In order to create the distance for the kind of overview I have attempted, here as in the first part of this volume I have used articles from both specialized magazines, like *Art Digest* and *Art News*, and more general publications such as *Commentary* and *The New Yorker*. I have deliberately included pieces from such widely different periodicals as the *New Masses* and *Fortune* magazine.[1]

Taken together, the republication of these articles will, I hope, allow the reader to see the diverse trends, character, and views of Social Realism, as well as the response of the American public over the last thirty or forty years.

[1] *Fortune* published a special color spread of twenty-six pictures of Lawrence's series ". . . And the Migrants Kept Coming" in conjunction with the exhibition at the Downtown Gallery. This national coverage helped launch his career.

Philip Evergood
Chronology

1901	Born New York City.
1909	Taken to England.
1914	Graduated from Stubbington House School.
1915–19	Student at Eton until graduation in 1919. Admitted to Trinity Hall College, Cambridge, after being tutored in Belgium.
1921	Left Cambridge and entered Slade School, London, where he studied under Henry Tonks and Harvard Thomas.
1922	Visited the United States briefly with parents who had returned and settled here.
1923	Graduated from the Slade School. Studied at the Art Students League in New York under William von Schlegel and George Luks. Learned etching from Philip Reisman and Harry Sternberg.
1924–25	Studied in Paris with Jean Paul Laurens at the Académie Julian, and with André Lhote. Studied at British Academy in Rome.
1927	First one-man show, held at the Dudensing Galleries, New York.
1929	One-man show, Montross Gallery, New York City, where he showed again in 1933 and 1935.
1930	Lived and worked in Paris. Studied briefly with Stanley William Hayter at Atelier 17.
1931	Married Julia Cross, a painter and dancer. Visited Spain for six months.
1934	Included in Whitney Museum's Second Biennial and all subsequent Annuals through 1967.
1934–37	Joined Public Works of Art Project.
1935	One-man show of drawings, Hollins College, Virginia.
1936	One-man show, Denver Art Museum. Participated in "219 Sit-in Strike" in protest against layoffs from the WPA Art Project. Strike took its name from the number of artists participating. Assigned to Mural Section of the Federal Art Project.

149

Was a member of the American Artists' Congress. Later was president of the Artists' Union. He has been a member of the American Society of Painters, Sculptors and Engravers, An American Group, the National Society of Mural Painters, and in the Forties was a founding member of Artists Equity Association.

1936–37 Taught at the American Artists School, without salary.

1937 Worked on mural for the Public Library at Richmond Hill, New York.

Two-man show with his father at the Athenaeum Gallery, Melbourne, Australia. One of his paintings was purchased by public subscription for presentation to the National Gallery of Victoria, Melbourne.

1938 Mural for Post Office in Jackson, Georgia.

Appointed Managing Supervisor, Easel Division, New York WPA Art Project.

One-man show at ACA Gallery, New York, where he had successive shows in 1940, 1942, 1944, 1946, 1948, 1951, 1953, and 1955.

1940–42 Artist-in-residence, Kalamazoo College, Michigan.

One-man show, Kalamazoo Institute of Arts.

1942–43 Taught once a week at Muhlenberg College, Allentown, Penna., and had classes at Settlement Music School, Philadelphia.

1942 Carnegie Corporation grant.

1946 Tuthill Prize, Art Institute of Chicago.

Retrospective, ACA Gallery.

Taught at Contemporary School of Art, Brooklyn, and at the Jefferson School, New York.

1949 Gold Medal, Pennsylvania Academy.

Second Prize, Carnegie Institute.

1950 Illustrated *Short Stories* by Gogol.

1951 W. A. Clark Prize, Corcoran Gallery, Washington, D.C.

1952 Moved to rural Connecticut, where he continued to live.

1953 One-man show of drawings, Allen R. Hite Art Institute, University of Louisville; one-man show, Kansas State Teachers College.

1955 Retrospective, University of Minnesota, Duluth.

First Prize, Baltimore Museum of Art.

1956 Grant from the National Institute of Arts and Letters.

1957	One-man show, Newcomb Art School Galleries, Tulane University.
	One-man show, Iowa State Teachers College.
1958	Grant for Painting, American Academy of Arts and Letters.
1960	Retrospective, Whitney Museum of American Art, New York.
1962	One-man show, Terry Dintenfass Gallery, New York.
1963	One-man show, Gallery 63, Rome, Italy.
1964	One-man show, Gallery 63, New York.
1967	One-man show, Hammer Galleries, New York.
1969	Retrospective, The Gallery of Modern Art, New York.
1971	Benjamin Altman Prize, National Academy of Design.
1972	One-man show, Kennedy Galleries, New York.
1973	Died in Bridgewater, Connecticut.

Sure, I'm a Social Painter

PHILIP EVERGOOD

WHEN William Michael Rossetti wrote the memoir of his illus-
trious brother Dante Gabriel in 1895 he refrained from making any
remarks "upon the general measure of attainment" of the poet
painter, preferring (because he did not want to be accused of bias)
to record the opinions expressed about him by other poets and
painters of his day. The atmosphere of plush footstools and doilies
developed circumspection in William.

Today, with the slightest encouragement, painters bare their
chests immodestly (be they male or female) even distending this
part of their anatomy in no uncertain terms. Some write about
themselves and their work sentimentally; some anecdotically. Some
open up to tell of escapades on roof tops and intimate goings on
with illustrious friends all over the place—as a means of getting
attention. Others indulge in technical tomes, written with a flair of
authority and an eye on the student trade, the museum brother-
hood and the buying public, as if they have been blessed as the
sole inheritors of those deep dark secrets of material and perma-
nency known only to the old masters.

Still others concentrate on their own inner selves, and, by putting
their inflamed entrails on public view, divulge irrevocably the fact
that these convulsive viscera have stimulated a desire for fame far
beyond their owner's artistic capacity. In short, artists of this epoch
write about themselves, whereas in 1895 the self-made man was
about the only individual so brazen as to satisfy his ego by this
indulgence. One might say that the autobiographical bug is ram-
pant on a fully sown field.

My Victorian inheritance prejudices me against the fad. On the
other hand, in sticking my neck out I am invoking the right of the

From the *Magazine of Art*, November 1943, pp. 254–259. Reprinted by permission
of the American Federation of Arts, 41 East 65th Street, New York, New York.
10021.

self-made man. Once I read a newspaper account of a young mil-
lionaire who renounced all his earthly riches to live as a Bowery
bum with the sole object of becoming a self-made man. I gained
this distinction by almost as drastic a change. In my youth I fled
from the chance to live securely, prosperously and dully, under
most propitious auspices, in order to live more agreeably though
precariously as an artist. I do not wish to suggest any similarity
between the professions of Bowery bum and artist, although I
have met malicious people who would delight in the comparison.
Autobiographically speaking, the pitfalls are the same today as in
Rossetti's time, but then critics were as plentiful as painters, and
consequently there was little public demand for the artist to evalu-
ate himself.

Critics are outnumbered these days ten to one, and overworked,
which is another reason for the artist taking up the pen. To our
own numbers have been added many from devastated Europe who
have sought a haven here. Although this spells a future for America
as the art center of the world, it places a great burden on the
critic. He is kept busy going from one one-man show to another
on roller skates. He sees the flaming torches, the pure white lights,
the burnt-out match sticks and the spluttering candles of the exhibi-
tion world with a fleeting glance. Generally, he must meet a press
deadline; often the discipline of an editorial policy, which develops
in him a chameleon tendency and great speed on skates. Very often
these handicaps result in verbal prolixity (for large columns have
to be filled), and the reading public must inch its way through
forests of words with the aid of a dictionary to discover which
brand the critic personally likes. Esthetic evaluation is often
omitted altogether. The old school of critics stick to the rules of
cricket, and most are dull. The new school are children of blitz
and strafe. They have grown out of World War I into World War
II and they are gifted with greater striking and demolition power.
Where the Pre-War I critic said blithely, "You squint, so I don't
like your face," the product of World War II says bluntly, "I
don't like your face, so you stink." At this stage I would not have
the reader think that this is a case of sour grapes. As a matter of
record, my work has received its modest share of attention from

critics good and bad alike during the past ten years. I hope I shall not be less endeared to any after publication of this.

In stepping for a moment into the role of critic of critics, I have no intention of decrying the honorable profession as a whole. I am simply pointing the finger at certain unhappy misfortunes for the benefit of progress, and am performing a kind of mental purge of certain annoying individuals for my own pleasure. Were I to strut in this role for more than a moment I might run the risk of being called a good critic by the painters, thereby suffering the fate of Dante Rossetti, who is said to have been honored by the painters of his day as a poet, and vice versa. I am bound to speak out and to complain that a large proportion of critics today do not provoke the remotest speculation as to why the painter paints the way he paints, or what goes on inside his skull. The balance scale should be the critic's most necessary appurtenance; many use the goose feather or the broomstick instead. Promotion counts for much today in art as in soap.

In this field gremlins are at work. The overload of imitative painting from the attics of Montmartre and the left bank must now be sold before it is completely outmoded. The ether employed as sales talk is calculated to cause as complete a mental anaesthesia as any a spoken word transmitted through the ether by wireless for commercial propaganda. The gremlin begins something like this:

"Modern art is subtle. Ancient art is obvious. The more modern the art, the harder it is to understand. The more modern the art the better. So the better the art the more difficult it is to understand. And conversely, the worse the art the easier it is to understand. One has to be esthetically cultured or initiated to understand good modern art because it is hard to understand. If you can understand art that is hard to understand you are cultured, initiated and belong to us."

By this time the victim has been lulled into a mild receptive mood, so the gremlin continues:

"You and I are the Intelligentissima. We the Intelligentissima give our stamp of approval to the Morticists, the Gagaists, the Neo-Impressivists, the Neo-Depressivists, the Neophytes, the Spherists, the Circumventors, the Distractionists, and all Factionists, the Super-Surrealists and the Pigmentary Exhibitionists, etc., etc. Real-

ism when it is unmutilated is dull and earthy. Realism when it is microscopic or telescopic and in the modern idiom is an excellent tool when it is used to bewilder. It is then ethereal and exciting. Chirico and Dali use it well in this manner. That is the only excuse for the use of Realism and when so used it is called Super-Surrealism.

"The artist should be a magician. If he is unable to mystify convincingly, he is a second rate Yogi. Mystery cannot be combined with true Realism because one contradicts the other. The work of Goya, Daumier and Rembrandt has no mystery because it contains true Realism and is therefore understandable to the man in the street. The mystery of Ernst is complete because he completely mystifies. Satire, Social Comment and Critical Statement are out of gear in modern art because to make their point they have to be understood and to be that they have to be clearly expressed, so they are not compatible with the aims of modern art, which intends to intrigue by mystifying and by making itself hard to understand."

The gremlin here skilfully performs an entrechat; then goes on smoothly:

Bruegel, Bosch, Hogarth, Blake—who made critical statements and social comment—were justified because of their historical limitations. But today with all the really unpleasant things that are happening in the world, it is bad taste to bring these to public attention, to mention them or introduce them into painting, which should be unuseful to be good. If art is useful it becomes bad art automatically, just as a woman becomes ugly if she becomes useful. True Realism and Satire are bad taste in art because they have use; they are boringly useful in helping to accomplish social betterment and change. The use of Satire and true Realism are excusable in Bruegel because he was homespun and a naive pioneer, but we have been taught by the school of Paris to discard these elements in art as vulgar."

At this point the time is about ripe for the gremlin to raise the Red bugaboo. In the art mart he uses this with gusto, though it is a more refined variety than the bedraggled but robust species found in politics and any corner saloon. This more primitive variety of Red baiting might not be digested by an intellectual object of prey. The victim might be revolted to hear that, "The work of so and so

contains revolutionary social comment and therefore he ought to be exterminated—the lousy Red." So, instead, the non-objectivized gremlin says:

"Turn your head away from this painter of the social scene. Beware! He has made a comment about life! He must be an illustrator, a caricaturist, and a clumsy proletarian who is insensitive to the esthetics of line, form and quality. He is attempting to pull us down to earth subversively. Again, beware!—Come into my private office where you will be safe in the clouds and I will show you a Klee and a Miro."

These objecting, non-objectivists are not satisfied to protest their love by shouting for a stew of line, form and color (with no flavoring added) like the protagonists of purity who used to gather in Montparnasse at the Closerie des Lilas, cloistering themselves against the faintest whiff of objectivity. These men today strive to make big business out of their weakness. One author recently went into a huddle with a group of his pets of non-objective persuasion to map an offensive strategy and then spawned a testimonial to their glorification which was sold to the public as a book on contemporary American art. The comparison made between the work of these endeared favorites and their artist competitors of other trends (based on a flimsy study of the latter's work) was odoriferous to all healthy noses. Anytime I would prefer to take my promotion with a smile, super dupered to a tune by Bing Crosby.

But to get back to clear air. Too many have gained a safe retreat in non-objectivity because they do not possess the mental equipment to be able to paint objectively in an interesting or profound way. It is easier to flee from life than to face it. But this flight is made a virtue by the self-delusion that it is actually innovation. The fleeing non-objectivists are always straining to excrete something new, which appears to be quite a painful operation. They get wet, like the man who thought umbrellas were old-fashioned.

Actually all art great and small in the past was objective. I am convinced that a great deal of it (both great and small) will be objective in the future. A painting can have all the abstract forces at work within it: the basic elements of sound structural design, all the precious qualities of pigment and surface, all the electrical alive-

ness of a personal caligraphic line of sensitiveness and strength— and at the same time tell a story or make a statement. The truth is that some painters are painters as some weavers are weavers, i.e., they weave with their feet and hands and not with their heads and vitals. As Charles Péguy says, "A word is not the same with one writer as with another. One tears it from his guts. The other pulls it out of his overcoat pocket." Not all painters are capable of using literary material without being illustrative. (Meissonier will always be a glowing example of this failing.) The greatest art is the result of human experience—a searching for the big truth in nature but not being enslaved by its petty details. When Picasso has given his genius to combining human experience with his tremendous power and knowledge of structure and form, he has hit his pinnacle, as in the *Guernica*. He has integrity.

Cézanne and Delacroix both said one must have integrity. And integrity in the artist is the effort to reveal and not to hide. But integrity is not the artist's prime requisite. There are stupid people of integrity. Bougereau appears to have been sincere in his desire to reproduce perfectly the peach bloom of the female buttocks, but how futile to devote one's life to that. Dali, on the other hand, whose immense technical equipment enables him to paint with astonishing precision and realistic preoccupation, is not stupid; but he has never pretended to be sincere. I gather that he despises integrity. He seems sincere only in one giraffe-like gesture, that of stretching his neck so people will look at him. Integrity in painting means the construction of a sound ideology. When an artist has built an ideology and grown into it throughout the years, a clear mental attitude permeates his complete productive mechanism and shapes what he says in a certain way. That is why the hand that engraved the *Horrors of War* was incapable, when it dealt with a queen, of painting a smug society portrait. It is equally true that if one paints the *Horrors of War* or a slum child with a love of life, with real devotion as well as with good mechanics, the chances are that the result will not spell propaganda but beauty and human enlightenment.

It is significant to note that after having made a few drastic comments about contemporary society over a period of years, when I paint an old woman sitting in an armchair (*My Forebears*

Were Pioneers), a nude (*Juju as a Wave*), or a beach scene at Provincetown (*Art on the Beach*), a little girl at a window feeding sparrows, or even a still life, there is always some bright guy who jumps to the fore to label it "social art," thereby attempting to damn it. The way I paint an old woman or a still life is more close to earth than, say, Maxfield Parrish. That is a bright discovery. Mine is social painting. Goya's is no less social than mine. And even if you like Goya better, you will have to concede after careful comparison that my work is no nearer to the cartoon or to politics than his. I have the sincerest respect for a good cartoon when it is by an Art Young or a Gropper. My talents unfortunately do not extend to that field. My only aim is to paint a good picture—a work of art—and, on this level plain, to say what I want about life.

As a matter of pure fact all good art throughout the ages has been social art. And because good art of the past has portrayed human beings and their habits, it has constituted the most pleasing record of the past that exists. Human customs, behaviors, and all the human emotions are written in the work of such men as Mantegna, Titian and Greco. If Greco had never existed the human race would be lacking one of the most revealing documents on the dignity of man. He was social in that respect. And he was abstract too. Look at *Christ in the Garden* at the National Gallery. Picasso learned a lot about abstraction from Greco. And so apparently did Cézanne (even though he denied it).

If in painting one uses literary material or that of a commentative nature, it goes without saying that one's aim is to use it in an intelligent way—structurally, dynamically and bigly, as did such men as Daumier and Toulouse Lautrec. This material can also be used in a new and different way, for there is plenty of scope for invention in this vast universe of objectivity. Think quickly of Assyrian sculpture, Leonardo's *Last Supper* and *Potato Eaters* by Van Gogh. They are all miles apart, but all objective.

The prodigious feat of combining art, modernity, and humanity can be accomplished today as it was yesterday by those who have the strong attributes of an artist, combined with patience, intelligence, and resolve. A few times I have done it. But you will have to wait on time for the proof.

The Plastic Organization of Philip Evergood

ELIZABETH MCCAUSLAND

PHILIP EVERGOOD got into the Slade School (when all the berths were being given to returning soldiers) because he made Henry Tonks laugh. The two facts—that he studied with Tonks and that he had even in his first imaginative drawings the power of making people laugh—are basic in his evolution into one of the most plastic painters of the period. Based on sound and subtle draughtsmanship, infused with the compelling drive of his own nature toward mirth and joy, his paintings are among the most gifted and the most affirmative work being done by younger American painters. They point the way, indeed, to a resolution of the dilemma of contemporary painting, where problems of form, organization and content still baffle the artist.

The development of Evergood into the powerful and moving painter he is, closely follows the main currents of life in the past two decades. Born on West 23d Street in 1901, educated at Eton and Cambridge, then at the Slade School, he had had no formal instruction in art when at 20 he stormed the studios of Harvard Thomas and Henry Tonks. The imaginative drawings which made Tonks laugh turned into heroic program pictures with biblical themes when he began to paint in 1924. Meanwhile he had had three arduous years of draughtsmanship with Tonks and Thomas and other *Wanderjahre* in France and Italy. Hals, Rubens, Leonardo, Tintoretto had left their mark on his thinking. But chiefly the values current in the world at this time controlled his work. The first painting by Evergood to be exhibited was shown at the National Academy in 1924, a still life. Three years later, in the "modern section," he was represented by *Daughters of Cain* and *Centaurs and Men*.

In the light of Evergood's present plastic and conceptual growth,

From *Parnassus*, Vol. 2 (March 1939), pp. 19–21. Reprinted by permission of the *Art Journal* of the College Art Association.

it would be easy to dismiss this phase of his work as of little value. On the contrary, the work of Evergood which possesses significance and virtue for 1939 grew out of precisely all those early energies and ideas. It is important to note, for instance, in the *Centaurs and Men* of 1927 qualities of composition and organization which today may be seen fully and consciously developed in his paintings. In these biblical subjects ("the only means I knew of expressing myself") he was not merely recapitulating myth and allegory; he was utilizing the language and the values of the era. It was to take a world economic crisis to bring artists into direct contact with real life and to turn their gaze outward toward realism and social content.

Nevertheless during his first decade as a painter, Evergood was not idle. His first one-man show was held in 1927 at the Dudensing Gallery (which at that time was showing the work of younger living American artists) and consisted of fifty-three paintings and etchings. Murdock Pemberton uttered a mildly prophetic wish: "We predict some painting that will be full of guts, and, we hope, of Evergood." By the time of his second one-man exhibition in 1929, held at the Montross Gallery, he had begun to paint genre subjects—an initial movement away from the Bible.

Evergood's emergence as a painter of the world about him may be said to date from the Museum of Modern Art's exhibition, "Murals by American Painters and Photographers," held in 1932. Although he had not completely emancipated himself from the device of allegory and although his titles were extraordinarily literary (*The Angel of Peace Offering the Fruit of Knowledge to the World*, for example,) nevertheless his design shows that flair for composition which is so dynamic a part of his equipment for painting. His direction towards realistic subject matter was suggested in the two figures of workers in the panel *Apotheosis of Ancient and Modern Learning*. His tying together of the three panels by the simple device of carrying the branches of the tree over from the central panel into the flanking panels is economical and effective, while the reenforcing of the column of the temple with a steel girder is characteristic of the artist's humor.

This evolution was carried on logically under the Public Works of Art Project and the Federal Art Project. For the former Ever-

good painted a huge canvas, *Government Report on North River*, 8 by 5 feet, in which a dozen strata of life are integrated in a complex composition. Men lounging on the water front, the West Side Express Highway, ocean liners, tugboats, ferryboats, lunch-carts, clam houses, construction, are all packed into this one canvas. The effect is not, however, like that of a grocery store with rows of shelves, but that of the reality of sight; for daily in life, the eye tastes a rich, often indigestible but still varied diet. This multiplicity, this tension between parts, this conflict of forces, is the essential subject matter of Evergood today—and a theme treated with plastic virtuosity.

The growth of an artist is bound to be slow, especially in the midst of economic chaos. Though Evergood's bent is plainly toward the mural, he has had to throttle down his abounding energy to the smaller form of the easel painting, except for the mural, *The Story of Richmond Hill*, finished for the Federal Art Project in 1937. This is a large design, 27 feet by 5 feet 8 inches, which required two years for completion. Here is an ample visual demonstration of what the painter could do, if he had further opportunity in the mural field. The three sections of the mural deal with the history, occupations and diversions of Richmond Hill. The material is freshly observed and presented. But again it is the amazing plastic relation of his forms that excites comment.

The central section binds the wall together, establishes a center of gravity, sets the mural solidly on its feet as a celebration of local history. For the personages depicted in this passage are all prominent in the late XIX century history of the community. But from the esthetic point of view, the thrilling thing about this composition is the powerful modulation from the central section into the two larger sections at the right and the left. This is accomplished by the device of a broken brick wall at the right and of the wreathing smoke from a locomotive at the left. Organically one section moves into the next and the whole picture functions within its framework in dynamic equilibrium.

During his evolution Evergood has exhibited continuously, won prizes, had his work purchased by museums, served an energetic term as president of the Artists' Union, and—continued to paint. This season his work has been seen at the Whitney exhibitions of

contemporary American paintings and of sculpture, drawings and prints, at the American Artists' Congress "Art in the Skyscraper," at the A.C.A. Gallery, the Midtown Gallery and at the Carnegie International.

In the stress of life today, one would be brave indeed—or very rash?—to nominate a man's masterpiece. Without question, in addition to the Richmond Hill mural, an extremely important painting is *Mine Disaster*, a canvas 8 feet by 4 feet 6 inches. The triptych on which its design is built has been assimilated into an organic entity, so that one is aware of its scheme but never disturbed by any separation of the picture into fragments. The left section deals with actual mining operations such as drilling, hauling out the coal with mule teams, transporting the coal within the mine. The right section shows the disaster: one miner is picking at a seam of coal with a crowbar, a second miner sees the impending cave-in, throws up his hands in a tragic and fatalistic agony, then is buried by the sliding earth, and only his anguished hands are to be seen.

Plastically the transition from these two themes to the central panel (*The Rescue Squad*) is executed with great skill. This shows the miners ready to go down to save their fellow-worker. They are resolute, determined, grim, but *not* hopeless. From the left a miner holding a warning flag in his hand moves toward them. At the right stands the wife of the buried miner, holding a child. Through the whole painting glow strong blues and reds, positive colors, meaningful and rich. The miner is not rescued alive, as one learns from the coffin in the lower righthand corner of the picture; nevertheless the function of the whole is not defeatist, but tragic in a noble catharsis. This purpose is aided by the psychic montage of elements, in which Evergood produces an effect comparable to that of the moving picture, by a juxtaposing in space of events which have happened in time.

One of the exciting things about Evergood's painting is that he does not solve his problem by formula. *On the Beach*, now in the National Gallery, Melbourne, Australia, takes for its theme the welter of "Art" on the beach at Provincetown. A model in sailor pants poses; men and women, old and young, with paint brushes etc. paint; two sailors observe the proceedings, a third sketches. Bustle, confusion, conflict of elements, characters, textures, shapes,

colors—chaos. Then the beautiful unifying passage of the bay, dotted with seacraft, painted with a quality like the Chinese. And for that Evergood condiment of humor, a scrawled caricature in the hands of one of the sketchers and the words "Zut alors. I can't draw. The model has sailor pants."

In *Music* the organization is effected in another manner. Seated in a semi-circular amphitheater, the musicians are hard at work— the violinist bowing with a great sweep, the trombonist at full stretch, the tympani player smiting a triangle, all the bodies moving in time with the music and the right action of their instruments. They are held together, not by the conductor (though his raised arms have their function in the composition) but by the painter, who modulates his forms with great subtlety.

Human beings in motion are part of the vocabulary of *Collecting Specimens*, but since they live in another environment and for different values, both the psychological evocation of the painting and the method of statement differ from *Music*. Here is a satire on present-day forms of social intercourse, on the foibles, pretensions and affectations of our intelligentsia. The mood is created by the attitudes of the figures, by the upraised hand of the man in the center, by the herringbone pattern of the parquet floor, by the rococo ornament of the punchbowl and by the fragile cut-glass chandeliers.

A basic composition which Evergood uses with great success is a circular motion. In *Thousand Dollar Stakes*, a sardonic jest at dance marathons and walkathons, the circle of the dance arena is repeated in the spider-web of its board floor, so that as one looks one becomes slightly dizzy with the sense of never-ending movement. In *Sunday in Astoria* the motif is used to create an entirely different mood, a roistering, hoydenish spirit of play on a day free from work. Free from work are the figures in *Social Security*, winding in weary ellipses toward the Old People's Home. In *Pink Dismissal Slip* the form of the staircase utilizes an arc, but in how different a spirit than Pierre Roy's *Danger on the Staircase*, where the organization is concerned with a sliding snake and the textures of wood. In Evergood's picture, the materials used are human life and its insecurity, expressed plastically in the motion of the stair's hand-rail sliding out of the picture.

These analyses suggest the complexity of Evergood's plastic organization; they do not exhaust the riches of his work. One could mention his color sense, his strong draughtsmanship which underlies every composition, his inexhaustible joy of life even in crisis. Such a brief study of a few of his recent canvases does prove, however, that in the "painting full of guts and Evergood," America has one of its most fruitful and happy painters.

Evergood's Art Is Based on the Infinite Richness of Reality

MARION SUMMERS

PHILIP Evergood is a painter of whom we can be very proud. He is a social artist of intellectual power, emotional depth and poetic sensitivity. In a retrospective exhibition at the ACA Gallery, covering 20 years of fruitful activity, he emerges as an artist of the first rank who gets better as he gets older.

Evergood creates out of the wealth of human experience. And each of his pictures is like a new experience, a fact which some people find confusing. He is a hard man to pin down within a strict formal classification. He sees things so freshly and expresses himself with such directness and sincerity that everything he does, even when he is not entirely successful, is a human revelation.

He is not an artist easy to understand, and many of his pictures need explanation. Seen from a larger historical perspective, Evergood is an Expressionist. Expressionism is a current within contemporary art which goes back to Van Gogh. It is neither a simple representation of visual experience nor the formal architecture of abstract shapes and colors. Basic to Expressionism is the expression of emotion. The Expressionist is moved by some aspect of reality which he attempts to impart to the beholder, not through a recreation of reality, which is the cause of the emotion, but through the recreation of the emotion itself. This is, of course, only a bald and generalized definition within which great leeway in style is possible. Kandinsky, for instance, attempted to reproduce emotion in abstract terms, so that the final artistic creation has no apparent relation to reality. Van Gogh, at the other end of the scale, retains always the visual reality which he imbues through artistic distortion with his own turbulent and ecstatic emotional reaction.

Evergood also retains the original reality, altered to express more

From the *Daily Worker*, 2 May 1946, p. 13. Reprinted by permission of the *Daily World*.

fully his own conception of its significance. But whereas Van Gogh expressed certain simple emotions evoked by reality, Evergood expresses more complex emotions and ideas growing out of human relationships. In other words, he presents social ideas in extremely personal and emotional symbols. And this is the point at which his art becomes difficult. Symbols which are absolutely clear to him and distortions which are absolutely necessary as far as he is concerned are not absolutely understandable to the audience. The beholder has not gone through the emotional experience with the artist and all he has with which to recreate its significance is the finished final work of art.

Therefore, we may be moved unconsciously by the emotional impact in terms of color or form, but bewildered by a meaning which is often not clear or a formal distortion which appears unmotivated. The result is a powerful social art which unfortunately sometimes falls short of its ultimate objective of communication. This is a dilemma whose solution is not simple. The richness of Evergood's art resides in the intensely personal way in which he views the world. It is through his genius that he enriches our experience. And it is a genius we do not wish to restrict. The audience must make an effort to understand his meanings. On his part, Evergood should supply the audience with more specific clues, perhaps in the form of a written program.

Not all of Evergood's work is esoteric. Much of it is clear, forceful and very moving. Often we may miss secondary meanings, but the central theme is so powerful that we are able to accept the whole. Evergood's art is not only rich in the material of contemporary life; it is rich artistically as well. He has a tremendous range, from the stark pathos of *Comradeship* to the tender lyricism of *Seeking a Future*, from the explosive bitterness of *Quarantined Citadel* to the surging optimism of *Men and Mountain*.

Just as each of his works is a new intellectual and emotional experience, so it is a new esthetic experience. Evergood clothes every idea in its appropriate form. He lavishes a tender and delicate beauty upon his visions of hope and slashes with crude anger at evidences of injustice. He becomes painstakingly realistic or broadly expressive as conditions demand. His sole object is always to express himself as completely as possible in artistic terms.

Evergood is making major contributions to a social art in America. He stands well up among the best artists we have today—on any grounds. His forms just as forms are as interesting as anything in abstract art. This, too, is experiment, experiment which is not confined to the restricted area of the studio, but which finds its basis in the infinite richness of reality.

Evergood Paints a Picture

FAIRFIELD PORTER

FOR *Girl and Sunflowers*, the first thing Philip Evergood did was to make several charcoal sketches of one of his neighbor's children posed among the flowers in his yard—including a separate drawing of her face, and one oil sketch on paper. The next step was in the studio: with the drawings all over the floor and the drawing of the face pinned up beside his easel, he sketched in the whole picture broadly with charcoal, and then laid in a lot of wet sickly-blue paint down to where the figure began. This blue was deliberately banal in color, "like a postcard."

The medium with which Evergood thins out his oil colors is an emulsion. It begins with a whole egg: the volume of the egg is the unit of measure used. To one volume of whole egg he adds half a volume of raw or sun-thickened linseed oil (sun-thickened oil beats up better) and half a volume of dammar varnish. He may add water, but only up to one volume in quantity. This makes the emulsion flow more easily. Also a variation is to add half a tea-spoonful of oil of turpentine (not spirits of turpentine) which makes the whole amalgamate better. This mixture must then be beaten with an electric egg beater. He may add a few drops of carbolic acid to prevent rotting, or keep the mixture in the ice box. Evergood's emulsion is many years old—he keeps adding to it in the same container. It is good for it to age, as if it were yoghurt.

After the blue was laid in, he drew the sunflowers: he began to design them and observe them and think about them and their shapes in different positions "because this is the first time I ever looked at sunflowers." When he got bored with this charcoal drawing—"I want to be stimulated into paint"—he began to blot out the charcoal with paint. Colors were determined by examination of a sunflower, "an uninteresting browny raw sienna," which he used, but then discovering that it would not do, replaced it

From *Art News*, Vol. 50, No. 9 (January 1952), p. 30. Reprinted by permission.

with a crimson and yellow green. The overalls were painted a crude ultramarine to which a little viridian and cobalt were added. He used a green called "El Greco green," a warm strong color, for the leaves. The next day, the proportions of the figure were changed, for Evergood discovered that he had made it too dwarfish. Lengthening it downwards, he then filled in around the body and changed the stalks to get a better rhythm. He began to fill in the face and body of the child. All this time the ground was unpainted except for a muddy grey to take the "sting" out of the bare canvas while painting the child. For a whole day he painted only the sky variations around the sunflowers and child, to establish a postcard blue behind the girl. If this had been painted later it would have blended at the edges and the sharpness which he wants would have been lost.

The artist often enlarges his paintings. Using white-lead paste thinned with dammar varnish as an adhesive, he fastens the linen canvas to a larger piece of board or plywood, and pieces out around the edges with more canvas, or "curtain material" soaked in gesso and stuck to the board (instead of stretched on) or simply stuck on with white-lead paste. Then he paints thickly over the joints with Dutch Boy white lead mixed with the emulsion, enough to hide the piecing out. This makes for a roughness in the enlarged part of the painting. Then if the enlargement is a little too much, he cuts down the whole panel with his buzz saw. But in this painting, the position of the figure on the canvas was such that there remained enough room to allow for changes.

On the brush tray of his easel there is always a can of mineral spirits for washing the brushes, and for thinning the medium (the pool of emulsion on the palette). Evergood finds that benzine or its equivalent does not cut into any wet paint he may be painting over: the layers stay separate.

Before each day's work he sprays on retouching varnish, either at the beginning of the day or the night before, so that it will seep in overnight and get tacky. This helps to preserve the over-all skin, the picture plane, which either "from lack of understanding or lack of technical knowledge" is the hardest thing of all to do. The difficulty with oil, which does not exist in tempera, is in keep-

ing the black areas luminous enough so that they do not become holes.

Sometimes he puts the canvas on the floor and spreads on a very wet coating of synthetic resin varnish, with or without a tone of umber or blue to counter the yellow of the varnish, then wipes it off and spreads it with a rag, to pull the areas together.

When the canvas was almost all covered with the final colors, he painted back and forth with a palette knife, scraping off, painting in, overlapping and bringing out areas and pushing others back. The bricks were put in with a palette knife, directly; they seemed to work at once. The forms should connect "like mosaic," Evergood says, illustrating by interlocking the fingers of his hands.

The drawing comes last. The face of the girl took approximately four days, about half the time for the whole painting. The expression that he wanted came and got lost again while he painted one mouth on top of another until he got what he wanted, and then he began to soften it out until the drawing became incised lines rather than colored lines. From this point he softened out from the face, radiatingly, until it "set" properly. This was a matter of the drawing, not of color, for he wanted there to be a "crude jump" from the face to the acid green and sharp brightness of the sunflowers. "The greatest challenge, the most exciting phase of the painting is the mysterious, changing, fleeting expression of a face."

There is a great deal of art in Philip Evergood's background, and most of it is painting. His father was a landscape painter and his mother had studied both art and music. Her father was a very good amateur painter, who could have been, if he had wanted, a member of the Royal Academy. There is also a great deal of rebellion, of rejection and assertion in his background. His father's father, Philip Blashki, fled from Prussian Poland, and eventually settled in Australia, where Miles Evergood Blashki was born. The Australian Blashkis and the English Perrys both objected to the marriage of their children—Philip Evergood's parents. And when Miles wanted to be a painter, and was met with a blast of disapproval from his parents, he changed his name, in turn disowning his father. Attracted by some idea of newness, Miles Evergood and his wife came to New York, where Philip was born. The family moved around a lot, and finally Philip was sent to England to get

an education. Here he was under the care of his English uncle, a famous engineer who wanted to civilize this American barbarian, and after he had completed studies in law and English at Cambridge, to take him into the firm. At Cambridge his friends all had much better social and financial positions than he, and they offered him security if only he would identify himself with the right sort. "You can't be an artist, it's not done . . . at any rate be an amateur, not a 'professional'." But Evergood felt he was wasting his time; he loafed, he did not study, he rowed on the river. He told his decision to quit and study art to Henry Bond, Master of Trinity College, who, impressed with Evergood's sincerity and originality, recommended that he resign from the University and gave him a letter to the famous Henry Tonks, head of the Slade School. As this decision meant giving up his best chance for security, and as he could not be sure of being admitted to Slade, it took courage. He brought down to London some drawings he had made illustrating the Bible, which were shown to Tonks. Evergood was admitted to the presence. The drawings were spread out on the desk. "If I accept you for the Slade School you are going into a religion; you are coming into a monastery to devote all your energies toward perfecting yourself. As for your drawing, you cannot draw even one line. However I am very rarely made to smile or laugh, and your drawings have a quality of humor or imagination that is unusual."

Henry Tonks taught drawing "in the grand manner." Leonardo was the model. A pencil had to have a needle point. "Drawing is a delicate operation." (Tonks had been a surgeon.) This discipline, this attempt "to search for the true form" supplied one of the firm elements in Evergood's background. "I would become sloppy if I didn't bring myself back on the tracks all the time by this kind of investigation of the form of the face, or by taking out figures from a composition that I have worked on for two years. It is easier to knock something off quickly."

Evergood lives in East Patchogue, Long Island, in a house that is in the process of growth. Mostly white-painted cinder blocks, the outside reveals the irregularity of the inside. The studio is incompletely insulated, and the bats stapled between the rafters are still uncovered by wall board. It supplies him with shelter and a space

in which to work, but beyond that there is no obvious reason why he lives here rather than somewhere else. Where does he belong? Though there are painters who do belong, to a place, to a group, to a clique, there are many who do not. In Evergood there is a sense of not belonging, for one thing, to any school of painting. Think of the variations from painting to painting and within single paintings, and of his strain of deliberate anti-professionalism. Though an unevenness in one painting is "against the rules," it is a quality that Evergood desires. He likes to know that there is something ugly or unprofessional in a painting; he wants human weaknesses to show, to express something unusual by showing faults. "When a man is dead, it only matters if he leaves something acid and something sweet behind him and it doesn't matter if anyone likes this at all—though it is nice if they do. I learned this by looking at Brueghel, at Beckmann, at Klee, the early drawings of Grosz, the drawings of Dürer, at Ryder's skies and Goya's mysterious, searing portraits."

When he decided to be a painter, he was both refusing and choosing. The Slade School imposed limits as well as work. His living where he does seems to express only a desire to get away from the city. And there is in his life a great deal of the discipline of Not. And here it is appropriate to bring up Evergood's social consciousness, which is partly an affirmation of the ugly. What is real? "I do not want to make a cartoon," he says. He was moved by the tragedy of the unemployed he saw in the 'thirties at the foot of New York's Christopher Street, living in shacks of old crates with mattresses for roofs, huddled in the snow around fires of burning rubbish. He wanted to make art out of what is not art; he was fascinated by the expressions of the strugglers and the sufferers: by frostbitten knuckles, by boots with lump toes, the stitching of blue jeans, ordinary Sears Roebuck ugly things, things that were really being used. And so there are no heroes among Evergood's workers: their scars are as important as their perfections or beauties.

Though Evergood studied also at the Art Students League—which he liked for its free spirit and humanity which implies that life is as important as working behind the easel—though he studied there under George Luks, he never studied painting under anyone.

"Painting cannot be taught," he believes. "People should not want to be taught it. Your own playing with mud pies—gooey material that can be made rough or smooth, violent in color, cheesy, crumbling or uniformly one color, is what matters. All the ranges are so terrific that if you try to teach painting you are bound to arrest the originality of the man you are teaching. He will never learn until he has played with mud pies for many years. One can teach about space—and what is great about great things." For him painting is a putting down of one flat color next to another to get solidity. "Gauguin and Seurat had a sense of this, of putting things down flat . . . That is painting: it takes greater strength to do this than to brush and stroke, and when I find myself brushing and stroking I hate myself for it."

As a young painter, Evergood found a tube of megilp in the box of paints his maternal grandfather left him. There was also in this paint box a badger-haired brush (like a shaving brush) for blending and softening. He asked his father what megilp was, and was told that it was like something Frans Hals used to get crispness and freshness. He found that it did just that, but he has not used it for a long time. It also helps to give a continuous skin, a unity of surface. "If a man could paint thinly and beautifully at once like Hals, perhaps that would be better than fumbling around for thirty years like Ryder. But few men outside Rubens and Hals could do this." The best brushes Evergood owns were made by his father: ½-inch round bristle brushes, naturally pointed, with long hairs in the middle and short hairs around the sides, not trimmed, so that each hair has its proper taper. The ferrules, which are strong, smooth and bright, also were made and soldered together by his father. These brushes he uses only occasionally, and though old, they are still in better condition than most brand new ones. He more commonly uses flat 1- to 2-inch hardware-store brushes—at the rate of hundreds a year—sometimes one is used up in a day and thrown away. He uses brush cleaner and soap. "Paraffin oil preserves brushes best . . . but I am too lazy to use it." On the table in the center of the studio is an old enamel pan filled with benzine in which brushes are standing.

Evergood considers a painting done when it is "perfected" as much as possible. "I used to be a direct painter," he said, striding

back and regarding *Girl and Sunflowers* with his head on one side. "By losing things . . . and bringing them out again . . ." here he scumbled on paint with a palette knife, "you gain something a direct painter does not get . . . this looks fumbling . . . yet an intellectual man might be sure of himself from the start (and in large paintings this is necessary) but a man relying on his senses is not. The smaller the canvas the more of this there is. Perfection means a rhythmical balance of lacy lines against sweeping ones, of broken areas against glass-like areas, of open against filled."

For him, balance is balance around a center of gravity, as an automobile wheel is balanced in a garage: "if the painting in imagination were spun around a nail, if it were in balance, it would stop spinning anywhere" equally in any position, as a balanced wheel should, and if it should seem to come to rest always in one position, this would be, just as in the case of a car wheel, a sign of unbalance. The lacy lines against the sweeping lines are one of the individual qualities of Evergood's paintings, so that when a painting of his has the right amount of drawing black details, it is like a dish correctly salted. This formal salt has its counterpart in the affection-with-an-edge-to-it of much of his content even when the content is not "social."

Philip Evergood: A Retrospective View

GEORGE DENNISON

CONTEMPORARY painting has occasioned a lot of talk about *pure plastic values*—a good bit of which originated with the artists themselves. But the art has proven itself so vigorously, and there is now so much of it, both good and bad, that it is clear the best abstract painters are those who "say" a lot, who feel a lot, who capture important experience and find eloquent terms. Of course they do it with paint, so I suppose it's plastic, but they certainly do not do it by manipulating *plastic values*—the proof of which is that the abstract style has turned out to be a difficult style to work in, not an easy one: it reveals a paucity of feeling, or of conception, or intelligence, or daring, as readily as representational painting; and conversely, it is as personally descriptive as might be desired. When the dust settles from the huge activity of the present heyday in New York (but this is rhetorical; the heyday was ten years ago)—let us forget the dust: it is quite evident that most of the work on the current scene is an imitation of half a dozen intensely personal styles. No doubt the imitation is important, for it will lead to new images, but in the meantime it is clear that *plastic values* simply are not transferable from one painter to another: only those can use them who are capable of digesting the embodied human values, and such a use is always a transformation, so that in fact the one thing that is never transferred, per se, is *plastic value*. (The human value, on the other hand, passes from one to another —in precisely which way the artists of all media are the guardians and transmitters of culture, and art itself is profoundly conservative.)

And yet it does make some sense when artists speak among themselves of plastic value, for then it's shop talk, and there is an implied understanding that they are all a little crazy: the word

From *Arts Yearbook 6, The Best in Arts* (New York: 1962), pp. 112–113.
Reprinted by permission of *Arts Magazine*.

"red" does not refer merely to a color, but to a highway that goes down the middle of the psyche. In the late forties, when such talk was especially rife (and most meaningful), it played a positive role which by now has vanished. The notion of pure plastic values served as a smoke screen (this too was shop talk, but passed unrecognized; such is the hunger of critics to think like artists)—a smoke screen that gave protection at a time of discovery, of poking around and running risks. At such a time it's a good idea not to refer directly to a creative process which needs to establish itself in new terms, needs to be *well* established before exposing itself to the jealous demands of the old ones. The protective ritual tends to be justified by the emergence of the new form; and it tends to fall away as the new work is accepted. In fact there is a growing need —expressed more by the older artists than the younger ones—for an aesthetic that will make sense of recent experience, *not* as an explication, but as a response, the kind of response that preserves the necessary dialogue between the artist and his audience. For in many ways the best abstract art has had no audience, only champions—champions ringing it protectively and showing the artist the backs of their heads. It is the younger painters who have suffered most from this militant in-group, for the idea of *plastic values* has entered the general vocabulary, debauching the public (what a dry debauch!) via critics and museums, transforming the lightheaded ticklishness of girls and boys into a lightheaded sobriety that does nobody any good, least of all the artist who is applauded because his work comes closest to being painted tomorrow. It is as if the younger generation have inherited only the purity of the notion that was passed around by their elders. Tenth Street, in the meantime, is secure as the most boring Left Bank in history, while the Cedar Bar has become the *Underground* of the Lion's Den at Columbia.

Now I want to say that these dire considerations were both highlighted and mitigated by the Philip Evergood retrospective at the Whitney [April 6-May 22, 1960]. Highlighted because Evergood has been extraordinarily unfashionable, has been and *is* unlike everything I have just described. And mitigated because of the lively pleasure his work afforded.

Evergood is representational; his work is frequently narrative, sometimes didactic; it is always explicitly (though not *merely*) significant. And though my own penchant has been for abstract art, I found these paintings (especially in this big array) exciting, rewarding and liberating. In the New York of today, it was positively encouraging to see so much earnestness and such a robust response to life. What these paintings forced upon me was an immediate readjustment in my sense of "our period": it is more commodious than I had supposed.

It was encouraging, for instance, to see that a man, at this late date, can still use prototypes and narrative ideas in his work simply by *putting them there*, the way a child does. Eisenhower's silly grin, for example—what a curious meaning it has for us! (What European could understand our complicated response?) Evergood paints it into a picture that I find hilarious, hilarious in the most intelligent and provocative way, a picture called *The Enigma of the Collective American Soul.* (It has Churchill, too—which is a stroke of genius.) The hilarity of this picture recalls the frenzied comedy of Dostoevski; it is an exquisitely manic leap-in-chains on a platform of solidified grief and rage. It is not cathartic—and to my mind it is not high art—but it *is* extraordinary, a superintelligent yet wild glee that triumphs in the fact that it remains alive under all conditions. This is not Evergood's characteristic expression, and yet it is present in maybe half a dozen works of this big show.

The most striking thing about Evergood's work is the quality of his vision, which is a very lively mixture of observation and invention, of intelligence and feeling, and of simultaneous reference to the real and the ideal. It is a vision of impressive range and flexibility. I can think of no other painter, in fact, whose responses to contemporary life are more revealing and provocative than his. If one compares his relatively didactic work of the thirties, for instance, to the traits of Social Realism that have fallen into disrepute (and rightly so), one finds an important difference. Taken as a school, Social Realism turned out to be very boring because it merely *claimed* a superior reality while at the same time it stifled aesthetic invention under a burden of short-range goals. Evergood, however, seems to have taken that program—quite correctly—as

an aesthetic device, a method, an invention; as such it is no more real than Cubism, and is quite likely more idiosyncratic. He handles it, then, for its aesthetic potential. The subjects belong to life rather than to the school, and the crux of the matter lies not in attitude but quality: are the insights true, the event important, the feeling strong?

Evergood's painting is anecdotal and occasional, and therefore it is rewarding to see a lot of it at once. Then there is a long-range flow of emotion, and thought, and concern, together with specific events—and the most tangible web of sensibility is laid out before us. His occasions and moods are various. Some are domestic, some political, others fantastic, and still others socio-philosophical. The attack is equally various, ranging from harsh to tender, from mocking to angry, and from erotic to tragic. There are several paintings, too, which abound in a fierce compassion that I find very moving, such as the portrait of his mother, with its unblinking acceptance of the estrangement at the heart of the closest relations.

Even the most didactic of Evergood's works are complex. His early *American Tragedy*, for instance, which is a scene of strikers attacked by brutal police, is more than a simple protest and appeal for action: it has the clarity and disproportion of nightmares and obsessive images, and it compresses into one expression a number of feelings which we do in fact experience together (however contradictory they may be), but which we rarely find linked together in political theory. The much later *Moon Maiden*, though it has elements of the cartoon, is another example of the organic development of idea. The web of human motives here is so dense that the didactic element is absorbed into the richness of the humor and the pathos and the irony. It is a scene of luminous dusk (acidly, sourly luminous); a glamour girl floats hugely in the sky, or rather in her own imagined apotheosis (so we judge by her painfully dreaming eyes)—and yet she is really desirable: the yellow bees at her thighs are a pointed simile for the tuxedoed playboys perched like sparrows on the telephone wires behind her. Down below, some proletarians gaze through the bars of a cell, while a couple of hoboes doze on a bench. Floating high above it all, most out of reach, is the globe of the moon with the Statue of Liberty inside. Schematically the painting is

harsh, but in fact it is without malice; rather it is disinterested—simply fascinated by the curious elements of the human comedy, and specifically our American one. It seems likely that Evergood began with an idea, and then was propelled beyond it by the proliferation of his own feelings. The still later *Passing Show* (1951) is another work of obvious "reference," but it is not so easy to say what the reference is. In this picture a big Negro man sits on the curb in front of the Five and Ten. White women—they are lumpy, careworn housewives—pass to and fro in transparent skirts that reveal their garter belts and stockings. The man is not looking at them, but is gazing away contemplatively. In the abstract it is full of "issues": race, class, etc. But here, as elsewhere, it is Evergood's virtue (an artist's virtue, rarely a sociologist's) to see that money is erotic, class is erotic, power is erotic; that money is physical, class is physical, power is physical; that "money," "class" and "power" are ideal conceptions—and that ideal conceptions themselves have their own physicality. There is a hovering atmosphere, in this painting, of the feverish dream people must penetrate in order to touch each other.

There is a good deal of the cartoonist in Evergood, as there is in Daumier and Grosz, and occasionally his work suffers from the lack of aesthetic flesh. But more frequently the cartoon elements are used brilliantly. His wit, unlike Daumier's, which is penetrating and triumphant, is diffusive; it tends to evolve into humor, or to step back into technique out of deference to emotion. (Evergood's colors are among the most personal and successfully eccentric on the scene today.) His intelligence has that quality which is often called instinctive—frequently misunderstood as "unaware"; it is simply the disarming clatter of the senses, neither lagging the insight nor preceding it, but going in a body like a good brass band. And because of the responsive range of his intelligence, one takes a picaresque pleasure in this long succession of paintings.

Evergood's use of types is striking in this connection. They are very well known: the Glamour Girl, the Cool Doll, the Brutal Cop, the Tough Urchin, the Worker, the Magnate, the Playboy, the Farmwife. But where the cartoonist or satirist tends to ridicule the type for being a type, Evergood treats it in depth.

When people do, in fact, approximate a type, they are usually guided into their absurdities by some self-image. (Evergood touches this autointoxication very neatly in his handling of gesture and expression.) The self-image itself, however, is a social invention: the person is imagining that others are looking at him in such and such a way—and thus the type is essentially a *situation*: the one who approximates it walks in an aura of imagined responses and roles. It is this situational aspect of the type that Evergood handles so well—in which handling the harshness passes over into humor and pathos. Too, he is glad to admit the desirability of the desirables, however foolishly people strive for them: the glamour girl really *is* lovely, in spite of her mirror-image eyes; and the worker's dream of modest self-sufficiency is clearly an energizing wish. In pieces like *American Shrimp Girl, Satisfaction in New Jersey* and *Woman of Iowa*, he is not depicting types at all, but is expressing an admiration for intrinsic vitality, together with an indulgent smile at the curious form it takes.

Some of the types that Evergood has used are already passing out of our social currency—and certainly any commentator runs this risk. But on the other hand, a type, rendered in depth, will often pass over into a lasting symbol.

I have selected only a few aspects of Evergood's work. Some of his best pieces lie quite outside the things I have described, pieces like *Juju as a Wave, Portrait of My Mother, Happy Entrance*. They are hauntingly sad, full of a bitter tenderness; one reads these faces like an album, or a narrative of the past—and the past is a series of defeats: the defeat of good intentions, of youthful hopes, of domestic ideals; and yet something spirited is preserved, though it is quiet and meek.

When one considers the diverse elements of this work—for it is variously vulgar and sensitive, brash and indirect, harsh and playful, fantastic, didactic, erotic, astringent, sensual—it adds up to an *oeuvre* that captures a feel of American life more directly and powerfully than any other painting of its kind. It is significant, too, that Evergood *expresses* these qualities rather than depicts them, expresses them in the sometimes garish color, the crowded composition, the knowingly naïve confrontation of

detail—and especially in his handling of images, jamming them and overlapping them—sometimes isolating them—always milking them for what they are worth, so that he can produce at will the inexplicable clarity of hallucination, or the indicative certainty of political cartoon, or the diffuse glow of mixed emotions.

Having tromped in and out of galleries all season, and having seen so much that is glamorous and trivial and overblown, I found that this show at the Whitney filled a very immediate need for earnest thought and strong feeling.

But it is not the lack of good painters—there are more than a dozen—that makes New York such a curious place these days. It is the horrible, green-decadent *glamour* of culture—the fashionable galleries, magazines and theaters. Everything seems to be exciting and yet nothing makes any difference. Nor am I in the least encouraged by the fact that *industry is buying abstract art*, for to my mind abstract art is an art of crisis—its power is in its extremity—and there is something a little scary about its assimilation into the ladies' magazines. (On the other hand, what *else* can be assimilated?) I am frankly at a loss to judge the total effect of these things. People are not as grim as they were ten years ago (nor are these days as creative as those), and yet an honest thought is rarer than it ever was, there are ten times too many galleries, and in terms of sheer litter such a quantity has never existed in one place before. Looking back over the season, two things come to mind that are encouraging: the Milton Resnick show at the Wise Gallery, and this present show at the Whitney of Philip Evergood.

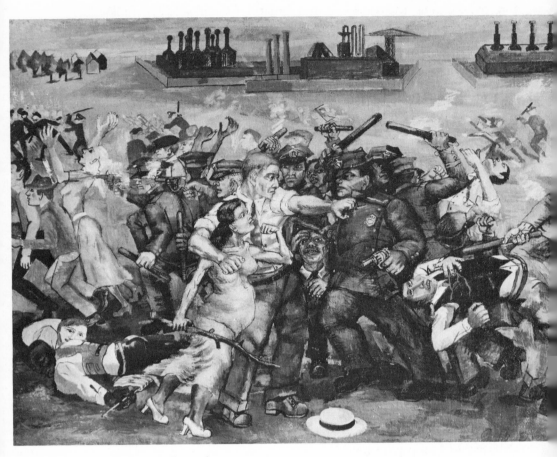

American Tragedy PHILIP EVERGOOD

1937
Oil
29½" × 39½"
Collection of Mrs. Armand Erpf
Photographer: Geoffrey Clements

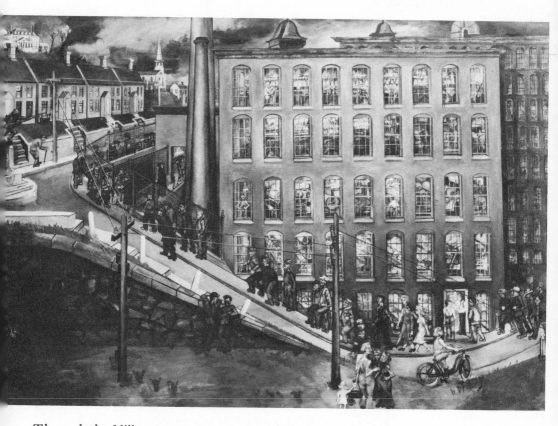

Through the Mill PHILIP EVERGOOD

1940
Oil
36″ × 52″
Collection of The Whitney Museum of American Art, New York
Photographer: Geoffrey Clements

William Gropper
Chronology

1897	Born New York City.
1912	Left high school.
1912–15	Studied with George Bellows, Robert Henri, and Howard Giles at National Academy of Design and New York School of Fine and Applied Arts.
1919–21	On staff of *The New York Tribune*.
1921	Contributed cartoons to *Revolutionary Age*.
1924	Married Sophie Frankel.
1925–27	Cartoonist for *New York World*.
1925–49	Cartoonist for *Morning Freiheit*.
1927	Visited the Soviet Union with Sinclair Lewis, Theodore Dreiser, and Scott Nearing.
1929	*The Golden Land*, drawings of the USSR, published in France.
1930	*Collection of Drawings* published by ACA Gallery, New York.
	Delegate to Kharkov Conference, USSR.
	Alley Oop, a novel in drawings, published.
1936	First one-man show, held at the ACA Gallery, New York.
	Attended First American Artists' Congress.
	Post Office Mural, Freeport, Long Island.
1937	One-man show, ACA Gallery, New York.
	Guggenheim Foundation award.
	Metropolitan Museum of Art purchased two paintings.
1938	Murals for Interior Building, Washington, D.C.
	One-man show, ACA Gallery, New York.
1939	Post Office mural for Northwest Station, Detroit. Now removed to Wayne State University in Detroit.
1940	One-man show, ACA Gallery, New York, followed by another in 1941.
1946	Third Prize, Carnegie Annual.
1948–50	One-man shows in France, Poland, USSR, Czechoslovakia, Bulgaria.

1951 One-man show of prints, Associated American Artists, New York.
 A set of 10 lithographs, "American Folklore," published.
1954 Wrote and illustrated *The Little Tailor*.
 One-man show, ACA Gallery, New York, where he showed again in 1956, 1958, 1961, and 1962.
1964 One-man show in Rome; circulated to Milan, Turin, Bari, etc.
1965 One-man show of etchings, Associated American Artists, New York.
 Ford Foundation and American Federation of Art Grant, Artists-in-Residence program, Museum of Evansville, Evansville, Indiana.
1967 Tamarind Lithography Workshop, January-February.
 Stained-glass windows for Temple Har Zion, River Forest, Ill.
1968 Elected to National Institute of Arts and Letters.
1971–72 One-man show, "Fifty Years of Drawing," ACA Gallery, New York.
 Circulated nationally.

A Statement

THE synopsis of my fifty or sixty years is variation. I have done a lot of non-objective abstractions under my paintings. I put a base on first, then I work up and down and around, but I don't end up with an abstraction. I can't stick to one way of doing work. I get bored with it, so I change, but I don't follow schools.

I'm not against abstract art. I think we are living in a wild time and everything has its place and purpose. I think that the emphasis, the fetish or worshipping of one art over another is stupid, it's silly. It's limiting one's vision. I come back to Bellows and my old teachers: "There are many points of view."

At an early age, I went in for Denman Ross's theory and color. I studied Hambidge's dynamic symmetry. I went in for an awful lot of things, when I was young, but the tough part is forgetting it. We take in an awful lot of garbage. It's easy to take in and hard to shake. It's like the smoking habit.

Schools don't influence me, as much as life. I do people with faces, with noses and eyes, in all the forms that I can understand. There have been a number of years when I've seen all of this disappear and the faces became circles and the circles became lines and forms disappeared. Disappeared to a point of black on black and so on. It's been a lonely period, but living in the country and being very much aware of people, I think that I will not be deformed that much. I carry on.

I react to life and it's a stimulant to me. It could be a phase, it could be an attitude, it could be a mood. It's broad. I'm open for any little thing, but I am of a period. I come from a sort of

From the chapter titled "His Statements" in *William Gropper: Retrospective* by August L. Freundlich, published by the Ward Ritchie Press (Los Angeles: 1968), pp. 27–29. Reprinted by permission of William Gropper.

humanistic element. I love people and when I draw or paint, it comes out people and the landscape is what these people make it.

I look at a wall and if I see a touch or a semblance of life, it could be a line, a human element and I communicate somehow. I feel good, but when I see lines that are not lines, forms that are not forms, then there is no root, no foundation. If a picture can last on a wall and I get a certain response, a certain feeling, then I keep it there. But, if it does not move me or I feel it is a little bit off, then off it goes and I destroy it or work on it. As writers have characteristics, so have I, a color, a brush stroke. It's really a world in itself.

I work very fast, because spontaneity is something I have been trained to do in newspaper work. As a cartoonist, I had to knock them out, get them in by the deadline. I like working that way— it's sort of a challenge. I think life is challenging—art is challenging.

I have done a great deal of graphics, although at the same time I feel the luxury of color is another world. I don't know what I am primarily; I am a graphic, when I am doing graphics. I am a painter, when I am painting and I am a sculptor, when I am sculpting. I think that would be the most honest answer.

There are times, when I'm painting or drawing, that I feel we are conditioned by our society and that our painting is our reaction or behavior to society.

WHAT I BELIEVE

"The visual artist" is fortunate to have been trained to be perceptive to our environment, to things happening. Like the nonobjective abstract art. This had to come because of our conditions, atomic energy and national security. And I am fascinated by the youth. I challenge them when I meet them, because they are living in a marvelous period. They have created new criteria, a new measurement, a new way of thinking. We are living in an age now, where rules are out of date, inches are out of date and weight is out of date. Now, it's light years, it's weightlessness.

It's not one and one make two, but a question of what is one? New values that they have to find and I think they will. And what art has done—it has eliminated countries and borders, the restrictions of nations. Cultures will be assimilated, but the human element, I don't believe, will be lost. No matter how we try to put the human element into computers, it's still making mistakes. It's still doing good things too.

That's my heritage. I'm from the old school, defending the under-dog. Maybe because I've been an under-dog or still am. I put myself in their position. I feel for the people. It may also be attributable, in part, to my cartoon experience. The vitality of an idea or thought is the vitality of a situation and you are for or against a villain and a hero. It's the old plot that you keep hearing and seeing.

I cannot endorse a Utopia, which I'm afraid I will not live to see. I've gone through the illusions of Utopia, but I would like to suggest it by showing the other side. I don't think flowers are the answer for me. It is probably, for a great many people. I have to face things in the most brutal way that I can and let it out and then I feel better. Maybe it's my heredity or maybe it's my way of life. I can't close my eyes and say it is the best of all possible worlds and let it go at that. I become involved. For example, if the Mexicans in Los Angeles were mistreated, I would feel Mexican. I react, just as Negroes react, because I have felt the same things as a Jew, or my family has.

I have been, at times, very interested in extremes. The extreme left as well as extreme right. I went into it one hundred per cent. I never joined any organization or party, but I drew for them openly. I didn't change my name, as a lot of other people did. So, I was more or less classed as an extremist, but I have also drawn for very erudite publications and very snazzy publications like *Vanity Fair*.

There is one thing I want to do, I want to be honest with myself. I am only here as a vistor, like everybody else. I will be facing myself, whether in the mirror, psychologically, or in my work. It's sort-of-a basis, an outline for my behavior. I shouldn't be ashamed of anything I did—I should be honest.

THE ART WORLD

Most artists, or I should say sincere artists, create their own little world. Even if they have the model in front of them, it becomes their world. The beauty of all this art that we have is it's challenging and you cannot disprove it. All of these are little worlds and it is part of our world.

In the thirties, when more people began to take up art in their leisure, I thought it would be a better world and easier for everyone to enjoy art more. The idea of art for the masses and I was all for it. Now I am very much against it. I'm getting the idea of what it really is. I think that the expressing of emotions, the idea of therapy, of senior citizens who are bored and the neurotic people who are going in for painting is lousing up my world. There is no feeling, no respect, no integrity for the profession. You go into any home and look on the walls and I can tell you what the person is like, by the pictures they have selected or have had selected for them, or by their books and their records. It's confusing, especially with people you like and know. They can really expose themselves, undress, when they put their pictures on the wall.

I think this art explosion is not a good thing. I find that in it, the good things are lost to a great extent and the exposure of wrong things uppermost, and people are led to a museum and they respect a museum, then the artist takes a toilet and puts it on canvas, or puts it up as sculpture and they are told it is art.

This is what has happened to a great extent. *Garbage Expression!* and it inspires the weaker, the non-developed and they throw it into the face, well, my face, let's say. I am offended, but I will not carry a picket sign and protest. I think they deserve what they get.

The younger generation hasn't discovered me yet. There is a thing I get a tremendous kick out of. I'm fascinated by things, techniques, surface painting. I get a charge out of them, but it's not my mission, it's theirs. I'll enjoy it with them. I love touching various materials and textures, but I don't have to take LSD. I'm on a trip ever since I was born.

A long time ago, I was assigned by *Vanity Fair* to cover the

Senate. I stayed two or three weeks and painted the Senate as I saw it. I think the United States Senate is the best show in the world. If people saw it, they would know what their government is doing. The painting that I did was rejected by every show I tried to get it into. Then it was brought back and the Museum of Modern Art had it and now it is in every show. I get bored, so I did one or two Senates, and now I will do a Senate only when a Senator makes a speech that makes me mad.

In 1947, I was invited, with brother artists from all over the world, not many, to the unveiling of the Warsaw Ghetto monument. I'm not Jewish in a professional sense but in a human sense; here are six million destroyed. There is a ritual in the Jewish religion of lighting a candle for the dead, but instead of doing this, I decided to paint a picture in memory, every year. In this way, I paid my tribute, rather than burning a candle.

I have been drawn into many causes and lives of my friends, when they have been sought by authorities because they were idealists. They were against a system that was doing wrong to them or to their people. I really react; I have reacted that way all my life—I just can't repeat myself.

I don't think I will ever retire; I'm just, well, I just show promise. I'm the guy who is always discovered. I lean toward those who are struggling for something better. I want to paint the truths that I feel, and, at times, I have been criticized for that.

William Gropper, Proletarian

HARRY SALPETER

THE goose hangs high for William Gropper, radical cartoonist, proletarian painter, yesterday a Bowery bum. For his pictures are hanging in the salons of homes in the kitchens of which he could not have been too certain of a civil reception some years ago. Said proletarian dealer to proletarian artist, describing the destination to which he had just delivered a recently sold Gropper canvas: "You should see where it's going to hang! It isn't a castle, it isn't a palace; it's a *mansion!*"

Up to a short time ago the picture buyers who lived in mansions could only admire, they could not possess. For so far as they and the general public were concerned, Bill Gropper was a black and white artist, a cartoonist and caricaturist, the bulk of whose work might be seen in reproducton in books and magazines. An occasional drawing or lithograph might be had, but infrequently. It was known that his industry was maintaining the radical press in cartoons and caricatures, but only a few friends who were on visiting terms were aware that privately Bill Gropper was doing a little easel painting.

In the furore which followed the first public exhibition of Gropper's paintings, it must be understood that Bill Gropper did not seek out the people who live in mansions, they sought him out, or, rather, they sought out his pictures. On principle Gropper doesn't like people who live in mansions; even in practice he doesn't like them, for they are the routine villains of his stream of cartoons. They are fat with profits and hard with privilege. They are either actual or potential Fascists, either the immediate oppressors of the poor or living unjustly on the inherited right to unearned increment wrung from the supine masses. These gentry can have his pictures if they will pay properly for them, as they

From *Esquire*, September 1937, p. 105. Reprinted by permission of Esquire Magazine © 1937 (renewed 1965) by Esquire, Inc.

have. Bill Gropper's no snob. Robin Hood was supposed to have given to the poor money taken from the rich. Bill Gropper doesn't do that, but he does sell to the rich that he may more freely make pictures for nothing for radical magazines so obscure that even radicals haven't heard of them. He is only a propagandistic Robin Hood. Although he still lives in the shadow of days when a nickel was money, Bill Gropper is as successful in pocket as in reputation, unable to resist a commission from a capitalist individual, a capitalist corporation, or a capitalist government, a living affirmation of Horatio Alger morality in a world so dominated by the conveyor belt that there is supposed to be no hope for youth now but in communal activity for communal ends. He is the individualist poor boy who continues to make good in a collective world in which most of us have all but become numbers. Even the radical press which affirms the collectivity as against individuality wants not cartoons but Bill Gropper's cartoons. Yet whatever may be the status of most of us, whatever may be Bill Gropper's limitations and restrictions as an individual, he is one of America's most brilliant black and white artists, one of its most vivid and dramatic painters. In the light of his distinction, his quality and his contribution in art, it does not matter so much that outside of art he has the mind of a high school radical. This is not so much a blemish as a shadow which brings into higher relief the bright tints of the picture.

The public's recognition of Bill Gropper as a painter dates from February, 1936, when his first New York exhibition was opened in a small downtown gallery. By that time he had already "published" a few murals in color on commission from architects and the U. S. government, but few people knew or cared. Even his dealer had expected to show, and asked the artist to get together, a group of drawings; Gropper rather thought that his paintings, on which he had been working quietly for the past fifteen years, were now ready to be displayed. The reviewers, proletarian and otherwise, went wild. The gallery had no clientele of rich collectors who could be privately nudged, in the best 57th Street and Fifth Avenue manner, to get on to a good thing. Nevertheless, they temporarily deserted the mouse-

traps of uptown and beat a pathway to the door from which they could examine and purchase Bill Gropper's superior product.

When the dust of departing critics and purchasers had settled behind them and Gropper could spare a minute for an examination of accounts he must have felt somewhat like the Scotsman of the story who won 20 pounds on a 20 to 1 shot at the race track and wondered how long this could have been going on. In five months of furious painting during which he surrendered not one of his cartooning chores and fulfilled every other commission for which he had contracted, Gropper produced a better exhibition of paintings and water colors than he had been able to get together in the fifteen years preceding his first exhibition. The critics, proletarian and otherwise, might have reserved for the 1937 display the gasps of admiration and the adjectives they had lavished on the first. They were faced with an anti-climax but the exhibition turned out to be an ascent. His color had become purified and more brilliant, his forms more direct, more simple, more dramatic. His best paintings had the force and drive of cartoons in color; his worst were decorative panels obviously deriving from the Japanese, Chinese and Persian traditions. But his worst were only so by contrast with his best; they show up better than many another painter's best. Even these were interesting as an acknowledgment by tomorrow's cartoonist of his debt to the ancient past in art. The exhibition, in its entirety, was good painting and as exciting, in contrast with the average art show, as a Western horse opera against a desiccated society drama. It was contemporaneous, it was a success. The Modern Museum bought from the first exhibition, the Metropolitan Museum from the second. Half of the first show was sold out, two-thirds of the second. As this is being written, Gropper is painting his way to his third exhibition, which will probably be on view early in 1938.

From the Communist point of view Bill Gropper has a perfectly kosher proletarian history. He was born forty years ago of poor and honest parents, in the depths of the East Side, in a house on Pitt Street since destroyed in the construction for an approach to the Williamsburg Bridge. He recalls his father as a cultivated misfit who knew eight languages but couldn't hold

any of the few jobs available. His mother, the support of the family, was a seamstress. She had been introduced to the sweatshop by her own father who came to the New World as an advance scout and subsequently introduced his wife and children (among them Gropper's mother) to the airless Bedlam that was the clothing loft of several generations ago. Gropper is not so old but that he remembers his own sweatshop experience.

At first it was limited to his carrying bundles from the sweatshop to his home. His mother sewed through the night and the next day, after school, young Bill carried the finished business back to the sweatshop and brought home other work for his mother. He was no scholastic prodigy and it is easy to believe that he flunked in every subject but drawing. That was in his blood. But he did graduate and won a medal for drawing into the bargain. While at school he had heard about the life classes at the Ferrer School which Robert Henri and George Bellows were then conducting. He attended these for two years and recalls among fellow students, each of whom chipped in twenty cents to pay the model, Man Ray, Robert Minor, Ben Benn, Manuel Komroff (the novelist) and Benjamin Greenstein. The atmosphere was free and easy, neither Bellows nor Henri stood in the place of Deity, the students criticized each other and honest expression rather than rigid adherence to formula was encouraged. Gropper recalls that although the 1913 Armory Show had ended the year before he enrolled the effects of that exhibition were continuing to agitate the younger artists and to make them feel that participation in art could be and was an adventure.

But he had to heed stern calls to reality, young as he was. He had had his taste of the sweatshop, but he was not to escape with merely carrying bundles to and from it. For a four and a half year period, falling between and overlapping his school life and his art studies, he worked as bushel boy in a loft factory on a twelve-hour day, six days a week schedule. During the Christmas rush he worked fifteen hours a day with no extra pay. This experience alone would give Gropper complete proletarian status. He was one of the oppressed.

Somehow he managed a term or a year at high school, which gave him a scholarship to the National Academy of Design, which

threw him out after two weeks. The occasion for the expulsion illuminated the Academy's inflexible and not quite intelligent method of teaching, a method so hard and fast as to imply negation, if not positive hatred, of the art spirit. At the Ferrer School Gropper had learned the method of free, easy and quick sketches. Even had he not learned it, that method was in his cartoonist's blood. At the Academy he was set to work copying a plaster cast. He had to begin at the toes and work his way up so slowly that, as he puts it, "by the time you reach the hips you're an old man." Gropper planned to live a long time, but not exclusively in that room of the Academy. Later that afternoon his instructor found Gropper before another cast, one which he was not supposed to reach in months. "You're supposed to be working on that one," indicating the first. Gropper pulled out a sheaf of finished sketches and said: "I've done them all. Tomorrow I start sketching the students." The instructor was horrified. "What's this, moving pictures?" He compelled Gropper to return to the first cast and showed him, approvingly, an elder student's sketch, one so exact and lifeless that it might have been a photograph. The next day Gropper reported to the life class. Other students raised hell and still others followed his example. The plaster cast instructor complained to the Academy's heads who first reprimanded and then expelled the rebel student.

He looked for work. He found it in a clothing store at Fifth Avenue and 23rd Street. For $5 a week, working ten hours a day and twelve and thirteen on Saturday, he was general handyman, ran the elevator, acted as doorman, lettered show cards, sold umbrellas (on rainy days) and addressed postal cards and letters. On many of these postcard reminders to old customers who hadn't revisited the store he drew caricatures of salesmen and other personal touches, such as: "Why not have yourself fitted for a new suit? Maybe you've grown since 1906." This card came back with: "Don't know. He's been dead since 1906. Maybe he has grown." But another card with one of Gropper's personal touches in caricature found its way into the letter box of Frank A. Parsons, then president of the New York School of Fine and Applied Arts. Mr. Parsons sought out the young man who had drawn the sketch on the postal card. He offered him a half-day

scholarship at the New York School if his employer would let him off for that period. His employer readily consented, but cut his pay in half, to $2.50 a week. Bill Gropper kept the job and improved each shining hour at the school for the year 1917–18 by winning every cash prize to which students were eligible, Pirie MacDonald's $50 for the best caricature of himself, Annette Kellerman's $100 for the best drawing of herself in a bathing suit, Collier's $100 for an illustration and Wanamaker's $100 for the best drawing in a city-wide exhibit. Then the New York *Tribune* asked him would he please to come on the payroll at $150 a week doing illustrations and caricatures for the Sunday Magazine section. Then he left his $2.50 a week job and his employer thought he was ungrateful to do so.

The *Tribune* inadvertently introduced Bill Gropper to the radical movement. He was just an ordinary East Side boy with no political or social point of view or orientation until his editor, apparently a simple-minded and uninformed person, put him on the job of making drawings of the I. W. W. headquarters in New York. Robert Reis, a reporter, was to write the story. Reporter and illustrator were seriously warned to look out for bombs. They took this straight and were honestly frightened. When they arrived at sinister headquarters all that they saw was a grey-haired fellow sweeping the floor of a shabby, deserted room. (This was the basis for one of Gropper's lithographs, *Union Hall.*) "Where do you keep the bombs?" the innocents asked the sweeper who, in reply, went to a desk, pulled out a leaflet, held it out to them and said: "Here's the I. W. W. preamble. This ought to blow you up." Reis and Gropper read without a pause and in a common gesture slammed down 50 cents apiece in evidence of desire to join, thus becoming full-fledged members of the I. W. W. (The union hall sweeper was none other than Lee Chumley who later, in more prosperous garb, conducted one of the more picturesque restaurants of Greenwich Village.) They returned to the *Tribune*, no bomb, no story, no illustration. From that time on what passed for a soul in Bill Gropper belonged to the radical movement and his first effort on behalf of the I. W. W. was the organization of the Printers-Publishers Union, of which

he also served as secretary; shortly thereafter he began to draw for the revolutionary press.

In 1919 Gropper left the *Tribune* and took a boat for Cuba for no better reason than that New York was cold. Robert Reis came along. They landed in Havana with no more than $13 between them but both found jobs immediately on the Havana *American*, which folded up two weeks afterwards. The Sinclair Oil Company was then building a railroad into the interior and they were taken on as timekeepers. About that time the sugar crash of 1920 brought down in its wake the bank in which they had their money. They quit their jobs, signed on an oil tanker and arrived in New York with no more than the clothes on their backs. It must have been at this time, if at any, that Bill bummed his way across the country, as far as Butte, Montana, earning an occasional dollar as a sign painter. However, upon his return to New York he had to live in Bowery flop houses, earning a precarious livelihood as dishwasher in beaneries along Second and Third Avenues.

We need not be too sorry for our hero, for all this experience was to be valuable in the building up of his proletarian history. Besides, the tide was to turn in his favor, and in a most curious way. As the more prosperous (because the most industrious) of a small group of bums he was constantly subject to panhandling levies. There was one bum who was particularly insistent in demanding nickels from Gropper. He may have obtained even dimes. Bill had at no time understood why the idle should live on the industrious and after passing over a number of nickels and even a few probable dimes, he rebelled, swearing a great oath that he would not give that bum another nickel.

Bill Gropper was as good as his oath. The bum couldn't budge him. Egging on the panhandler was a third hobo, a former journalistic associate. But Bill said to both of them, "I'm through, I don't know you," and proceeded walking northward on the Bowery, the two tagging along. It was a strange procession. First Bill, with "I don't know you," then the panhandler whining "Give me a nickel" and then the inciter saying, "Aw, give him the nickel." At Union Square Bill turned west, found 13th Street and struck a row of sedate brick houses. At 152 West he saw a

house with a brass plate, *The Dial.* He knew it was a magazine. Dirty and unshaved as he was, he walked up the steps and rang the bell. A prim young woman came to the door. "Give him a nickel," yelled the inciter. "I don't know these guys," said Gropper. "I want to see the editor." "Oh, you mean Mr. Thayer; he isn't in." Just then a limousine came into view and stopped, the chauffeur opened the door and up the steps pranced a delicate young gentleman dressed in the pink of fashion. "Mr. Gropper to see you, Mr. Thayer." "Ah, the painter!" unknowingly anticipating the distant future. "Come right in" and, within, Bill Gropper was treated to tea and an invitation to contribute drawings at the rate of $25 apiece for reproduction rights alone and an additional sum in the event the original was bought. Had he any little thing available? "The painter" said he would look through his portfolios in the studio. His "studio" was a bed in a flophouse, but what Mr. Thayer didn't know wouldn't hurt him. When the outside door closed on Bill the two bums were still waiting for him. Somehow he shook them. At the Washington Square Book Shop, then run by Egmont Arens, editor, littérateur and connoisseur, Gropper asked for a few sheets of paper, pen and ink. In only a little more time than it takes to tell he had dashed off four drawings. That afternoon Scofield Thayer bought reproduction rights and originals and the still unshaved bum walked out with a check for $200. The story of the nickel Bill Gropper did not give is Bill Gropper's and it may be left to the reader to judge which one of the three bums it exhibits in the most pitiable light.

The Bowery never again knew Gropper except as occasional visitor. He rented a studio in Greenwich Village. He began drawing for the public prints and painting for hmself against the future. In his spare time he threw himself into the radical movement. In 1921 when John Reed organized *The Revolutionary Age* he gave it proletarian cartoons. The *Liberator, Pearson's,* the New York *Post, Shadowland, Photoplay,* the *Smart Set* and the *Bookman* printed his cartoons and caricatures. *Vanity Fair** and

* It was the August 1935 issue of *Vanity Fair* which carried Gropper's cartoon of Emperor Hirohito pulling a coolie cart on which reposed a rolled-up parchment representing the Nobel Peace Prize, the cartoon which so deeply out-

even *Spur* used his facile pen. Book publishers sought him out and paid his price. He illustrated two of Jim Tully's novels, among many other books, and even published two of his own, one a volume of drawings, *Sketches of Soviet Russia*, reminiscences of a year's stay, and *Alley Oop*, the story in pictures of an acrobat's home life. He has accepted an advance for a book of memoirs, not exclusively in pictures, which he wonders when he will find the time to write.

In 1925 the Sunday editor of the New York *World* engaged him to make little pictures for the columns of F. P. A. and Frank Sullivan and do other odd assignments. "It was practically a job," and he stayed with it until that newspaper collapsed in 1931. In 1925 he was engaged also as political cartoonist for the *Morning Freiheit* (Freedom), Yiddish Communist daily and he is still on that payroll. *Freedom* gives him freedom to comment in caricature on the day's news. He draws six cartoons a week for this paper but contributes twice as many more for the radical press, without pay. The *Daily Worker* reprints his Freiheit commentaries. For the *Sunday Worker* he draws an additional cartoon. He presents no bill for services to the *New Masses*, or the *Fight Against War and Fascism*, or *The New Pioneer*, or the *Labor Defender*, or *The Hammer*, for which he draws a cover every month. If a left organization or a radical labor union requires a poster by means of which to rally the boys and girls to a protest meeting, Bill Gropper is elected. He is on constant call. He contributes lithographs and drawings for auctions and raffles benefiting radical causes. He was one of the organizers of the John Reed Club and of the American Artists' Congress. With Sinclair Lewis, Scott Nearing and Theodore Dreiser he was a delegate to the celebration of the tenth anniversary, in 1927, of

raged the Japanese Foreign Office that it shook its American Ambassador out of his summer retreat in Connecticut and rushed him down to Washington to make representations to Secretary of State Hull. *Vanity Fair* lost its Japanese customers that month, the editor, Mr. Crowninshield, said that no offense had been intended and Gropper improved this shining opportunity to declare verbal war on Japanese imperialism and to draw for the *New Masses* another cartoon, *Behind the Japanese Screen*, a much more propagandistically vigorous assault on the slant-eyed Fascists. Other cartooned improbabilities on that *Vanity Fair* page included Huey Long entering a monastery, Morgan soap-boxing against capitalism and Hearst taking the trail to Moscow as American Ambassador.—H. S.

the U. S. S. R. and was a guest of the government for a month. He remained an additional eleven months, traveling throughout Russia and drawing for Soviet publications. Out of these pictures he subsequently made a book.

He lives in his own house (which he hurries to add is heavily mortgaged) in Croton-on-the-Hudson and comes to New York three times a week to do his cartoons and his incidental bit in the war against Fascism. The other four days are his, for painting and other enterprises. His first lessons in painting date from the early years when he could spare a few moments for the museums. They were his least disappointing art schools. In them he studied Rembrandt, El Greco, the Flemish painters, especially Breughel and Hieronymous Bosch, the Japanese print makers and the Chinese masters, particularly of the T'ang period. He studied also Goya, in color and in aquatint and learned much from him in both mediums, as his paintings, drawings and lithographs show. Among the French he looked hardest at Daumier, Géricault, Manet and Cézanne.

Gropper is an artist of intense activity with many irons kept hot in the fire. In 1934 he painted a pair of panels for the Schenley Liquor Corporation, one of which, *Wine Festival*, a Breughelesque composition, was exhibited three years later. After the artist had pocketed his rather handsome check and packed up, it was discovered that he had worked caricatures of Grover A. Whalen, chairman of the board of directors, and Harold Jacobi, president, into either *Wine Festival* or *Schenley Bar*. The caricatures were erased. About the same time he decorated a wall of the coffee room of the Hotel Taft in New York with characters and situations suggestive of the Colonial period. In the year of the Schenley commission, Gropper also took $38 a week from the P. W. A. for a mural for the postoffice in Freeport, Long Island: he is now at work on a companion panel for the same building. More recently he was commissioned to paint a three-panel mural on the subject of *Reclamation*, including Boulder Dam, for the new Department of the Interior building in Washington. This commission came to him from the U. S. Treasury Arts Projects division which engages painters and sculptors for the embellishment of public buildings with reference only to their ability and

not to their need. The Guggenheim Foundation this year jumped aboard the Gropper bandwagon, as it has jumped aboard so many other bandwagons, by giving the artist a fellowship which will enable him to visit the Dust Bowl and make sketches on the spot in preparation for the paintings he will later finish in his Croton studio. Unlike the average painter, who is happy to spend a full year on a Guggenheim fellowship, Gropper will see fit to devote only a brief part of the year in the exclusive ful- fillment of this project. In this case also the fellowship is a re- ward for merit rather than a recognition of need.

Bill Gropper appears not to be presumptuous in his ambitions. All that he wants is to do more painting and more cartooning. He loves, he says, to do cartoons because the need for doing them keeps him in touch with the vital currents of the times. "The cartoon," says he, "can be as pure a form of art as painting." It is perfectly proper for him to believe this because even his painting has the form and movement of the cartoon. His capitalist mural jobs he regards as so much crocheting, which makes one marvel that he takes on so many of them, since they do not feed the hunger for self-expression and are not urgently required to feed the belly either. His alibi is that he likes to make deadlines, the old newspaperman that he is. He enjoys being faced with the chal- lenge of having to complete thrice the normal man's engagements, and completing them. He enjoys the challenge, for example, in- volved in the difficult process of making wash drawings on Japa- nese paper. He does not know how to relax, he can't take a vacation. For outdoor sports he throws darts and pitches horseshoes, which diversions have the advantage of keeping his cartooning and paint- ing arm in trim. He reads only while commuting. He approves of Molière and Voltaire. Out of one of the more violent episodes in the latter's *Candide* he made a painting so that he must have read the book at some time. Once upon a time he paid an occasional visit to the newsreel theatre so that he could see how politicians look in the round, a great help to a caricaturist, but he has no time now for even so useful a pastime. Among contemporary painters he admires Arnold Blanch, George Picken, Louis Ribak and Yasuo Kuniyoshi. (Gropper and Kuniyoshi beautifully caricatured each other, each skilfully employing the other's style.) Gropper grants

that a man may be a good painter without having a social point of view. Among Gropper's private reasons for accepting every capitalist commission are two small boys who are exhibiting a dangerous, but not encouraged, penchant for art. At present, however, Bill Gropper doesn't seem to be particularly worried about that or anything else. The proletarian revolution is still a considerable distance in the future. He will jangle his chains awhile.

Satirist Into Painter

LEWIS MUMFORD

Two years ago, William Gropper's first murals were shown at the mural painters' show. There he proved himself a gay interpreter of such rural scenes as Breughel knew and loved. Last year, Gropper held his first show of easel paintings, and established beyond doubt that his talents in black-and-white are outshone by his gifts as a painter, as was also true of Daumier. This year, at the A.C.A. Gallery, the demonstration is carried to completion: one can definitely say that Gropper takes his place henceforth as one of the most accomplished, as well as one of the most significant, artists of our generation. The dingy gallery on West Eighth Street, with its comically forbidding entrance, houses the most distinguished contemporary American show we have seen this winter since the Marin exhibition.

Gropper's paintings are so thoroughly imbued with his social feelings and his revolutionary political point of view that I am tempted to underline their abstract merits. As a painter, he is distinguished by a subtle palette and by his marvellous sense of movement and action. His color is as completely individualized as Kuniyoshi's; from his palette he draws forth a world of dull greens turning toward yellow or turquoise, and violent dark greens that serve for contrast where more naturalistic painters would be tempted to use blue or violet. All these greens are in effective harmonic relation with his browns and yellows; they supply a ground for the more dramatic reds that leap across the canvas, or for those terrible whites that suddenly freeze the eye.

In his power of condensation, Gropper has few rivals; he concentrates in the smallest possible compass, with admirable economy of line and mass, something that another painter might require a whole acre of canvas to express. His long course of training in

caricature has probably been an aid to him here; he has learned to suppress all the preliminary facts and observations, and to give the concluding strokes, as if he had jumped immediately to them. This places the burden of selection where it belongs—in the mind of the painter. Such an eye, naturally, implies a scale of values; one must be sure of one's objectives before one can cast away so nonchalantly all the props and incidental confirmations. The result is so clean and spacious and free from apparent effort that it gives the spectator the peculiar sense of release that only perfect skill offers.

Is there anyone painting in America today—except Orozco, Marin, and perhaps Benton—who has anything like Gropper's dynamic feeling for form? Movement is not merely the subject of some of Gropper's paintings, as in the trees and bodies hurtling helplessly through the air in *Tornado*; it exists in his handling of the masses of a quiet landscape. One could tell from any painting of his that he does not believe in a fixed world, or in one slowly succumbing to dissolution; he believes in effecting change and in commanding it. Hence the way in which Gropper's imagination supplants the literal fact, even when it comes closest to the raw details of a social catastrophe. Action in Gropper's paintings has many phases—the muscular violence of *Combat*, the gay, flapping flight of clothes in *Wash Day*, the rapid panic of the *Refugees*—but even in his most lyric paintings, one feels that the mere pressure of the trigger might release an explosion. A sense of exaltation is inseparable from even his most brutal images—a feeling that derives not from the subject but from Gropper's own fighting confidence. It is the feeling that a mountain climber knows when he makes a desperate jump.

Perhaps the most significant element in Gropper's designs, both graphically and symbolically, is the part played by his use of white. In *Moby Dick*, Melville has a chapter on the capacity of white, "coupled with any object terrible in itself, to heighten that terror to the furthest bounds," and one might write a whole essay on Gropper's cunning use of it in his paintings. Note the white figure of the *Prisoners* (No. 5), and the white teeth of one of the Moors in the haunting water color called *Foreign Legion*; all the deviltry and brutality are concentrated in those two white fangs. Turn to the white horses and the white, prostrate woman's figure in *Cops*.

Consider, in *Tornado*, the effect of the figure hurtling through space, its head smothered in white clothes. In the mass, these paintings are a contrapuntal display of terror and delight, of horror and beauty, of misery and ecstasy, and they give Gropper a preëminent place as an interpreter of the mangled reality that people confront today. Too long, perhaps, Gropper has let himself be dispersed by the trivialities of propaganda, in response to the day's demands. Now it is time for him to concentrate his energies and to focus them in paintings that demand his utmost powers. His unflinching realism, his imperturbable aesthetic command, his irrepressible gaiety, and his abiding sense of the values of life are superb. These paintings are the best answer the artist can make to the cold violence of the men of ill will who seek to make the world safe for black nightmares and brown shirts.

Gropper, 1940

JOE JONES

THIS year (1940) is the 20th year since Bill Gropper left his job
on the *New York Tribune* and began drawing a daily cartoon for
progressive newspapers and periodicals devoted to the economic
problems of the working class. There is nothing extraordinary
about a cartoonist who is doing his daily job for twenty years
anymore than anyone else who is working for a living and living
that long after being responsible for his own sustenance. But when
the movement Bill works for organizes a tremendous celebration
for his twentieth year on the job, attended by hundreds of his
friends, long-distance admirers, and newspaper readers, we then
have something extraordinary. It makes something stable out of
Bill, something enduring to all those people, something that goes on
or through Bill's life that has a pattern, I might say a rhythm of
living his life that is dependable in the minds and hearts of so many
people who are now celebrating his 20th year on the side of pro-
gressive thought and action.

Bill has seen many people come and go in this movement that
fights for a better life. Writers, painters and other creative and
intellectual people. Individuals who burn hot with the desire to be
on the side of things that go forward and lead to a better way of
living for all. And now when there is so much unintelligent and
undignified support of Hoover's Mannerheim and nickel at the
expense of American hunger and slums, it is just plain good feeling
to realize that where the conviction runs deep, it also runs long. In
Bill Gropper I believe we have as integrated and purposeful an
individual as any to be found. I don't know whether he is a great
person or a great artist. What I do know and I think needs to be
known of anyone, is that his day by day examination of himself,
society and his work is approached with the single idea of under-

From the American Contemporary Art Galleries' William Gropper exhibition
catalog, 1940. Reprinted by permission.

standing. This search equipped with a powerful drive in Bill, reaches its important stage in his ability to understand and his great talent to express himself in painting and drawing. This I believe all leads to something pretty good, maybe a great human, or maybe just someone to celebrate every twenty years and be glad he is with us.

Perhaps much can be learned about a person when we are familiar with his attitude toward his work. I know for example (I am thinking of painters now) there can be many approaches to a canvas. A way of making money (a living) can be an approach, an escape from reality or the painful world we live in can be the reason to paint. There are many psychological and material struggles that can torment a painter with or without his knowledge. The dominating interest of the creative person, of which I have only cited two of the most obvious and common types, does give us something to go by in our consideration of that person.

It is when a work of art tells us something of life around us in a way that is revealing and the artist makes his discovery with aesthetic enjoyment, that makes us feel we are in the presence of the beautiful. Here I want to offer the proposition that discovery in life expressed in aesthetic enjoyment is human progress and if accompanied with artistic talent, is a thing of beauty. Therefore I believe that life is beautiful because its direction is forward and expressive. Individuals can be, but are not always.

Somewhere in between men and life we find the arts, a kind of sounding-board for the human reaction to life itself. The reactions some of these human beings have towards life is remarkable to watch. Perhaps the most amazing piece of human fear and ignorance, is found in that large and pathetic group of individuals who think and travel in directions that lie behind them. Worse still is the immorality of these people in their insistence and power to ensnare the broad masses of people into their frightened fold through expressions of inferiority disguised as theories of national superiority.

Although I could pick out a few personalities like Hitler, who patterns his direction in the backward and destructive impulses, I will confine myself to the cultural front and only in the field of painting.

Some art critics seem to be the unofficial leaders of the direction our American painters are taking. Thomas Craven gets together with Benton, Wood, and Curry, resulting in a theory of Mid-Western horse-sense, virility, uncontaminated by the French, Americanism in painting voiced by Craven as a national superiority. Benton on his way back from Europe traveling his backward direction, stops in New York for twenty years or so, and feels that in order to complete his journey he ought to go back to his native Missouri. Being a little guilty of this urge inside him and self-conscious of his artistic importance, he expressed a series of rationalizations before a large audience at the Art Students League, and elsewhere, pointing out the superiority of the Mid-Western painters over those "New York intellectuals" in the East. Benton was soon to learn that in all his years of absence from the Mid-West, telephones and other forms of communication had invaded his native state. The painters had been looking at French art and people were alike everywhere. This was a sad blow to Mr. Benton when he expressed himself over a national radio hookup from Kansas City. Since then he has boisterously stated that he is now staying on in Missouri, only because he thought the next book he has in mind titled, "After Ten Years Back Home" will be a best seller. But anyone can see that, if Benton continues in the direction from which he came, he will be frustrated and disappointed when he finds it ends where life starts.

Since we are concerning ourselves here with questions of art and not passing judgment on people, we must forget their clowning and look at their work. We are then confronted with a series of grave-digging pictures, like Curry's *John Brown*, Grant Wood's G. Washington cutting down the cherry tree and Benton with his whole repertoire of hill-billy legends and a general tendency in all his work to portray fifteen-foot Indians in the foregound of his murals, and as the incidents become more contemporary they correspondingly recede into the background. Faced with a mind that is working in this backward fashion, which is certainly dominated by a psychological pattern, it bears examination, and can only be explained in the behaviorisms of the individual himself. Finding again that art is made out of the effect of life upon the individual, we must now examine what goes on between society and this type

of art. A society that is in the throes of insecurity, and withdraws into itself as though it were a child coming into contact with fire for the first time, must preserve its feeling of well being, and console itself with ideas of national superiority. This wound-licking is always looking for company in its misery. What could be a better art for America today than an art that only deals with the good old days, walks backwards and brags of its unwillingness to expand.

Now with the national OK on everything that looks backwards, it is no wonder that we find critics, like Edward Alden Jewell of *The New York Times*, and Peyton Boswell of *Art Digest*, forming a block with Craven to make hay while the sun shines. I don't think Jewell and Boswell are as strongly patterned as Craven, but they are giving up the fight forward, for the easy and, I hope, uncomfortable trip through the mustiness of a life already lived. They will find old familiar values that will sour in their hearts with the realization that their opportunism is only their own human weakness by their extended egos. Shorn of their ideals they can now prattle contentedly in their disguised inferiorities.

Because the true artist is a person who deals in things of harmony and progression, he will find very little in common with those elements that lead away from his problems as a creative person and are in the direction of everything destructive, including war.

No greater contribution is being made today in any medium that exposes the degeneration of certain elements of life and society as we know it than in the pictures of Bill Gropper. Because Gropper's approach to his subject comes from his deep sense of ideals and desire to go forward searching for a better life, the performance is beautiful to watch for he is happy in his expression of what is on the way.

Bill Gropper

PHILIP EVERGOOD

IN America we have our institutions. Some are durable, some are incurable and others are plum unendurable. A President, the fliv-ver, Bethlehem Steel, the Senate, Hearst and the oyster season. Take your pick, but as long as we have institutions William Grop-per is here to stay.

His earliest schooling in life was in a great American institution —the sweatshop, on New York's lower East side and there he be-came a part of the people for his life and ours. There he learned the hard way about their sufferings and about their fight and became a battering ram in that fight.

Some aesthete one day asked Gropper why the color in his paintings of the East side was so subdued—why he didn't splash and revel in the full orchestration of a luscious palette. Gropper replied that when he worked in the sweatshop the cloth seemed grey—the light was poor—his back was tired and there was an awful stink in the place. He could not paint these struggling people's lives in roseate hues. The little tailor, the pretzel vendor or the bloated human symbols of the vested interests which had trodden them under.

For twenty years Gropper has drawn cartoons. You know them as well as I. They must average over one a day because he draws for several publications as well as his daily newspaper work. They are great cartoons judged by the highest standards of the present and the past. His cartoons are art because he lives and burns in the fervor of a cause and because they are big in concept. He neither minces words nor minces lines. His calligraphy is bold, sensitive and original. You get it straight from the shoulder and you get it good. Gropper has found time to write several books, illustrate several more as well as raise a sturdy family. The man has energy.

From the American Contemporary Art Galleries' William Gropper exhibition catalog, 7 February 1944. Reprinted by permission.

Ten years ago when he started to paint pictures, reaction tried to pigeon hole Gropper and pin him down. Reaction patronized him by acknowledging he could draw a good cartoon but suggested he stick to that form and not dabble in aesthetics.

Since that time he has painted the work for over ten one-man shows, has several large public murals to his credit and is represented by paintings in many of our important museums.

Gropper's painting is not a lukewarm self indulgent flowing out from the finger tips for its own sake. His canvases are not the receptacles for scientific research or the hypersensitive reactions to microvariations of the color spectrum like those of say Seurat either, nor are his compositions linearly adjusted to a two thousandth of an inch like those of Ingres or Modigliani.

Gropper has come by his art through revolt against oppression and through an insatiable creative urge, artistic intuition and joy of life. He works fast. His work is not the reflection of a lonely self effacing soul like Ryder's but contains something of the aggravated spontaneity of Van Gogh and something of the vigor of Hokusai. Gropper's art springs from the same kind of urge that impelled Noah to build the Ark and with a similar result. The Ark was sturdy and was beautiful too, to those who rode in it.

Once Gropper told me, "We painters for the People must not only tell them the truth in human justice and righteousness but we must convince them. The awareness of this truth makes us more alive to the fact that we must say it better and with more conviction than anyone else in order to be accepted."

On another occasion he remarked: "The reactionaries don't want to see us grow, they want to see us in the good old way. The artist has to grow all the time and grow with the People." And at another time, "The artist doesn't create life, he reflects life."

I have known Bill for fifteen years and I have witnessed several of his personal victories. One of these was the occasion of a celebration for his twentieth year as a cartoonist. It was held at Mecca Temple and the stage was filled with a variety of celebrities ranging from Gypsy Rose Lee to Kuniyoshi.

The victory for Bill was in the audience for the place was jammed to the rafters by a milling, shouting mass of toilers—the friends whom he had won for himself as an artist and as a fighter.

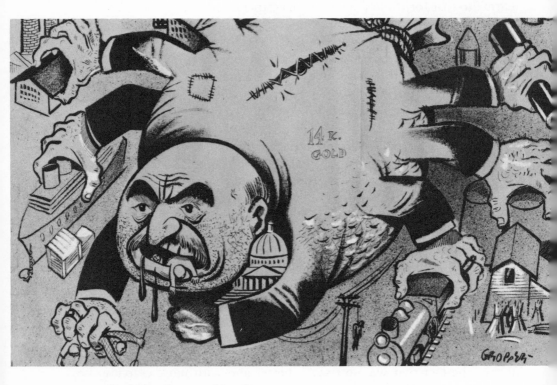

Capitalist Cartoon Number 1 WILLIAM GROPPER

1933
Ink and chinese white
12¾″ × 17″
Photo courtesy of ACA Galleries, New York City
Photographer: Eric Pollitzer

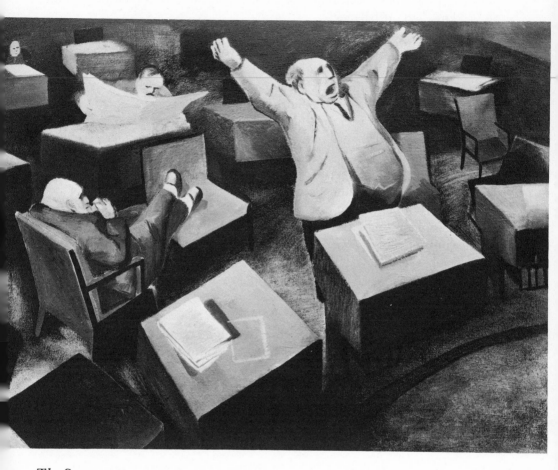

The Senate WILLIAM GROPPER

1935
Oil
25⅛" × 33⅛"
Collection of The Museum of Modern Art, New York
Gift of A. Conger Goodyear

I have only seen Bill once in adversity and even then he was not knocked off balance.

I shared this unhappy experience with him and this fact alone may qualify me to know the real Gropper and to write about him.

Last year Bill, Refregier and I were asked by the War Department Art Committee if we would go along with our troops to North Africa to make a pictorial record of War.

Here at last was the chance a Peoples' painter had been waiting for. To record the heroic deed of our men in the greatest fight against the evil forces of the World.

We accepted the offer in good faith and within us we felt the honor and the challenge to give our utmost as artists.

After months of preparation and adjustment to thoughts of a completely new life which included the signing of a Government contract and inoculations for about every disease under the sun, we each received a terse note signed by a Lieutenant of Engineers announcing that we were ineligible to accompany the armed forces of our country.

On further inquiry from a higher source we got the hint that on the basis of our work we were fully acceptable but were not wanted because we had been involved in the fight against Fascism at too early a date.

It hit us pretty hard. Bill, who usually looks somewhat cherubic in countenance, appeared quite haggard. Ref and I must have looked about the same.

Bill's three sentences pulled us together.

They made a big mistake.
Our country is the loser.
We must carry on.

We are now about to see Bill's work of carrying on.

I saw one new canvas of the rending of a world by high explosive.

It was vivid and high in key and seemed to symbolize the purification by fire.

Perhaps the change in Bill's palette indicates the coming of a better world to live and work in.

Jacob Lawrence
Chronology

1917	Born Atlantic City, New Jersey.
1930	Family moved to New York City. Attended Utopia Children's House, Harlem settlement house. Attended high school for two years.
1932	Studied with Charles Alston in College Art Association class at Harlem Workshop.
1934–37	Studied with Henry Bannarn in WPA classes.
1937	Worked at CCC camp for about six months.
1937–39	Scholarship to American Artists School, where he studied with Anton Refregier, Sol Wilson, and Eugene Morley.
1938	First one-man show, held at Harlem YMCA and sponsored by the James Weldon Johnson Literary Guild.
1939	Worked on WPA as member of the easel division for about eighteen months, until sometime in 1941.
1940	Rosenwald Fund Fellowship, renewed 1941–1942. First major New York one-man show, held at the Downtown Gallery, where he had successive shows in 1943, 1945, 1947, 1950, and 1953.
1941	Married Gwendolyn Knight, a painter from the British West Indies.
1943	One-man show, Portland Museum of Art.
1943–45	Served in the United States Coast Guard, beginning as a Steward's Mate, whose duties were "the feeding and maintenance of officers and their quarters," and ending as a Specialist Public Relations Third Class Petty Officer, his duties "painting Coast Guard activity."
1944	One-man show, Museum of Modern Art, New York. "Migration of the Negro" series circulated nationally by the Museum of Modern Art; re-exhibited 1971.
1945	One-man show, Boston Institute of Modern Art. "John Brown" series circulated nationally by the American Federation of Arts.
1946	Guggenheim Foundation Fellowship. Taught summer session at Black Mountain College, N.C.

1947 Commissioned by *Fortune* magazine to travel in South, where he painted ten pictures.

1948 Illustrated *One Way Ticket* by Langston Hughes.

1953 Citation and grant, National Institute of Arts and Letters.

1954 Chapelbrook Foundation Fellowship.

1956–70 Instructor at Pratt Institute, Brooklyn, with several leaves to live and paint in Lagos and Ibadan, Nigeria, plus teaching leaves as noted below.

1957 One-man show, Alan Gallery, New York. Retrospective circulated by AFA.

1961 Retrospective, Brooklyn Museum.

1963 One-man show, Terry Dintenfass Gallery, New York, where he held one-man shows again in 1965 and 1968.

1965 Elected to membership, National Institute of Arts and Letters. Artist-in-residence, spring semester, Brandeis University, Waltham, Mass.

1968 Illustrated *Harriet and the Promised Land*, a children's book about Harriet Tubman, written in collaboration with his wife.

1969 One-man show, Harlem Studio Museum.

1969–70 Visiting artist, California State College at Hayward, from September 1969 through March 15, 1970. Visiting artist, University of Washington at Seattle, April through June 15, 1970.

1970 Spingarn Medal, awarded by NAACP. The citation reads in part: "In salute to his unswerving commitment, not only to his art, but to his black brother within the context of hope for a single society."
Honorary Doctor of Fine Arts, Denison University, Granville, O.

1970–71 Appointed Coordinator of the Arts and Assistant to the Dean of the Art School, with the rank of full professor, at Pratt Institute.

1971 Appointed full professor at the University of Washington, Seattle, where he remains, teaching drawing, painting, and design.

1971 "The Artist as Adversary" exhibition at the Museum of Modern Art, New York, included the reunited sixty paintings in the "Migration of the Negro" series.

1972 Commissioned to design poster for the 1972 Olympic Games.

The Effect of Social Realist Thought on Me

JACOB LAWRENCE

MOST of my work depicts events from the many Harlems which exist throughout the United States. This is my genre. My surroundings. The people I know . . . at work . . . at play . . . at worship. A free hospital clinic . . . vaudeville comedians . . . children in a library. The happiness, tragedies, and the sorrows of mankind as realized in the teeming black ghetto.

Statement solicited by the editor in 1972.

Jacob Lawrence

ELIZABETH MC CAUSLAND

It's the little things that are big.

A man may never see combat, but he can be a very important person...

The man at the guns, there's glamor there.

Men dying, men being shot, they're heroes.

But the man bringing up supplies is important too.

Take a cook.

He just cooks, day in and day out.

He never hears a gun fired, except in practice.

He's way down below, cooking.

Now the coxswain, or the gunner's mate, the man at the wheel, people admire what they do. But the cook—

The cooks may not like my style of painting. But they appreciate the fact that I'm painting a cook.

Jacob Lawrence is describing his work as a specialist third class, public relations branch, United States Coast Guard. His sentences are punctuated by long pauses which make paragraphs. His spurts of speech have the rhythm of his titles for paintings, and of his paintings, too. This is logical, since he wants his paintings to be musical and lyrical, but with this "other quality—strength, belief in life," as he says.

In your own work, the human subject is the most important thing.

My work is abstract in the sense of having been designed and composed, but it is not abstract in the sense of having no human content.

From the *Magazine of Art*, November 1945, pp. 254–259. Reprinted by permission of The American Federation of Arts, 41 East 65th Street, New York, New York 10021.

An abstract style is simply your way of speaking.
As far as you yourself are concerned, you want to communicate.
I want the idea to strike right away.

Such beliefs underlie the extraordinary paintings of Coast Guard
life, some of which were exhibited at the Museum of Modern Art
last fall. Jacob Lawrence enlisted in October, 1943, but did not
receive a specialist's rating till September, 1944. For over a year
now he has been hard at work on this record of Coast Guard
activity. First he worked in the Atlantic, traveling back and forth
on troop transports between the United States and England, Italy,
and northern and southern France. Now he is in the Pacific. He has
painted troops embarking, coming home, in their bunks, at mess,
tying up at the docks, "just what the fellows do"—and, of course,
cooks. Because

The public like to see what is going on in the armed forces.

Through Jacob Lawrence's eyes, we, the public, see the orderly
routine and discipline of daily work and play—signal practice,
general quarters, handling the line, holystoning the deck, chipping
the mast, officer's mess, bakers, machinist's mate making repairs,
wrestling, boxing, card playing, checkers, worship, prayer. Such
fragments reconstruct that world of tense action which was the
war and give us in art a lasting chronicle of a dramatic and crucial
period in history.

Lawrence's latest phase as an artist is most encouraging. His first
Coast Guard paintings, shown in October, 1944, marked a great
advance over the brilliant promise of his youth, when he painted
the *Migration of the Negro* series at 24 and the *Harlem* series at 26.
In the past year he has grown even more. The late paintings possess
a warmth and tenderness not immediately obvious in his earlier
visual histories of the underprivileged in the South and in northern
Negro ghettos.

Jacob Lawrence's continued growth is gratifying; for racial dis-
crimination has not bred positive social attitudes toward the war in
all Negro intellectuals. That Lawrence paints hopefully is hopeful,
and that the United States Coast Guard gave him a chance to make

his visual record is hopeful. The creative human result is revealed in his remark, made before V-J day, that "we must get the war won" before planning for after the war. The creative esthetic result is plain in his new work.

How did Lawrence break the barriers of intolerance?

I first came in contact with art when I started going to the Utopia Children's House, a settlement house in Harlem.

My mother took me there to keep me off the streets.

I was thirteen or fourteen.

Like all kids, I always liked to draw and paint.

I met Charles Alston, the art instructor, there. He was going to Columbia then. He encouraged me.

So Jacob Lawrence began his career as an artist. He was born in Atlantic City, N. J., September 7, 1917, grew up in Philadelphia and New York, and was educated in the public schools. He took required courses in art, all practical, and for two years he went to the New York High School of Commerce, because "I knew I wasn't going to college."

His story is typical of a generation of Americans. Coming to New York with his family in the early 1930s, Jacob Lawrence grew to manhood under the blight of depression, but found channels of personal fulfillment opening out through the New Deal. His experience recapitulates the period. From the Utopia Children's House art classes, he moved to classes held under the auspices of one of the relief programs.

Then Alston got a job with the College Art Association. That was before the WPA.

They had classes at the 135th Street Library. For the neighborhood—children and adults. I used to go there.

Then they had a studio on 141st Street and had art classes there. That was under the WPA.

Henry Bannarn came to teach painting and sculpture and graphic art. He was from Minnesota. Last year he won a $300 prize at Atlanta.

This was about 1939. Meanwhile I had gone to CCC camp in 1936. I came out the end of 1937.

About this time I got a scholarship at the American Artists School, through Harry Gottlieb, president of the Artists Union. I studied with Refregier, Sol Wilson and Eugene Morley. The Harlem Artists Guild also helped me.

Earlier I had become interested in Orozco. Everything was toward expressing labor then.

Toward the end of 1938 I got on the Federal Art Project and worked in the easel division for eighteen months. That was when they had the "eighteen months" clause.

All this time Jacob Lawrence worked at easel paintings, doing some oils, but mostly gouaches. He does not know where his paintings were allocated or what happened to them.

Already the youthful painter had had successes. In 1938 he exhibited in a two-man show at the American Artists School. He also exhibited in group shows at the Harlem Artists Guild and in traveling exhibitions. His first one-man show was held toward the end of this year at the Harlem YMCA. This was one of a series of activities to encourage young Negroes and to acquaint the public with promising talent. These were sponsored by the James Weldon Johnson Literary Guild. In 1939 he won second prize at the American Negro Exposition in Chicago.

In May, 1940, Jacob Lawrence received his first Rosenwald fellowship, just about the time his eighteen months on the Federal Art Project would have been up. The grant was renewed in 1941, and again in 1942. This brought Lawrence up to the time he enlisted in the Coast Guard.

The Rosenwald fellowship gave me a chance to work, organizedly and uninterruptedly.

At first I was living at home, with no family to support. Then the Project came along, and then the fellowship for three years. Then I joined the Coast Guard on October 27, 1943.

I was lucky, because I had a chance to work.

Lucky, too, he says, in that the period's ferment of artistic activity gave him a grounding in life and art. In the classes at the 135th

Street Library, in the studios of Alston and Bannarn, at the Negro Theater of the Federal Theater (housed in the old Lafayette uptown on Seventh Avenue), in the Harlem Artists Guild, and in the Federal Art Project's Harlem Art Center, Jacob Lawrence shared the experiences of his generation. There is no question that our best young artists came up through the channels of opportunity created by the Roosevelt policies.

It was my education. I had no college education. But I met people like Saroyan before he got famous. They all used to talk about what was going on in the world. Oh, not only about art, but everything.

The artists were all working together. We'd go down together to King Street [New York City Federal Art Project headquarters —Editor.] to sign in. We saw each other's work. We talked about art.

Thus young Jacob Lawrence began his career as a painter, within the limitations of the opportunities offered by the relief programs. At best, these were temporary and partial. Yet without them, how much potential talent would have been lost to America!

On his Rosenwald fellowship Lawrence continued to develop his creative gifts under favorable auspices.

I painted the Negro Migration *series then. Before that I had done several other series. I always liked history.*

I had started the Migration *before I applied for the Rosenwald fellowship. When I received it, my research was almost done. Then it took me about a year to paint the series.*

The Migration of the Negro During World War I consists of sixty paintings, now in the Museum of Modern Art and the Phillips Memorial Gallery. The series was first exhibited at the Downtown Gallery in November, 1941—Lawrence's art world debut. That month *Fortune* published color reproductions of twenty-six of the paintings under the title, "And the Migrants Kept Coming." These were later issued as a portfolio.

The series was purchased by the two museums in 1942 and has

been circulated to many American cities—including, among others, San Francisco, St. Louis, Cambridge, Los Angeles, Sacramento, Portland, Ore., Poughkeepsie, New London, Kalamazoo, Andover, Mass., and Bloomington, Ind. In October, 1944, part of these paintings were shown at the Museum of Modern Art, together with Coast Guard subjects.

How did Lawrence get the idea in the first place?

I was always interested in Negro history. Contemporary Negro life was the only thing I knew to do. I would just do pictures, and that's all I knew. Naturally I was interested in the problems of the Negro people.

In 1937 he had painted *The Life of Toussaint L'Ouverture,* after seeing *Haiti* at the Lafayette; in 1938 *The Life of Frederick Douglass;* and in 1939 *The Life of Harriet Tubman.* Later, in 1942, he painted the *John Brown* series, twenty-two paintings which have not been exhibited in New York but which were shown in Boston last year.

The *Harlem* series, twenty-six gouaches, was exhibited at the Downtown Gallery in May, 1943. In September, 1943, *Vogue* reproduced five in color. Private collectors have bought these paintings, and the series is now dispersed.

What kind of "scenario" did Lawrence work from?

I just divided the subject into two parts. How things were in the South and the reasons why people migrated.

I did plenty of research in books and pamphlets written during the migration, and afterward. This was at the 135th Street Library, in the Schomburg Collection. I took notes. Sometimes I would make ten or twenty sketches for one incident.

By the time I started work on the Migration, *I was more conscious of what I wanted to do. I was looking consciously at things and for things.*

The series form is the solution Lawrence worked out to fulfill his desire to communicate his thoughts and feelings in his work.

His account of his early ambitions also helps explain the "punch" of his paintings.

I wanted to tell a lot of things. This was the only way I could work and tell the complete story.

My first ambition was to design masks.

Then I wanted to do stage sets, and I did build a few. I was always interested in the theater.

Then I wanted to do murals. It was about this time I learned about Orozco and began to take note of outside well-known artists. He was the first.

If I did murals, I probably wouldn't work that way.

Jacob Lawrence's choice of words is significant. He is not scornful of communication, content, or "telling a story." On the contrary, he wants "the idea to strike right away." He is not a talker. Rightly, he prefers to have his work speak for him. However, his terse sentences prove he has thought about issues of contemporary esthetic dispute and knows where he stands.

Perhaps I can explain best by telling whom I like. Orozco. Daumier. Goya. They're forceful. Simple. Human. In your own work, the human subject is the most important thing. Then I like Arthur Dove.

I like to study the design, to see how the artist solves his problem, how he brings his subject to the public.

Lawrence's device to "tell a lot of things" ties in with these ideas, as does his use of titles with his pictures. His laconic, poetic "shooting scripts" (if one may call them that) show how verbal and visual mediums may be integrated. Of his titles, Lawrence says he wants them to be "not too long, not to take away" from the paintings.

Generally, Jacob Lawrence avoids verbalization about art. He has no facile clichés. On a concrete subject like his favorite medium, gouache, he is, however, more articulate. His flat, two-dimensional, semi-abstract style he attributes to his early art work.

I started as a kid. They gave us kids poster paints.

Then I went right on to gouache. Because some one told me it was more professional than poster paints, richer.

Then I went to egg tempera. I use both mediums now, though not since I've been in the service.

I work a long time on the idea *for a painting. Then I work fast on the painting.*

I use pure colors, primary and secondary—three reds, three yellows, two blues, black, brown, white, two greens.

Comparison of the *Migration, Harlem* and *Coast Guard* series shows that Lawrence's palette has grown higher in key, more brilliant and more colorful, a physical counterpart no doubt of his rising mood of optimism and hope.

What of Jacob Lawrence's hopes after the war?

I'd like to do something on Negro folklore. And I'd like to travel, to South America and the West Indies.

But—we must get the war won first.

Well, the war is won, and Jacob Lawrence may be home soon. Will the peace allow him as much opportunity to continue his creative development as war and depression did?

"... And the Migrants Kept Coming"

THE twenty-six pictures reproduced on the following pages were selected from a complete series of sixty panels executed by Jacob Lawrence, a young Negro artist whose work promises to earn for him the same high recognition accorded to Paul Robeson, Marian Anderson, W. C. Handy, and other talented members of his race. His use of harsh primary colors and his extreme simplicity of artistic statement have extraordinary force. In November, Artist Lawrence's full series will go on exhibition for the first time at the Downtown Gallery in New York. *Fortune*'s choice was made partly on the basis of pictorial values, partly to preserve the continuity of the story of the American Negro that Lawrence tells through the medium of his sixty panels. The captions accompanying the pictures are his own.

Here is a strategic front in the Battle for America. Though they constitute a far larger minority group than any on the European continent, and though they represent a social and economic enigma of terrifying proportions, the 15 million U. S. Negroes are citizens of a shadowy subnation that is terra incognita to most whites. While carrying the "four freedoms" to the earth's ends American democracy might well bestow them on its Negroes, who are woefully in need of them. Except when one intrudes on the nation's consciousness as a great singer, musician, pugilist, or actor, the Negro is not an individual man but a great, dark, moiling mass with unknown aspirations, unknown potentialities. Today that concept is on the verge of imminent change. For the Negro is one-tenth of the U. S. population, and as the nation strives to develop the full measure of its strength it cannot for long ignore that one-tenth—or the problems it both faces and creates.

Theme of the story told by Lawrence's pictures is the great

Reprinted from the November 1941 issue of *Fortune Magazine* by special permission; © 1941 Time Inc.

south-to-north migration of Negroes that commenced during the first world war and has continued in lesser degree ever since. In one of the biggest population shifts in U. S. history over a million Negroes quit the crumbling, semi-feudal cotton economy of their forefathers and trekked to the industrial cities of the North. Behind them were poverty and the flaring prejudices that grew with poverty. An average of fifty-six Negroes were being lynched every year. Then the war-burdened factories of the North sent out a call for cheap labor. Labor agents roamed the South, promising the moon or better. The Negro press exhorted the Negroes to move, and earlier migrants, already settled in the North, wrote to their friends and relatives to tell of good jobs, good pay, and an amiable society wherein a colored man had a chance of living like a human being. Hundreds of thousands of southern Negroes responded. The first wave of migrants went north between 1916 and 1919 to relieve the acute labor shortage. The second great movement occurred between 1921 and 1923—after the immigration laws choked off the European labor supply. The Negro population of the North jumped almost 100 per cent, and much of the increase was concentrated in six cities—New York, Chicago, Philadelphia, Cleveland, Detroit, and St. Louis. Today nearly half of all U. S. Negroes are city Negroes.

While the war boom lasted the North seemed to fulfill some of its promises, though, from the start, Negroes were forced to live in overcrowded, segregated areas. Throughout the industrial North there was a series of race riots, often involving white and black laborers. Organized labor was no friend of the Negro, partly because he would work for low wages, partly because of his record as a strikebreaker, beginning in the 1850's when Negroes were brought up from the South to break a longshoremen's strike in New York. Symptomatic of the Negroes' confusion and despair was the rise of Marcus Aurelius Garvey, who promoted a fantastic scheme to take colonists back to Africa and found a Pan-African empire. Thousands contributed to Garvey's cause, and he purchased a steamship, first of his projected Black Star Line, to be used as a transport. But the ship was unseaworthy and sank in Newport News, and no colonist ever went to Garvey's Africa.

The North did give the Negro the right to vote, did send his children to school, and otherwise permitted him a modicum of dignity that he could not have in the South. It was this hope for the chance to live "like a human being" that inspired the continuing migration of the 1930's for in the six cities of the North about a third of all the Negroes were on relief. Even in Harlem, where half a million Negroes are crammed into three square miles, white owners controlling 95 per cent of its business had always refused to hire Negroes. During this period, and before and since, communist organizers were extraordinarily active among Negro communities in large cities. Aside from strengthening race solidarity, they have had surprisingly little effect, despite ideal conditions for agitation. Thus far, at least, the average Negro has been immune to direct ideological leadership.

The great majority of U. S. Negroes still live precariously, from meal to meal, and the Negro's long-range economic future looks no better. And still, in the concluding words of Artist Lawrence ". . . the migrants kept coming." They will come in ever-growing numbers, and they seem to be about to enact a tragic repetition of the events of the last war. Currently thousands are being drawn to Washington, D. C. by the lure of government jobs. It is common to hear whites predict "trouble" and talk of race riots if the influx continues. But Negroes by and large harbor no animosity against the whites. They plot no overthrow of the white man's domination, though as time goes on they become more articulate and begin to grasp the meaning of the power of masses —chiefly because circumstances force them to. The modern northern Negro has largely discarded the humble counsel of Booker T. Washington, who urged his followers to "know their place" and to crawl into the white man's kingdom through the back door. After many formal protests failed, a few months ago the Negro leader A. Philip Randolph, head of the Pullman porters union, announced plans for a "March on Washington" to protest against discrimination facing Negroes in the army, in industry, in every phase of the defense program. Fifty thousand Negroes pledged themselves ready to march July 1. Then on June 25 President Roosevelt issued an executive order to end discrimination and to implement it the OPM established its Com-

mittee on Fair Employment Practice with two Negro members. Randolph's 50,000 marchers primarily wanted jobs, of course, but they also wanted more—the chance to belong. The reasons for their hunger in both respects are elaborated in the captions accompanying the pictures.

Jacob Lawrence

GWENDOLYN BENNETT

MAINSTREAM is proud to present, in its first number, a group of reproductions of the work of the distinguished American artist, Jacob Lawrence. These paintings, from the collection of Mr. and Mrs. Milton Lowenthal, are part of twenty-two gouache works comprising the artist's John Brown series.

It was just five years ago that Jacob Lawrence came to the attention of art critics with the showing of his work at the Downtown Gallery. In his thirtieth year now, Lawrence begins to attain his full stature as one of America's important artists. His paintings have been exhibited in many of the country's outstanding art shows and examples of his work are part of the permanent collection of several museums and galleries. To Jacob Lawrence goes the well-deserved distinction of being the first Negro painter to have had a one-man show at the Museum of Modern Art.

Any evaluation of the work of Jacob Lawrence must take into consideration his beinnings and the sure, steady growth of his art. Artists and teachers who knew Lawrence when he was beginning to paint scramble for the honor of having first discovered his ability. Charles H. Alston, whose work is well known, says, "I discovered Jake first," and goes on to tell of the grave, solemn-eyed youngster of ten who drew weird masks with colored crayons as a student in his classes at Utopia Children's House, a community center in Harlem. Later Lawrence studied with Alston, Henry Bannarn and Lesesne Wells at the Harlem Art Workshop, a project sponsored by the Government.

I remember Lawrence as the youth of nineteen whose work had just been praised by Vaclav Vytlacil, then a teacher at the Art Students' League, and who turned to me with a troubled

From *Mainstream*, Vol. 1, No. 1 (Winter 1946–1947), pp. 97–98. Reprinted by permission of *American Dialog*.

frown, saying, "I'm worried about the fact that no matter how I try I just can't draw like the rest of the fellows up at Mike's." "Mike's" was the studio Alston and Bannarn maintained to which younger artists were encouraged to come and work. I have always prided myself that I urged Jacob Lawrence not to worry about whether his work was like that of others around him.

When critics first began to notice Lawrence's work, many referred to it as "primitive." This characterization is inadequate and misleading. For here is an artist who has studied hard, worked ceaselessly, learned from many people, but who has always molded what he saw and learned into a form that was distinctly his own. The result is an art that is disciplined and refined in an adult sense, yet filled with the childlike clarity of pure-colors, boldly juxtaposed. In the organization of his canvasses Lawrence shows a strong angularity, creative strength, and a clear perception of transitions and contrasts. His harmonies are original and telling. In his work, subject and form are amalgamated into an exciting whole. His symbols are clearly legible. His subject matter is as broad as the history of the Negro people; his method of tackling it as uncompromising as their struggles and growth. His message is a ringing affirmation—that people are strong and from their strength must come their liberation.

Lawrence Uses War for New "Sermon in Paint"

JO GIBBS

IT would be almost impossible to estimate how many people have seen, and been moved by, Jacob Lawrence's eloquent "series" sermons. Aside from New York exhibitions for all of them, 26 out of the 60 panels which comprised the *Migration* group were reproduced in *Fortune*, and, now jointly owned by the Museum of Modern Art and the Phillips Memorial Gallery, are still touring the country. The 1942 *Harlem* series was broken up, but Mr. and Mrs. Milton Lowenthal, who bought the *John Brown* series, have yet to take possession of it—it is being circulated by the American Federation of Arts.

It is hoped that some public-spirited and generous person or institution will buy the entire new *War* series, for it bears a poignant and well-expressed message of universal recognizability that would bear wide distribution. In these 14 temperas, the artist's consistent development over the past five years, already noted in his individual easel paintings, is particularly noticeable. Though still muted and dark, his color is richer, more subtle, and has greater range and luminosity. A few of the designs retain a certain primitive quality, but more of them are complex, sophisticated, and verge on the abstract.

In the *War* series Lawrence avoids grandiose symbolism and sticks to the simple facts of his subjects—two praying women, tiers of bunks occupied by soldiers *Shipping Out*, beachhead operations, the loneliness of a fox hole, the tension of an attack, the effect of a letter or casualty notice on a mother or sweetheart back home, and, finally, *Victory*, as embodied in one tired but stolid soldier, and *Going Home*.

From *Art Digest*, December 1947, p. 10. Reprinted by permission of *The Art Digest, Arts Magazine*.

Alert would be a brilliant semi-abstraction even divorced from its context, as would *Docking-Cigarettes Please* and *On Leave*, while the single bowed figure in *The Letter* is the embodiment of pathos and drama.

Review of Jacob Lawrence Exhibition

JACOB Lawrence [Downtown; Dec. 2–27], at thirty the best-known Negro painter in America, in his first one man show since his Coast Guard service, reverts to the "series" form in the fourteen panels, *War*, which he just completed on a Guggenheim Fellowship. Unlike his other series (*Migration of the Negroes, John Brown, Harlem*), these are joined primarily by mood and cumulative effect. Lawrence has modified his style of patterns made up of bright, flat, simplified areas like pieces in a child's jigsaw puzzle. Color now is somber—browns, greens, dark blues, with black and white for stinging accents; certain areas are modeled (but always with the lights and half-lights used as part of the design); and he has dared far more complicated groups of figures than ever before. One is strongly reminded of Egyptian wall painting. Look, for instance, at *Shipping Out*, where the five soldiers lie one above another in their shallow bunks, their helmets, rifles, and jackets piled trophy-like on the vertical post. As in Egyptian paintings the figures are brought close to the front and, despite their individualized and urgent gestures, there is a sense of repetitive rhythm. The reminiscence is reinforced, too, by the way Lawrence (in spite of modeling) depends on outline, preferring the stark silhouette of a profile with a strongly defined full-face eye. He makes stylized pattern of everything: the ropes of a ship docking, hands upstretched for cigarettes, bandages and casts of the figures in *Purple Hearts*, the barbed wire in *Reported Missing*. Three of the panels have enormous single figures of women, praying and grieving. They play their role in the series, emphasizing the solitary woman at home as opposed to the communal life of the fighting men and leading to the last panel *Victory*, where a soldier sits hunched in the despondency of fatigue and disillusion, but artistically they seem less successful, for Lawrence's style is basically one of pattern

From *Art News*, Vol. 46, No. 10 (December 1947), p. 44. Reprinted by permission.

and he can better organize many small elements into a whole than manage a single large one. He is one of the few painters who can make stylization and design function beyond decorative ends, and if proof were needed, this moving record can supply it.

Jacob Lawrence

ALINE B. SAARINEN

JACOB Lawrence represents a phenomenon almost unique in our
time: he is a narrative painter. Like the Egyptian artists who
covered the walls of tombs with processions of events and the
Renaissance painters who unfolded tales from the Bible and
their daily life, Jacob Lawrence likes to tell stories.

Sometimes, in a formal series of several dozen small pictures,
he relates the course of a man's life (Toussaint l'Ouverture; John
Brown). Sometimes, he records the sequence of events in a
phase of history (". . . and the Migrants Kept Coming"). Occa-
sionally, the individual paintings of a given period are formal-
ized with a title, such as *Life in Harlem* or *War*. But even when
they lack such nomenclature, the single works of any particular
time are linked together by common subject matter and atti-
tude. Facets of a theme, they, too, take on a narrative quality.
Such, for example, are paintings of Negroes, practicing trades,
paintings of the theater, of life in a mental hospital, or his recent
depictions of neighborhood life.

Lawrence is a pictorial narrator, but he is more than an illus-
trator. For an illustrator, a literary idea is the starting point. For
Lawrence, the springboard is always a visual image which has
been impelled by an emotional response. He not only *experiences*
through his eyes; he also *comprehends* through his eyes. His re-
search on historical themes is painstaking and it results in orderly
outlines of facts. But the paintings that culminate this research
have no textbook connotations. What has materialized into paint-
ings are those particular incidents and moments which involved
Lawrence in something as important and immediate as a per-
sonal relationship and which he both perceived and understood
in visual terms.

First published as a catalog by the American Federation of Arts, 1960. Reprinted
by permission of The American Federation of Arts, 41 East 65th Street, New
York, New York 10021.

Those terms are never rooted in naturalism. His concern, he says, is "reality," which, with an informal, personal Platonism, he defines as that which lies behind natural appearance. Reality, in Lawrence's thinking, is made manifest in artifice—in masks, in the theater, in the sleight of hand of the magician, in caricature and pantomime—in all those instances, in short, where everything is stripped away except the essential gesture, the salient "prop," the indispensable detail and where, in turn, these are grandly emphasized.

Such "artifice" he has practiced consistently in his painting. Stylization is his hallmark. He has invented a set of conventions as strict and personal to him as were the conventions of Egyptian art to generations of Egyptians. He crystallizes figures into simple, precise shapes, often into flat silhouettes, exaggerating or minimizing a head or a finger or a body as needs be. The sizes of figures vary according to expressive necessity (note the poignancy achieved by making infants exaggeratedly tiny with arms and legs chicken-bone thin). Reduced to caricatured features, faces are masks, masks which reveal rather than hide. Objects are "props," chosen to illuminate mood or incident (look, for instance, at the drooping flower in the toothbrush glass in *Depression*.)

Frequently the figures exist in airless, unmeasurable areas made spaceless and unreal by planes of color or complex, over-all pattern. When they do exist in space, it is usually a constructed, box-like space, often narrow as a coffin and usually tipped upward. These are spaces which may relate back to the stage sets which Lawrence made in shoeboxes during his adolescence. When light illumines his figures, it is apt to be intense side light, like that directed from the tormentors on the sides of a stage. Color is always arbitrary, whether somber and glum or neon-bright, and always charged with expressive power.

It is true that the first medium he encountered—the poster paints available in children's art classes in a Harlem settlement house—encouraged pure, unmodulated color and flat, silhouetted shapes. But later, when he was free to choose, he still eschewed oil. He has worked consistently in tempera or the chalkier casein, whose possibilities and limitations, though richer

and subtler, impose conditions similar to poster paints. They obviously suited his needs for sharp, unequivocal shapes, intense color and the creation of intricate, small scale pattern.

Thus everything in Lawrence's style is consciously directed at making "real" the incident or experience that gripped him and the emotion it generated. The singleness and forcefulness of this purpose comes through to give his paintings their peculiar intensity.

Were this powerful singleness of purpose all, however, Lawrence's paintings might be placed with those of children or so-called "primitives." What distinguishes him from these other exponents of direct expression are, of course, not only the greater dimension of his experience and perception but also his conscious sensitivity to and control over his artistic means. Communication may be his primary aim, but it cannot be disengaged from the inner necessity of creating a work of visual delight. For the painter, the maker of pictures, artistic sensibility dictates not the general fact that color or shape should be expressive, but *what* color and *which* shape, used *here* or *there*, in relation to *these* and *those* and *what* composition, *what* rhythm, *how* everything should lock into a visual totality.

Now forty-three, Lawrence is a deceptively solemn-looking man, with a bullet-shaped head, closely-set ears, richly brown skin and large, searching, somewhat upward-slanting eyes. His appearance is as neat and precise as his studio, where jars of ground pigment stand in rows as tidy as those in an apothecary's. Modest, even shy, he nods in polite and grateful agreement with proffered suggestions about artistic motivations and intentions.

He is, of course, an artistic anomaly. As a narrative painter, he is at odds with artistic fashion today. Yet his paintings are sold as soon as they leave his easel. His work is in major museum and university collections, from Brooklyn to Brazil, and is owned by a marvelously varied group of private collectors whose ranks include the Hon. John Hay Whitney, Governor Nelson A. Rockefeller, Harpo Marx and Joseph Hirshhorn.

The wheel of artistic fashion has turned very fast. The genesis of Lawrence's interest in narrative art belongs to the period, in

the not so distant past, when Story-Telling Pictures and Social Consciousness were much in vogue. When the wheel turned, Lawrence stood pat. The genre he had chosen was so natural— even necessary—to his temperament and his circumstances that it never occurred to him to do anything but try to expand and enrich it.

The significant facts are that Jacob Lawrence is a Negro and that he came of age in the Depression. He was born in Atlantic City, New Jersey, on September 7, 1917, but he spent his early childhood in Pennsylvania. His father, a cook on a Pullman train, was always a shadowy figure in the little boy's life, and, in 1924, he disappeared from it entirely. Mother and son moved to New York. Worried about keeping her son "off the streets" while she worked, Mrs. Lawrence sent him to the Utopia Children's House after school.

The thirteen-year-old exuberantly turned out masks and stage sets, although many years were to pass before he had the ecstatic experience of actually entering a theater—the old Apollo—and seeing vaudeville. Impressed by pictures of Persian rugs and Moorish tiles, he also covered countless sheets of paper with crayoned webs of tiny, intricate, geometric repeat-patterns, very much like those which spin over the background of *Vaudeville*.

These inventions marked the beginning of a life-long addiction to pattern, whose fascination—as the arch example of stylization, of anti-naturalism—is obvious. Love of pattern has been both boon and snare for Lawrence. When he is master of his passion, he makes it a remarkable servant: he uses it to determine his large compositions as well as to enliven small areas and he employs it vividly as a rhythmic device to induce mood. Pattern can even function as subterfuge, fusing occasional weak shapes or stereotyped symbols into a richness greater than its component parts. Occasionally, the passion enslaves him and takes over, fragmenting the paintings and breaking unified expression into busy fussiness.

The youngster's work at the settlement house attracted the attention of the Negro painter Charles Alston, who encouraged him to go on with art. On and off, from 1932 to 1939, Lawrence

worked with Alston and another Negro painter, Henry Bannarn, in their workshop, first at the 135th Street Library, sponsored by the College Art Association, later at a studio on 141st Street, supported by W. P. A.

These were tough years economically. In 1937, Lawrence joined a C.C.C. work gang. He "learned the feel of lots of things —of a shovel—of how it feels to throw dirt up above your shoulders." A scholarship to the American Artists School brought him back to painting. Then, in 1939, he "got on" W.P.A.

The Federal Arts Project, which saved so many significant artistic lives, was strategic for Lawrence. "It was my education," he says, "I met people like Saroyan, just on the edge of fame. They all used to talk about what was going on in the world. All the artists used to go down to project headquarters on King Street to sign in. We would meet each other and we talked and we talked."

It was an exciting, fermenting period. The concept of social content in art, which had flared in America in the late Twenties with the *New Masses* group, had become the overriding conviction. For Lawrence, the vocalized excitement was essentially a confirmation and a reassurance. He had already been painting what he saw and knew and felt: melancholy paintings of the somber life around him, whether the mirthless pageant of the free clinic or a cheerless street-corner crowd. He had no inner conflict of art-for-art's sake versus art-for-content's sake.

His interest in history, especially that of the Negro, was quickened. A lecture on the life of Toussaint l'Ouverture, Haitian patriot and martyr, moved him. "I couldn't get it all in one picture, so I made it into a series," he says simply. He also recounted, in "series," the lives of Harriet Tubman the abolitionist leader, and of the intrepid John Brown. Then, supported by Rosenwald Fund Fellowships, he widened his range to tell the story of the migration of the Negroes after World War I.

On the day of Pearl Harbor, December 7, 1941, Jacob Lawrence's first major one-man show, consisting of these Migration paintings, opened at The Downtown Gallery in New York and simultaneously twenty-six of the pictures were reproduced by *Fortune* as a color portfolio. Overnight, Lawrence was a success. The critics raved. The Museum of Modern Art and The Phillips

Memorial Gallery, vying with each other for the whole lot, divided up the series by taking even and odd numbered pictures respectively.

Lawrence was not present at his debut. Earlier that year he had married West Indian-born Gwendolyn Knight, a handsome, spirited, wide-eyed painter whom he had know since W.P.A. days. They were honeymooning in New Orleans.

In the fall of 1943, Lawrence joined the U. S. Coast Guard as a Steward's Mate. Stationed briefly in St. Augustine, Florida, he experienced the ugliness of prejudice and made the only bitter, satiric drawings of his career. (Later, he returned to the South on a *Fortune* assignment and painted enthusiastically a series on opportunities for Negroes, from classes at Tuskegee Institute to the reclamation project at Gee's Bend.) Service in the Coast Guard was ultimately rewarding. He was part of the first mixed crew, serving on a weather patrol ship, U.S.S. *Sea Cloud* (former yacht of Joseph E. Davies, one-time U. S. Ambassador to Russia) under Lt. Commander Carlton Skinner. "The best democracy I've ever known," Lawrence remarks. Recognizing his talent, Skinner got him a Public Relations rating. It enabled him to paint the documentary series on Coast Guard life which was exhibited, in 1944, at New York's Museum of Modern Art. Beaming, dressed in his navy blue sailor-suit, Lawrence was present at this opening along with a considerable number of Coast Guard brass.

Toward the end of the Forties, Lawrence came to the edge of a nervous breakdown. Something of the franticness and anxieties which must have been burdening him is reflected in some of the paintings of this period, where too busy patterning, jagged, angry points and razzle-dazzle sparkles run rampant. He sought help by voluntarily entering Hillside Hospital, where his difficulties, stemming from childhood emotional problems, were resolved. The necessity of telling the story of what he sees and experiences did not desert Lawrence during his year in the mental institution. In eleven paintings, exhibited in 1950, he documented the routines and moods of the patients, from the frenzied absorption of patients seeking release in the occupational therapies of weaving and gardening to the listlessness of the de-

pressed, wandering aimlessly about, each imprisoned in his own introspective agony.

During the last ten years, Lawrence's artistic keyboard has widened and his control over his means increased. The latest series is an ambitious undertaking. Called *Struggle: from the History of the American People*, it is concerned with incidents from the War of Independence to the Industrial Revolution. Thirty of the projected sixty pictures were exhibited at the Alan Gallery in January, 1957.

The subtleties of the whites; the clarity of blues; the stunning touches of scarlet and the play of browns and blacks; the dramatic thrusts and counterthrusts of compositions; the wing-like sails and tents; the distillations of period and incidents and even personalities into visual imagery; all these contribute to documents both vivid and moving. There is a new breadth of scale (astonishing when actual dimensions are as small as 10 by 14 inches) and a new, well-tempered balance between abstract pattern and symbolic graphics.

Apparently more at peace with himself and the world, Lawrence's paintings of the last year tell the pleasant story of neighborhood life. The bigger scale and rhythm have become even surer; the use of color authoritative. He has returned to the bold simplicity of his early work, but it is enhanced by new richness and resonance.

If Lawrence's subject matter, both in the formal and informal stories, is largely concerned with Negroes, it is simply because as a Negro this is material he knows and finds moving. He is no militant racist. He sees the Negroes' struggle for liberty and freedom as part of the struggle of *all* men to achieve human dignity. The tales from history are full of blood and violence and oppression as well as courage and hope. The scenes of daily life often reflect squalor and cheerlessness as well as joy in work and the warmth of friendliness. Lawrence's mood throughout is compassionate rather than protesting. He paints neither sermons nor pamphlets. He is telling compelling stories the only way he knows—pictorially.

Jacob Lawrence

CLIFFORD WRIGHT

EVEN if it rightly irritates and hurts artists who happen to be negro to be described as "the best negro artist" as though there were two standards, one for whites and a lower one for negroes, I want to use this designation for Jacob Lawrence. He is exactly that—the best negro painter in U.S.A. and it is not beside the point to emphasize his race, for his works treat the life of the negro in U.S.A. in a fantastic yet deeply convincing way and in a pure and extremely precise style. Thus it is important in this case that the artist himself is a negro, besides being an eminent painter with a very personal style—an artist who bears comparison with practically any contemporary colleague, white or black. Jacob Lawrence is still young (about forty). He has been painting for more than twenty years and has gained a safe and recognized position in American art. He is an industrious worker and has already completed eleven series of paintings with such themes as the wanderings of the negro over the earth, as a slave and as a free man, and the negro throughout history. He is represented in the most important collections all over the country and three of his series are in their entirety to be found in museums (the Whitney Museum of American Art has one series). In these days where shocking acts of violence occur in the American South as well as in South Africa and elsewhere, it is more than ever needed that mention be made of those negroes who have attained the best in their fields. And Lawrence is a radiant example of the unconquerable spirit combined with the knowing hand. His contribution to American art is of the greatest significance and he deserves to be known also in Europe where the assumptions about what is happening in American art are still generally very rudimentary, and where characteristically the sweet, old, funny but definitely not significant Grandma Moses is

From *Studio*, January 1961, pp. 26–28. Reprinted by permission of Studio International.

generally known while an artist of Lawrence's stature is quite un-known.

The iconography of Jacob Lawrence leads us straight back to the Middle Ages. Curiously enough, he has never been outside America. The fantastic motifs and treatment of figures in medieval frescoes have parallels to fundamental features in Lawrence's works. His painting has a number of mutually contradictory tend-encies that have been harmonized with great success. His figures look stiff and stylized, but at the same time they express almost mystically spontaneity and life. His pictures always radiate the deepest human compassion. The people in them are God's mario-nettes, but while you look at them they turn into living beings that inhabit this earth. The innocent and ignorant people in Law-rence's pictures do not see the divine in each other and in everyday life in factories, bars, offices, clubs, streets and homes. But Law-rence shows us this divine element.

Lawrence uses a medium that seems to be much more popular in America than in Europe, egg tempera. He uses also casein and gouache, but rarely oil. His colours are luminous and bizarre, put on in angular elements that are played against large areas of blacks, browns and greys, and at first glance the overall impression is a kaleidoscopic one, but later everything falls into place as parts of scenes from everyday life—people working as carpenters, weavers, bricklayers, or on their way to work in buses and trains, children playing in back yards, factory workers, canteens—but also people who have a very good time at carnivals, circuses or in music halls. The pictures have an exotic effect but are always moving and sad as only good art can be even though it treats of jolly subjects. It is remarkable and encouraging that the frankly storytelling picture in these days of flourishing abstract art can have such an over-whelming effect that it takes your breath away and quite over-shadows the largest pyrotechnical wall-sized opus so conspicuous in contemporary American exhibitions.

The distinguished American art historian Oliver Larkin wrote about Lawrence: "Few mural artists could have built such nervous and powerful commentaries as Lawrence did on small panels in the *Harlem* and the *Migration of the Negro* series."

In these days of promise for American art (in 1958 an American

artist, Mark Tobey, was awarded the Grand Prix of the Venice Biennale for the first time since Whistler) Jacob Lawrence is one of the brilliant talents of American art. His works are as fresh as ever, his subjects are still painfully topical, but most important is his compassion that is above the topical and the personal—something universal and eternal in the description of the small and limited and mortal.

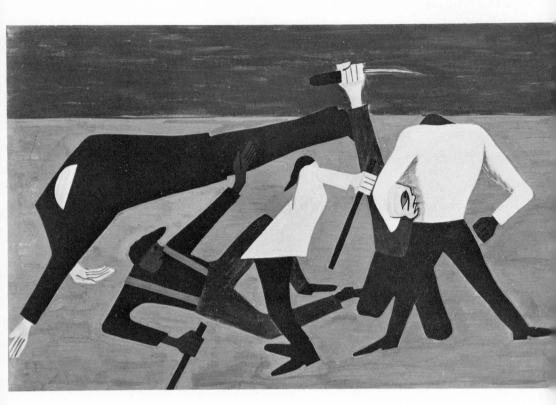

"One of the Largest Race Riots Occurred in East St. Louis"
Panel 52 from The Migration of the Negro JACOB LAWRENCE

1940–41
Tempera on composition board
18″ × 12″
Collection of The Museum of Modern Art, New York
Gift of Mrs. David M. Levy

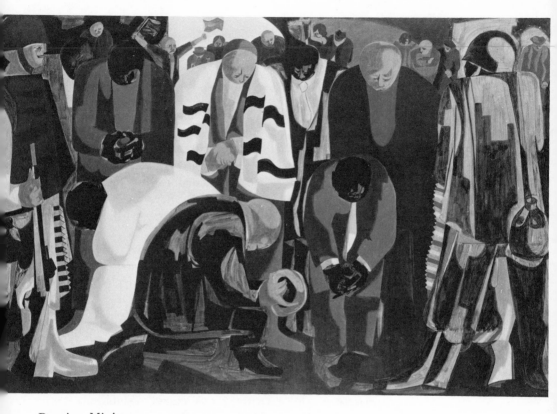

Praying Ministers JACOB LAWRENCE

1963
Tempera
24″ × 36″
Collection of Spelman University, Atlanta, Georgia
Photo courtesy of Terry Dintenfass Gallery, New York
Photographer: Peter A. Juley & Son

Jack Levine
Chronology

1915 Born Boston, Mass.

1924–31 Studied painting with Harold Zimmerman at the Jewish Welfare Center, a Boston settlement house.

1929 Left high school.

1929–31 Studied privately with Denman Ross, retired member of the Department of Fine Arts at Harvard University, at his home in Cambridge, Mass. Ross provided Levine and his fellow student, Hyman Bloom, with allowances of $12 a week.

1935–40 Employed by the Federal Arts Project, with some intermittent breaks.

1936 Joined the Downtown Gallery group in New York.

1939 First one-man show, held at the Downtown Gallery, New York. Subsequent one-man shows there in 1948 and 1952.

1942 Included in "Americans 1942" exhibition at Museum of Modern Art, New York.

1942–45 Served in the United States Army, spending 20 months on Ascension Island, St. Helena, a supply depot. He reached the rank of Technical Sergeant.

1943 Second Purchase Prize of $3000 for the painting *String Quartette* at the "Artists for Victory" exhibition at the Metropolitan Museum of Art, New York.

1945 Settled in New York City.
Guggenheim Foundation grant.

1946 Married Ruth Gikow, an artist.
Second Prize for the painting *Welcome Home* in the "Painting in the United States" exhibition at the Carnegie Institute, Pittsburgh, Penna.
Grant, National Institute of Arts and Letters.

1947 Guggenheim Foundation grant.

Several items in this chronology are assigned different dates from those in previously published sources. Every effort has been made to check the accuracy of this chronology.

The Third William A. Clark Prize and the Corcoran Bronze Medal for the painting *Apteka* at the Corcoran Biennial, Washington, D.C.

1948 Jennie Sesnan Award for landscape painting, Pennsylvania Academy of Fine Arts.

1949 Elected Fellow, American Academy of Arts and Sciences.

1950 Retrospective exhibition, Boris Mirski Gallery, Boston.

1950–51 Fulbright Award to Italy.

1952, 1953 Lectured at the Skowhegan (summer) School of Art.

1953 Retrospective, Institute of Contemporary Art, Boston. Show traveled to Currier, New Hampshire; Manchester, N.H.; Akron, Ohio; Colorado Springs; Phillips Gallery, Washington, D.C., before reaching the Whitney Museum, New York, where it was shown in somewhat revised form.

One-man show, Alan Gallery, New York. Subsequent shows there 1957, 1959, 1960, 1966, and 1967.

1955 Retrospective, Whitney Museum of American Art.

1956 Elected to membership, National Institute of Arts and Letters.

One-man show, Colby College, Waterville, Me.

1957 Awarded Honorary Doctor of Fine Arts, Colby College.

1958 Grand Prize, Inter-American Exhibition, Palacio de Bellas Artes, Mexico City.

1959 The Second William A. Clark Prize and the Corcoran Silver Medal for the painting *The Girls from Fleugel Street* at the Corcoran Biennial, Washington, D.C.

Included in State Department exhibition, Moscow.

1960 One-man show, Second Mexican Biennale, Mexico City.

One-man show, Randolph-Macon Woman's College, Lynchburg, Va.

1963 Two one-man shows at the Alan Gallery, New York, one of paintings and drawings related to *Gangster Funeral*, and the second of drawings and graphics.

One-man show, Berkshire Museum, Pittsfield, Mass.

1964 Two-man show with Nathan Olivera, Galleria George Lester, Rome, Italy.

1965 One-man show of graphics, Klutznik Exhibit Hall, B'nai Brith Building, Washington, D.C.

1966 One-man show of graphics, Kovler Gallery, Chicago.

1968 One-man show, Il Gabbiano Gallery, Rome.

One-man show of graphics, San Juan, Puerto Rico.
Restrospective, De Cordova Museum, Lincoln, Mass.
1971 Two-artist show with his wife, Ruth Gikow, at the Hillman
Snead Gallery, Rockford, Ill.
1972 One-man show, Kennedy Galleries, New York.

Form and Content

JACK LEVINE

As an artist I am in a situation right now where certain "significant" modern forms do not signify very much to me. They should, I suppose, and maybe they will at some future time, but I do not particularly have that drive at present. For a reason.

Much has been said today about the development of forms in modern painting. When you look at a Cézanne like the *Card Players*, it's a wonderful painting of card players. His self-portraits have an objectivity in their approach to his own features which remind one of nothing less than the great self-portraits of Rembrandt. Can it be that in analyzing Cézanne we have tossed away the fruit and nourished ourselves on the husks?

I think Picasso would be known if only for the magnificent readings he has given us of a wounded horse or a bull. Even though a work based entirely on form may seem to acquire a content of its own, I like to approach art as an integrated thing, pretty much a matter of form *and* content. I think that in the long run either becomes repetitious and meaningless without the other.

There are certain social pressures, certain political stresses which wring some response from me. I was in the army a long time and I came out with a long pent-up bitterness about army caste. This bitterness had to come out in some way. Had I painted an "abstract" of the thing I had in mind, it would not have expressed me. I would have exploded with frustration. I may have been angry or bitter, but I don't stay that way. I paint these pictures and get it out of my system. (The anger, that is; the conviction remains.)

The ferment, the power of the 1930's and the business of being on WPA opened my eyes to a great many things. I felt a strong motivation toward social art. I took my place in the late 30's as part of the general upsweep of social consciousness in art and

From *College Art Journal*, Autumn 1949, pp. 57–58. Reprinted by permission of the *Art Journal* of the College Art Association.

literature. It was part of the feeling that things were going the
right way, we were all making a point. True, there was fascism in
the world; we were all antifascists and we had a feeling of confi-
dence about our ability to do something about the world.

After my recent trip to Europe I realized certain things were
going on in the art of the United States, a certain vitality lacking
elsewhere. Was this the result of the amazing social experiment for
artists carried on by the Roosevelt Administration? Artists were
retained by the government, not just to paint banal commissions,
but with freedom to develop. It meant a certain continuity, three
or four years perhaps. I think the general level of art during that
period showed a steady advance. If things are livelier here today,
if the new things look more interesting, it is largely attributable, I
think, to the existence of this project.

The characteristic of this advance was the maintenance of the
large groups of artists by the project. My understanding of Artists
Equity statistics is that 60% of our membership have no gallery
outlet for their works. Their other economic problems can easily
be deduced from this. Furthermore, gallery representation in no
way indicates economic security for the remaining 40%. With all
due respect to collectors and dealers, I do not feel that they can
ever disperse sums large enough to take care of the large body of
American artists. We must think of solutions to the economic
problems of America's artists, so that they may have a little con-
tinuity of work, so that there may be a future for culture in this
country.

We can never take our eyes from the problem of the struggling
artist. It is the crux of every artist organization. We have to think
in terms of the 50,000 artists, of the students getting out of art
schools with nothing very much to look forward to. We have to
advance arguments and plans which will benefit the artist. What we
had in 1938 we need now, and more. There are greater difficulties
standing in the way than existed at that time. The politicians'
contemptuous remarks on American art, the State Department's
auction of a splendid collection of paintings as "war surplus" are
indicative of that.

Gangster's Funeral

JAMES THRALL SOBY

In Boston, where the tradition in art was thought to be predominantly genteel, there occurred fifteen-odd years ago a most surprising event. This was the emergence of a violently talented young painter, Jack Levine, whose technique at the time owed something to maverick contemporary masters like Rouault and Soutine and flouted prevailing trends in American art toward abstraction or toward a revival of realism and romanticism. Levine's gifts were so striking that some of us wondered whether he could hold his giddy, youthful pace; I remember writing about him in 1948 that "his struggle now is against virtuosity itself rather than against Puritan leanness of means." But recently Levine has put all such doubts at rest. Last summer he completed what seems to me to be not only his finest picture but one of the most remarkable images created by a twentieth-century American artist. This is *Gangster's Funeral*, the subject of this piece.

But first a word about Levine's development as a painter. His fame was solidly established by a picture called *The Feast of Pure Reason*, painted in 1937 for the WPA Art Program, when he was only twenty-two. The picture portrays a capitalist-gangster, a wardheeler, and a policeman seated in a murky room before a table with a glass decanter. The three figures are vividly defined and recall the fact that civic corruption in Boston, if less homicidal than in sister-cities like New York and Chicago, has been extremely colorful as to the personalities involved. Levine remembers these personalities from childhood and, though he now lives in New York City, Boston probably still adds to the treasury of his imagination. "I miss Boston, which has wonderful buildings and streets," he told Frederick S. Wight in 1952. "It is a day nearer Europe, as Mayor Curley used to say."

The satirical impact of *The Feast of Pure Reason* is heightened by the sumptuous quality of Levine's technique. It is heightened, too, by his sensitivity to casual and not necessarily damaging detail, as when the policeman scrutinizes with immense seriousness a hangnail on his pudgy finger. For Levine such details are human accents whose inclusion is not meant to condone or accuse his subjects but to bring them alive. (He has revived this particular detail in the recent *Gangster's Funeral*, wherein the cop attending the bier picks idly at his cuticle.) He himself made the matter clear in notes written for the Museum of Modern Art's exhibition, "Americans 1942," in which *The Feast of Pure Reason* was shown: "If a policeman reposefully examines a hangnail, that is not necessarily the sum total of his activity. In this case it is an enforced genre to familiarize the spectator with the officer, to point out that he, too, has his cares and woes."

When beginning to work on *Gangster's Funeral* Levine referred to *The Feast of Pure Reason*, painted sixteen years before, as "the work which is most like me." Obviously the two paintings are based on the same satirical concept. This concept stems from an awareness on the artist's part of the terrifying sincerity of insincerity itself among the corrupt. In *Gangster's Funeral* the civic dignitaries, the two widows (one official, the other presumably not), the almost Prussian chief of police in the rear—these figures press forward toward the gangster's coffin, wrenched by an emotion of benevolent piety in which they doubtless believe for the moment, their moral rot preventing their knowing that the ritual they comprise and attend is ethically bogus to the core.

Levine does not condemn these people as directly as Hogarth might have done or Daumier. He gives them the truth of their lie, so to speak, a fact which strengthens rather than weakens the efficacy of his own moral fury. And let no one doubt that this fury is real. Just before commencing the picture he declared with convinced simplicity: "I should like to paint a narrative because it is possible for adolescents to buy marihuana and cocaine on our streets with the connivance and complacency of the powers-that-be. Consequently, I am at work on a painting of a *Gangster Funeral*." But for all his anger Levine knows the value of humor as a satirical weapon, just as did his great predecessors Hogarth

and Daumier. "I want the painting as a comedy," he said in 1952. "It must not be a tragedy." In brief, Levine makes us laugh before we gag.

The first oil study for *Gangster's Funeral* was completed early in 1952, and that spring Levine made a number of magnificent drawings of the general composition and of its main figures. Late in April he sketched in the big canvas. It was finished in June 1953, together with a group of oil studies of its various characters. The creative process was long and painstaking. But there are no signs of niggling labor in the work itself. On the contrary, *Gangster's Funeral* is among other things notable for its headlong freshness. The handling of light and space is masterly throughout. No wonder Levine spoke constantly of Rembrandt while the work was in progress. One likes to think that the great Dutch master would have been impressed by the young American's deft control of volumes, highlights, and surrounding air.

By comparison with all Levine's previous works *Gangster's Funeral* shows a new and impressive fluidity of drawing and tone, as though he had learned a great deal from painting pictures like the *Pawnshop* of 1951, which suppress satirical content in favor of an almost abstract manipulation of forms. Indeed, his brief apprenticeship to near-abstraction appears to have been calculated. He spoke of it to Frederick Wight as an essay in "flexibility," so that he might be able "not to do it." Like all true artists Levine knows where he is going, even when detours in his progress seem puzzling and unrewarding to his followers. Perhaps the shimmering brillance of *Gangster's Funeral* would not have been possible without the semi-abstract preamble of 1951. He was obliged, it seems, to meld and blur his figures before bringing them forward again in the convinced clarity of *Gangster's Funeral*.

And what clarity this is! The lumpy man with bowed head standing beside the bier, the tycoon at the right palming his gloves, the "unofficial" widow with one eye covered by a handkerchief and the other eye wide-open and avid, the little man in pinstriped suit and behind him a handsome stalwart of some nameless corruption—each figure is at once a type and a person and unforgettable as both, as in all first-rate caricature. The moment depicted is hushed, but there is a strong illusion of motion.

The only figure in the room not sharply characterized is that of the dead gangster. This is entirely deliberate on Levine's part. He has reversed the procedure of the Romantic landscape painters, who intended that the observer should form his impression of a given scene through the eyes of the principal figure within the composition. The *Gangster's Funeral* is a picture of an audience. The features of the corpse are purposefully obscured, since it is the audience's attention they should hold, not ours. "I will show the corpse," Levine declared, "but the emphasis could be on the embalming." It is indeed. The foreshortened gangster in his coffin is the key to the painting's structure. But the figure is free of that psychological insistence which gives the mourners their vitality. The picture tells a story, of course. And Levine, in an era when storytelling in art is widely condemned, has had the courage to proclaim his faith in text. "The libretto," he wrote, "in no way invalidates the possible creation of a work of art. On the contrary, it inflects it, it enriches it, it makes the project more complex. I see no harm in putting the conscious mind to work in this fashion."

Jack Levine

FREDERICK S. WIGHT

"You can't disregard the whole world for some silly paint spots . . . before anything I have to find out the valid thing to do as an artist and as a man . . . I have the problem of painting the Bowery or Washington Street . . . therefore, I shall always have to repudiate certain contemporary concepts, because I've got a job that has to be done."

Jack Levine, at thirty-seven, is given to repudiations, and his art is dedicated to the service of something above itself. This is nothing less than humanity as a whole, but as it turns out it is not humanity mechanized as an ideology, nor a poignant scene observed at the corner of a dim street. Instead, Levine comes up with an imagined drama or a sermon in paint. A brilliant talent harnessed to ideas is something to observe. One can report on the ideas; and Levine is only too willing to help by holding everything up to consciousness: his pride is in awareness, in the mind.

The painting currently on the easel is a pawnbroker's shop, a persistent theme, for his largest painting, completed last year, has the title *Pawnshop*. Whether Levine has pawned his talent in order to give the proceeds to the poor is a purist's question. He would, one feels, gladly do so. "You can't get away from the idea of poverty in a pawnshop."

Below the easel there are chalkmarks on the floor which as it turns out are caricatures for the diversion of his three year old daughter. Pages of *Life Magazine* and old newspaper photographs are on the walls, such as struck Levine's fancy for their sardonic subject matter. Levine perches on one piece of furniture or another, with a line to upper arms and shoulders which suggest a bird's hunched and folded wings. He has something of the look of his own figures: he exists in head, hands and wrists, the pale blue

From the catalog of the 1953 Jack Levine retrospective exhibition, pp. 3–15.
Reprinted by permission of the Institute of Contemporary Art, Boston, and of
Frederick S. Wight.

eyes magnified by glasses, the face below the long nose subtly diminished, and the body of no material interest: a suit of clothes. At once intense and devoid of color, Levine seems to have been born for the observation of people in cities, of streets at night.

The painting on the easel is a battleground which has undergone vast changes, for Levine is a painter of infinite facility, earnestness and discontent. "The painting began with high colors; there was a bright blue sky, cobalt, cadmiums for flesh."

Now it has a Rembrandt atmosphere "as if it might be under the L." Levine is not wordless about the struggles in the changes on the canvas. What has been going on this last month is a "revaluation of light and shadow . . . for its exciting potentialities in making a picture. *Light and shadow* has two functions: 1) it thrusts the image into structural saliency, and 2) it is a system of break-through." Points to be taken up one at a time. Structural saliency leads at once into a discussion for which the mysterious gold-green and tonality of the unfinished canvas provides a ground. "Both Rembrandt and Daumier had their Comedie Humaine. They worked with the real things of this world . . . Rembrandt's picture frame was a proscenium, he peopled his stage with characters both seen and imagined by him, to play roles often enough inspired by the written word. . . . Rembrandt's forms are of necessity massive-sculptural. Only so can he grasp the tangibility of the substances of this world. . . . This is content in an inspired sense. It contradicts no valid concept of form. This approach can never be obsolete. . . . All considerations of modernity or contemporaneity fill me with horror."*

Which adds up to Levine's later reflections in his studio: "Within light and shadow I can express some kind of drama which is most like me."

Now for the second point, "Light and shadow as a system of break-through." Levine means a break-through into the world of form. He feels that light and shadow add meaningful patterns, a sort of extra dividend. Form thus is eased over into conscious

* From *Modern Artists on Artists of the Past,* by Jack Levine, Museum of Modern Art, 22 April 1952. Quotations not from this source are from conversations with the painter.—F.S.W.

logic, away from obscure symbolisms with which Levine does not hold. Levine has a book in hand: *Architectural Shades and Shadows*, by Henry McGoodwin. "We recognize things by their shadows. The projection of shadows gives you the image along with the other aspects," says Levine, teaching by the book. "It offers a clue to relationships."

He is particularly fascinated by a column's discontinuous shadow rippling down a stair. By means of shadows, "You can disintegrate an image and still have the image. Forms are forms which reveal the object."

This is Levine's frontier on the side of abstraction, where he holds outposts in what for him is the enemy territory of painters he calls "Space Cadets."

His big canvas *Pawnshop* is not precisely a turn toward abstraction; it is an essay in "flexibility," so that he may be "able *not* to do it. It may be a direction or a rebound from a direction." He may have done it "not to be balked." Levine, then, is waging a sort of Counter-Reformation, with one intention: "To bring the great tradition, with whatever is great about it, up to date."

Here follow two repudiations: "The cubes and planes and alarm clocks created by man to conquer the problems of this life are for me secondary objects of contemplation . . ." and "Dehumanization seems the keynote of every field of modern endeavor."

The second repudiation is more subtle and arresting. Levine has a quarrel with Expressionism for its subjective arrogance. "It is not my direction. . . . Individuality at the expense of communicativeness is not finding itself, it is losing itself. . . . Expressionism puts too high a premium on subjective reactions."

He thinks he is not interested in the subjectivity of a person. He is "against exchanging one jadedness for another." All of which means, I take it, that whatever is less than conscious is viewed with malaise and had better make itself clear.

Then what of the distortion so characteristic of Levine?

"Distortion and Expressionism are not the same thing. Clouet, Corneille de Lyon distort. You distort for empathy. You give something a larger area because it is more important. And a madonna is more important than an apple, every time. You distort

for editorial reasons—a dignified way of saying caricature—that has always been, and *that* isn't Expressionism. I would smooth out every brush stroke in favor of the structure of the head. . . . I have always distorted for satire or pathos or one thing or another, but never just to express myself. Distortion is always a dramatic vehicle. Drama in an external sense. The world is certain, and figures have a certain height proportionally. Sure, I distort them. It is a distortion, but it also relates . . . it *does* relate," Levine insists.

"Maybe I have an idea about a norm which I don't intend to follow. I don't intend to lose sight of it either. To lose sight of it is to lose everything." Levine will not have the outer world belittled for fear the moral world would be denied, or be dissolved in aesthetic indifference. And his thought, like religious thought, cannot tolerate a break with the past. His "interest is in continuity."

Biography never accounts for genius, which is somehow on an impersonal scale, the emerging biography of a race. But biography has something to say about ideas, and a man's view of himself is a distortion that communicates. Levine was born in 1915 in the slums of Boston's South End. Here he lived for the first six or seven years of his life. The Levines came from Lithuania. Levine has four brothers and three sisters. The eldest brother was twenty when Jack was born, and it was this brother who named him Jack, because he was born in America and it was such an American name. The notion of Jack as a victim of these circumstances should be discarded at once. Another brother was a boxer of ability who ran interference for Jack's childhood: "It was rough, but it wasn't rough on me. . . . I would see drunks getting arrested —that sort of thing. The life of the streets. No objection to it. Life was interesting. *The Feast of Pure Reason* comes from that background."

The Levines then moved to Roxbury, and Jack was in the "Museum kids' class" between the ages of seven and ten. He knew the painter Hyman Bloom at nine. At about this time too, he met the painter Harold Zimmerman through the Jewish Welfare Center in Roxbury; and when he was fourteen he met Denman Ross, of the Department of Fine Arts at Harvard. Both Zimmerman and

Ross were important influences in Levine's development. Ross, to be sure, played the more significant part, but both tended to implant in Levine his zeal for continuity. Zimmerman, Levine thinks, "sustained the childish process of drawing," so that he had a continuity in his work from childhood to maturity. "It was the process of having an idea and doing it anyhow." Both Zimmerman and Ross encouraged imaginative drawings and working without models. "I now use what is in my fingertips; I can draw any kind of person, but must look at *things* from time to time."

Levine, along with the slightly older Bloom, used to trek to Zimmerman's studio on Dartmouth Street. Later when all of them came under Ross's eye—Levine knew Ross before Zimmerman knew him—Zimmerman moved his studio to Cambridge, and Levine followed along. Ross now set up his protégés Levine and Bloom with a "stipend" of twelve dollars a week. Perhaps this early recognition from Ross went to the boy's head, or at least Levine is now prepared to think so. In any case, serving two masters was a strain on Levine's temperament and Zimmerman was the loser. "The situation deteriorated," by which Levine means that he felt Zimmerman's nature change, and that "Zimmerman no longer believed in my work." Zimmerman was frank about this. Guiding genius is something of a dangerous trade, and Levine came to think that "this guy made a mess out of me and I'm going to get him. Hunt him out. Dog his tracks. Cut him out of the act. I still feel irked."

For years, until now in fact, there has been no Zimmerman for Levine, but looking back, "it seems silly now," and he can "see the days of Ross and Zimmerman as a comedy of errors." And since Zimmerman exists once more, a posthumous debt to him emerges —this continuity from childhood to maturity which so many artists of our time have belatedly striven to regain.

The influence of Denman Ross has always been acknowledged by Levine, who reveres Ross, yet the tutelage must have been trying, as Ross's ideas on technique were elaborate and were mandatory on his pupils. His palette was built on a system of organization as complex as the eye of a fly, and given procedures were essential. Ross, like Charles Wilson Peale before him, appears to have had the notion that he could mix a prescription which would bring forth

talent. In these days Levine and Bloom made some extraordinary youthful drawings, and Levine drew a String Quartet which has much of the quality of a Degas—and no resemblance whatever to the big *String Quartet* canvas which was to come along in a few years.

But the debt to Ross is a major one in Levine's view. It was Ross who banished his ignorance. "He put me in touch with the European tradition and the great painting of the past at an early age, when I knew nothing about it. He gave me roots a long way back. Imagine, Ross taught the teacher of Max Weber. I owe to Ross what I'm interested in—continuity. I don't want to lose it. I want to know what I'm doing."

Levine is humiliated by the thought or spectacle of lost techniques. But it is also the lost morality which challenges him. "How can the modern artist align himself with the past? The secret medium of the Van Eycks is still a secret. It is no less a secret for those friends who are quite sure that no one can paint like that because this is the Twentieth Century, that the essence of Vermeer is the rectilinear of Mondrian, that cubist diagrams equate El Greco with our living tradition.

"Perhaps the most apparent thing about artists of the past is their freedom from crisis and dilemma in the sense we find it."*

All this is part of the debt to Ross. It was Ross's sensibilities rather than Levine's which gave way first. "Ross believed I had said something, made some derogatory statement, which was not so."

For Levine, his life falls into four phases; Ross and Boston; the W.P.A.; the Army and Ascension Island; marriage and New York. Levine was precocious, with a facility only matched by his moral earnestness; and the W.P.A. period, with its inspiring answer to a bleak and wretched situation for the American painter, provided a dour seasoning to his work. The Metropolitan Museum's *String Quartet* was painted on a Federal Arts Project in Massachusetts. It dates from 1937 when Levine was only twenty-two. In that same year, the Whitney Museum of American Art first showed Levine in its Annual Exhibition of Contemporary Art, and has showed

* Levine's *Artists of the Past*—F.S.W.

him almost yearly since that date. The Museum of Modern Art was showing Levine as early, and its outstanding *Feast of Pure Reason* also dates from 1937. Its remarkable large *Street* dates from 1938—a painting in which Levine allows himself bolder distortions—presumably to convey confusion of sound—than he will ever later employ. The Museum's *Passing Scene* dates from 1941. This was an exceptionally productive year. The Museum of Modern Art included Levine in its talent-spotting exhibition, "Americans 1942."

Looking back, Levine, under the technical and moral spell of Rembrandt as he is, sees the *Feast of Pure Reason* as an early example of the "work which is most like me." This is the opening of a vein rich in dignity and feeling, which gives us *Passing Scene*; *The Banquet*, in the Roy Neuberger Collection, also of 1942; *The White Horse* of 1946; *Apteka* of the following year; and *The Golden Anatomy Lesson* of 1952, which is scarcely dry. And doubtless the new *Pawnbroker* on the easel. All these paintings are rich, massive and glowing, and fired with the painter's broad feeling for humanity itself.

The *Apteka* is remarkably fine, a study in humanity without people, the contrast of the reds and greens resonant, the clash of the two reds part of the man-made chaos. It is noteworthy that the destruction in the scene apparently satisfies the artist who does not seem to feel the need of "disintegrating forms" and gives us a structure at once more orderly and more formal than is his wont.

These paintings are of course not without the Levine satire, which is omnipresent; but they are deeper than satire; they are not as brittle in mood as Levine can sometimes be.

"The Rembrandt thing is not adulative. It is closer to me. Preferable. It gives me a direction in which to continue. It takes me closest to the subject, the human drama. It fits me better.

"I feel the harder problem is to be resolved. It is not to go back to Rembrandt, although that takes skill and study—not to break with Rembrandt . . . but to bring the great tradition, and whatever is great about it, up to date."*

* Levine's *Artists of the Past*—F.S.W.

This is the main vein of Levine's work leading out of the W.P.A. period into the present. It is easy to imagine the W.P.A. period, with its rock bottom economy, as the basis of this sobriety. But Levine reminds us that "there is a lot of frivolity in me," and there are other sides to his art.

Levine had great resources in technique at his disposal, and as he haunted museums, it must often have been a question—whose continuity is it to be? The talk is now of Rembrandt, but there is a great deal of Soutine in the red faces of the *String Quartet*, and no little of Rouault in the large heads. There is tribute to Daumier and Van Gogh, and there is much of Greco, not merely in the distortion, but in the shimmering play of light that ripples over muscles. The important *Tombstone Cutter* of 1947 seems to owe the shimmer and web of light to Greco. The figure appears flayed; it lets the eye into its anatomy, into the subtle, raw, sensitive thing that it is.

There is Greco and Soutine too in a flock of little canvases, mostly eight by tens, which form a gallery of Old Testament figures, and here one feels an atmosphere of tenderness, acceptance, the artist's identification with the subject. Here the large heads come flagrantly into play. *King David* is a major example; the proportions, the whole aspect, suggest childhood—almost infancy —at play with harp and crown. But the head is bearded. It is a fusion of boy David and old king. *Planning Solomon's Temple*, of 1941, falls into this category too, a sensitive canvas painted as a memorial to the artist's father who died in 1939. The *King Saul* of this present year continues the series, and the small scale seems significant, as if the painter were embarrassed by his own tenderness. For Levine cannot be accused of over-loving.

"Those I love I simply leave out. A painter should do what he does best." Levine feels he is "equipped to punish."

In a sense all of Levine's major paintings are paintings of punishment. A large series of canvases is given over to mordant satire. Here Levine is at his most characteristic or at least his most familiar, more eye-catching as these paintings are than the "Rembrandt thing." The spectacle of authority is not pleasing to Levine. One runs into revealing flashes of the disarming political optimism of the first generation American: speaking of the Whitney Museum's *Reception in Miami*, "It is everything I was taught had no place

in America." Crowns and coronets are a belated symbol of oppression, and he is in no mood for a truce just because they are off. The *End of the Line* of the Phillips Gallery, painted in 1948, is a massive sermon on the degeneration of power, and the somber *Royal Family* of the same year in the Gersten Collection, one of the few canvases in which Levine creates a Byzantine pastiche, is in the same mood. Levine's catalogue of things that should have no place in America is long.

The most effective in this kind is the Brooklyn Museum's famous *Welcome Home* of 1946, in which Levine celebrates the festive return of a Brigadier General. This is the conclusion of the Army phase, which is represented by a blank space in Levine's creative life. There is a view that military life is designed to get men fighting mad before turning them loose on the enemy. Levine was not turned loose on the enemy. He was twenty months on Ascension Island—"and you had no way of knowing it was going to be just twenty months."

"I went out as an Army artist. I didn't want to be one. Nobody asked me." He was a technical sergeant and did clerical work at an air base on the island. After the war he was at a rest camp, and then at a second rest camp. He was on a recuperative furlough and tried to find a job in New York.

"I got an (army) job in Public Relations on lower Broadway. The PRO wanted pictures . . . I got out of the Army gradually." He was finally separated at Fort Devens. *Welcome Home* is superb as satire, and the light facile handling is its essence. The sketchy perfection which sets the table recalls Degas. According to Levine, "*Welcome Home* is a buoyant painting," part of what Levine calls his frivolity.

Finally there is another continuity in Levine which cannot be synthesized with the "Rembrandt thing" and which seems doomed to be relegated to a lesser place as his morality does not approve of it. This is the Rubens thing, the neo-romantic Levine, which—according to the artist's wife—is a cab driver reciting Shakespeare.

"I have an ambivalent feeling about the good life. I don't know what status nudes have for me. When I look at Rubens or Matisse, sometimes I feel but for the grace of God I could spend my life doing that. I do sort of indulge in fooling around."

Levine has looked at Rubens to some purpose. "He is the most

effective, capable painter that ever lived. When the M.F.A.
(Museum of Fine Arts in Boston) acquired the *Queen Tamaris*
in 1939, it was a major event in my life. I stood between two
rooms where I could look two ways, at the new Rubens and at
the Renoir (the *Dance at Bougival*). There was no comparison.
The Rubens had the upper high notes, the opalescence totally
lacking in the Renoir."

Latterly, Levine has been impressed by the lectures of Ruhe-
mann on Rubens's technique, and he has taken to experimenting
with "transparent grays which have no black in them" glazed over
umber.

The *Lady with a Pink* in the Spaeth Collection is a fine example
in this neo-romantic vein; and so is the *Homage to Boston* of 1949,
a nude of Rubens's rather than Levine's proportions, with the State
House, and the Old State House at the head of State Street, as
attributes. "I miss Boston, which has wonderful buildings and
streets. It is a day nearer Europe, as Mayor Curley used to say."

After the war, Levine married the painter Ruth Gikow, and
moved to New York. The Levines were abroad in 1947, and again
in 1950–51, for eleven months spent in Rome on a Fulbright
Award. They now live in St. Mark's Place.

It may seem fruitless to discuss a painting which has not yet
been painted, except that Levine does discuss it. Since only slight
studies exist, the idea, the planning, the verbalization, are in a
pure state. The subject is the *Gangster's Funeral*, and Levine's
preparatory meditations might be those of a playwright. Of this, of
course, he is perfectly aware.

"Immediately questions arise such as what sort of dress shall be
worn; what do people wear at a gangster funeral? This may seem
a concern for a dramatist, a novelist. I envy them these interesting
concerns.

"If they be wearing street clothes instead of cutaways, it be-
comes possible to have the fat man show a broad mourning band
on his thick little arm. It would be amusing to make it a heart
instead of a hand, but unfortunately that isn't possible.

"A widow, in deep mourning, clad in rich furs. Better yet, two
widows, one very very shapely. The chief of police comes to pay

his last respects—a face at once porcine and acute—under no circumstances off to one side as a watcher. This would suggest a thesis other than mine, a policeman's thesis. He must be in the line of mourners, filing past to view for the last time the earthly remains of his old associate. Who would, if he could, remonstrate with him for exposing himself in this manner.

"If the chief's function is thus made clear it becomes possible to add a patrolman in a watchful capacity. I must now look for ways of establishing the identities of the mayor, the governor, et alia.

"It may be said that the idea is more fit for a novel or a film. This is ridiculous. As far as the novel is concerned, a picture is still worth a thousand words; as far as a film is concerned, the Hays code requires it to show that crime does not pay, which is not my thesis either.

"This libretto in no way invalidates the possible creation of a work of art. On the contrary, it inflects it, enriches it, makes the project more complex. I see no harm in putting the conscious mind to work in this fashion."*

Later, speaking of the *Gangster's Funeral* in his studio, smoking over the first studies, Levine wants "no element of the macabre. I want to state it but not show it, to get behind it as soon as possible. I want the painting as a comedy. It must not be a tragedy. I will show the corpse but the emphasis could be on the embalming."

Levine is certainly burying something, on the face of it something which is but ought not to be in America, but the struggle is of course deeper. For one thing he is choosing to bury lawlessness. "I am in rebellion against what is going on." As it turns out, he is for continuity and awareness and a living tradition.

People who believe that tradition is alive are of course conservatives . . . Levine, then, lives in a world where values take precedence. He is in search of the best company, and genius may be living down the street in a world capital, but it may also have an address in another century. Values—Levine seems to say—may be unlocked by talent, but talent is only a key to them. Fortunately, they are forged out of human nature itself, of which talents are only a part.

* Levine's *Artists of the Past*.—F.S.W.

The Hazards of Modern Painting

HILTON KRAMER

For more than a decade now the names of Hyman Bloom and Jack Levine have been linked in the art world as the special contribution which Boston has made to contemporary painting in this country. That their talents have always been disparate and their work unequal has not discouraged museum officials, art critics, and the rest of the officialdom of the art world from capitalizing on their biographical connection. In a period when all too few American painters have provided material for the legend of the artist—of which the public is still so fond, after the fact—their story has been a bit too juicy with sentiment for the official mind to pass up. Add to this the fact that both artists work in a highly literary mode of painting which makes itself readily available to easy biographical and philosophical "interpretations," and that their Jewishness (always a sure source for the sentimental side of their story) has formed an important part of this literary content, and you will have some idea of the basis on which their fame and success rest today. The twin retrospective exhibition of their work this year at the Whitney Museum in New York—a truly amazing and disturbing event for artists of their age and achievement—was entirely symptomatic of the kind of homage the public is willing to pay to this sort of legend.

To be sure, their story is an engaging one, for it is nothing less than the story of two sensitive and talented Jewish boys making good in the world of Gentile culture. In 1927, when Bloom was fourteen and Levine two years younger, they met in an art class which the painter Harold Zimmermann, only ten years their senior, taught in the Community Center of Boston's West End. Both of them were sons of shoemakers who had immigrated from Eastern

Reprinted from *Commentary*, by permission; Copyright © 1955 by the American Jewish Committee. Article excerpted from "Bloom & Levine: The Hazards of Modern Painting—Two Jewish Artists from Boston," *Commentary*, June 1955, pp. 583–587.

Europe; Bloom himself was born in Lithuania and came to this country at the age of seven. Both were endowed with the kind of artistic gifts which augur well for the future when one's whole energy is bent toward establishing the *fact* of talent, but not its quality or direction.

The agent of their early development and success was a Harvard scholar named Denman Ross, a figure out of the Berenson era for whom the practice of the fine arts meant a strict reverence for the old masters. Apparently Bloom and Levine were introduced to Ross through Zimmermann, for Ross—a collector, painter, writer, and museum benefactor as well as professor of fine arts at Harvard —was soon making every effort to help all three: first making work space available in the Fogg Museum and later renting studios in which they could work. He also provided the boys with a weekly stipend of twelve dollars.

Ross's influence extended far beyond this patronage, however— and here we leave the engaging story of the boys from the wrong side of the tracks, as it were, and enter into the realm of their artistic ideas. Insofar as these ideas were influenced by Ross, they can be summed up in this sentence from his book *On Drawing and Painting*: "The experience of the past should be referred to and only methods well tested should be followed." (In context, the remark deals with methods of preparing a surface for painting, but it can properly be taken to represent Ross's whole intellectual position.) Both Ross and Zimmermann seem to have been completely shut off from the artistic ferment of modern Europe, and particularly from the School of Paris, where the most significant artistic ideas of the century were being generated. For Zimmermann, it was a matter of physical isolation, at least in the beginning: he had simply not seen the work. (Later, when he did see it, it seems not to have touched him very deeply.) Ross's isolation was more a matter of intellectual disposition. As Bloom himself remarked, "Ross couldn't stand Rouault or even Cézanne," and this is only one of many signals which indicate that Ross's understanding of the Western tradition in painting was essentially a scholar's and not an artist's.

Inevitably, there was a cleavage of affinities, and it was Levine who worked more directly under the discipline of Ross's ideas. It

270 Five Social Realists

is significant that these early years under Ross's tutelage were devoted to drawing, for it is above all in draftsmanship, and in technique generally, that the academic mind takes refuge in the presence of conflicting artistic demands. Levine's crayon drawing entitled *Jewish Cantors in the Synagogue*, dated "before 1933" in the Whitney catalogue, not only reveals the artist's early proclivities as formed under Ross's teaching, but it is also, I believe, a good index to the real loyalties of his plastic sensibility. Other drawings of the same period are similarly executed: the effort is all toward rendering volumes and contours in a traditional, pre-Impressionist manner; nowhere is there a line or gesture which bespeaks the kind of impatience with the past which we recognize as the beginning of artistic maturity. All energies were still being spent on the *fact* of the artist's talent.

Equipped with this point of view, which placed upon draftsmanship the major burden of the painting art and surrounded it with a constellation of technical devices culled from Rembrandt and other masters, Levine entered into the turmoil of the depression, making a place for himself as a WPA painter. Now in retrospect the Federal Art Project can be said to have had only one positive value: it allowed certain painters to survive. But as a period in the history of art it was dominated by an intellectual and pictorial provincialism which was suffocating to serious goals in painting. And like Ben Shahn, Philip Evergood, and others who made their reputations in the 30's, Levine found in the provincialism of "social realist" art something entirely apposite to his academic training.

Moreover, as the son of an immigrant and a Jew, he was a member of the class which embraced the political ideals of the depression with the greatest intensity. In the context of unemployment, rising fascism, and the other terrible burdens of the 30's, the commitment which Levine made to "social realism" must have seemed at the time like a commitment to modern life itself— particularly, alas, for a student lately out of Denman Ross's atelier.

The style which Levine went on to develop in the 30's was a heavy, satirical mode of realism which relied almost exclusively upon caricature for its effects—caricature, that is, "dressed" in a painted surface which has practically no independent interest of its

own. The first major statement of this style is a work called *Feast of Pure Reason*, dated 1937. With variation and increasing subterfuge, it is the style which Levine continues to practice.

There are three figures in the *Feast of Pure Reason*: a policeman in uniform, an underworld character, and—there being no other name for the "gentleman" in formal afternoon dress, high collar, walking stick, cigar, etc.—a capitalist. They are seated together in a dark, interior atmosphere, but the implication is unmistakably clear: this meeting represents the corruption of our society. The method of organizing the picture is equally unmistakable: the figures—who resemble nothing so much as those imported crockery figures which used to be made after characters in Dickens, with their names in relief on the bases—are immersed in shadow so that light may be allowed to reveal faces and hands in all their double-chinned, baggy-eyed, knuckled ugliness. Highlights also fall on "significant" objects: in this case, an expensive-looking whiskey decanter, a symbol of the conviviality —Oh, the irony!—with which these supposed enemies in society, the Law-enforcer, the Law-breaker, and Respectability itself, come together for mutual benefit and profit.

These themes dominate the major canvases of Levine's *oeuvre*: the privileged status of the underworld in *Gangster Funeral*, 1952–53; the hypocrisy of politicians and patriots in *Welcome Home*, 1946, and *Election Night*, 1954; the corruption of the moneyed classes in *Reception in Miami*, 1948.

It is worth noting that the dates of these pictures place them in the last decade, some of them in fact within the last couple of years; for what gives them an overriding coherence is their indulgence in a form of easy irony and social comment which we associate with the "innocence" of the 30's. Levine has been frank to say that "All considerations of modernity or contemporaneity fill me with horror," and although I am sure he meant this declaration to apply to his technical means and not to his thematic materials, his pictures, even pictures of a couple of years ago, seem already terribly "dated," already given over to subject matter which has little contemporary relevance on any level: the satire no longer applies and the painting is simply a series of *hommages* to the old masters, in some cases not very well understood.

(Anyone who thinks that "Rembrandt's forms are of necessity massive-sculptural" does not have an infallible notion of what the old masters were up to.) Levine's paintings represent ideas which he has had in his head for years; they represent an idea of reality, social reality, on which he has not allowed the brute facts of experience to make the slightest alteration. It rather confirms one's suspicion that "social realism" is one of the most extreme forms of mannerism in modern painting.

If Levine's sense of reality gave him no warning that his subject matter had lost its urgency, his phenomenal success should have. For after Ben Shahn, one would be hard-pressed to name another American painter today whose work is so conspicuously present in the major museum and private collections in this country—and purchased, one must add, at prices which stagger the imagination as his pictures never do. But it is characteristic of this kind of "liberal" artist in our time—one thinks of Arthur Miller on Broadway—never to allow the success of his work to give him pause; never to interrupt the warm glow it must give him to utter what seem heresies; never to face the possibility that what is being said is no longer heresy but the most easily digestible cliché of the public imagination.

With his subject matter stabilized (a curious turn of events for a "social realist"), Levine has been free to dwell more and more on the mannered details of his pictures, and the zenith of this concentration is reached in *Reception in Miami*. Of all the improbabilities imagined during the Federal Art Project, none would have strained credulity more than a "social realism" gone rococo—but that is precisely where this picture has brought it.

Jack Levine—The Degrees of Corruption

FRANK GETLEIN

IF the complete history of this country's brief plunge into government-patronized art is ever compiled, a striking and inescapable conclusion will concern the difference in over-all tone between the theatre and movie projects and the painting projects. Of the movies you remember poetic and powerful special pleading for conservation and flood control policies. In the theatre new techniques combined with new social thought to produce the Living Newspaper, outright propaganda for the New Deal in agriculture and against the Nine Old Men, epic theatre based on the fact that syphilis can be cured. In painting, by and large, the results were an endless proliferation of historical and geographical post office murals and a superabundance of easel painting recording the visual facts of America in the thirties.

The difference may stem from the basic fact that theatre and movies are group enterprises; the spirit of the times was certainly one of group activity; the collection of writers, actors, designers, electricians, and cameramen could easily feel that their own working together echoed the larger effort of the nation. The painter, alone with his eye and his hand, pretty much put down what he saw or, in the post offices, constructed respectful images of the early settlers.

Happily there were some distinguished exceptions to this rule and among them was Jack Levine. In 1937, at the age of 22, Levine embarked on a program of political analysis by way of imaginative, characterizing portraiture that is still going on. In that year, for the WPA, he painted *The Feast of Pure Reason*, which is now in the Museum of Modern Art. The content sounds like an IWW caricature. A millionaire, a city boss and tough cop sit at their ease, the complacent, massive heads held by the reversed triangle of a richly framed painting on the wall, a de-

From *The New Republic*, 6 October 1958, p. 20. Reprinted by permission.

canter in the foreground and a plaster *Winged Victory* between the cop and the politician. The painting is an absolutely pitiless response to the cruelty and insensitivity of its subjects and the perversion of the democratic idea they represent. Levine's *Syndicate*, painted two years later, employs two of the same characters with a wardheeler instead of a cop, but seems inflated and flabby compared to the first picture.

While that particular statement was made once for all in one of his first important paintings, Levine was by no means finished with the big city politician. And it is interesting to notice how often ceremonial eating and drinking affords the moment of observation. *Welcome Home*, in the Brooklyn Museum, is a public dinner for a returned general who salts his celery with infinite care and who is served by an aging waiter whose body is a masterpiece of obsequious grace.

Election Night, in the Modern, uses Levine's almost patented compressed space to assemble victorious politicos whooping it up surrounded by a statuesque cigarette girl, a bellhop and an embracing couple. The compressed space makes it possible for the picture to yield person after person hidden in Levine's technique of the blurred image and in his embellishment of what might be called a "white writing" that has something to say.

This "writing" comes from the glint of light on crystal, or rhinestones, or folds of fabric. It appears in a lot of Levine's work but it is at its best in *Reception in Miami*, in the Hirshhorn collection, one of the dozen or so major works of the painter. The scene once more is a public place, and for a change, the principal characters are people we know by name, the Duke and Duchess of Windsor, presented as a pair of expressionless mummies who must be rolled about on wheels. Curtsying are a pair of awestruck American ladies. To the right an old Levine type plays the headwaiter, snapping his fingers for an underling. Behind, baroque stairs, columns, arches, balustrades, chandeliers; spang in the center foreground, a little dog who scratches his ear and thus repeats the curtsy. Over the whole thing the white writing glistens and swoops in a rhythm of its own.

Levine's most monumental painting is *The Trial*, in the Art Institute of Chicago, done five years ago. The picture is hung

next to Winslow Homer's magnificent *Herring Net* and the juxta-position suggests an American antecedent for the white writing. The Institute owns the drawings for *The Trial* and I went through them recently, but they are little more than notes or blueprints for the picture. In them appears a sketch labelled "The eyes of J. Donald Coster," and these may have survived as the eyes of the judge, to whom the whole structure pyramids. The weariness of time and power are once more present in the faces, but the artist's judgment is now withheld.

Perhaps it is less a question of judgment withheld than a per-ception that goes beyond judging. The effort in Levine's late work is clearly to understand all—not to forgive all, but simply to grasp the truth, part of which is certainly ignored at *The Feast of Pure Reason*. In terms of subject matter, this restraint may be expected in the series of exquisite little portraits of Hebraic kings and teachers, but it comes as a distinct shock in Levine's recent salute to General Franco, *The Turnkey*. Alone in the white-washed prison interior, surrounded by old-fashioned gimcrackery, the decorated, jackbooted general is corrupt and slightly ridiculous, but there is also a recognition of the uneasi-ness and loneliness of the man.

Levine's task, thematically, has been to take the measure of the corruption wrought by power. Upon his success rests a large part of our time's claim to artistic achievement beyond corrup-tion.

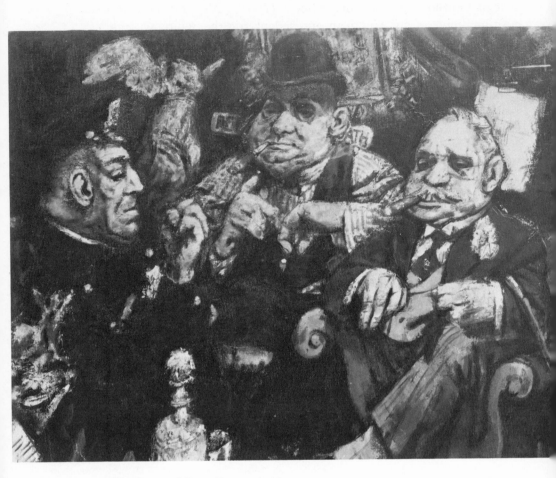

The Feast of Pure Reason JACK LEVINE

1937
Oil
42″ × 48″
Collection of The Museum of Modern Art, New York
On extended loan from U.S. WPA Art Program

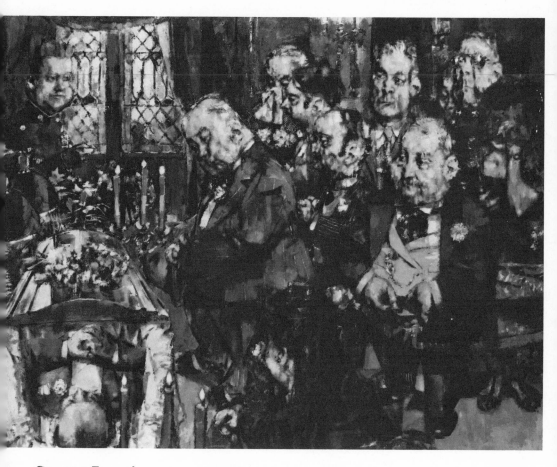

Gangster Funeral JACK LEVINE

1952–53
Oil
63″ × 72″
Collection of The Whitney Museum of American Art, New York
Photographer: Geoffrey Clements

Ben Shahn

Chronology

1898	Born Lithuania.
1906	Family emigrated and settled in Brooklyn, New York.
1913–17	Apprentice in lithography shop during day, student at night.
1919–22	Studied academic subjects at New York University and then at the City College of New York before joining life drawing classes at the National Academy of Design.
	Three successive summer scholarships at the Marine Biological Laboratory in Woods Hole, Mass., for biological study.
1922	Married Tillie Goldstein, whom he later divorced.
1924–25	Traveled to North Africa, Spain, Italy, France.
1926	Refused opportunity to have one-man show because he felt his work was still too derivative.
1927–29	Returned to Europe and North Africa.
1929	Met Walker Evans and through him began to be interested in photography.
1930	First one-man show, held at the Downtown Gallery, New York, where he had successive shows in 1932, 1933, 1944, 1951, 1952, 1955, 1959, and 1961.
1932	Assisted Diego Rivera on the Rockefeller Center murals.
	One-man show at the Harvard Society of Contemporary Art.
1934	Married Bernarda Bryson, an artist.
	Joined Public Works of Art Project.
1934–35	Worked on mural for Riker's Island Penitentiary New York, with Lou Block. Studies for mural rejected by Municipal Art Commission.
1935–38	Employed by Farm Security Administration as artist, photographer, designer. Took approximately 6000 photographs.
1938	Completed fresco for the federal housing project at Roosevelt, N.J., where he subsequently settled.
1938–39	Murals for Bronx Central Annex Post Office in New York. Assisted by his wife, Bernarda Bryson.
1940	One-man show, Julien Levy Gallery.

1940–42 Murals for the Federal Social Security Building, Washington, D.C.

1942–44 Posters for the Office of War Information and the Political Action Committee of the CIO.

1945–46 Director of the graphic arts division of the CIO. Published four posters.

1946 Included in "Survey of American Painting," Tate Gallery, London.

1947 One-man show circulated in England by the Arts Council of Great Britain.
One-man show, Museum of Modern Art, New York.
Taught summer session at Museum of Fine Arts, Boston.

1950 One-man shows at the Albright Art School, Buffalo, N.Y., the Frank Perls Gallery, Los Angeles, Calif., and the Phillips Memorial Gallery, Washington, D.C.
Taught summer session at University of Colorado, Boulder.

1951 Instructor at Brooklyn Museum Art School.
Group show with Willem de Kooning and Jackson Pollack at the Art Club of Chicago.

1952 One-man show, Boris Mirsky Gallery, Boston.

1953–54 Represented United States at Venice Biennale with Willem de Kooning.
One-man show, Art Institute of Chicago.

1956 Elected to National Institute of Arts and Letters.

1956–57 Charles Eliot Norton Professor of Poetry at Harvard University.
The publication of *The Shape of Content*, based on Harvard lectures.
One-man shows at the Fogg Art Museum, Cambridge, and the Institute of Contemporary Art, Boston.

1958 Designed sets and posters for Jerome Robbins' ballet, *New York Export—Opus Jazz*. Awarded Institute Medal by American Institute of Graphic Arts.
Included in Venice Biennale.

1959 Elected to the American Academy of Arts and Letters.
Mosaic mural for Congregation Oheb Shalom, Nashville, Tenn.
One-man show, Leicester Galleries, London.
Traveled to the Far East.

1960 Mosaic mural for Congregation Mishkan Israel, New Haven, Conn.

One-man shows, University of Louisville, University of Utah.

1961 Designed sets for E. E. Cummings' play *Him* and Jerome Robbins' ballet *Events*.

1961–62 Museum of Modern Art circulated retrospective one-man show to museums in Amsterdam, Brussels, Italy, and Austria.

1962 Mural for Lemoyne College, Memphis, Tenn.
Posters for Lincoln Center and Boston Arts Festival.

1962–63 One-man show of prints, circulated by the Museum of Modern Art, opened in Germany in 1962 and closed in Japan in 1963.

1963–64 Commissioned to do two mosaic murals for Israel's *S.S. Shalom.* These were later purchased by the New Jersey State Museum.

1964 One-man show, Leicester Galleries, London.

1965 Window for Temple Beth Zion, Buffalo, N.Y.

1967 Mosaic mural for Huntington Beard Crouse Building, Syracuse University.
One-man show of prints, Philadelphia Museum of Art.

1967–68 One-man shows: Santa Barbara Museum of Art and LaJolla Museum of Art, Calif.; Art Association of Indianapolis; and Herron Museum of Art, Ind.

1968 One-man show, Kennedy Galleries, New York.

1969 Died.

1969 Retrospective exhibition, New Jersey State Museum, Trenton, N.J.

1971 One-man show, Kennedy Galleries, New York.

How an Artist Looks at Aesthetics

BEN SHAHN

ARTISTS are people who make images. Aestheticians are people who tell other people *why* artists make images, and what the images mean. They also tell people why they—the people themselves—either like or do not like the images that artists make. For reasons best known to themselves, artists and aestheticians rather sedulously avoid each other's paths. Perhaps the failure of artists and aestheticians to fraternize might be attributed to a certain hyper-sensitivity on the part of both as to their claims upon art.

For instance, the aesthetician shares none of the responsibility for the creation of works of art. He can eat well, digest his dinner, smoke a cigar, and then move on to the studio, gallery, or drawing room where the work of art awaits him, a *fait accompli*. He then views the work, draws his conclusions, and possibly moves on to the next meal. But no such tranquillity attends the movements of the artist. His hours are fraught with nerve-wracking decisions from the moment when he has decided to make the damned picture until its conclusion. There are times during its unfolding when he wishes that he had not started it, and there are other times when he wishes that he'd never been born. If he has a meal to eat, he can't digest it, and he is fully warranted in wondering whether the picture is even likely to provide him with another meal.

The artist's point of view is entirely one of *foresight*; he has enlisted all his faculties in the making of something that has never been seen in this world before. The aesthetician, however, views the whole process with *hindsight*. He can not be expected to anticipate the artist's purposes; he can draw conclusions only on the basis of already existing art, and upon the aesthetic accomplishments of the past. That being the case, the artist is likely

From the *Journal of Aesthetics and Art Criticism*, Vol. 13 (September 1954), pp. 46–51. Reprinted by permission.

to want to claim full authorship of the work that he has produced. But, in reading works on aesthetics, he is likely to come upon the theory that the deeper meanings of art arise out of some remote source, perhaps one that "passeth understanding," or at least one presumably beyond his humble grasp. Thus it remains for some intermediary body of opinion to rise to the occasion and to supply the hidden meanings. Such opinion has never been wanting. During the great religious periods, art was likely to be regarded as a manifestation of the Deity—working, of course, through the artist's hands. As individualism rose to its high point, one might suppose that the artist would have been accorded direct authorship of his work—but no. During the late nineteenth century, the theory of "mad genius" was popular, and the artist was supposed to paint because "he simply had to." Then both Marxism and psychoanalysis came along with new interpretations; the one attributing the artist's work to historical determinism and the struggle of the proletariat; the other tracing the meanings of art to a subterranean personality far below the artist's consciousness.

Artists themselves have not remained untouched by such theories and we have a great deal of art today that seeks to be automatic, or therapeutic, or fecal, or biomorphic, or that earnestly strives to return to the womb. On the whole, however, the artist is much more intensely absorbed with his own work than with what is written about it. His world is one of images. I think that his power to invoke images is much more highly developed than is that of the average person. He must, and does maintain a high degree of sensitivity to the varying qualities of images—to their moods and meanings and emotional colorations. He must, for his own purposes, make a sharp differentiation between what we might call primary images—that is, the images that are fresh and personal with him, and those secondary images that have already been formulated as art, as language, as signs and figures, and that have accrued to themselves one—or even more than one —meaning. Even among the images of his own consciousness, he must differentiate as to those that are *direct impressions of experience* and those that he has created out of his own imagination.

I daresay that some hypothetical artist, asked to put forth a theory of knowledge, would promptly reply that *all knowledge exists in the form of images.* He would imply not only visual images, nor only symbolic images; he would mean as well the many other sensory images—touch, taste, hearing, pain, and so on; the images of emotional states; of complicated intellectual experience; motor images; the combined and compounded images that involve senses, mind, and emotions all at once. He would probably regard behavior patterns as imagery, and certainly language, both written and spoken. *Thinking,* according to his view would consist in the marshalling of appropriate images toward an implied end. And *knowledge* itself is an awareness and an ability to invoke all manner of images at will.

Aesthetics pays a beautiful compliment to art in asserting that symbol-making is innate in man, and that art is thus one of his basic instincts. I would like to think so, but I'm forced to believe that there is a more basic need—the need to communicate—and that symbol-making arises out of that need. Even those individuals who are not at all of a creative or imaginative disposition still must communicate with each other, and their only means of doing so is through symbols. And of course, even in the absence of the need to communicate, symbols are necessary to the formulation of ideas—or one might say, communication with oneself. And thus ever since man first created crude symbolic marks and sounds and gestures, he has been busy building up an increasingly versatile store of symbols with which to communicate more and more complicated material. The artist is engaged in making symbols toward realizing and communicating new meanings, value meanings, and perhaps that is the reason he so jealously guards his sensitivity to the fresh image, still unencumbered by previous meanings; and why he is equally acutely aware of the meanings and shades of meaning of the traditional, or symbolic, image.

If I am about to make a painting of singers, I have no interest whatsoever in repeating the many value statements about singers that have been made in the past. Della Robbia has already given us singers with the look of innocence that might befit an angels'

choir. That was a beautiful statement; it is done; it stands imperishably as a symbol of that kind of attitude toward singing.

However, my own observation of singers, my own experience with them, has given me an entirely different emotional attitude toward them. Song, I observe, does not issue from an untroubled face; quite the contrary, the beautiful sounds, the subtleties and delicacies; the minors, the accidentals, all require an intense concentration on the part of the singer. That concentration produces a facial expression nearing agony. To test, to implement my point of view, I call up, one after another, specific impressions of singers. (I believe that it is commonly held that we cannot observe such an inner image. Yet I know that artists must do so continually.) One asks himself, "Now just exactly *how* did Alan Lomax look on that autumn afternoon in my studio when he sang 'Dry Bones' so movingly?" There occurs an instant image of the singer at a moment of song; then another; first this gesture, then that; a fleeting smile followed by the intense frown. Again, "How did he look in our living-room—the day Robin was along? When his little daughter Kitty sat in his lap?" Now, another singer: "What did Tom Glazer's face look like when he sang 'The Vicar of Bray,' when he sang 'The Demon Lover,' 'The Two Sisters' at our breakfast table just as morning dawned on a memorable occasion when singing had gone on all night?" One recalls specific image after image, each one almost as sharp as a fresh impression.

Having called up such a series of images, I wonder how I can capture a little of each and unite them into one face, or two faces that will hold the fierce intensity of the folk singer—and perhaps reflect too something of the rapt absorption of the listener. I will introduce a delicate play of leaves back of the singers which may create a visual contrast as striking as the real life contrast between tortured face and delicate song. The upshot of all this careful planning was a painting that I called *Composition for Clarinets and Tin Horn*. It contained no singers whatsoever, but only tortured hands covering a face which is half-hidden behind a playful array of clarinets. I discovered, after considerable struggle, that it was an *emotional* image that I wanted to symbolize, rather than the literal one of the singers. The emotional image, for me at least, is caught and held in the painting. Such is

the game of hide-and-seek that one must play with his own images in the making of a picture.

The painter must respond, as well, to the suggested imagery of materials—to the accidental depths, and the unexpected forms that are so characteristic of this or that medium—so that the images, while they may originate in his mind, will be *of the very nature* of whatever plastic medium is used.

Almost all artists delight in the introduction of *symbol*-images —those that have an already acquired flavor and meaning—into their work. One recalls the many collages of Picasso and Braque in which the big handsome letters of *Le Journal* appear. They lend a very special kind of association to the paintings. And what an entirely different flavor would result if the letters used were those of *The Journal American!* With this awareness of symbol-images goes a similar alertness toward the special qualities of sign and symbolic gesture. Whenever such symbols are introduced into a picture, they must be isolated in such a way as to give them point and emphasis—sometimes to borrow their meaning, sometimes to distort it, to add to it, to create contrast between the old symbol and the new art image.

A year or so ago I made a painting which I called *Ave*, and in which I placed two sombre, official-looking gentlemen next to seven or eight garish little chromo-lithographs of the San Genaro, all hanging in a row from a string. I found it necessary to paint the little chromos in a very tight, meticulous way, not at all like the rest of the painting. This served both to isolate them and to preserve their original character. I thought they served rather nicely to emphasize the meeting of two incongruous worlds.

Artists have considerable commerce with a certain group of people whom they often smilingly refer to as "word men." "Word men" are people whose customary tools are words, and whose habit therefore is to think in *word symbols* almost exclusively. This term usually is applied to editors, art directors, and writers who would like to have their works illustrated. Artists learn— sometimes early, sometimes late—that the word man is not capable of projecting images beyond the words or print that describe them. From time to time one comes upon such an individual who cannot comprehend even a completed pictorial image unless

it is couched in terms of already familiar images. And artists have often found, to their private amusement, that if a painting or illustration is explained to such a person *in words*, the meaning will immediately become clear, and that the same editor or art director may become an enthusiastic supporter of a piece of work which he was at first inclined to dismiss.

All this has no derogatory implication. But it may suggest that those persons whose habit it is to think in terms of existing art and language symbols, may find it exceedingly hard to accept the notion of a more immediate, unformulated, and plastic kind of imagery.

The real theoretical struggle that artists undergo is not with regard to images. An artist may own a rich and varied imagery without bothering himself about its whys and wherefores. But the one problem that he must face, and must solve somehow for himself, is the problem of values. For his attitude toward values will actually determine the kind of an artist that he is going to be. If, for instance, he is persuaded that the value aspect of his work lies in *direct communication*, he will probably emerge as a highly realistic painter, perhaps even as a commercial artist— although that too implies its own special attitude toward value. If the artist believes that value inheres in the *act* of self-expression—and that any content at all in his work will only serve to impair its value, then obviously he is going to become a nonobjective painter. There are many other kinds of value attitude that artists may adopt as fundamental, and each one will profoundly affect or alter the kind of work that he produces.

It is small wonder then that a conference between artists and aestheticians, which took place at Woodstock a year or so ago, wound up in a complete impasse upon the matter of values. The artists wanted a long and enlightening discussion on the subject, while the men of the aesthetics team stoutly refused to go into the matter. Every artist had hoped to have his point of view either altered or (what is much more likely) implemented by the discussion, and I think that the aestheticians didn't want to commit themselves.

I would heartily endorse a reluctance on their part to set up *absolutes* in value, and I think that was probably their reason

for not going into the subject. I daresay that artists are as well aware as aestheticians of the damage that has been done to art from time to time by the assumption of absolute values. But since values are still the central meaning of art, I think we owe them some passing recognition.

Of course anyone's personal values are those categories of things which he holds most precious—and they always have their opposites, the things he utterly repudiates. Such values are undoubtedly deeply rooted within us and must originate in family and racial and environmental sources and in long-forgotten emotional incidents, as well as in those conscious, intentional beliefs that we all adhere to.

I find that my own array of values—at least the conscious ones —rotate around the central concept of man as the source of all value. Thus whatever institutions and activities have the avowed purpose of broadening man's life, enriching his experience and his self-awareness are particularly dear to me. Everyone is, to some extent, an advocate of his own values. To the artist, and I am quite sure, to the aesthetician—such advocacy is his life's work.

I think that I went out on a limb a little while back, and said that I believe that underlying even symbol-making is the basic need to communicate. Advocacy also requires communication. But that does not at all imply that one must communicate the obvious. I am sure that every new level of public understanding must once have been reached by the introduction of symbols not previously familiar.

The symbols of art are often those representing the deepest reaches of human consciousness. The artist, in formulating such symbols, wishes to convey the *wholeness* of his feeling. He has no desire to say something slightly less, or somewhat different from what he has in mind, and thus meet an existing public standard. To do so would be to cheat his purpose.

I've heard Arthur Miller's play *The Death of a Salesman* quite severely criticized for what has been called its morbid tone. That sort of thing had always been regarded as "very bad box-office" until Miller produced the play, and it turned out to be wonderful box-office. What Miller wanted to emphasize, of course, was that

our national belief in salesmanship is a morbid business. Had he softened the grim picture that he presented, the very meaning of the play would have been defeated.

Communication, which has no doubt been the chief instrument of civilization, has also, and particularly in our time, become its curse. Some twenty to thirty years ago, our great captains of communication discovered a certain hypothetical fourteen-year-old mentality that was supposed to be the norm of the public mind, and they have been assiduously addressing it ever since. This ideal individual is without moral conviction, without taste, without any critical capacity. Thus presumably any matter that is outside or above his intellectual level would be controversial and might end in some major sales disaster. But in their earnest search for an ever and ever more common denominator, the wonderful communication systems have gone far toward *creating* just such a public as the one that they assume. And I think that one might deduce from that situation that *communication cannot be held as an ideal in itself*. There is always the *stature* of the thing communicated. The artist must operate on the assumption that the public consists in the highest order of individual; that he is civilized, cultured, and highly sensitive both to emotional and intellectual contexts. And while the whole public most certainly does not consist in that sort of individual, still the tendency of art is to create such a public—to lift the level of perceptivity, to increase and enrich the average individual's store of values.

Whether there exists some outside hierarchy of values in the light of which those of any given time, or of a nation, or of individuals could be judged true, or false, must, I suppose, always remain a moot question. But if there should be such a hierarchy of values, I believe that they could be, (or have been) achieved only through an earnest search for truth—truth in the zone of politics, or of justice; in the realms of interplanetary space, or planetary affairs—truths of poetic perception; of spiritual matters; of art. Of course these truths themselves must alter with each new era of understanding. But I believe that it is in a certain *devotion to concepts of truth* that we discover values.

The Passion of Sacco-Vanzetti

WALTER GUTMAN

Ben Shahn's exhibition of twenty-three gouaches called *The Passion of Sacco-Vanzetti*, on view at the Downtown Gallery until April 17, is disappointing. A "passion" should mean a narration of sufferings leading to a sacrifice, but this series fails to give any idea of the importance of the agony of Sacco and Vanzetti. It might have been called *The Agonies of Nature*, for it consists of clever satires of human types. There are a policeman, some government officials, a judge, some prominent citizens, and some dilapidated men and women. Most of them are made without clichés; they are amusing; and they illustrate what would seem to be a sound point of view, namely, that the human race is too prevalent at present. But to partisans of Sacco and Vanzetti they must seem flippant. They do not in any way express what these men were to themselves or are to us. The artist has failed to realize any of the emotional or idealistic significances of the martyrdom, nor has he built an interesting hierarchy of characters. His drama rests on personalities, but these personalities have no dramatic division. While the authorities seem brutishly insolent, the underdogs seem brutishly stupid. The real motivation of the pictures is a type of nihilism, whereas the martydom of Sacco and Vanzetti grew from the clashing positivisms of the rulers and the risers. Shahn, however genuinely ambitious he may be to do so, is not the artist to interpret Sacco and Vanzetti. He is too much concerned with the cleverness of his outlook and his craft. If one considers his art from the point of view of his subject, it is not powerful. If one considers it from that of art, there are some agreeable things one can say about it. But why choose a subject like Sacco and Vanzetti if one is not prepared to become a propagandist? Callot, Goya, Daumier, Thomas Nast—all had the ability to invent symbols expressive of their subjects. Shahn

From *The Nation*, 20 April 1932, p. 475.

has not shown that ability. Until his feelings are more passionate, more spontaneous, and more partisan he cannot create those eloquent symbols which are typical of an art deeply concerned with affairs.

The Passion of Sacco-Vanzetti

MATTHEW JOSEPHSON

THE trial and death of Sacco and Vanzetti are now part of our modern revolutionary mythology. The legend of "the good shoe-maker" and "the poor fish-peddler" has evoked a body of literature, juristic, dramatic, poetic and historical; and to this there is now added a quite remarkable and accurate contribution by a young painter, Mr. Ben Shahn, who has made the whole Sacco-Vanzetti case the theme of twenty-three small, bright gouaches, shown during this month at the Downtown Gallery in New York City.

Seen all at once, Mr. Shahn's group of pictures have a vivacity, a dramatic intensity, which is certainly augmented by the historic or folk-lore values of his theme-painting. Yet the painter is by no means a man of narrow gifts; nor is it to be taken that he has in any great measure "betrayed" Pure Art. Indeed he has shown himself a clever draughtsman in this difficult water-color medium. Instead of the gloom one might have expected, one enjoys here the play of a curious, intelligent mind, with a quite literary flair for satire and character; such qualities as one enjoys in a mightier range, of course, in Pascin, or in the mordant, revolutionary Grosz. George Grosz has done a great deal to undermine the German bourgeois by painting them with transparent trousers and skirts. By being similarly "hardboiled," by making his "anarchist bastards" pathetically funny, sallow martyrs—though reverent all the while—Mr. Shahn has been able to let himself go rippingly on the subject of Judge Thayer, the Lowell Committee, the Four Prosecutors and their colleagues. Here is fishy, green-eyed, bony-faced, lantern-jawed Thayer, painted for all posterity in his hollow robes of justice. Here are the three silk-hatted, degenerate-looking Yankees of the Lowell Committee, against a classical, papier-mâché courthouse. Judge Thayer, the

From *The New Republic*, 20 April 1932, p. 275.

Lowell Committee, won out in 1927. But what of 1937 and 2027? One senses, at this point, the enormous, latent power of artists and poets over human events—if they would but use it. The statesmen propose; the artists, poets, historians, dispose, in the long run.

From the perspective of the springtime of 1932, when poor and rich alike have the sacred right to sit on park benches, the lifelong rebellion of Bartolomeo Vanzetti seems always more prophetic. The purple-gray heads of Vanzetti and of Sacco, appearing out of their biers, in the picture called *That Agony is Our Triumph*, make a most dignified last testament.

Our modern painters may emerge, then, from the impasse of Pure Art by way of theme-painting, of symbolist murals or super-realism, provided that they observed the traditional formal demands of good painting.

This collection of water colors, properly named by the painter *The Passion of Sacco-Vanzetti*, should have been held intact, instead of being sold individually. It composes a little monument that might well be preserved by some institution here which approved of the growth of a native revolutionary mythology.

Review of Ben Shahn Exhibition

ONE of the most arresting and vital pictorial documents of our immediate time comes to light in Ben Shahn's *Passion of Sacco-Vanzetti* that Edith Halpert is showing at her Downtown Gallery. Mr. Shahn, who has shown before at this gallery, makes a ten-strike with his series of gouache drawings illustrating with satiric intent the various principals and proceedings of that famous Massachusetts trial. From the superbly realized presentment of Judge Webster Thayer to the row of six witnesses "who bought eels from Vanzetti" the story is unfolded in all its tragic implications. It is the first time in a long while that any American painter has made a pictorial issue of such an event, has used a page of contemporary life for purposes of dramatic interpretation. His work, which has changed considerably in style by becoming more laconic, more basically determined, admirably suits the nature of this tale told with a fine simplicity and yet always poignant and revealing. The Downtown Gallery is apt to become something of a storm center during the two weeks of the exhibition, and Mr. Shahn is henceforth someone to be reckoned with. He also shows a number of the lithographs that he designed to illustrate de Quincy's *Levana*, one of the four essays in *Suspira de Profundis*, the sequel to his *Confessions of an English Opium Eater*. These works, in the earlier manner, are vivid, compelling, and filled with imagination.

From *Art News*, 9 April 1932, p. 10. Reprinted by permission.

Review of a Ben Shahn Exhibition

At the Downtown Gallery this week Ben Shahn is showing his series of sixteen gouaches dealing with the Mooney Case. The foreword to the catalog is written by Diego Rivera. I am told that the Mexican artist became acquainted with Ben Shahn's work last year when he dropped in to see the Sacco and Vanzetti canvases by an artist who was then unknown to him. Rivera was so impressed that he later employed him as an assistant on the murals which, until Tuesday, he was doing for Rockefeller Center.

This show at the Downtown Gallery emphasizes an alive issue of the moment: the place of propaganda in art. And from the point of view of propaganda, Ben Shahn could not have a better case than that of Mooney. Yet I do not see how these paintings advance the cause. To me, they are purely illustrative in treatment. They do not, as they surely should, rouse the emotions and quicken the will to action in behalf of a man so abominably condemned to suffer. They are rather a personal outlet for those feelings for his class which, as Mr. Rivera says, absorb the artist.

Rivera, on the other hand, holds that the "case of Ben Shahn demonstrates that when contemporary art is revolutionary in content, it becomes stronger and imposes itself by the conjunction of its esthetic quality and its human expression. To the extent that it answers the demands of the collective spirit, the collectivity will respond by according success to the painter." An easy recipe to insure success, but not one that will necessarily produce what we call art. Rivera, however, greatly simplifies the whole question by holding that "art should be propaganda," a point of view which will certainly come in for a lot of discussion this coming week.

Looking at the works as painting, however, one is struck with the fine feeling for color. Here one senses the artist in the man,

From *Art News*, 13 May 1933, p. 5. Reprinted by permission.

expressing himself, as it were, subconsciously. In the *Three Lawyers for the Defense*, for example, Ben Shahn depicts the men ranged in a row against a gray background, making, obviously, no effort to please. But he cannot help it. Unconsciously, one feels, he enlivens dull grays and browns with beautiful play of light and shade. Again, the artist protrays the *Two Witnesses*, Mellie Edeau and Sadie Edeau, with uncompromising realism, but can't resist giving one of the ladies a beautiful yellow hat. His color range is small, but with one green, one blue, a yellow, rose and black he can do a great deal. Even in the portrayal of Gov. James Rolph, Jr., which is a telling bit of character delineation, reproduced in last week's issue, one is conscious of an unusual warmth of color, introduced by a sumptuous pink car, contrasted with a yellow waistcoat and buttonhole flower.

Review of a Ben Shahn Exhibition

CLEMENT GREENBERG

BEN Shahn's gift, though indisputable, is rarely effective beyond a surface felicity. What his retrospective show at the Museum of Modern Art (through January 4) makes all too clear is how lacking his art is in density and resonance. These pictures are mere stitchings on the border of the cloth of painting, little flashes of talent that have to be shaded from the glare of high tradition lest they disappear from sight.

Shahn first came to notice as a "socially conscious" painter, working in that routine quasi-expressionist, half-impressionist illustrative manner derived from Cézanne, Vlaminck, and other pre-cubist French artists, examples of which year in and year out fill the halls of the Whitney, Carnegie, and Pepsi-Cola annuals and the showrooms of the Associated American Artists (Bohrod, Brook, Blanch, Bouché, Dodd, Pêne du Bois, Sterne, etc., etc.). Shahn appears to have been momentarily successful within the very narrow limits of this style: thus in the gouache *Walker Greets the Mother of Mooney*, a real instinct for pictorial unity imposes itself on tawdry color and banal drawing. But his real originality, such as it is, emerges only with the entrance of the influence of photography, a medium he has practiced in addition to painting. It was the monocular photograph, with its sudden telescoping of planes, its abrupt leaps from solid foreground to flat distance, that in the early 1930's gave him the formula which remains responsible for most of the successful pictures he has painted since then: the flat, dark, exact silhouette placed upstage against a receding empty, flat plane that is uptilted sharply to close the back of the picture and contradict the indication of deep space. Chirico is felt here.

Some striking pictures issue from this formula. They are all in tempera, which lends itself best to Shahn's precise contours and extremely simple color sense; among them are the *Handball* of

From *The Nation*, 1 November 1947, pp. 481–482. Reprinted by permission.

1939, the *East 12th Street* of 1947, the *Ohio Magic* of 1945. The influence of the photograph, with its startlingly irrational unselectivity of detail, is also applied to advantage in the *Self-Portrait Among Churchgoers* of 1939.

On the whole Shahn's art seems to have improved with time. The later pictures become more sensitive and more painterly. That his "social consciousness" has at the same time become less prominent does not, in my opinion, play much of a role here; it is simply that Shahn gains better control of his medium as he goes along. Yet there has been a certain loss of vigor. Nothing improves upon or repeats the shock of *Handball*. There is an attempt to strengthen and vary color, but to little avail. Shahn, more naturally a photographer than painter, feels only black and white, and is surest of himself when he orients his picture in terms of dark and light. All other chromatic effects tend to become artificial under his brush.

This art is not important, is essentially beside the point as far as ambitious present-day painting is concerned, and is much more derivative than it seems at first glance. There is a poverty of culture and resources, a pinchedness, a resignation to the minor, a certain desire for "quick" acceptance—all of which the scale and cumulative evidence of the present show make more obvious. Yet Shahn has a genuine gift, and that he has not done more with it is perhaps the fault of the milieu in which he has worked, even more than his own.

Ben Shahn

JAMES THRALL SOBY

"ALL art," wrote Roger Fry in *Vision and Design,* "gives us an experience freed from the disturbing conditions of actual life." If we accept this definition, then we must reject much of Ben Shahn's painting, as Fry rejected Bruegel's, for it does more than remind us of the living world; it takes strong issue with contemporary reality, and urges us to sympathetic choice. Shahn himself is the opposite of the "pure" painter nourished in his studio by esthetic faith. He prefers to work part of the week for a labor union or a government bureau, leaving the rest of his time for painting. He feels that he needs this contact with social activity, since otherwise, he says with alarm, "I might be left with a paintbrush in my hand."

In general conviction Shahn has not lacked precursors, of course —Daumier in the nineteenth century, George Grosz in our own, to mention two of the greatest. But what is exceptional about him is that he has been able to effect so direct a translation of his easel art into social instrument, as when he converts some of his paintings into posters by the sole addition of lettering. Moreover, the transfer of function works equally well in reverse; *The Weld-ers* was originally designed as a poster, and is among his most impressive paintings. The same interchangeability applies in another connection. He has twice executed pictures for specific advertising purposes. One of these, rejected by the commissioning agency, survives as a poetic easel painting.

In a word, Shahn's vision is all of one piece. As propagandist he is involved in mass appeal on the far-flung scale peculiar to our times, and consequently faces an insistent temptation to sacrifice quality for communicability. He never yields. His paintings, posters, murals, advertisements, proceed from the same steady eye and are informed by a relentless integrity. All, *pace* Mr. Fry, are art of uncompromising order.

From *Ben Shahn,* Penguin Books (West Drayton, Middlesex, England), 1947, pp. 3–16. Reprinted with permission.

Like several leading American artists of today, Shahn was born in Russia of Jewish parents and came to this country as a child. His heritage is apparent, not only in the larger matters of his compassion and emotional frankness, but also at times in his stylistic usage. His love of bright, flowered patterns and his persistent response to festive occasion seem related to folk-art traditions. Yet since 1931, when he suddenly reached maturity as an artist, he has been unmistakably an American painter, as American as nineteenth century genre artists like Charles Caleb Ward and Eastman Johnson. On the whole he has not shared the earlier painters' devotion to homely anecdote, though sometimes he has drawn near them in this regard, if always on far less obtrusive terms. The *Four Piece Orchestra*, for example, is at least secondarily notable for its humor and for the story-telling contrast of overalled figures to a cellist whose clothes and manner suggest the trained musician.

It is interesting to note how frequently Shahn portrays men informally playing musical instruments, for his art is often so closely identified with American episode that it furnishes a visual parallel to our epic folk songs. Significantly, he remembers himself most clearly as a child listening to a band. His pictures of the ordeal of Sacco and Vanzetti, his painting of the blind accordionist who played out his grief when Roosevelt's funeral procession passed— are akin in simplicity, fervor and tenacity of refrain to such songs as "John Brown's Body" and the modern anti-lynching ballad, "Southern Trees Bear a Strange Fruit."

But whatever the relation of Shahn's painting to folk art and folk songs, he is in no sense a primitive artist. If some of his pictures belong to a series conceived on Sunday excursions through the New Jersey countryside, this is because his subjects are relaxed on that day, and he has always been interested in what people do when in theory they do nothing at all. Far from being a "Sunday painter," Shahn knows everything that can be of use to him about the advanced forms of contemporary art here and abroad. His paintings are far from abstract; indeed, they are nearly all utterly committed to subject. Yet his fine control of placing has benefited from the lessons of cubism and its satellite movements; his work is as inspired in structure as in humanistic content, a fact which once or twice has caused left-wing critics to accuse him of unduly

subordinating message to form. It would be difficult, indeed, to think of another living American artist who has so successfully applied abstract precedent to a personal realism. And his line, though it often carries great satirical weight, can also have the autonomous, hieroglyphic intensity of Paul Klee's drawing, which Shahn reveres.

When Shahn arrived in this country from his native Kovno in 1906, he was already absorbed in drawing, and as a child growing up in the poor sections of Brooklyn, he was often bullied by local toughs into making sidewalk sketches of their sporting idols, working always under a threatening injunction to be exact. From 1913 to 1917 he attended high school at night and during the day was employed as a lithographer's apprentice. He continued to support himself at lithography until 1930, with interruptions, and perhaps this long training accounts in part for the precision with which he now handles such pictorial details as intricate patterns of fabric or minute lettering; certainly it helps to explain the technical proficiency of his lithographed posters.

Shahn's realism is not, however, merely stylistic. It is a fundamental of his philosophic approach. One of the most imaginative of modern American painters, he ordinarily insists on accuracy in his choice and execution of subsidiary motifs. "There's a difference," he says, "in the way a twelve-dollar coat wrinkles from the way a seventy-five-dollar coat wrinkles, and that has to be right. It's just as important esthetically as the difference in the light of the Ile de France and the Brittany Coast. Maybe it's more important." When he includes automobiles in his compositions they must be of a make and vintage their owners could afford; if architecture appears he prefers to have seen its prototype in fact or print. His love of exactitude pertains not only to inanimate accessory but to human contour: the feet and the postures of the boys in *Peter and the Wolf* evoke a sharp memory of American childhood; the springy stance of the youth in the right foreground of *Handball* is unforgettably real. Shahn consistently uses photographs as points of reassurance, and until recent years himself worked expertly at photography. He is no less inventive than the most orthodox surrealist, but he gravely suspects loose flights of fancy. Like John Hersey, who gives in *Hiroshima* the exact trade names of Japanese

sewing machines found in the atomic wreckage, Shahn insists on the facts he transcends.

When he graduated from high school, Shahn attended New York University and then City College of New York, leaving the latter in 1922 to study at the National Academy of Design. In 1925 and again in 1927 he went abroad, and traveled in France, Italy, Spain and North Africa. In Paris he absorbed the art of the living masters, especially, if rather incongruously, Rouault and Dufy. He returned home in 1929, and the following year exhibited at the Downtown Gallery in New York a number of watercolors of African subjects and three studio compositions in oil. There is little in these early works, except quick vigor of line, to indicate the artist he was to become.

In 1930 he went to live at Truro, Cape Cod, and painted a number of small beach scenes in the casual, expressionist technique he had acquired abroad. Then he made up his mind. "I had seen all the right pictures," he says, "and read all the right books—Vollard, Meier-Graefe, David Hume. But still it didn't add up to anything. 'Here am I,' I said to myself, 'Thirty-two years old, the son of a carpenter. I like stories and people. The French school is not for me.' "

He turned first to racial themes, completing twelve remarkable border illustrations for a copy of the Haggada, followed by ten watercolors on the Dreyfus case. "Then I got to thinking about the Sacco-Vanzetti case . . . Ever since I could remember I'd wished that I'd been lucky enough to be alive at a great time— when something big was going on, like the Crucifixion. And suddently I realized I was. Here I was living through another crucifixion. Here was something to paint!" Within seven months he had completed twenty-three gouache paintings on the trial of the American-Italian anarchists, Nicola Sacco and Bartolomeo Vanzetti, convicted of the murder, on April 15, 1920, of a paymaster and his guard in South Braintree, Massachusetts.

A detailed summary of the aberrations of the Sacco-Vanzetti trial was published in the *Atlantic Monthly* for March, 1927, by the Honorable Felix Frankfurter, who became legal advisor to the Sacco-Vanzetti Defense Committee. In brief, no reliable evidence had been adduced to prove that the defendants were at the scene

of the crime, nor had any of the stolen payroll been traced to them. In the hysterical atmosphere of a "Red" hunt then sweeping the country, the two men were nevertheless convicted of murder in the first degree on July 14, 1921, and the presiding judge, Webster Thayer, denied an appeal for a retrial on the tenuous legal grounds that Sacco and Vanzetti exhibited "consciousness of guilt." His summary of the case was riddled with prejudice, his charge to the jury virtually a plea for conviction. But thanks to the efforts of Labor and fair-minded men of all stations, the case dragged on for six years. An appeal to the State Supreme Court failed. As a last resort, Governor Fuller of Massachusetts was deluged with demands for a pardon. His investigating committee, with President Lowell of Harvard as chairman, issued an unfavorable report, and the defendants were executed in August, 1927.

The patent injustice of the Sacco-Vanzetti case inspired fevered demonstrations in the United States and, indeed, throughout the world. But Shahn's series of paintings is remarkable for its restraint. Its accusation is the more deadly for clinging to fact and avoiding extravagant caricature and allegorical disguise: it threads protest through the needle of reality. *The Lowell Committee*, to be sure, is a scalding satirical image, but for the most part the impact of the series comes from its laconic dignity. Judge Thayer, for example, is not presented as a monster, but as a high court functionary, the very man who did what he did, though his narrow eyes and pendulous ear give a clue to inflexibility of mind. Most of the other characters in the case—the defendants, their families, the witnesses, the prosecutors—are depicted much as they appeared in stark press photographs. Yet gradually we become aware how skilful has been the painter's intensification of truth. The handling of the background in *The Lowell Committee* is exceptionally imaginative, and illustrates a recurrent factor in Shahn's art: the use of architectural setting as both psychological foil to human figures and as expressive abstract pattern. The line which moulds the paneling in *Sacco and Vanzetti* goes beyond the descriptive to create a glowing palimpsest. And in the latter picture, for all its understatement, the moral fervor of Vanzetti plays against Sacco's rougher honesty, so that we need no further reminder that it was Vanzetti who spoke the moving valedictory: "Our words—our

lives—our pains nothing! The taking of our lives—the lives of a good shoemaker and a poor fish peddler—all! That last moment belongs to us—that agony is our triumph."

Among the visitors to the New York exhibition of the Sacco-Vanzetti pictures was Diego Rivera, then at work on his murals for Rockefeller Center which were later destroyed for political reasons. Impressed by the exhibition, Rivera hired Shahn as an assistant in the spring of 1933; his influence on the younger painter reached its climax in the latter's first completed mural commission at Roosevelt, New Jersey. Meanwhile, during the summer and fall of 1932, Shahn had completed a second series of small gouache paintings on a public issue—the case of the persecuted labor leader, Tom Mooney. The didactic force of the series is no greater than that of the Sacco-Vanzetti panels, but there is an evident advance in technical assurance. The color, mostly muted and solemn the previous year, now became brilliant and light; yellows, pinks and fresh greens replaced the browns and blacks of the Sacco-Vanzetti gouaches. At the same time, the forms grew bolder, the use of contrasting motifs more skilled. In *Two Witnesses* a tremulous line supplies the devastating facial characterization, but the huge yellow hat shows the painter moving in the direction of Lautrec's compositional boldness. The same new freedom is apparent in Shahn's image of the California governor who refused Mooney a pardon. The figure's vacuous cordiality is suffocatingly real, yet there is more than iconic power to admire in the picture as a whole. The volumes are freely and eloquently distorted for emotive purposes, the opposition of pink automobile to the governor's yellow waistcoat is as arbitrary—and as sensitive—as the French Symbolists' transmutations of natural color.

In 1933 Shahn was enrolled in the Federal Government's Public Works of Art Project, and presently completed eight small tempera panels on Prohibition. . . . His reference to architecture is more detailed in this series than ever before, and he makes frequent use of recessive diagonals as wings to human drama, possibly as a result of his mural training under Rivera. At this period, encouraged by the brilliant American photographer, Walker Evans, Shahn took numerous photographs of New York street scenes, emphasizing an unposed intimacy between figures and setting. He also

became interested in America's insistent public typography—its signs, printed slogans, posters, advertisements—and in the Prohibition series he uses this typography as a choral accompaniment to his figures' actions, while in later paintings its function becomes more purely atmospheric. There results a strangely appealing inner commentary, text within pictorial illustration. Similarly, Shahn often suggests by title and subject a music we cannot hear.

From September, 1935, to May, 1938, Shahn worked for the Farm Security Administration as an artist and, very briefly, as a photographer, with the euphemistic title of "Senior Liaison Officer" to guarantee him a living wage. But he had previously undergone the most bitter experience of his thorny early career. In 1934 he and a fellow artist, Lou Block, had been commissioned by the Federal Emergency Relief Administration to prepare murals for the penitentiary at Riker's Island in New York Harbor. The commission involved months of research and a detailed first-hand documentation of prison conditions; its iconographic plan was to show on opposite walls of a main prison corridor the contrasting aspects of old and reformed penal methods. The completed sketches, almost entirely Shahn's work, were approved by the Mayor and the Commissioner of Correction, but were rejected by the academic-minded Municipal Art Commission in 1935 as "artistically, and in other respects . . . unsatisfactory and unsuitable for the location for which they were intended." A poll of prisoners at another jail proved an overwhelmingly favorable reaction to the sketches, but official charges of "psychological unfitness" prevailed, and the project was abandoned. A painful loss of time, work —and enthusiasm. But Shahn's sketches for the narrow and difficult prison corridor had taught him a control of asymmetric contrasts of space and form which he has since utilized to the full.

His first complete mural was the single-wall fresco at Roosevelt, New Jersey, a considerable achievement despite its stylistic and ideological debt to Rivera. The fresco is installed in the community center of Jersey Homesteads, a Federal housing development for garment workers where Shahn himself lives. Its statement is the most impassioned the artist has made in a large-scale work, its political message the most explicit. At the left of the wall, immigrants follow Einstein down a gangplank, away from Jew-baiting

Germany, past the coffins of the American martyrs, Sacco and Vanzetti. Arrived in this country, the refugees find the contrasts of reality; they sew by hand in poor light, or by machine in good; they sleep in a park or live in a decent home; they work under improved factory conditions or press clothes with heavy irons in a barren, brick stockade. In the fresco's central panel they discover through organized labor the means to guarantee the reforms that appear in the mural's right section: adequate schooling; cooperative stores; the kind of community planning and building exemplified by Jersey Homesteads itself.

The composition is based on the undulant principle which Shahn had adopted in his Riker's Island sketches; frontal groups of figures are projected against deep boxes of space; architectural diagonals act as splints to lively interplays of human action; the forms zigzag in and out, swelling and receding. The result is an emphasis on dramatic contrasts of identity and scale, here perhaps too closely knit and dependent on Rivera. The emphasis has been retained in much of Shahn's subsequent easel and mural painting; he habitually creates a psychological as well as a schematic tension between the segments of his compositions. "(But) most important," he said recently, "is always to have a play back and forth, back and forth. Between the big and the little, the light and the dark, the smiling and the sad, the serious and the comic. I like to have three vanishing points in one plane, or a half dozen in three planes."

In 1938 Shahn and his wife, Bernarda Bryson, began work on thirteen fresco panels for the lobby of the Bronx post office in New York; the task was completed in August, 1939. Since the building is used by a large and changing urban population, rather than by members of a small community of professionally related workers, Shahn decided to create a geographic panorama from which visitors might learn something of their vast nation—the South and the North, agriculture and industry, city and country, planner and worker, and presiding over all, Walt Whitman as teacher and prophet.

Shahn had traveled widely in America during his years with the Farm Security Administration, and he now drew on a stored imagery of the various regions, sometimes in the form of photographs he had taken. In place of the divisional symbolism of the

Jersey Homesteads wall, he substituted a more spontaneous and monumental iconography. His figures are still dramatized through distortions of scale and placing, but they are handled with new fluency and conviction, their plasticity strengthened by fuller use of color in modeling. Though Shahn himself typically prefers the Jersey Homesteads mural because of its intimate identification with its audience, the Bronx panels are a far more impressive esthetic achievement. Observe, for example, the soft, devotional concentration of the Negro who gathers cotton as if it were manna, the skill and inventiveness of *Textile Mills*, with its masterly definition of perspective and clean grasp of inanimate forms. Yet even more exceptional than Shahn's technical prowess is the emotional warmth of the Bronx murals as a whole. In an era when fresco painting has often assumed machinery's cold dryness, Shahn retains an almost romantic intensity of mood. In the Bronx panels he transcends Rivera's schooling to make his own statement, in which may be felt an open and fervid love of the American people and land.

Shahn continued meanwhile to paint easel pictures. The economic distress of the mid-1930's is reflected in certain of his paintings of this period, their anger and protest aroused by incidents he witnessed on his travels through the country. But when he exhibited his easel pictures in 1940, he was revealed not only as a powerful satirist still, but as one of the most gracious of modern American artists. From a savage commentary on a West Virginia coal strike he could turn to the poignant *Vacant Lot*, so penetrating in its evocation of childhood and absorption in play. Soon afterwards he produced the rapt image of a solitary workman playing "Pretty Girl Milking the Cow" to the flutter of autumn leaves. Henceforth his easel subjects are often presented as if viewed through one end of a telescope or the other. His figures loom large and near, or are dwarfed by an intervening space which emphasizes their emotional segregation, their peculiarly American loneliness.

In paintings belonging to both categories, Shahn has restated the esthetic of "unbalance and surprise" which Degas had founded out of a dual regard for the casual, shocking patterns of Japanese prints and of instantaneous photographs. This esthetic had affected

certain American painters of the 1880's and 1890's, not only the celebrated expatriates, Whistler and Mary Cassatt, but also William M. Chase in *Hide and Seek* and Thomas W. Dewing almost continuously, and it has been a conscious influence for older living artists, notably Edward Hopper. But Shahn goes beyond his predecessors in his seizure of the split-second juxtapositions furnished by accident, as though his eye's shutter were capable of faster speeds. His approach to photography was almost certainly dictated by his vision as a painter. Nevertheless, it is significant that as a photographer he has often used the device known as the right-angle view finder, as may be seen in one of his self-portraits. The device makes formal composition difficult, but encourages spontaneity by permitting the photographer to record his subjects unawares. And while Shahn's acute sense of dramatic off-balance has perhaps been sharpened by his own experience with a camera, it owes something to the photographs of Walker Evans and even more to the superb snapshots of Henri Cartier-Bresson, exhibited in New York in 1933, which revealed the extraordinary tensions underlying commonplace actions if "stopped" by a super-sensitive eye.

It remains to be said that while Shahn's painting often records a photographically arrested reality, its impact is quickened by the most exacting and imaginative painterly means. For example, he originally photographed the scene which appears in *Handball*. The painting retains the photograph's opposition of small, dark figures to bright, looming wall; its young athletes are realistic in type and stance. But the painting's architectural background is a composite of New York buildings, and the figures are reduced in number and drastically rearranged by comparison with the photograph. Even when Shahn works quite directly from a photograph, as in *The Welders*, he produces a separate image, in this case through a structural aggrandizement which recalls certain figures in Piero della Francesca's Arrezzo frescoes in hushed clarity and monumentality. In brief, Shahn uses photography as other artists use preliminary sketches, and from its notation proceeds under the compulsion of a painter's inner vision.

From 1940 to 1942 Shahn executed murals for the Social Security Building in Washington, D.C.: three large rectangular panels,

faced by a continuous fresco wall broken by three doorways. The latter shows the Family in the center, flanked on the right by Home Building and Food, on the left by Employment through Public Works and by Education and Recreation for Children. The panels opposite refer to those whom Social Security may most benefit—the old, the crippled, the Negro, the young and poor, migratory workers. Both walls include enlargements of earlier easel works. The school boys playing basketball are projected against *Handball's* composition; the lone figure of *Vacant Lot* appears twice; a central group is based on the painting, *Willis Avenue Bridge*. The change of scale from easel work to mural motif is persuasively effected, though a special virtue of Shahn's easel art is its tight condensation. The Washington murals are far brighter in color than those in the Bronx; the areas are more open; the action more continuously frontal; the contrasts of form less extreme. The result is a new serenity and decorative cohesion which leaves behind both the strenuous didactics of Shahn's Jersey Homesteads wall and the atmospheric romanticism of his Bronx panels.

However impressive Shahn may be as a muralist, he is first and foremost an easel painter. He began his career by creating closely related works in series. He has developed over the past six years into one of the most varied of living American painters, not only as to pictorial discovery but in prevailing mood and expressive means. In an age when a discouraging number of artists have passed in youth the climax of their creative powers, Shahn has grown steadily more eloquent and assured.

In the beginning he depended primarily on line for both structure and accent. His drawing remains the backbone of his art, and perhaps nowhere can his gifts for plastic organization be seen more clearly. . . . In recent years Shahn has used linear and tonal modeling with equal authority, as may be seen in *Hunger*, where the chiaroscuro of the head is complemented by the bold contours defining the hand. He has learned lately to apply transparent over opaque tones, with resultant increase in luminosity and textural vivacity. His color itself has become more and more sensitive, and whereas in earlier paintings he often worked within a close tonal range, now his palette is changeable and rich. In many recent works a blood red recurs with symbolic persistence, as in the felled

trees of certain landscape passages or the steps ascending the ruin in *The Red Stairway*.

. . . We need only compare *Portrait of Myself When Young* with *Reconstruction*, or *Liberation* with *Hunger*, to appreciate his capacity for renewal. He can be ferociously witty, as in the *Self Portrait Among the Churchgoers*, which takes revenge for a sermon preached in the Bronx against his murals there. He can be gentle and tender, as in the *Girl Jumping Rope*. He has no fear of sentimentality, knowing that he can give it adequate dignity. He narrows cosmic horror to a dramatic fragment, as in *Pacific Landscape*, the climax of a recent perseveration concerned with myriad pebbles. And then abruptly he expands a lyric vision to include the paraphernalia of dreams.

There is, however, a constant to be observed in Shahn's painting since roughly 1943. He has become in these recent years more consistently poetic than before, and has shown a formal grace which made itself felt only indirectly in many of his earlier works. The war appears to have released his compassion in more elegiac terms. Though no image of battle could be more grim than *Death on the Beach*, for the most part his reaction to world devastation has been expressed as lyric mourning. He has dwelt particularly on architecture in ruins, and his sorrow has attached to Italy, where almost no fallen stone has merely common meaning. Yet it is as though a relentless faith has relieved the horror he felt at war. Children rather than warriors are his usual protagonists, and he has often projected their inextinguishable imaginative life against scenes of desolation. In *Reconstruction* Italian children pose and teeter upon the shattered blocks of ancient civilization.

Has Shahn's sympathy for the people of Europe led him nearer European sources of art? At any rate, his recent painting, if still plainly American, is linked as never before to those foreign artists, from the fourteenth century Sienese through Fra Angelico to the seventeenth century brothers Le Nain, whose vision was distinguished by a kind of elegant humility. He has progressed lately to a closer communion with lyric, world tradition, though he has sacrificed none of his originality or vigor. The idyllic figure carrying a basket in *The Red Stairway* contrasts startlingly with the 1932 image of Governor Rolph. The pole in *Liberation* is as bright

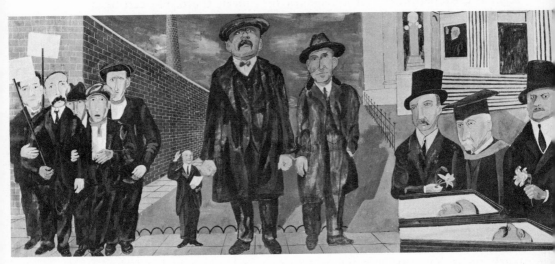

Sacco and Vanzetti BEN SHAHN

1932
Tempera
21″ × 48″
Collection of Mr. and Mrs. H. John Heinz III
Photo courtesy of Kennedy Galleries, New York

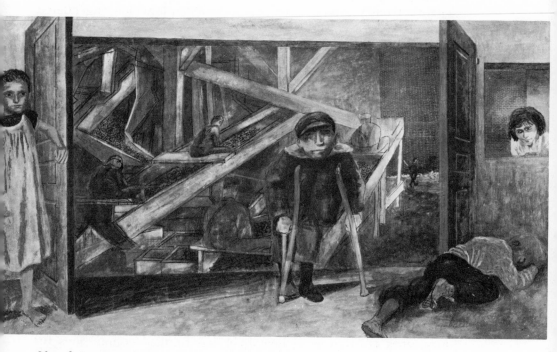

Sketch for Mural, Federal Security Building,
Washington, D.C. BEN SHAHN

1940–42
Tempera
8¾″ × 15½″
Photo courtesy of Kennedy Galleries, New York

and enchanted as a maypole by Ambrogio Lorenzetti; the child at the left of the composition is like an early Renaissance angel of Annunciation—a very far cry indeed from the stumpy figure in *Sunday Painting*. Yet Shahn's recent pictures still derive their vitality from the humanism and love of truth which engendered his first mature works. He painted *Liberation* only after he had seen children swinging wildly in his yard, half in pleasure and half in pop-eyed fear, when it was announced that France was free. The children's legs are piercingly real in weight and flourish. The picture's architectural rubble was painted from a handful of gravel brought in from Shahn's driveway.

"You cannot invent the shape of a stone," the artist explains. But Shahn, who respects reality's humblest fragment, belongs to the rare company of those painters who have achieved a totally creative ambiance for facts. He is becoming known abroad as an artist whose contribution is internationally valid. In this country we can say pridefully that our Federal Government has given him four mural commissions, that our State Department has bought two of his paintings, that our museums own a dozen of his finest works. After an early career studded with rebuffs, he has emerged as one of the most successful of our living painters. Therein lies a paradox. For Shahn, who belongs to the Left, is appreciated by both Left and Right; his work has been published in conservative magazines as often as in liberal; he has fulfilled commissions for labor unions and for industrial corporations; his paintings are bought on completion by collectors of every political hue.

A paradoxical situation, yes—but one of immense reassurance for American artists and plain citizens alike. No one has told Shahn what or how to paint. He has worked from personal conviction, under no imposed directive or compulsion. So doing, he has earned an acclaim which, though in no sense popular as yet, is in diversity something of a tribute to this country's critical resilience, its willingness to treasure the artist who speaks with sincere authority, in whatever idiom he alone prefers.

Section IV
Appendices

A Selected List of Social Realist Artists

Any list such as that which follows of Social Realist painters is of necessity to some degree arbitrary. No doubt some artists will be as offended to find themselves excluded as others will be to find their names included. What I have tried to do is select painters who, for a brief part of their careers or for the entire length of them, based their work on the belief that art was a weapon for social change. In particular I have listed artists who attained some degree of notice and maturity in the Thirties as Social Realists, even if they have long since parted company with didactic art. On the other hand, I have omitted artists who may have considered themselves Social Realists in the Thirties and even after, when, in my judgment, their names have not generally been associated with the period and the movement. My apologies to any artist inadvertently omitted.

Phil Bard
Maurice Becker
Edward Biberman
George Biddle
Henry Billings
Isobel Bishop
Arnold Blanch
Julius Bloch
Lou Block
Peter Blume
Aaron Bohrod
Alexander Brook
Bernarda Bryson
Jacob Burck
Paul Burlin
Nicolai Cikovsky
Adelyne Cross
Adolf Dehn
Aaron Douglas
Camillo Egas
Philip Evergood
Louis Ferstadt
Seymour Fogel

Maurice Freedman
Hugo Gellert
Ruth Gikow
Maurice Glintenkamp
Aaron Goodelman
Max Gordon
Harry Gottlieb
William Gropper
George Grosz
Philip Guston
James Guy
Robert Gwathmey
Minna Harkavy
Abe Harriton
Theodore Haupt
Zoltan Hecht
Joseph Hirsch
Stefan Hirsch
Eitaro Ishigaki
Joe Jones
Lev Landau
Mervin Jules
Leo Katz

Frank Kleinholz
Benjamin Kopman
Yasuo Kuniyoshi
Chet La More
Edward Laning
Jacob Lawrence
Jack Levine
Russell Limbach
Louis Lozowick
Reginald Marsh
Fletcher Martin
Paul Meltsner
Edward Millman
Paul [Pablo] O'Higgins
Elizabeth Olds
George Pickens
Gregorio Prestopino
Walter Quirt
Anton Refregier
Phillip Reisman
Louis Ribak
Emanuele Romano

Lincoln Rothschild
William Sanger
Honoré Scharer
George Schreiber
Ben Shahn
William Siegal
Mitchell Siporin
Miron Sokole
Isaac Soyer
Moses Soyer
Raphael Soyer
Alexander Stavenitz
Harry Sternberg
Chuzo Tomatzu
Abram Tromka
James Turnbull
Tshcacbasov
Stuyvesant Van Veen
Lynd Ward
Max Weber
Nat Werner
Charles White

Notes on Contributors

GWENDOLYN BENNETT is a black poet, one of the Harlem Renaissance, whose poetry continues to be published. At one time a member of the editorial board of the black magazine *Opportunity*, and for a period a member of the faculty at Howard University, she had earlier studied art at Pratt Institute as well as at the Académie Julian and the Ecole de Panthéon in Paris.

GERTRUDE BENSON has been a Carnegie Fellow. Her criticism has appeared in *Art Bulletin*, *The New York Times*, and other journals, and she was the art editor of the *Philadelphia Enquirer*. She joined the faculty of the Philadelphia Museum College of Art in 1960, and in 1964 became the Editor of Publications at the Drexel Institute of Technology in Philadelphia.

THOMAS HART BENTON was known to everyone interested in American art as a leading Regionalist painter, teacher, and spokesman in the Thirties. His work, widely represented in museums throughout the United States, includes murals in such public buildings as the New School for Social Research, the old Whitney Museum on Eighth Street, and the Harry Truman Library. One of the specially invited participants in the first John Reed Club exhibition, he later broke with left-wing artists to try to "Americanize aesthetic attitudes." His "democratic" kind of art, he believed, "reflected the reality of the American people's life and history in a way which the people could comprehend."

ANITA BRENNER, a writer sometimes associated with Lionel Trilling and Eliot Cohen in their public quarrels with the American Communist Party, also wrote as early as 1937 on Stalinist repression in Spain.

JACOB BURCK was a political cartoonist for the *Daily Worker* and the *New Masses*. Later, when his political views changed, he worked for the *Chicago Sun-Times*, and it was for cartoons appearing in that paper

that he was awarded the Pulitzer Prize in 1941. In the Thirties he was considered a spokesman and polemicist for the artists of the Left.

THOMAS CRAVEN, an idiosyncratic Middle-Westerner, despised the School of Paris and lauded the "Americanism" of the Regionalists in his many popular and popularized books and articles. More a publicist for styles and artists he liked than a serious critic, he nevertheless exercised considerable influence.

JOHN STEUART CURRY was famous in the 1930s for his stylized Regionalist paintings, particularly those of his native Kansas. Along with Thomas Hart Benton and Grant Wood, he was one of the most widely exhibited and influential Regionalists. Like so many other artists, he served for a time on the WPA Arts Project.

STUART DAVIS, once president of the Artists' Union and a secretary of the American Artists' Congress, was a modern painter of international reknown who from time to time wrote for various art publications. Never a Social Realist—indeed, he was one of the youngest exhibitors at the startling 1913 Armory show and he continued to paint bright abstractions—he became socially conscious in the Thirties while working on the WPA Arts Projects.

GEORGE DENNISON has written for *Kenyon Review*, *Commentary*, and *Dissent*, and has been an editor of *Arts Magazine*. He has also worked as a Gestalt therapist, and he is best known as an author for his sensitive record of a remarkable experiment in education, *The Lives of Children*, published in 1969.

HUGO GELLERT, one of the editors of the *New Masses* in the early Thirties, is an artist and illustrator who won several important awards in the Forties. His remarks, in the Thirties, can be considered representative of the views of artists who looked to the Communist Party for leadership.

FRANK GETLEIN has been the art critic for the *New Republic* and the *Washington Star* and is the author, with his wife, Dorothy, of a number of books on art. One of these is his monograph on Jack Levine.

Jo GIBBS had contributed art criticism to *The New Yorker*, *Cue*, and *Art Digest*. She became an editor of the last named in the 1940s.

CLEMENT GREENBERG has written many monographs—Miro, Matisse, and Hans Hofmann—and his influential comments on art have appeared in such periodicals as the *Nation*, *Commentary*, *Partisan Review*, *The New York Times Book Review*, and in almost every American art magazine. His book *Art and Culture* is considered by many a key work on mid-twentieth century art.

WALTER GUTMAN wrote art reviews for *The Nation* during the Depression years.

OAKLEY JOHNSON was expelled from his teaching job at a state university in the Thirties because of his Communist opinions. Thereafter he lived for a time in Moscow before returning to New York to write regularly for various Communist Party publications.

JOE JONES, in the Thirties, was one of the best known Social Realist painters, although his work in the main pictured farm rather than industrial activities. He painted many United States Post Office murals, one of which, in Missouri, was suppressed in 1935. He broke with the Left later and served as a war artist with the Army in Alaska during hostilities. (Evergood, Gropper, and Refregier accepted similar appointments, but their commissions were revoked by the War Department because of their political reputations.)

MATTHEW JOSEPHSON was an expatriate in Paris during the Twenties. He was a member of the young surrealist circle of writers and painters and the editor of a little magazine, *Broome*. He has written authoritative works on Zola, Rousseau, Hugo, and Stendhal, and his interest in economics has led to several works on that subject, the first of which was *The Robber Barons*, published in 1934.

HILTON KRAMER, formerly the Managing Editor of *Arts Magazine* and now art news editor of *The New York Times*, taught for a time at Bennington College. He has contributed articles on art and literature to periodicals such as *Commentary*, *Partisan Review*, the *New Re-*

public, and the *New York Review of Books*. He is considered one of America's major art critics.

JOHN KWAIT (probably a pseudonym) wrote on art and related subjects for *New Masses*.

OLIVER LARKIN, who taught at Smith College for virtually his entire career, published *Art and Life in America* in 1949. One of the first major intellectual surveys of the history of American art, it was awarded the Pulitzer Prize in History in 1950. Before his death in 1970 he wrote two more books—one on Samuel F.B. Morse, and the other on Daumier.

ELIZABETH McCAUSLAND, trained by Professor Larkin at Smith College, was for a long period the art critic for the *Springfield Republican*, (Mass.), but her comments had wider notice than the paper's circulation might suggest. She became a well-known critic of American art, one usually friendly to the work of Social Realists, and she contributed an impressive number of articles to *Parnassus*, *Art News*, and other periodicals.

LEWIS MUMFORD, an architect and city planner, frequently wrote criticism on these topics as well as on art and literature. His many books include *Sticks and Stones*, and *Technics and Civilization*. His *City in History* won the National Book Award in 1961. A prolific author of great acuity, he wrote on art for *The New Yorker* for a number of years. Now at work on his autobiography, he has praised the Arts Projects for planting "the seed of the fine arts . . . in every village and byway in the country. . . ."

FAIRFIELD PORTER, a figurative painter respected by the abstract expressionists, has been as active as a writer on art as he has been as a painter. In 1959 he won the Longview Fund award for criticism in *The Nation*. He is the author of *Thomas Eakins*. The recipient of many portrait commissions, he has shown works in major American group exhibitions.

DIEGO RIVERA is the renowned Mexican muralist and easel painter through whose influence Trotsky was allowed to enter Mexico. His inclusion of a portrait of Lenin in his Rockefeller Center mural caused it to be rejected, engendering one of the celebrated causes of the Thirties.

ALINE B. SAARINEN, author of a unique study of art collectors, *The Proud Possessors*, had long been an art critic for *The New York Times*, various art journals, and for television. Her numerous awards include one for the best foreign art criticism at the Venice Bienniale in 1951, another from the American Federations of Arts in 1953, and a Guggenheim fellowship in 1957.

HARRY SALPETER wrote frequently on art and literature before opening his own New York art gallery, where he showed figurative work during the some twenty years he ran it before his death in 1967.

MEYER SCHAPIRO, a distinguished scholar, is now University Professor at Columbia University where he taught for almost forty years. He is the author of books and articles on medieval as well as contemporary art, and he has been an editor of the *Journal of the History of Ideas* and *Dissent*. In 1967 he was the Charles Eliot Norton professor at Harvard, and the following year the Slade Professor at Oxford University.

JAMES THRALL SOBY continues his association, begun in 1943, with the Museum of Modern Art, although his enormous production of monographs appears to have slowed down. In the interval between *After Picasso* in 1935 and a study of Magritte thirty years later, he has published monographs on Dali, de Chirico, Tchelitchew, Rouault, Klee, Modigliani—and no fewer than three books on Ben Shahn.

"MARION SUMMERS" was the pseudonym of a collective of art historians whose criticism appeared frequently in the *Daily Worker* during the Forties.

FREDERICK S. WIGHT is an exhibiting painter and has also written monographs on Van Gogh, Goya, Marin, Morris Graves, Hans Hof-

mann, Arthur Dove, Richard Neutra, and Modigliani. He is Director of the Art Galleries of the University of California at Los Angeles.

CLIFFORD WRIGHT, an American painter living in Denmark, his wife's native country, writes frequently for *Studio International*. In 1963 he published the first book in Danish on the art of the United States.

A Bibliography of Social Realism

Aaron, Daniel. *Writers on the Left*. New York: Harcourt, Brace, & World, 1961.

Agee, William. *The 1930's: Painting and Sculpture in America*. New York: Whitney Museum of American Art, 1968.

Anon. "American Artists' Congress Opens First Annual in Eight Cities." *Art Digest*, 15 April 1937, p. 6.

Anon. "The Angry Art of the Thirties." *Fortune*. March 1955, pp. 88–91.

Anon. "Art and Politics are not Congenial Bedfellows." *California Arts and Architecture*, 50 (October 1936), 7, 44.

Anon. "Chicago's Winners Present a Forlorn America." *Art Digest*, 12 (11 December 1937), 7.

Anon. "Crisis in American Letters." *Mainstream*, Winter 1947, pp. 5–9.

Anon. "Documents: *Cahiers d'Art* Questionnaire on Artists and the Class Struggle." *transition*, 49 No. 5 (1949), 110–126.

Anon. "John Reed Club Resolution Against War." *New Masses*, July 1932, p. 14.

Anon. "L'Art et les masses." *Beaux Arts*, 3 March 1939, p. 1.

Anon. "Obstreperous Art." *Arts and Decoration*, 41 (May 1934), 35–37.

Anon. "Official Reports on Artists' Relief Work." *Art News*, 32 (7 April 1934), 11.

Anon. "Oil by Gropper is Purchased by Metropolitan." *New York Herald Tribune*, 27 May 1937.

Anon. "Proletarianism: America 1936." *Art Digest*, 1 January 1937, p. 13.

Anon. "Proletarianism: America 1936." *Art Digest*, 1 February 1937, pp. 3–4, 23.

Anon. "Proletarian Gloom." *Time*, 14 November 1935, p. 37.

Anon. "Recent Trends in the Arts: Findings of the Committee on Social Trends." *Survey Graphic*, 22 (January 1933), 37–42.

Anon. "R. O'Neal Agrees with A. Millier's Communistic Indictment of the Congress; A. Emptage Disagrees." *Art Digest*, 1 February 1938, pp. 8–9.

Anon. "Two Proletarian Artists: Joe Jones and Gropper." *American Magazine of Art*, 29 (March 1936), 188–189.

Anon. "We Gather Together." *American Magazine of Art*, 29 (February 1936), 130.

Anon. "WPA Takes Stock at Washington." *American Magazine of Art*, August 1936, pp. 504–506.

Arnault, Charles. "Painting and Dialectics." *New Masses*, 14 August 1945, pp. 28–30.

Baron, Herman. *Gropper*. catalog. New York: ACA Gallery, 1941.

Baron, Herman. *Philip Evergood.* catalog. New York: ACA Gallery, 1951.

Barr, Alfred H. Jr. "Is Modern Art Communistic?" *New York Times Magazine,* 14 December 1952, p. 22.

Baskin, Leonard. "The Necessity of the Image." *The Atlantic,* April 1961, pp. 73–76.

Baur, John I. H. *New Art in America: 50 Painters of the 20th Century.* New York: Praeger, 1957.

Baur, John I. H. *Revolution and Tradition in American Art.* Cambridge, Mass.: Harvard University Press, 1951.

Baxendall, Lee. *Marxism and Aesthetics, an Annotated Bibliography.* New York: Humanities Press, 1969.

Benson, E. M. "Artists' Union Hits a New High." *American Magazine of Art,* 29 (February 1936), 113–114.

———. "Two Proletarian Artists: Joe Jones and Gropper." *American Magazine of Art,* 29 (March 1936), 188–189.

———. "Whitney Biennial." *American Magazine of Art,* 29 (April 1936), 258–260.

———. "Whitney Sweepstakes." *American Magazine of Art,* 29 (March 1936), 187–188.

Benton, Thomas Hart. "American Wave." *Art Digest,* 7 (July 1933), 6.

———. *An American In Art,* Lawrence: University Press of Kansas, 1969.

Berdanier, Paul F. Sr. "Social Justice—Bah." *Magazine of Art,* 31 (August 1938), 492.

Bergum, Edwin Berry. "Proletarian and Soviet Art." *Marxist Quarterly* (London), December 1934, p. 633.

Berkman, Aaron. "Revolution in the Art World." *American Mercury,* 34 (March 1935), 332–342.

Biddle, George. *An American Artist's Story.* Boston: Little Brown & Co., 1939.

———. "The Artist Serves His Community." *American Magazine of Art,* 27 (September 1934), 31–32.

———. "Art Under Five Years of Federal Patronage." *American Scholar,* 9 (Summer 1940), 327.

Blume, Peter. "After Surrealism." *New Republic,* 80 (October 31, 1934), 338–340.

———. "On His Painting 'The Eternal City'." *Daily Worker,* 11 January 1938, p. 7.

Boswell, Peyton. "American Art as it is Today." *Studio* (London), 13 (January–February 1937), 4.

———. "Centaur or Mule?" *Art Digest,* 10 (1 March 1936), 3.

———. *Modern American Painting.* New York: Dodd, Mead & Co., 1939.

Brace, Ernest. "William Gropper." *Magazine of Art,* 30 (August 1937), 464.

Brandon, Henry. "A Conversation With Ben Shahn." *New Republic,* 7 July 1958, pp. 15–18.

Brenner, Anita. "Life Crashes the Art Salons." *The Nation*, 138 (2 May 1934), 514–515.

Brown, John E. *Philip Evergood*. catalog. New York: ACA Gallery, n.d.

Brown, Milton W. "The Marxist Approach to Art." *Dialectics*, 2 (1937), 23–31.

Bruce, Edward. "Implications of the Public Works Arts Project." *American Magazine of Art*, 27 (March 1934), 113.

———. "Uncle Sam's Plan: Treasury Department." *Art Digest*, 1 December 1935, p. 3.

Bulliet, C. J. "Too Involved." *Art Digest*, 15 April 1937, p. 6.

Burck, Jacob. "Max Weber—Reborn Artist." *Sunday Worker*, 30 May 1937, p. 8.

———. "Revolution in the Art World." *American Mercury*, 34 (March 1935), 332–342.

Burke, Kenneth. "The Nature of Art Under Capitalism." *The Nation*, 13 December 1933, pp. 675–677.

Burnham, James. "Marxism and Aesthetics." *Symposium*, 4 (1933), 3–30.

Cahill, Holger. "American Art Today." *Parnassus*, May 1939, p. 14.

Canaday, John. *Mainstreams of Modern Art*. New York: Simon and Schuster, 1959.

Calmer, Alan. "Portrait of the Artist as a Proletarian." *Saturday Review of Literature*, 31 July 1937, p. 3.

Calverton, V. F. "Cultural Barometer: Social Art." *Current History*, 48 (January 1938), 56–57.

Chanin, A. L. "Shahn, Sandburg of the Painters." *The Sunday Compass Magazine*, 30 October 1949, p. 14.

Charlot, Jean. "Painter's Insight, Public's Sight." *American Scholar*, 6 (1937), 131–144.

Cheney, Martha. *Modern Art in America*. New York: McGraw-Hill, 1939.

Chipp, Herschel B. *Theories of Modern Art*. With contributions by Peter Selz and Joshua C. Taylor. Berkeley and Los Angeles: University of California Press, 1968.

Christensen, Erwin O. *Index of American Design*. New York: Macmillan, 1950.

Clarke, Vernon. "The Guernica Mural—Picasso and Social Problems." *Science and Society*, Winter 1941, pp. 72–78.

Cohen, George M. *A History of American Art*. New York: Dell, 1971.

Connolly, Cyril. "An American Tragedy." *New Statesman and Nation*, 29 June 1946, pp. 467–468.

Corey, Lewis. "Human Values in Literature and Revolution." *Story*, May 1936, pp. 4–8.

Cowley, Malcolm. *Exiles Return*. New York: W. W. Norton & Co., 1934.

Cowdrey, Mary Bartlett. *American Academy of Fine Arts and American Arts-Union, 1816–1852*. New York: New-York Historical Society, 1953.

Craven, Thomas. "Both Wrong: Rise of the Middle Western School." *Art Digest*, September 1935, p. 14.

———. *Modern Art: the Men, the Movements, the Meaning.* New York: Simon and Schuster, 1934.

———. "Nationalism in Art." *Forum and Century*, 95 (June 1936), 359–361.

———. "Renaissance Near?" *Art Digest*, 1 September 1931, p. 9.

Crawford, W. R. "Freedom in the Arts." *The Annals of the American Academy of Political and Social Science*, 200 (November 1938), 95–101.

Crossman, Richard, ed. *The God That Failed.* New York: Harper, 1949.

Crowninshield, Frank. "The Other Side: A Reply to C.B. Ely on 'The Alien Flood'." *Art Digest*, 15 October 1931, p. 6.

Davidson, Martha. "Art or Propaganda." *Art News*, 36 (25 December 1937), 14.

Davis, Stuart. "Reply to Peyton Boswell's 'Centaur or Mule'." *Art Digest*, 10 (15 March 1936), 25–26.

Devree, Howard. "Two American Shows." *Magazine of Art*, 30 (December 1937), 741–743.

Dimitroff, Georgi. *The United Front Against Fascism and War.* New York: Workers Library Publishers, 1935.

Egbert, Donald Drew. *Socialism and American Art.* Princeton: Princeton University Press, 1967.

Ehrenburg, Ilya. "Culture and Fascism." *New Masses*, 11 No. 9 (29 May 1934), 23.

Ely, Catherine Beach. "The American Artist Loses His Market." *Art Digest*, 1 October 1931, p. 10.

Evergood, Philip. "Art is not a Popsicle." *American Dialog*, 1 (October–November 1964), 15–17.

Farrell, James T. "Notes for a New Literary Controversy." *New Republic*, 29 April 1946, p. 616.

———. "Stalinist Literary Discussion." *New International*, April 1946, p. 112–115.

Fast, Howard. "Art and Politics." *New Masses*, 26 February 1946, pp. 6–8.

Finkelstein, Sidney. "Form and Content of Art." *Masses and Mainstream*, January 1963, pp. 30–50.

Flanagan, Hallie. *Arena.* New York: Duell, Sloan, and Pearce, 1940.

Frankfurter, A. M. "Art and the Depression." *Fine Arts*, 19 (December 1932), 21.

Freundlich, August L. *William Gropper: Retrospective.* Los Angeles: The Ward Ritchie Press, 1968.

Gaunt, William. "Five on Revolutionary Art." *Studio* (London), 11 (February 1936), 74–76.

Geist, Sidney. "Prelude: the 1930's." *Arts*, September 1956, pp. 49–55.

Gellert, Hugo and F. Gardner Clough. "Another Dispute." *Art Digest*, 10 (15 November 1935), 15.

Genauer, Emily. "ACA Gallery Presents Gropper's Work." *New York World-Telegram*, 13 March 1937, p. 9A.

———. "First Big Show Dedicated to New Deal." *New York World-Telegram*, 20 August 1938, p. 15.

———. "Obscure WPA Artists Exhibit Clever Work." *New York World-Telegram*, 20 August 1938, p. 15.

———. "Peace Dominates Fair Art Factions." *New York World-Telegram*, 20 August 1938, p. 15.

Getlein, Frank. *Jack Levine*. New York: Harry N. Abrams, 1966.

Gold, Mike. "Kharkov Conference—Part 1." *New Masses*, February 1931, p. 14.

———. "Kharkov Conference—Part 2." *New Masses*, March 1931, p. 7.

———. "Notes on the Cultural Front." *New Masses*, 7 December 1937, p. 4.

Goodrich, Harold T. "Critics Accused." *Art Digest*, 15 November 1931, p. 6.

Goodrich, Lloyd. *American Genre: The Social Scene in Paintings and Prints*. catalog. New York: Whitney Museum, 1935.

Goodrich, Lloyd and John I. H. Baur. *American Art of Our Century*. New York: Frederick A. Praeger, 1961.

Goodrich, Lloyd and Frederick S. Wight. *Jack Levine*. catalog. Boston: The Institute of Contemporary Art and the Whitney Museum of American Art, 1953.

Grafly, Dorothy. "Art as Argument." *Art Digest*, 7 (15 January 1933), 26.

Graubard, Mark. "The Artist and the Revolutionary Movement." *New Masses*, 31 July 1934, p. 24.

Gregory, Horace. "An American Show." *New Republic*, 73 (11 January 1933), 243.

Gurstein, A. "Artist and Class." *New Masses*, December 1932, pp. 8–9.

Harrington, Michael. "A Marxist Approach to Art." *New International*, Spring 1956, pp. 40–49.

Hauser, Arnold. "The New Outlook." *Art News*, June 1952, pp. 43–46.

Hess, Thomas B. "Ben Shahn Paints a Picture." *Art News*, May 1948, p. 20.

Hicks, Granville. "The Thirties: A Reappraisal." *Saturday Review*, 4 May 1963, pp. 27–28.

Holme, Bryan. "Whitney Annual Exhibition." *Studio* (London), 15 (February 1938) 101–103.

Hopper, I. A. "America in Washington." *American Magazine of Art*, 28 (December 1935), 719–725.

Howe, Irving. "Cultural Conference." *Partisan Review*, 16 (May 1949), 505–511.

Jewell, Edward Alden. "The Place of the Artist in the Community." *Parnassus*, 6 (April 1934), 1–4.

Johns, Orrick. "The John Reed Clubs Meet." *New Masses*, 30 (October 1934), 25–26.

Kainen, Jacob. "Recent Second Artists' Congress Emerges With Broader Program." *Daily Worker*, 27 December 1937, p. 7.

Kent, Rockwell. "Reply to Peyton Boswell's 'Centaur or Mule'." *Art Digest*, 10 (15 April 1936), 14.

Krutch, Joseph Wood. "The Political Subjects." *New Republic*, 18 March 1936, pp. 352–353.

Kuniyoshi, Yasuo and Saul Schary. "Artists' Congress Reply to F. G. Clough." *Art Digest*, 10 (1 December 1935), 34.

LaFollette, Susan. "American Art: Its Economic Aspects." *American Magazine of Art*, June 1935, pp. 36–44.

Lane, James W. "Whitney Museum's Current Biennial." *Parnassus*, 8 (April 1936), 26.

Larkin, Oliver W. *Art and Life in America*. New York: Rinehart & Company, 1949.

———. *Twenty Years of Evergood*. New York: Simon and Schuster, 1946.

Lawson, John Howard. "Art Is a Weapon." *New Masses*, March 19, 1946, pp. 18–26.

Levine, Jack. "Homage to Vincent." *Art News*, December 1938, p. 26.

Lewis, Wyndham. "The Future of American Art." *Creative Art*, 5 (October 1929), 687–690.

Lowe, J. "Recent Directions in American Art." *North American Review*, 246 (December 1938), 385–389.

Lozowick, Louis. "Artist in the Soviet Union." *The Nation*, 135 (13 July 1932), 35–36.

———. "Government in Art: The Status of the Artist in the U.S.S.R." *First American Artists' Congress*. New York: 1936.

———. "John Reed Club Show." *New Masses*, 3 January 1934, p. 27.

Lukacs, Georg. "On Socialist Realism." *International Literature*, 4 (1939), 87–96.

Lunacharsky, A. V. "Marxism and Art." *New Masses*, July 1932, pp. 12–14.

Lurçat, Jean. "The Social Sterility of Painters—Part 1." *Art Front*, May 1935, p. 4.

———. "The Social Sterility of Painters—Part 2." *Art Front*, July 1935, p. 5.

Magill, A. B. "John Reed Clubs." *Daily Worker*, 11 October 1930, p. 4.

Maltz, Albert. "Moving Forward." *New Masses*, 9 April 1946, p. 8.

Mangravite, Peppino. "Aesthetic Freedom and the Artists' Congress." *American Magazine of Art*, 29 (April 1936), 234.

McCausland, Elizabeth. "America Today—A Graphic Experiment." *Print*, 7 (December 1936), 110–111.

McCoy, Garnett. "Poverty, Politics, and Artists." *Art in America*, 53 (August–September 1965), 96.

McMahon, Audrey. "May the Artist Live?" *Parnassus*, 5 (October 1933), 1–4.

Mellquist, Jerome. *The Emergence of an American Art*. New York: Scribners, 1942.

Micacchi, Dario. *Jack Levine*. catalog. Rome: Galleria d'arte il Gabbiano, 1968.

Millier, Arthur. "Artists' Congress Held Red Tool; with a reply." *Art Digest*, 12 (15 January 1938), 12–13.

Minor, Marcia. "Jacob Lawrence's Works and Development." *Daily Worker*, 17 August 1938, p. 7.

Mitchells, K. "The Work of Art in its Social Setting and in its Aesthetic Isolation." *Journal of Aesthetics and Art Criticism*, Summer, 1967, pp. 369–374.

Moe, Ole Henrik. "Ben Shahn." *Kunsten Idag* (Oslo), 1 (1956), 30–58.

Morse, John D. "Ben Shahn: An Interview." *Magazine of Art*, 37 (April 1944), 36–41.

Myers, Bernard S. *Modern Art in the Making*. New York: McGraw-Hill, 1959.

O'Connor Francis V. *Federal Support of the Visual Arts*. Greenwich, Conn.: New York Graphic Society, 1969.

———. "Official Reports on Artists' Relief Work." *Art News*, 7 April 1934, p. 11.

———. Ed. *The New Deal Art Projects, An Anthology of Memoirs*. Washington, D.C.: Smithsonian Institution Press, 1973.

O'Higgins, Pablo. "Art for the People's Sake." *Sunday Worker*, 5 February 1939, Section 3, p. 1.

Orozco, José Clemente. "General Report of the Mexican Delegation to the American Artists' Congress." In *First American Artists' Congress*. New York: 1936.

Pach, Walter. "Rockefeller, Rivera, and Art." *Harper's*, 167 (September 1933), 476–483.

Phillips, William. "Art and Society." *Art Front*, Nos. 3 & 4 (1937), 23–24.

———. "What Happened in the Thirties?" *Commentary*, September 1962, pp. 204–212.

Perret, George Albert. *Gropper*. catalog. New York: ACA Gallery, 1970.

Porter, Fairfield. "Murals for Workers." *Arise: The Labor and Socialist Magazine*, 1 (April 1935), 21–23.

Prellwitz, E. M. "Tempests in Paint Pots." *American Magazine of Art*, 26 (February 1936), 73–76.

Rahv, Phillip. "Twilight of the Thirties." *Partisan Review*, Summer 1939, pp. 3–15.

Read, Herbert. "Picasso and the Marxists." *The London Mercury*, November 1934, pp. 95–96.

———. "Where England Looks to America." *Architectural Record*, March 1937, pp. 45–46.

Reiser, Max. "The Aesthetic Theory of Socialist Realism." *Journal of Aesthetics and Art Criticism*, 16 (December 1957), 237–248.

Rickey, George. "Answering C. J. Bulliet." *Art Digest*, 11 (15 May 1937), 11.

Rivera, Diego. "The Mooney Case." catalog of Ben Shahn exhibition. New York: The Downtown Gallery, 1933.

———. "The Stormy Petrel of American Art: On His Art." *Studio* (London), July 1933, pp. 23–26.

———. "What is Art For?" *Modern Quarterly* (Baltimore), 7 (June 1933), 275–278.

Robeson, Paul. "Paul Robeson Evaluates An Important American Artist." *Daily Worker*, 4 February 1946, p. 11.

Rodman, Selden. "Ben Shahn: Painter of America." *Perspectives U.S.A.*, Fall 1952, pp. 87–97.

———. *Portrait of the Artist as an American*. New York: Harper & Brothers, 1951.

Rose, Barbara. *American Art Since 1900: A Critical History*. New York: Frederick A. Praeger, 1967.

Rosenberg, Harold. "The Wit of William Gropper." *Art Front*, March 1936, pp. 7–8.

Rourke, Constance. "American Art: A Possible Future." *American Magazine of Art*, July 1935, pp. 390–405.

Sayre, A. H. "Whitney Show." *Art News*, 30 May 1936, pp. 5–6.

Schapiro, Meyer. "The Nature of Abstract Art." *Marxist Quarterly*, 1 (January–March 1937), 77–98.

———. "The Patrons of Revolutionary Art." *Marxist Quarterly*, 1 (October–December 1937), 462–466.

———. "The Public Use of Art." *Art Front*, November 1936, pp. 4–6.

Schary, Saul. "Tendencies in American Art." In *First American Artists' Congress*. New York: 1936.

Schomburg, A. A. "Paintings by Negro Artists." *Bulletin of the Milwaukee Art Institute*, 5 (January 1932), 2.

Shahn, Ben. "An Artist's Credo." *College Art Journal*, 9 (Autumn 1949), 43–45.

———. "Art Education 1949: Focus for World Unity." *Magazine of Art*, November 1949, pp. 266–269.

———. "The Artist's Point of View." *Magazine of Art*, November 1949, p. 266.

———. "Realism Reconsidered." *Perspecta*, 1957, pp. 28–35.

———. "Shahn in Amsterdam." *Art in America*, No. 3, 1961, pp. 62–67.

———. *The Shape of Content*. New York: Random House, 1957.

Sillen, Samuel. "Art and Politics." *Daily Worker*, 12 February 1946, p. 7.

———. "Art and Politics." *Daily Worker*, 13 February 1946, p. 6.

———. "Ideology and Art." *Daily Worker*, 14 February 1946, p. 6.

———. "The Path Before Us." *Daily Worker*, 15 February 1946, p. 6.

——. "Spectators or Creators." *Daily Worker*, 16 February 1946, p. 6.

Siqueiros, David Alfaro. "The Mexican Experience in Art." In *First American Artists' Congress*. New York: 1936.

——. "Open Letter to Soviet Painters." *Masses and Mainstream*, March 1956, pp. 1–6.

——. "Rivera's Counter-Revolutionary Road." *New Masses*, 11 No. 9 (29 May 1934), pp. 18–19.

Soby, James Thrall. "Ben Shahn." Museum of Modern Art *Bulletin*, Summer 1947, pp. 1–47.

——. "Ben Shahn and Morris Graves." *Horizon* (London), October 1947, pp. 48–57.

St.-Armand, Henri. "A French Answer to C. B. Ely's 'The American Artist Loses His Market'." *Art Digest*, 15 December 1931, p. 27.

Stamm, John Davies. *Evergood*. catalog. New York: ACA Gallery, 1944.

Stevens, Elizabeth. "The Thirties Revived." *Art Forum*, June 1966, pp. 43–46.

Summers, Marion. "Abstract Art and Bourgeois Culture." *Daily Worker*, 2 January 1947, p. 11.

——. "A Disturbing Vagueness in New Weber Show." *Daily Worker*, 17 March 1946, p. 14.

——. "Behind the Anti-Realist Attitude." *Daily Worker*, 21 July 1946, p. 14.

——. "One Man's Reaction to Nature." *Daily Worker*, 6 March 1946, p. 11.

——. "Problems of the Social Artist." *Daily Worker*, 7 April 1946, p. 14.

——. "Problems of the Social Artist." *Daily Worker*, 14 April 1946, p. 14.

——. "Problems of the Social Artist." *Daily Worker*, 21 April 1946, p. 14.

——. "Realism, Handmaiden of Progress." *Daily Worker*, 14 July 1946, p. 14.

——. "Social Art Must Breathe the Air of the Common Man." *Daily Worker*, 7 April 1946, p. 14.

Ternevetz, Boris. "John Reed Club Art in Moscow." *New Masses*, April 1933, p. 25.

Thwaites, J. and M. Thwaites. "Chicago Artists' Union, First Exhibition." *Magazine of Art*, 31 (January 1938), 39–41.

Trilling, Lionel. *Middle of the Journey*. New York: Viking Press, 1947.

Trotsky, Leon and André Breton. "Manifesto: Towards a Free Revolutionary Art." *Partisan Review*, Fall 1938, pp. 49–53.

Trotsky, Leon. "Art and Politics." *Partisan Review*, 5 (August–September 1938), 3–10.

Von Wiegand, Charmion. "Expressionism and Social Change." *Art Front*, November 1936, pp. 10–13.

Watson, Forbes. "Innocent Bystander." *American Magazine of Art*, 27 (November 1934), 600.

――――. "Innocent Bystander." *American Magazine of Art*, 27 (December 1934), 676.

――――. "Innocent Bystander." *American Magazine of Art*, 28 (January 1935), 43.

――――. "Innocent Bystander." *American Magazine of Art*, 28 (February 1935), 112.

――――. "Innocent Bystander." *American Magazine of Art*, 28 (March 1935), 166.

――――. "Innocent Bystander." *American Magazine of Art*, 28 (May 1935), 284.

――――. "World Without Elegance." *Parnassus*, 7 (May 1935), 2.

Weber, Max. "The Artist, His Audience, and His Outlook." In *First American Artists' Congress*. New York: 1936.

――――. "Whither American Art?" *Menorah Journal*, April 1938, p. 244–247.

Werner, Alfred. "Ben Shahn." *Reconstructionist*, 3 October 1958, p. 16.

Whiting, F. A. Jr. "Two Versions of American Art." *American Magazine of Art*, 29 (December 1936), 812.

Whiting, Phillipa. "Speaking About Art." *American Magazine of Art*, 28 (August 1935), 492.

Wilenski, R. H. "A London Look at U.S. Painting." *Art News*, August 1946, pp. 23–29.

Willison, Thomas. "Revolutionary Art Today." *New Masses*, 1 October 1933, pp. 17–30.

Wolfe, Bertram. "The Patrons of Revolutionary Art." *Marxist Quarterly* (New York), 1 (October–December 1937), pp. 466–470.

Index

Abbot, Berenice, 22
Abramovitz, Albert, 80
abstract art, 7, 122–123, 125, 167, 175–176, 177, 181. *See also* nonobjective art
ACA Gallery, 3, 26, 32 n.33, 162, 165, 203
aesthetician, point of view of, 281
Agee, William, 28–29 n.2
agitprop, in Soviet Union, 62
Alan Gallery, 242
Allston, Washington, 29 n.4
Alston, Charles, 220, 222, 230, 239
Amalgamated Clothing Workers, 135
American art identified and exhibited, 8–9, 17
American Artists' Congress, 128–130, 199; exhibits of, 25, 130, 162; as forum, 18; founding of, 19, 22, 33 n.42; key arguments of, 23–24
American Artists' School, 19, 221
American Art-Union, 17
American Federation of Arts, 232
American folk art, 8, 33 n.36
American neglect of arts, 29 n.4–5
American Negro Exhibition, 221
American Scene, 4, 7, 17; attacked, 95, 102–103; Benton and Craven, 208–209; defended, 100–101, 108–109; social realism aspect of, 29 n.3
American Society of Painters, Sculptors, and Gravers, 113, 130
American Writers League, 19
Arens, Egmont, 198
Armory Show, 7, 74, 75, 128, 194
art: audience and collectors of, 15, 28, 56, 60, 124, 127; as communication, 14, 16, 238–239, 283; forms of, 77, 98–99, 102–105, 119, 123, 125–126; function and meaning of, 16, 17, 84–85, 89; as international language, 57; for the masses, 59–60, 190; as propaganda, 77–78, 84, 87, 92–93, 109, 294; as protest, 3–4, 24; as reflection of class, 16, 54–56, 72, 123–124, 282; as reflection of society, 99–100, 103–105, 116, 118–127; revolutionary, 63,

64–67, 70–72, 100, 106; as self-expression, 14, 282; in Soviet Union, 13, 44, 45, 49, 57–60, 61, 63–64; subject matter of, 108–110, 121–122; as symbol making, 15, 283; as weapon, 18, 55, 57, 64; and WPA, 251, 253, 262, 264. *See also* social realism
art-for-art's-sake, 4, 15, 56, 240
Art Institute of Chicago, 275
artist: as businessman, 6, 56, 67, 112; in class struggle, 71–72; as middle class, 111–112, 114, 124–125; as pander to rich, 123–125; as working class, 11, 15, 18, 34 n.58, 114, 115
Artistes Républicains of 1848, 18
artists: class origins of, 20–21, 111–112; exploitation of, 6, 112–113; government support of, 11–12, 22, 30 n.18, 31 n.20; as Marxists, 6, 13, 70–72; as political beings, 21; in Soviet Union, 13, 44, 45, 49, 57, 59–60, 63–64
Artists Aid Committee, 113
Artists' Committee of Action, 114
Artists Equity, 252
Artists Federation of the 1870 Commune, 18
Artists' Union, 6, 11, 113–117, 161, 221; and *Art Front*, 102; exhibitions of, 12; as forum, 18; function of, 115; gallery of, 26
Art Students League, 172, 208, 230
Ash Can School, 17
Associated American Artists Gallery, 296
Ault, George, 22
Avery, Milton, 22

Bacon, Peggy, 25
Bannarn, Henry, 220, 222, 230, 240
Bard, Phil, 75
Barker, Virgil, 9
Baron, Herman, 130
Barr, Alfred H., 9
Bearden, Romare, 136
Becker, Maurice, 22
Beckmann, Max, 172